EMERGENCE OF THE PATRIARCH
The Mao Xuhui Story

LÜ PENG

EMERGENCE OF THE PATRIARCH

The Mao Xuhui Story

SKIRA

Cover
Mao Xuhui, *Self-Portrait in the Bathroom No. 2*, 2006
Oil on canvas, 160 × 130 cm

Publishing Director
Pietro Della Lucia

Project Manager
Costanza de Bellegarde de Saint Lary

Mao Xuhui's Assistant
Zhang Guanghua

Editor's Assistant
Zhao Yisong

Art Director
Luigi Fiore

Editorial Coordination
Manuela Schiavano
Emma Cavazzini

Copy Editing
Doriana Comerlati

Layout
Sara Marcon

Translation
Stephen Nashef
Shen Zhi

First published in Italy in 2024 by
Skira editore S.p.A.
via Agnello 18
20121 Milano
Italy
skira-arte.com

© 2024 Skira editore

All rights reserved under international copyright conventions.
No part of this book may be reproduced or utilized in any form or by any means, electronic or mechanical, including photocopying, recording, or any information storage and retrieval system, without permission in writing from the publisher.

Printed and bound in Italy. First edition

ISBN: 978-88-572-5379-4 (Lü Peng)
ISBN: 978-88-572-5184-4 (Skira)

Distributed in USA, Canada, Central & South America by ARTBOOK | D.A.P.
75 Broad Street, Suite 630, New York, NY 10004, USA.
Distributed elsewhere in the world by Thames and Hudson Ltd.
181A High Holborn, London WC1V 7QX, United Kingdom

The book frequently draws on Mao Xuhui's personal (unpublished) writings and letters, which are the source of all the artist's quotations that follow, unless otherwise noted. However, it has not always been possible to trace information about the specific sources (diaries, notebooks, sketchbooks, etc.).

CONTENTS

7 Author's Foreword

15 Chapter 1. Enlightenment

17 *Reading and Inspiration*
29 *The Influence of the Plein-Air School*
37 *Experience*
53 *Creating Art as a Student*
70 *Works*

99 Chapter 2. The Tumult of Youth

101 *From Guishan to the Seine*
117 *Poems and Notes: The Quivering of Thought*
140 *"Corporeality"*
148 *Final Purity*
158 *Works*

193 Chapter 3. The New Figurative and Modernism

195 *A Goldmundesque Journey*
201 *The First New Figurative Exhibition*
213 *The New Figurative Continues*
227 *In Defence of Modern Art*
234 *Steppenwolf*
246 *Psychological Narrative*
262 *Works*

281 Chapter 4. The Patriarch

283 *Restless Soul*
298 *Patriarch*
310 *Works*

325 Chapter 5. Immaterial Light
340 *Works*

353 Postscript

357 Biographical Note

AUTHOR'S FOREWORD

From 28 January to 3 February 2016, I was in Kunming. Prior to this, Mao Xuhui and his assistant Zhang Guanghua had already spent some time collecting and organising various resources and documents in preparation for my writing of this book. I spent those few days in Kunming looking through photographs, notes, old diaries, sketchbooks, gouache and oil painting studies, as well as all manner of documents and manuscripts. In his studio in the Chuangku Art Center, to the accompaniment of Western classical music like Bach and Rachmaninoff, we found our minds wandering back to the 1980s, especially when we encountered old photographs or Mao Xuhui's early sketches, items to which our nostalgic sensibility was particularly susceptible. Looking through these materials, I was struck again and again by how quickly time tends to pass and everything is bound to change. What I was hoping to do was to delineate, analyse and evaluate the artistic landscape and questions of a specific historical period through a particular individual, a man who could be described as solitary, arguably even "afflicted".

On 13 November 2009, the China Contemporary Art Academy, which was affiliated with the Chinese National Academy of Arts, officially opened its doors under the directorship of Luo Zhongli, the painter of *Father* (*Fuqin*). No one quite knew the circumstances surrounding the emergence of this new official institution, but the boom in the prices of Chinese contemporary art in the global auction market from 2004 to 2008 had undoubtedly served to increase the prestige of contemporary artists who had previously little to no standing in China's official cultural institutions—contemporary art having almost never featured in official collections. Artists like Zhang Xiaogang, Wang Guangyi, Fang Lijun, Yue Minjun, Liu Xiaodong, Zhou Chunya and Zeng Fanzhi became widely known in Chinese society and the prices their artwork fetched abroad bestowed upon them a somewhat mythical aura. Their work was seen as establishing a "Chinese brand" in the global art market and even led some Western artists to joke, "If only I had a Chinese face!"

Regardless of the true nature of this situation, or whether it might be only the beginning of a broader problem, Chinese contemporary art had been dragged by money into the spotlight in a way that had transfixed and surprised the whole world, just as the rise of the Chinese economy and the impact of the "Made in China" label on the global economy had done in the past. The list of "academicians"—a term often used derisively—at the newly established China Contemporary Art Academy included Xu Bing, Xu Jiang, Sui Jianguo, Wei Ershen, Cai Guoqiang, Wang Jianwei, Ye Yongqing, Wang Gongxin, Lin Tianmiao, Zhan Wang, Feng Mengbo, Song Dong and Qiu Zhijie. During the ceremony when they were invited on stage to receive certificates of their appointment, these artists, who as a group held a wide range of political beliefs, artistic opinions and ethical values, were congratulated by the party, state authorities and the chairman of the National Artists Association. Perceptive observers might have asked themselves what all of this could have meant. Those who attended the December 2008 China Artists Association Directors' Enlarged Meeting would have remembered how that year's "Work Report" condemned cynical realism and political pop art for distorting China's image.

However, less than a year later, official institutions were now openly accepting artforms many had previously considered politically and ideologically suspect. Was contemporary art in China about to embark upon a process of legitimisation? Would these successful artists eventually extend a hand of gratitude to the government? The painter Chen Danqing, who attended the celebration, used the term "roving outlaws" to describe these artists who the day before were believed to be "beyond the pale". There was something prescient about the advice he gave to these maverick academicians who did not play by the rules: "No matter what, don't let your sharpness be worn down, don't slowly wither away. . ." Despite this, many critics have chosen to see this event as the "enlistment" of many formerly marginal and independent artists into the ranks of officialdom.[1]

Mao Xuhui attended the inauguration ceremony as a friend of Zhang Xiaogang. He knew the faces of the people on stage well. Zhang Xiaogang and Ye Yongqing were comrades-in-arms with whom he had studied painting in his youth and held similar artistic views during the modernist movement of the 1980s. Mao Xuhui was once the most important representative of southwestern art during the '85 New Wave, known for his expressionist style and described by critic Gao Minglu as a leading figure in the "current of life" school (in opposition to the other tendency identified by Gao Minglu, which he named "rationalism"). However, he was not one of the appointed members of the new academy, despite the fact there was no shortage of figures on stage who had done little for Chinese modern or contemporary art since 1979 and were far less important than he had been during this formative period of Chinese art history. Scenes from the past thirty years of Mao Xuhui's life appeared one after the other in his mind. He was there to congratulate his friends who had been given appointments, but sitting amongst the audience observing everything taking place before him, he was at a loss for words. After the ceremony was over, he told Zhang Xiaogang that there were some people who ought to have been on stage that weren't and others who shouldn't have been but were. Mao Xuhui clearly had his own assessment of the situation, but such a statement was based on a failure to distinguish his own values from those of official institutions and their ideological underpinnings.

It was already autumn in Beijing and perhaps as a result of the 2008 global financial crisis, the boom in Chinese art prices on the international art market had come to an end. Nevertheless, there was still excitement in the air and the establishment of the China Contemporary Art Academy can be seen as one of the final ripples of glory enjoyed by these "hot shot" artists who first began making waves in 2004. That the peak of their renown was now behind them, however, was a fact little recognised at the time.

"The Constructed Dimension—2010 Chinese Contemporary Art Invitational Exhibition" (*Jian'gou zhi wei—zhongguo dangdai yishu yaoqingzhan*), sponsored by the Chinese National Academy of Arts and the National Art Museum of China and co-sponsored by the China Contemporary Art Academy, opened in the National Art Museum of China on 18 August 2010 as part of the series of events held in honour of the establishment of the China Contemporary Art Academy. On 9 December, an exhibition curated by Gao Minglu and entitled "Farewell to

Mainstream: The Art of Mao Xuhui" (*Chuan shi: Damao de yishu*) opened in the Beijing Yanhuang Art Museum (a private art museum managed and operated by the Minsheng Bank-affiliated Minsheng Art Museum). This exhibition featured a collection of materials and texts produced by Mao Xuhui in the 1980s. Gao Minglu also compiled an illustrated catalogue comprising a selection of documents and letters Mao Xuhui had written, mostly during the 1980s and early 1990s, to provide an insight into the life of this artist from Kunming. However, such a grand solo exhibition did not appear to evoke the same enthusiasm amongst friends as similar events had in the past, which was understandable. That time had passed.

In the early 1990s, many artists and intellectuals were coming to believe that the arrival of free market economics had led to the soul being stifled by money. We can see a hint of chagrin in the notes Mao Xuhui wrote while based in his Zongshuying studio in 1995: "We have yet to do anything earth-shattering, which means we have failed to live up to the wild ambition of our youth." From 1993 to 1994, the intellectual community feared that China's humanist spirit might be waning, as the questions society and artists pondered—about politics, philosophy, religion and all those affairs concerning the human—became increasingly complex. Had something "earth-shattering" taken place? These questions cannot be answered in isolation from value judgments and political views.

Looking back over the materials available to us now, we can see that the path Mao Xuhui took as an artist was somewhat unique in the history of art. After his first forays into painting in the early 1970s, he grew as an artist first under the guidance of the older generation of painters in Kunming and then through the formal training of the art academy, before becoming a prominent figure in a nationwide modernist art movement. As early as 1990, when I was writing an essay about Mao Xuhui's art titled "Figures and Statements of Life" (*Shengming de juxiang yu chenshu*) I quoted a passage from the end of Robin George Collingwood's *The Principles of Art*:

The artist must prophesy not in the sense that he foretells things to come, but in the sense that he tells his audience, at risk of their displeasure, the secrets of their own hearts. His business as an artist is to speak out, to make a clean breast. But what he has to utter is not, as the individualistic theory of art would have us think, his own secrets. As spokesman of his community, the secrets he must utter are theirs. The reason why they need him is that no community altogether knows its own heart; and by failing in this knowledge a community deceives itself on the one subject concerning which ignorance means death. For the evils which come from that ignorance the poet as prophet suggests no remedy, because he has already given one. The remedy is the poem itself. Art is the community's medicine for the worst disease of mind, the corruption of consciousness.[2]

However, it is not merely the displeasure of their audiences that contemporary artists in China must risk today, but also social and political repercussions, as well as the possibility of losing their independent status. Their art lacks institutional guarantees. The values and views behind contemporary art mean that it is not treated as part of the nation's heritage and is on the whole considered

inconsequential by the National Art Museum in Beijing. This is a fact that is often overlooked. What complicates matters is that, despite the opposition to the official Artists Association Mao Xuhui shared with his friends in his youth, he later went on to accept a role as director of the Oil Painting Art Committee of the Yunnan Artists Association, which suggests that over time he came to realise that no other path remained to him by which he might seek validation of his artistic endeavours. At the time, he was not interested in contemplating how his pursuit of formal recognition from official institutions might relate to his youthful goals and ideals. In this regard he was no different from those restless "roving outlaws" who allowed themselves to be co-opted by the China Contemporary Art Academy even though the nation's institutions and ideological surveillance apparatus had yet to fundamentally change. Such reconciliations conducted under politically and ethically ambiguous circumstances often left artists feeling uncomfortable by blurring their former aesthetic and moral boundaries. We live in a complex age. If we lack the ability to form independent values or a historical consciousness that conforms to both reason and spirit, instead choosing to judge art based on fluctuating standards, whatever unequivocal assessments of art history might be expedient at the time, such that the work of artists like Mao Xuhui is deemed rubbish or an example of the spread of societal sickness—or "spiritual pollution"—then art will never be able to become a community's medicine for the corruption of consciousness. In truth, since 1978, regardless of glamorous and grandiose appearances, China has continued to do all it can to obstruct and cleanse what it considers to be a cause of societal sickness. This is something that these artists born in the 1950s and authors of such pioneering work during the 1980s might not have previously anticipated.

While writing this book, I came across a letter I sent to Mao Xuhui on 15 November 1989 which contains the following words: "I'll come back to Kunming soon if possible, but I can't say when for sure. I want to write a book called *Mao Xuhui*, just like that translated copy I have of *Dalí*. I'll try to stay a while in Kunming next year." In August the following year, I went to Kunming, after which, having returned to Chengdu, I immediately completed the article "Figures and Statements of Life". However, it has taken me until today to finish the detailed account of Mao Xuhui's artistic journey in the 1980s. Those were the prime years of this generation. Looking back on it now, a survey of the experiences of an artist during that time is not a simple case study but a perspective from which to regard that period of art history.

This book therefore is not intended to be a hagiography, but a record of the various questions encountered and posed by a young man, born in the 1950s, with a passion for art. The conditions are not available to us to carry out a thorough examination of the lives of every individual, but we can form an understanding of the past and the experiences of a generation through the example of a singular figure who might afford us an insight into the soul of a particular period, to the extent that such a soul is universal, which in turn will allow us to understand the artistic spirit and attitudes to life to which it gave rise. In 1985, Mao Xuhui wrote the following in a letter to his girlfriend: "A great master cannot determine that their crown be bequeathed to a man as opposed to a woman, or even any individual in particular. The master simply leaves it somewhere and anyone who happens to stumble across it is free

to place it on their head. The question is: Do you have the ability to get to that place? Of course, we don't go there for the crown. When someone has made true art, any crown becomes dull and meaningless."[3]

Written on a flight from Hangzhou to Chengdu on 12 February 2018

[1] Translator's note: The use of terms like "enlistment" and "roving outlaws" allude to classical Chinese fictional works like Water Margin, in which virtuous outlaws meet a tragic end after they are granted amnesty by the emperor and enlisted within a corrupt official structure.

[2] Translator's note: Robin George Collingwood, The Principles of Art (Mansfield Centre, CT: Martino Publishing, 2014), p. 336.
[3] Letter from Mao Xuhui to Sun Guojuan, 28 May 1985 (provided by Sun Guojuan).

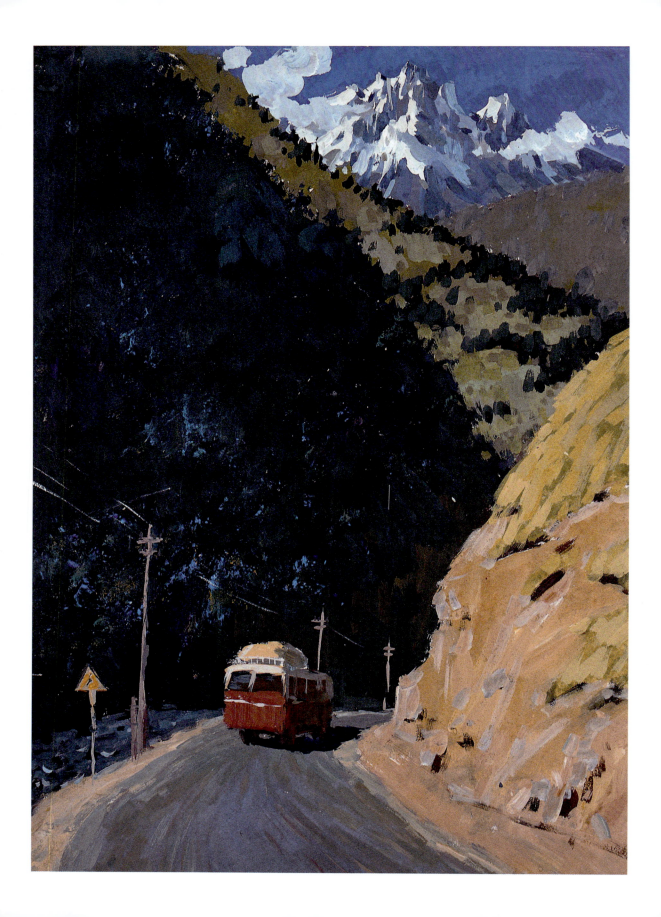

Chapter 1

ENLIGHTENMENT

A lonely Sail afar is gleaming
Across the blue and misty sea.
What happiness, what region dreaming?
Far, far from home, what destiny?

from *A Sail* by Mikhail Lermontou (1832)

The lines in exergue are quoted from the Chinese-language *Lermontov Poetry Collection*.[1] Mao Xuhui once said, "Everyone loved *A Sail* at the time. It was a poem we all knew by heart and took pleasure in reciting."

Mao Xuhui first read Mikhail Lermontov's poetry collection in 1972. The fact that a Russian writer's poem about his own state of mind could leave such a lasting effect on a Chinese youth is related to the meaning and emotion it conveys—the poem testifies to the growing sensibilities of a young boy born to an ordinary family, shedding light on how he began to form an understanding of the empirical world.

Mao Xuhui was born on 2 June 1956 to an ordinary family of teachers in Chongqing in Sichuan province. He was born just as the sun was rising, so his father named him Xuhui.[2] Mao Xuhui writes, "My parents worked in the Chongqing School of Geology (on the second embankment of Jingkou in Shapingba). We lived in a detached courtyard on campus where we could hear the sounds from Jialing River of boatmen's chants and steamers blowing their horns. In 1956, to support development in the border regions, the Chongqing School of Geology transferred some of their teachers to Kunming to establish the Kunming School of Geology." Mao Xuhui was the third of three brothers. The eldest was called Mao Qingxi and the second Mao Dalin. In the summer of 1958, Mao Xuhui and Mao Dalin were sent back to Chongqing to stay with their maternal grandparents. This was the first of many times he was sent there, and he spent many years shuttling back and forth between Chongqing and Kunming.

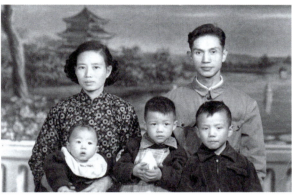

Photograph of Mao Xuhui's family taken in Kunming, 1956. Mao Xuhui is held by his mother, while his father holds his two elder brothers. In the middle is his second elder brother Mao Dalin; on the right, his eldest brother Mao Qingxi. The background is the Daguan Pavilion in Kunming

READING
AND
INSPIRATION

Page 14
Mao Xuhui
Into Lijiang (Zoujin Lijiang), 1978
Gouache on paper, 53 × 42 cm

17

These childhood memories are the main reason for the special emotional connection he would later have with Chongqing. At the Kunming School of Geology, his mother taught Chinese language and his father taught political economy.

Mao Xuhui's father came from a line of traditional Chinese doctors spanning three generations and originating in Sichuan province's Wusheng County. Mao Xuhui's grandfather's medical expertise brought him to Chongqing where he established the Mao Family Clinic in 1927. His father Mao Xiaochu (1925–2007) first got involved with underground Communist Party groups while he was in middle school. A reader of progressive books, he was democratically inclined and a fierce believer in justice; he was later expelled when he led the charge against corrupt officials at his school. In 1945 he was accepted to the Law Department of Chongqing University where he remained in contact with underground Communist Party groups, continued to read avant-garde books and established the Camel Bell Poetry Society, which sought to use poetry to extol democracy and freedom while revealing the darker sides of China's political rule. Because of his active participation in revolutionary activities as a core member of the university's student movement, he was seen as a dissident by the Guomindang[3] and arrested by special agents on 25 April 1949, before being transferred to Chongqing's White Residence Prison. He was lucky enough to escape the execution of all political prisoners ordered by the Guomindang on 27 November 1949. In 1950, he was transferred to the Civil Affairs Department of the East Sichuan Administrative Office and, in 1952, was sent to work in the Southwest Cadre School of Geological Prospecting, later renamed the Chongqing School of Geology. In October 1956, he was selected by the party to travel to Yunnan to help establish the Kunming School of Geology.

The relationship between Mao Xiaochu and Mao Xuhui's mother Chen Chuanzhen (1925–2009), which the couple had initiated independently,[4] was opposed at first by Mao Xiaochu's father who cut off all financial support to his son on the grounds that the woman he had chosen was from a poor family. When Chen Chuanzhen was young, her mother's inability to produce a son, and the premature demise of the daughters to whom she did give birth, led her father to abandon his wife and child and start a new family, which caused the single mother he left behind to go blind from grief. Mao Xuhui's grandmother was a devout Catholic and all those close to her, including Mao Xuhui's mother, also practised the faith. She accepted the marriage between her daughter and Mao Xiaochu but insisted the ceremony took place in a Catholic church. She was very ill at the time and shortly after her daughter's marriage she died in the arms of her son-in-law. These experiences made Mao Xuhui's parents open-minded people who never interfered in their son's life and career choices. He considers this one of the factors that facilitated his decision to become a painter. He also thinks he inherited his love of literature and zealousness from his father, while his mother passed on to him her sentimentality, which often produces in him a peculiar sense of sorrow.

In September 1962, Mao Xuhui was sent to study at Shangma Village Primary School near the Kunming School of Geology. In 1964, his parents were transferred to the Yunnan Geological Bureau on Kunming's Baita Road where his father worked as supervisor of the political department of the mineral exploration

equipment factory and his mother worked in the bureau's trade union. As a result, in September of that year, Mao Xuhui was enrolled in the primary school affiliated with the Geological Department. He studied there until the fourth grade when, in May 1966, the Cultural Revolution broke out causing classes to be cancelled a few months later, in September.[5] Political slogans could be seen and heard throughout every street in China. "During that time when there was no school, all we could do was help adults in different government bodies write big-character posters, hand out leaflets, etch characters on wax paper, and transport barrels of limewash paint on rickshaws to paint slogans on the ground and walls."[6]

These experiences are familiar to most people born in the 1950s. What made Mao Xuhui's situation different was the fact his father was labelled a "traitor" and "capitalist roader" because of his history in Chongqing's White Residence Prison.[7] As a result, he was prohibited from working and taking part in struggle sessions[8] at the factory until 1968, when he was allowed to return home once a week. The "Violent Struggle"[9] reached its peak in Kunming around 1968, and the home of Mao Xuhui's relatives in Chongqing was the only place his family could go to escape. Mao Xuhui remembers that it was while he was staying with his relatives in Chongqing that he read the American novel *Spartacus*, a tragic tale of heroic figures that profoundly affected him. Such notions as tragedy and heroism must have seemed very abstract to a boy who had not finished primary school. Perhaps they merely resonated with certain unconscious mental states that could only acquire a specific direction after he had begun to think for himself and gain a better understanding of the world. In 1969, Mao Xuhui visited Chongqing's Chaotianmen Dock and Liberation Monument with his eldest brother Mao Qingxi, his cousin Zhao Jianshi and his uncle Mao Chaozhong. These frequent excursions deepened the emotional connection he felt with Chongqing. In March of that year, Mao Zedong's call to "Resume Classes and Carry Out the Revolution" meant that middle school students throughout the country went back to class. When Mao Xuhui returned to Kunming, he was sent to the No. 11 Middle School in the suburbs of the city, before being transferred in May to No. 10 Middle School on Baita Road. He describes the enduring memories he has of that time: "Three months learning manufacturing (working the lathe and making components at the Yunnan Machine Tool Factory near Yan'an Hospital), three months learning agriculture (transplanting rice seedlings, raking fields, moistening dry earth), three months learning to be a soldier (marching formations, camp and field training, folding sheets and clothes), and a bunch of politics classes."[10] This was the experience of education shared by all middle school students at the time and was a direct result of the political situation. After the huge political struggle that characterised the first few years of the Cultural Revolution, Mao Zedong's enemies within the party had been eliminated and the former political management structures destroyed. Since the student-led Red Guards movement had accomplished its political goal, Mao Zedong called for graduates to go to the countryside and be re-educated by the poor and lower-middle class peasants. His aim in doing so was to dilute the now uncontrollable force of the Red Guards by scattering them throughout rural China. He hoped that going forward the education sector would be directed by workers and the People's

Liberation Army. The soldiers and workers entering the schools at this time may have had limited educational backgrounds, but Mao Zedong believed they embodied the correct political orientation because they represented the revolutionary proletarian vanguard championed by party leaders. Furthermore, by this point most of the former teachers had been labelled members of the bourgeoisie or were at least assumed to have been inculcated with bourgeois ideas. As such, they too had to be subject to constant political deprogramming and to accept the leadership of the working class and People's Liberation Army.

In March 1971, Mao Xuhui graduated from Kunming No. 10 Middle School and was allocated a job as a porter in the wholesale headwear and footwear department of a Kunming general merchandise store. This was his first encounter with a more complex social world. In his second year, when he was custodian of the Tanhua Temple warehouse, he began to exhibit a love for music. He and his colleagues sang together and when they heard song lyrics they liked, they would write them down. They also learned to play the accordion, harmonica, guitar and the "wenziling" (an eight-stringed instrument similar to a mandolin). On the inside cover of a notebook he used in 1972 to record song lyrics, he wrote, "Write all the lyrics you love here." The notebook contained pictures from the revolutionary operas[11] and Mao Xuhui either copied or cut and pasted the lyrics of many songs from other countries, including a number of love songs which could have easily been seen as bourgeois erotic art: Franz Schubert's *Serenade*, Polish folk song *Mother Has Decided to Marry Me Off*, traditional English folk song *Her Bright Smile Haunts Me Still*, Indonesian Maluku Islands folk song *Such a Shame!*, Romania's *If We'd Never Met*, Russia's *Beautiful Girl You Are Like Spring*, traditional Batak song *Sing Sing So*, Italy's *Torna a Surriento*, and so on.[12] Of course, these were not the sorts of songs one was permitted to sing openly during the Cultural Revolution, but Mao Xuhui and his colleagues continued to share their enthusiasm for such music quietly amongst themselves. In a photo taken in 1974, Mao Xuhui is smiling and enjoying the novelty of playing the violin while dressed in suit and tie belonging to the father of one of his colleagues, which the latter had snuck out of his family home. They could only enjoy this passion for

Family photograph with Mao Xuhui (back row, first from right) and his brother Mao Dalin (back row, second from right) evading the "Violent Struggle" of the Cultural Revolution at their grandfather's house in Chongqing during the Spring Festival in 1968
Photograph taken at the Red Star Photography Studio in Chongqing

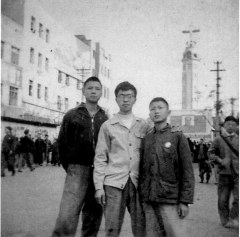

Group photograph with Mao Xuhui (right), his uncle Mao Chaozhong (middle) and his brother Mao Qingxi (left) at the Liberation Monument in Chongqing, 1969

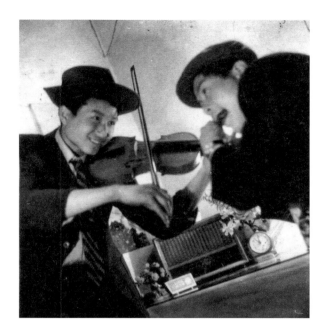

Mao Xuhui (left) and his friend Tang Keqiang (right) studying musical instruments in the Tanhua Temple warehouse dormitory of the Kunming General Merchandise Company, 1974

Lermontov Poetry Collection, Shidai Publishing House, September 1951, 1st edition

Western lifestyles and pastimes by imitating it in the privacy of their dormitory, because in this era during which all that was considered "feudal, bourgeois and reformist" was subject to severe criticism, these kinds of outfits and interests were strictly prohibited. Copying the lyrics of love songs reflects a youthful spirit with which many would identify, but it is also an early sign of this young man's natural yearning for freedom and creativity.

During the Cultural Revolution, music could be heard everywhere, but it was without exception the music of political propaganda. No deviation from the norm in terms of thought and emotion was permitted, and the sounds that could be heard blaring from every corner of the city were all based on Mao Zedong quotes and political slogans. As such, what was described as "the bourgeois tunes of petty emotion" could cause young listeners to get drunk on freedom, to borrow Plato's phrase. But Plato would have had nothing to fear about China at that time, when most people still believed that to enjoy such music in a private space away from society was to risk igniting dangerous longings for freedom. However, human nature means that such surreptitious enjoyment of illicit romantic songs from abroad would continue to take place as long as there were pockets that escaped the reach of this culturally oppressive force, such as the worker dormitories of a small company. In comparison to music, the written word has an even greater potential to inspire independent and rational thinking. In 1972, Mao Xuhui borrowed from his colleague a copy of *Lermontov Poetry Collection* and a Chinese translation of Heinrich Heine's *Poetry Collection* published by Shanghai New Literature and Art Publishing House in 1957. These books were in a poor state of repair after many years of improper care, but the young warehouse supervisor was enthralled by their contents.

An awareness of himself as a living being was gradually beginning to form in Mao Xuhui and he started to see the world through the prism of Lermontov's poem, *A Sail*. Society was as boundless as the ocean, which gave rise to flying waves and crying winds, and the living individual was caught within it like a white sail flapping against its creaking mast. Perhaps what everyone sought was happiness, but what the white sail really needed was a storm—"As though a storm could bring repose!"[13] This line evoked the conflicts and contradictions of inner life. Not only did Mao Xuhui begin to contemplate the meaning of the word "lonely"; he even started to recognise the appeal of solitude. This kind of thinking intensified a certain unconscious mental force within him and ensured *A Sail* was a poem he would always remember. Lermontov also wrote about nation, individual, love and sorrow, and the thought and feeling in all these poems left a profound impression on Mao Xuhui. This kind of writing acted as an oasis quenching the thirst of a young man born in an era bereft of thought and emotion.

Thou ling'rest still, deserted song! Now go,
And seek that long-lost vision; shouldst thou meet it,
On my behalf in loving fashion greet it, —
An airy breath to that dim shade I blow.

from *Visions* by Heinrich Heine

There once lived a knight, who was mournful and bent,
His cheeks white as snow were, and hollow;
He totter'd and stagger'd wherever he went,
A vain vision attempting to follow.
He seeem'd so clumsy and awkward and gauche,
That the flowers and girls, when they saw him approach,
Their merriment scarcely could swallow.

from *Prologue* by Heinrich Heine

I'll ascend the distant mountains
Where the peaceful huts are standing,
Where the breezes free are blowing,
And the bosom free's expanding.

from *Preface* by Heinrich Heine[14]

Like Lermontov's poetry, the work of German poet Heinrich Heine piqued Mao Xuhui's desire for freedom and humanity. The collection he read also featured beautiful illustrations that he dutifully traced in his notebook. However, it was still a very different atmosphere from that of the post-1978 poetry revival, and Mao Xuhui could only enjoy foreign literature and publications in private as it was still prohibited to read such works in public during the Cultural Revolution.

Mao Xuhui sought a deeper meaning in the texts he came across and was constantly noting down various passages relating to philosophy, history, politics,

Heinrich Heine's *Poetry Collection*, translated by Qian Chunqi, published by Shanghai New Literature and Art Publishing House, 1957, frontispiece

Heinrich Heine's *Poetry Collection*, translated by Qian Chunqi, published by Shanghai New Literature and Art Publishing House, 1957, pages 264–65

art and literature in the books and materials he read. He considered it valuable to return to these quotes which inspired him to think. Lermontov's *A Sail* was copied down in its entirety in his notebook.

Mao Xuhui was early to start developing an understanding of European culture and art history when he began transcribing extracts from the book *A Selection of Humanist Essays by Bourgeois Writers and Artists from the Renaissance to the Nineteenth Century*.[15] He copied such passages as Dante's "An individual is not ennobled by his family, but his family by him", and Giovanni Boccaccio's "Men are born equal" and "Wisdom is the source of happiness".[16] Mao Xuhui also copied lines from *The Notebooks of Leonardo da Vinci*: "And those men who are inventors and interpreters between Nature and Man, as compared with boasters and declaimers of the works of others, must be regarded and not otherwise esteemed than as the object in front of a mirror, when compared with its image seen in the mirror. For the first is something in itself, and the other nothingness—folks little indebted to Nature, since it is only by chance that they wear the human form and without it I might class them with the herd of beasts."[17]

He also began to form an understanding of human nature through these thinkers. He copied parts of Michel de Montaigne's philosophical prose to acquire a new perspective on human beings, their insignificance and potential for stupidity. This French writer's critique of human conceit contained ideas he had never come across before, such as the notion that all one can affirm through prolonged contemplation is one's own ignorance. Such a worldview was a striking contrast to the absolute truths and political platitudes about liberating humanity being promulgated by Beijing at the time. Mao Xuhui also copied the entirety of the biographical introduction to William Shakespeare into his notebook. He recognised that Shakespeare and the other humanists valued the right to pursue individual happiness above all others and emphasised that social status did not affect a human's essence. He also copied down a passage from Romeo and Juliet:

> *Conceit, more rich in matter than in words,*
> *Brags of his substance, not of ornament:*
> *They are but beggars that can count their worth;*
> *But my true love is grown to such excess*
> *I cannot sum up sum of half my wealth.*[18]

He also transcribed biographical information about various Western artists like Joshua Reynolds. Later Mao Xuhui would become much more familiar with the lives and works of such Western artists, but during the Cultural Revolution it was no easy task to gain access to such books. It was a time when reading about Western culture and playing the violin dressed in a suit had a similarly powerful effect on the psyche. Through these art history books, he gradually broadened his knowledge of Western painters such as Raphael, Rembrandt and Peter Paul Rubens. In his notebooks, Mao Xuhui was amassing a series of quotations and ideas that were completely different from what he had read in textbooks, newspapers and the big-character posters and political slogans emblazoned all over the city. Aside from

copying down Reynolds' famous speech about art, he also underlined the sections he thought were of particular importance:

Artistic tastes have unalterable and fixed foundations in nature, and are therefore equally investigated by reason, and by study; Art that appeals to reason is superior to art that appeals to sentiment.

But without such exaggeration, we may go so far as to assert, that a painter stands in need of more knowledge than is to be picked off his pallet, or collected by looking on his model, whether it be in life or in picture. He can never be a great artist who is grossly illiterate.[19]

Artists like Eugène Delacroix and Auguste Rodin, musicians like Ludwig van Beethoven, philosophers like Immanuel Kant, thinkers like Nikolay Chernyshevsky and writers like Stendhal provided perspectives on art that Mao Xuhui read, recorded and studied. Although the book he had been lucky enough to come across presented Western thought in a systematic manner, the writers it featured, who lived at different historical periods and were engaged in different cultural pursuits, did not so much provide him with the foundations for a specific system of thought, but rather activated his mind by introducing him to a different kind of language and new modes of thinking. More important than the established wisdoms a certain phrase might convey to him was its ability to clear away the mass of political mantras and slogans that cluttered his mind, thereby endowing him with the potential and impetus to continue his endless exploration of the inexhaustible sources of knowledge.

As his reading increased, so too did his ability to contemplate problems. The official thinking of the time had been imparted to him in various forms, from textbooks and official documents to meetings, but the books about Western thought he furtively read inspired him to develop a new understanding of life. His notebooks contain evidence of such reflection and independent inquiry. It is worth quoting in length from what he wrote in 1974 because it describes in detail his thinking at the time:

When you head east, through the broad and straight Dongfeng Road, you have already reached the fields in the suburbs. For me, the suburbs are a delicious dessert. They are vast and extensive, with layers of hills further in the distance. One can see the factories at the foot of the hills. The fields emit waves of fragrance (a genuine freshness unmatched by any garden). In spring, yellow waves roll in the warm spring breeze through fields of light-yellow rapeseed flowers under the azure sky. Groups of bees buzz busily above the flowers. Whenever I am in these fields, an indescribable joy fills my heart.
Today I was strolling, slowly, along a narrow track in the fields, and the clear water on both sides murmured softly. I was thinking then about Ba Jin's novel The Family, *which I had been reading for the past few days. The book is filled with grief and pain, tears and misfortunes. I see many people fighting, struggling, and resisting in the stream of life, those who cannot stand the test of struggle cowardly withdrawn.*

Many are restrained by the old customs; they cannot breathe, but they dare not make a sound, hiding in corners, shedding tears at falling petals, and sighing. One should accept new thoughts and be brave enough to struggle. Those who dare not struggle only reopen their own wounds and never find their way out. No matter how miserable they are, I will not sympathise with them.

This book is from a few decades ago, and looking at it now it seems a bit out-of-date. However, if you analyse it carefully, there is still much to be learned from it. (March 1974)

How long can a person live? If you count the days, it is frightening. There are about 360 days in a year; if you live to 60, it is only about thirty-thousand days. Such small numbers! An infant in his mother's arms has already turned into a grey-haired old man.

It being so frightening, how do some people cherish it? Some only desire to get through this life peacefully, without any twists and turns. This is enough to fulfil them. When they look back, they might lament things past: "Oh, how short this life is, and in these many years, how few were spent in joy." (March 1974)

My fleeting life, after more than a decade, my heart is still filled with love and hate, with happiness and pain. When I love, I love passionately, with all my heart, and when I hate something, I want to conquer it and fiercely struggle with it. When I'm happy, I feel proud and pleased with myself; when I'm in pain, I seek new light in the darkness.

. . .

I was as excited as everyone: I had never seen such great snow like this in my life. I stood on higher ground so I could see further into the field, which had turned white, and the trees were all silver. It was indeed a beautiful sight. And a hawk was flying in the sky above the field. It was fighting, circling high and low. It was engulfed by the snow for a while, but then it charged out from another place immediately. So brave is the hawk! I was admiring it in my heart. I was moved by this hawk: such a strong fighting will! In a great blizzard like this, it was fearless and still flying courageously. I watched this mountain hawk until I could no longer see it.

In our journey of life, we must be like the hawk who has a fearless spirit, a strong fighting will and an unwavering belief in victory. (27 March 1974)

All notes and diary entries are a result of one's desires and perspective. Here the way Mao Xuhui attempts to make sense of human life seems almost instinctive. In his notebooks that span different eras, he has not only copied down quotes he considered important but also recorded his own reflections upon and understanding of the issues. This is evidence of the fact that the effects of the official education system on his mind was not immutable. The new things he read were beginning to inspire in him a desire to understand a greater range of possibilities for the future. It was this state of mind and philosophical foundation that formed the conditions for his studies going forward.

Latent within everyone is the inclination and talent to paint, but certain circumstances are required for them to become manifest. Perhaps the earliest signs of

Mao Xuhui's artistic inclination can be seen in his notebook of song lyrics. After copying down the lyrics of a song, he often illustrated it with a drawing that acted as a pictorial interpretation of its content. These drawings also reveal his aesthetic preference for the exotic. In 1973, Mao Xuhui came across an instruction book for painting by Mikhail B. Khrapkovsky called *Letters to Beginner Painters*.[20] At least in the city of Kunming, there have been many artists who have described the influence this introduction to painting had on their lives. We can imagine that this book, which Mao Xuhui encountered just at the moment he was most in need of artistic direction, must have resembled a bible for art. Of particular import is the fact that the author does not limit his discussions of artistic learning to purely technical questions. In the opening he writes:

Simply explaining to young painters how to sketch correctly does not suffice. One must also indicate to them the correct artistic path.

As well as teaching beginners the necessary techniques for sketching, it is also important to awaken their creative thinking and guide them in approaching the phenomena of life in a creative way by broadening their horizons and making them see the beauty of nature.

The book discusses the views of many established artists, quoting from such towering figures as Leonardo da Vinci, Auguste Rodin, Ilya Repin, Albrecht Dürer, Rembrandt and Nicolas Poussin. The function of this kind of education on young artists is not merely to teach painting techniques but more importantly to provide a conceptual understanding of the path that the history of art has taken. The work of great artists like Pavel Chistyakov, Ilya Repin, Jean Siméon Chardin, Vasily Surikov and Raphael began to leave its mark on Mao Xuhui through the book's blurry black-and-white images. Although the poor-quality, monochrome printing in this early art book lacked the detail required for a thorough appraisal of the paintings within, an enthusiastic reader would be able to draw from their imagination to fill in the gaps and acquire an understanding of these works. Through these images, traces of Western art history were slowly leaving their mark upon this young student of painting.

From what remains of the sketches Mao Xuhui completed in 1973, we can clearly see his output at this stage lacked maturity and complexity. From the perspective of Soviet art education, his training had only just started. Perhaps the guidance of painters with more experience helped him to discover some of the mistakes he was making, because on various sketches he has written notes to himself on areas to improve. For example, on *Drawing of Yuantong Temple* (*Yuantong si xiesheng*) he writes, "The perspective of the stone bridge is all wrong—it's so glaring it affects the whole picture", and on *Drawing Dusk at the Pumping Station by Jinzhi River* (*Jinzhi hebian choushuizhan xiesheng bangwan*) he notes, "I haven't captured the flowing water in the river." The perspective in *Leather Jacket on Chair* (*Yizishang de pijiake*) is also clearly not right. The lighting, structure, tone and depth are those of a beginner, and there is no sense of texture to speak of. It's clear that despite the fact he had already read *Letters to Beginner Painters*, the true impact of this book's teachings would only gradually materialise later.

In November 1974, Mao Xuhui was transferred back to the general merchandise store's wholesale headwear and footwear headquarters on Baoshan Street, where he worked as pricing clerk and statistician in the finance and accounting office. From the materials available to us today, it would seem that this was when he first took the plunge into portraiture. He also collected various photographs and prints for future reference, which he extracted from a wide range of sources and pasted into a handmade scrapbook. It was a visually monotonous age during which any image with an exotic or unusual quality could spark one's imagination. In these spiritually barren times, it was difficult to encounter art that could satisfy one's psychological and emotional needs. The unforgiving political environment also meant that most human knowledge and thought was considered heretical. National power lay squarely in the hands of Mao Zedong, his wife Jiang Qing and their political faction. Although Zhou Enlai's illness meant Deng Xiaoping would take over his responsibilities running daily affairs in February 1973, the guiding ideology was still defined by figures such as Jiang Qing who continued to prohibit all art that contradicted official aesthetic norms.

On 19 July, Zhang Tiesheng, a young man who had failed his university exams, had a letter in the *Liaoning Daily* published in which he expressed his bitter disapproval of the university examination system. The letter was a denial of the necessity of knowledge and was used as a weapon in the political conflicts of the time. The Liaoning Provincial Party Secretary Mao Yuanxin wrote that Zhang Tiesheng, "may have submitted blank examination papers for physics and chemistry, but he has also provided an insightful and thought-provoking answer to the broader question of university admissions". In his self-righteous tone, he even went on to ask, "Should our standards for admission be one's performance in the Three Great Revolutions[21] or the score one gets in a culture exam?" In the end, Zhang Tiesheng was accepted to university and was named the "Blank Exam Paper Hero". The words and deeds of Zhang Tiesheng proved that acquiring knowledge through study was nowhere near as important as promoting the political opinions and slogans that fulfilled the requirements of those in power. On 21 October, Huang Shuai, a student at the Beijing Zhongguancun No. 1 Primary School, sent a letter to the *Beijing Daily* voicing her dissatisfaction with the way her teacher had asked students to adhere to class discipline rules (particularly his inappropriate use of language and mocking tone). She wrote in her letter, "In the era of Mao Zedong, must the youth really still be slaves under the tyranny of an old education system that advocates the 'majesty of the teacher'?" A disagreement between teacher and student that ought to have been settled on an individual basis was seized upon and amplified by the Jiang Qing faction, which resulted in an editor's note in the newspaper that transformed the minor affair into a political question of vital importance: "The courage Huang Shuai displayed in attacking the reformist education system is a vigorous demonstration of the new generation's revolutionary spirit nourished by Mao Zedong Thought." The young primary school student was referred to as the "Little Hero Going Against the Tide".[22] This was the political and social context in which Mao Xuhui started to learn painting. He began his art studies in 1975 under the tutelage of Yang Shijie, a man who worked for an acrobatic troupe. According to Mao Xuhui, "he lived in a single-

storey house on Kunming's noisy Chajie Street, was gloomy, untalkative and liked the art of the Peredvizhniki." Aside from demonstrating how to trace the artworks of Surikov, Yang also took Mao Xuhui out to the country to paint landscapes.

In 1976, Mao Xuhui read a Soviet young adult novel, published by China Youth Publishing House in 1959, called *Early Dawn*, which was based on the true story of the short life of Kolya Dmitriev, a young Soviet artist. Dmitriev started to paint as a child and was already stunning people with the maturity of his artworks at the age of fifteen when he was killed by a misfiring rifle during a hunting trip. He provided the illustrations for Ivan Turgenev's story *The Singers* and Ivan Krylov's *Fables*. His oil paintings gave the impression of being in the presence of a master and included works like *Prelude* and *Lyabinka Village Street*,[23] images of which were reproduced in the book Mao Xuhui read. The novel describes Dmitriev's family, his girlfriend, his life in art school, his friendship with classmates and his creative explorations. Although it was written in the Soviet period, the writer Lev Kassil's use of elegant language and dramatization of his protagonist's story was both moving and inspiring. It formed a striking contrast with the shrill and brusque tone of the political slogans and essays people heard and read every day. For the young Mao Xuhui, who was living in a country devoid of literature, poetry and art, it had a tantalising effect. Furthermore, the maturity of this young prodigy's art provided Mao Xuhui with a glimmer of hope, the aspiration that one day he too might become an artist.[24] Just like the music he enjoyed, the words contained in this book nourished his soul. He copied down large sections in his notebook to which he frequently returned:

In truth, dear child, you should know this. If you really want to become an artist, you must understand many things. An artist should recognise flowers and stones, understand bird songs, know the quirks of wild animals and the habits of humans. He should be familiar with everything—laws of light (that is optics), the movements of the stars, the changes in history, and the structure of the Earth ... Yes, dear little one, it must be this way! Also, the formation of crystals and the structure of human society. The price of bread, steam and electricity, the order of nations, and the principles that atoms secretly adhere to—all of these should govern the imagination of a true artist. Otherwise, he will become a flower that bears no fruit.[25]

This knowledgeable and insightful book was clearly an inspiration. It described an education untainted by ideology, an openness to the world that was difficult to come by in China at the time and formed an interesting juxtaposition with the critique recently levelled at the so-called "Black Paintings".[26] Like many of his generation in China, Mao Xuhui for some time saw in this Soviet artist who died at the age of fifteen a model to be emulated.

All forests, whether lush or barren, are teeming with living things both great and small. If you only cast your eyes upon the towering trees and vast landscapes, you will miss the lowlier lives eking out an existence in the cracks, slithering through the mud, crawling under rocks. Only the keen observer perceives the means of survival and modes of being of creatures like the humble ant. It is largely a need that emerges from somewhere deep inside, the dark recesses of the unconscious, that leads you to your destination. You begin to make out a few inconsequential figures whose way of life and feeling for the world resemble your own. In the 1960s and 1970s, Mao Xuhui discovered some painters in the forest that is Kunming, marginal figures living an inconspicuous existence who nonetheless drew Mao Xuhui to them for no other reason than they offered what he sought. He felt an affinity with these artists who would provide him with spiritual sustenance.

In the 1960s and 1970s, in various places around Kunming, including Green Lake, Haigeng, the Western Hills, Xiba Plant Nursery, as well as the city's thoroughfares and alleys, one would often see young people walking with ragged pochade boxes in their hands, or perhaps standing or squatting before a canvas,

THE INFLUENCE OF THE PLEIN-AIR SCHOOL

Pages 73–74 of transcribed songbook, used whilst working on Baoshan Street, October 1972

Pages 75–76 of transcribed songbook, used whilst working on Baoshan Street, October 1972

Excerpts from Immanuel Kant, transcribed in Mao Xuhui's notebook dated October 1973 to April 1980

engrossed in the act of painting the scene before them with oils. At the time, the practice was commonly referred to as "little landscape painting". Looking back on this phenomenon that lasted for almost twenty years, the art world today prefers the term "plein-air painting".[27]

This is artist Li Xiangrong's account of a period of art history largely forgotten. The paintings of artists mentioned in the article—Sha Lin, Jiang Gaoyi, Pei Wenkun, Pei Wenlu, Gan Jiawei and Chen Chongping—had a profound influence on the young Mao Xuhui.

They were negligible figures, living and struggling unnoticed on the fringes of society, and most of them came from families with no political standing. They were therefore not qualified to join the masses carrying out "big criticisms" all over the city and could only try to distance themselves from the fate meted out by the roaming crowds. However, they loved to paint, and painting was what brought these children of "cow demons and snake spirits"[28] together to pursue their shared interest. The oppressive environment of that harsh and colourless age meant such pursuits had been almost entirely extinguished. Mao Xuhui writes:

On the one hand, these painters did not wholly endorse or conform to the modus operandi of the Cultural Revolution, whereby a group of art professionals, led and financially sponsored by government departments, created artworks. This nonconformity was caused by many factors and concerned the social statuses and family backgrounds of these "amateur painters" and "art enthusiasts". During the Cultural Revolution, there was a strict classification based on class status. If one were born a "worker-peasant-soldier", one would have a bright future. However, if one was unfortunately born into the "Five Black Categories",[29] one's prospect would inevitably be shrouded in shadow. This was the universal and harsh reality of that era. Many "amateur painters" and "art enthusiasts" had problematic backgrounds, and it was hard for them to become the elite of that era, regardless of their talents. These "amateur painters" and "art enthusiasts" were commoners of this city, working in the factories or teaching in elementary schools. Only a limited few could take art propaganda jobs that were remotely related to their hobbies, and their primary responsibilities were writing political slogans and creating propaganda paintings, which hardly had anything to do with real painting. Most of these individuals were born before 1949 and experienced great upheavals and changes in Chinese society during their childhood and adolescence. Growing up in this border city, their formative years were intricately tied to the vicissitudes of the city.

They loved this city: its sunshine and sky, the waves and the morning light of Dianchi Lake, the boats and the water at Daguanlou, the crowd appreciating flowers on the begonia forest track on Yuantong Mountain, the lotus pond and the willows lining the bank of Green Lake, the wutong forest track and fallen leaves of Xijiao Plant Nursery, the clamour of the Zhuantang pier and shipyard, the old houses with celadon tiles and white walls along Panlong River, the Western-style buildings

on Sanshi Street, Jinbi Road and Xunjin Street, and the ancient architecture from the Ming and Qing dynasties along Wucheng Road, Weiyuan Street and Changchun Road. Day after day, year after year, regardless of the seasons, in the scorching sun or after the rain, dusk or dawn, they passionately painted the city and its suburbs. This way of painting influenced how people saw the city for a whole decade and became a fashion. On Sundays, you could often see the plein-air painters painting in parks, streets and alleys with their pochade boxes put up on the rear of their bicycles. They gave people an intuitive demonstration of what colours were, what oil painting was, and what the beauty of this city was. Bear in mind this happened during a period of intense political campaigns, and these everyday painting activities gave the city a unique charm. I was young at that time. Amidst the tension, unpredictability and chaos of the recurring political campaigns, seeing these people painting our city brought a beautiful sense of hope to my soul. I dreamed of becoming someone like them, painting under the sunlight.[30]

In these ants roaming through the city, Mao Xuhui saw a group of sensitive individuals with beautiful souls:

[The plein-air school] was always building their sacred and glamorous palace, working hard towards it, with primal obsessions and innocent fantasies. Every era has people like them, unsettled by the prevailing values, living elsewhere. They shared their innermost thoughts privately, considering each other as kindred spirits, comrades and friends. As time passed, their creations often gathered dust, overlooked and forgotten, to the point where even they themselves abandoned their once cherished illusions, returning to reality and assuming the role of a normal person.[31]

There are many unusual and interesting descriptions of these painters' devotion and passion:

Pei Wenkun's appearance was particularly memorable because his idiosyncratic look would appear "cool" even by the standards of the twenty-first century. His lanky body and long, narrow face resembled that of modern-day movie star Wang Zhiwen, except his jet-black hair was longer, and he wore a pair of old-fashioned rectangular black glasses perched on his nose. Over his dark grey shirt he wore a light grey suit jacket, which was uncommon at the time (it was made by his mother), and his trousers were long and baggy. There were always splotches of paint on his clothes. It's said that one day he was painting the lake in Haigeng and just as he was really getting into it a gust of wind blew away the tissues he used to wipe his paintbrushes. Dusk was settling in and he had nothing to clean his brush with, so, in his eagerness to paint, he began wiping the brush on the corner of his suit jacket.[32]

Pei Wenkun liked to paint the Dianchi and Haigeng lakes and was particularly influenced by Russian painters Isaac Levitan and Ivan Aivasovsky. The tone of his work is grey but bright, his brushwork free and unrestrained, and his handling of light has an impressionist quality. His landscape paintings had a

direct influence on Mao Xuhui, and he left a deep and vivid impression on the young painter, as can be seen in the following passage:

Old Pei was, in my opinion, a true maestro. He was lean and tall, with glasses stuck on his thin face. His long black hair waved in the air like a May Fourth youth,[33] his eyes always gazing into the distance. I hardly saw him smile, but his speech was gentle. Whenever we came across him doing plein-air painting, we would all pack away our pochade boxes and stand behind him to watch him work. No matter how many times you had seen him paint, you would never know where he would begin today. He didn't adhere to the rules and procedures familiar to the academy; he painted in his own way. . . . I remember this one afternoon the most: the sky was brilliantly clear, the sunlight dazzling, and Old Pei stood on the beach facing Dianchi Lake against the light. The wind and the waves were loud, and the waves rolled towards the shore rhythmically, spewing white foam. Waterbirds circled in the sky, and you could see the reflections of fishing boats moving on the lake in the distance. Old Pei set up his easel, held a brush in his hand, and gazed at Dianchi Lake for a long time. I held my breath and waited for him to start. After observing for some time, he worked on his palette swiftly, like a master chef cooking a dish. He mixed an olive-greyish-green colour and eagerly applied it, stroke by stroke, onto the canvas. It took me a while to understand that he was starting with the shadowed parts of the rolling waves. As he continued painting the spume and the sky in thick, bright tones, those initial strokes of olive-greyish-green seemed to become translucent and convey a dynamic sense of undulation.[34]

There is no comprehensive history of art from Kunming. In his essays "A Survey of Yunnan Oil Painting" (*Yunnan youhua gaishu*) (2005) and "Artistic Marvels in the Red-Earth Highlands" (2015),[35] the renowned and accomplished artist Yao Zhonghua discusses the development of Kunming art since the early twentieth century and the lives of its influential figures. Although he describes how artists from Yunnan and beyond had an impact on art in the city, he barely mentions the painters of "little landscapes" and the names of the members of the plein-air school rarely feature in his discussion.[36] Based on his own artistic awakening, Mao Xuhui has noted that these painter "ants" did have an influence on future artistic practice, if only his own. Much of his artistic education—from sketching and using colour to observing nature and understanding art through painting—was largely inspired by the colour and light in plein-air painting. He recounts his memories of the period in his essay on the origins of modern art in Kunming:

As a painter, I grew up watching those paintings and their painting methods. In the 1960s and 1970s, Kunming, like other parts of China, was engulfed in intense political campaigns. The Cultural Revolution broke out before I completed elementary school. After only two incomplete years of junior high school, I joined a state-owned enterprise and became a child labourer in the wholesale department of a local general merchandise store. My generation grew up in the economic depression and the political fervour of the time. Whether it was the hardships of

Mao Xuhui sketching in Haigeng, Kunming, 1976

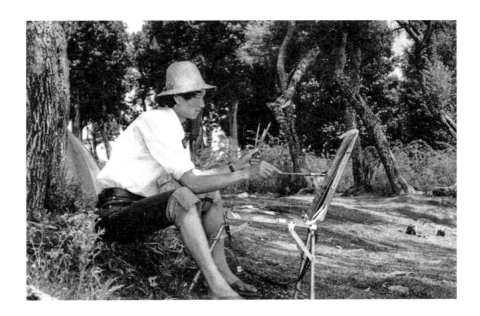

labour or the complex social realities, neither could provide a young person with a genuinely promising future. It was in those years that I met these painters who had a passion for landscapes and were active in this city. What their way of painting under the sunlight revealed to a young person like me was an alternative vision of life, a lifestyle free from revolutionary or political undertones and hollow abstractions. It turned out that there were more possibilities in life and that life could be spent creating things in a beautiful way. This brand-new revelation had an indelible impact on young people during that era.[37]

The natural and urban landscapes painted by what Mao Xuhui would later call the plein-air school were his primary point of reference in the years between 1973 to 1977. This was when he started to paint landscapes, met with the Kunming plein-air painters and began to make frequent "weekend trips to Daguanlou, Green Lake Park, Yuantong Mountain, Haigeng Park, Xihua Plant Nursery (now Xihua Park) and the suburbs to paint."

Mao Xuhui's time working on Baoshan Street also had a lasting impact on him. After being assigned a job as pricing clerk and statistician in the finance and accounting office in the general merchandise store's wholesale headwear and footwear headquarters in November 1974, he developed the habit of making to-do lists to organise his daily tasks. Many years later, as the leading figure of the New Figurative movement, he meticulously managed the limited funds they were able to raise for which he made clear and transparent accounts. It was also in this year that he started to paint portraiture. The sketches that remain from this period admittedly reveal a limited technical understanding. However, by the second half of 1976, one can perceive a change in his portraits, which begin to exhibit a greater awareness of structure and light.

Mao Xuhui began learning from the plein-air school in 1973, and by 1975 his landscape paintings revealed a sensitivity to and solid grasp of light and colour. One

33 | THE INFLUENCE OF THE PLEIN-AIR SCHOOL

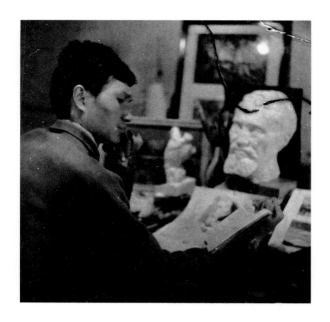

Mao Xuhui before starting university at the dormitory of Kunming General Merchandise Company, 1976

can already see an assured technique in paintings like *Looking at Panlong River from Desheng Bridge* (*Cong deshengqiao kan panlongjiang*), *Haigeng in Summer* (*Xiari de haigeng*) and *Drawing of Haikou, Kunming* (*Kunming haikou xiesheng*). Most of these paintings are a direct result of the influence of the plein-air school. Even at this early stage, his use of bold strokes to depict the glare of the sunlight and the contrast between cold and warmth pay testament to his capabilities as a painter. Although these techniques were not unique to Mao Xuhui, close inspection of his use of colour and brushstrokes reveals the extent of his natural talent. The plein-air school clearly inspired him to start drawing with the regularity of someone writing diary entries. He frequently painted with gouache, often inside his office where he tried to get down a general impression of the scene outside his window as quickly as possible. While working at the wholesale headwear and footwear headquarters, Mao Xuhui painted the scenes he saw on the streets near his workplace and dormitory, such as Tongren Street, Baoshan Street, Jinbi Road, Nanping Street and Dongfeng Road. The bright colours and uninhibited brushwork of these swiftly painted works reflect the exotic quality of the plein-air school's impressions of old Kunming. The streets and architecture of the city bore the traces of its history and as such constantly fascinated those of its residents who liked to paint.[38]

1976 was a year of national political crisis. Premier Zhou Enlai died in January, and the millions who came out on the streets to mourn his passing spoke to the people's discontent. In those politically austere times, people thought fondly of Zhou Enlai, who came across as amiable and caring, and expressed their dissatisfaction with the Jiang Qing faction through the act of mourning their former premier. In July, Zhu De, one of the founding fathers of the Communist Party of China, passed away and the people's unwavering commitment to important political figures was dealt another blow. Finally, when Mao Zedong died in September, it was for many as if the ground had given way beneath them. It was difficult for most Chinese people to adapt to Mao's death. His many years of rule and political teachings had meant the people placed the fates of both themselves as individuals and the nation at large on the shoulders of this one man. Now, the Great Leader had passed away, and the people were terrified about what the future would bring. It was an unstable time. Too many tensions had formed over the previous ten years of the Cultural Revolution that required resolution. The sense that there was a need for change was palpable. Mao's s death led to a power imbalance in the party, which brought about fierce political struggles. In October, members of the older generation of communist revolutionaries arrested one of the members of Jiang Qing's political faction, thereby consolidating their power. In July 1977, Deng Xiaoping, who was seen by Mao Zedong as the archetypal capitalist roader within the party and subsequently purged for a second time in April 1976, re-emerged to take political

power.[39] His stewardship of the party would bring about decisive transformations in China's political, economic and cultural spheres. For Mao Xuhui, the biggest impact of all this was that his father's political difficulties were over. The need to redress the injustices of the Cultural Revolution implied that the party's designation of his father as a class enemy was a mistake requiring rectification, and the increased freedom his father subsequently enjoyed gave the family more room to breathe. Mao Xuhui produced more than one painting of the memorial processions following Mao Zedong's death. In one 27 x 39 cm piece he uses broad strokes to depict the sunlit mourners; the hastily rendered floral wreaths and banners were the only sign of the historical significance of the moment. In this work, Mao Xuhui was clearly interested in capturing the dappled light on the procession of mourners, much as Claude Monet was interested in the play of light on his dead wife's face. It is less what is being depicted that is important here than the way light and colour come together in the painting to arouse the artist's interest. Mao Xuhui later said, "The year when Zhou Enlai and Mao Zedong passed away in quick succession, Su Xinhong and I stood on the roof of the general merchandise store watching the scene of people marching through the streets to mourn the deaths of these great figures, and we started to paint. Below us was Jinri Park and its fountain, with the general merchandise store on its right. The procession made its way from Dongfeng West Road, with Sanshi Street on its right."[40]

In the summer of 1976, Mao Xuhui was assigned to a "Learn from Dazhai in agriculture" work team.[41] He travelled with the team to the Xinjie Brigade in Baofeng Commune, Jinning County, where he met Xia Wei who was living there as a sent-down youth.[42] Mao Xuhui produced many landscape paintings during his time in Jinning. To find an assistant to help him paint the display windows for the Jinning general merchandise store, he went to a painting course organised by the Jinning Cultural Centre where he met other sent-down youths like Zhang Xiaogang, Chen Yiyun and Yang Yijiang. However, at this stage they were yet to become friends, and Zhang Xiaogang's apparent lack of self-confidence caused Mao Xuhui to doubt his ability to complete the task. As a result, Mao Xuhui chose Xia Wei, Chen Yiyun and Peng Shuming to be his assistants. For Zhang Xiaogang, Mao Xuhui was someone he had already heard much about. He was intrigued by this man who had come from the city and was renowned for his basketball and painting skills. Years later, Zhang Xiaogang would describe his first impressions of Mao Xuhui:

I remember the first time I met him was around early summer in 1977 on a fine art course for peasants in Yunnan's Jinning County. I was living there as a sent-down youth and because I liked to paint, I was often assigned "creative" jobs by the county administration. "Little Mao" was a cadre leader at the Baofeng Commune (a different rank from us). For that course, Director Xiang from the County Cultural Centre used his personal connections to invite some seasoned painters from Kunming to come to Jining and teach. Apparently, one of them said, "There's a master landscape painter hiding in your county called Little Mao." So Little Mao was personally invited to be a "distinguished guest" for a few days. I was a nobody in Kunming and knew very few people there, but through this painting course, I had

acquired a rough idea of the main figures in Kunming's art scene. Then one day at noon, a friend excitedly told me, "Little Mao's here!"

Even Little Mao's entrance was out of the ordinary. As soon as he had put down his bags, he joined in with a basketball game taking place on the court. After that he enthusiastically talked to us about two films he had seen recently, a love film with beautiful scenery called Ciprian Porumbescu and Walter Defends Sarajevo. He told us Ciprian Porumbescu was shot so beautifully, with such excellent composition and colour! And the most moving scene in Walter Defends Sarajevo was when the sound of a rifle shot caused a guerrilla fighter to fall and a huge flock of pigeons to fly across the screen... You can imagine the profound impression it left on me as a youth learning painting. This was the first time I met Mao Xuhui. Although he was only two years older than me, we were of a different rank (he was a cadre and I was a sent-down youth), so we didn't have the chance to really get to know one another. (2005)

On 13 August 1977, in Beijing, the Ministry of Education held the National Higher Education Student Admission Conference where they decided to resume the Gaokao examination system.[43] In the winter of 1977, Mao Xuhui's "Learn from Dazhai in agriculture" team was assigned a different rural site in Chenggong, but he continued to spend his time going all over the region to paint the "plein-air" scenes he was so captivated by. He registered for the art college examination in Chenggong and in 1978 received an acceptance letter from the Fine Arts Department in Kunming Normal College (later renamed the Yunnan Arts University), which at the time was the only college in Yunnan that had an art major. As far as Mao Xuhui's future was concerned, this was a decisive turning point in his life.

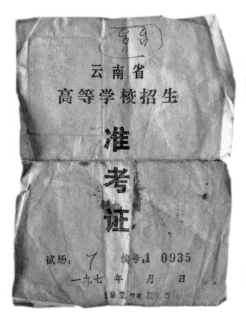

Mao Xuhui's admission ticket to Yunnan Province Higher Education Entrance Exams, December 1977

During his experience in the "Learn from Dazhai in Agriculture" work team, Mao Xuhui never stopped painting landscapes in his spare time. Two landscapes painted on Liangwang Mountain and the area surrounding Chenggong demonstrate the sincerity and simplicity of his painting approach in those days. In March 1978, Mao Xuhui finally began his studies in oil painting at the Fine Arts Department of the Kunming Normal College (previously known as the Southwest Associated University Normal College), where he started learning drawing fundamentals more or less according to the proto-Soviet Chistyakov system.[44] The Chistyakov system was not new to Mao Xuhui who had come across related images when he visited older painters who had studied in universities outside of Yunnan or had been transferred to Yunnan for work. Chinese art enthusiasts in the 1950s found the Chistyakov system very convincing, in large part because of its influence on the paintings of the Russian Peredvizhniki.[45] These Chinese students of art invariably sought to fashion their own painting approach by learning from Chistyakov system textbooks, Peredvizhniki artworks and the teachings of Konstantin Maksimov,[46] which meant there was little substantial difference in their output. A photograph from 1976 shows us that during his time working for the general store, Mao Xuhui and his friends looked far and wide for plaster casts they could use to practise sketching, but it was only when he started studying at Kunming Normal College that his plaster cast sketching saw a noticeable improvement. One sketch in August 1978 received a mark of 85 out of 100 by his teacher and was more accomplished than the sketch of a plaster cast mouth he had completed in April of the same year. However, his *Apollo* (*Aboluo*) drawing two months later was even more impressive. His teacher demanded his students accentuate a sense of depth and atmospheric perspective in their work, which was a more mature long-term approach to drawing techniques and structural composition.

Towards the end of 1977, Mao Xuhui, Zhang Xiaogang, Ye Yongqing and others had begun to consider the possibility of getting into university. Around the time of the entrance examination, they went to a photo studio to have a picture taken commemorating the occasion. Mao Xuhui seems happy, seemingly confident about his exam performance, at least far more relaxed in appearance than Zhang Xiaogang in the first row. A fellow painter who met Mao Xuhui in Jinning, Zhang Xiaogang later said that he lacked the confidence to face his own future at the time. Ye Yongqing, on the other hand, got into Sichuan Fine Arts Institute in 1978.

EXPERIENCE

Mao Xuhui and his art friends during the national college entrance exams in 1977. Front row, from the right: Zhang Xiaogang and one of his classmates; back row, from the right: Liu Yong, Mao Xuhui, Ye Yongqing, Chen Yiyun

However, in terms of painting, the three of them shared common interests and artistic tendencies and so they became friends. The atmosphere and environment of the university post-Cultural Revolution left a profound impression on Mao Xuhui, as Nie Rongqing writes: "One evening, Mao Xuhui was walking on the playing field after leaving the canteen when he suddenly heard Schubert's *Serenade* being played from the loudspeakers. He froze on the spot as tears welled up in his eyes and rolled down his cheeks. He couldn't quite believe that this kind of music was being played publicly. It was as if the world had been turned upside down."[47] During their first summer holidays in August 1978, Mao Xuhui invited Zhang Xiaogang and two other classmates, Zhang Chongming and Chen Xiaoyan, to go to Lijiang to paint. The landscapes they drew there, as well as those they went on to do in other places like the farm at Xundian Academy, were completed with the methods they learned from the plein-air school. While in Lijiang, he bought his first Western art book, *Rodin's Theory of Art*. All he had read prior to this were old books published in the 1950s that, despite the ban on books promoting bourgeois thought, had survived the Cultural Revolution in people's private collections.[48] After 1976, China gradually started to publish books from the West touching on philosophy, history, politics, economics and culture. In a small bookshop in Lijiang, Mao Xuhui discovered a book by Rodin, a name with which he was already familiar, and realised he could finally properly read this French sculptor's story. He copied down a passage in his notebook:

> Guard against imitating your elders. While respecting the tradition, learn to discern what it contains that is eternally fecund: the love of Nature and sincerity. These are the two strong passions of the geniuses. All have loved Nature, and they have never lied. Thus, tradition hands you the key ... It is the tradition itself which demands you to constantly question reality and prevents you from submitting blindly to any master.

For Mao Xuhui, this kind of guidance acted more as a kind of mental preparation, providing encouragement and spiritual support for his artistic career. Rodin's specific ideas and opinions about art might have only had an oblique effect on this young man born in Chongqing and raised in Kunming, but we can be certain that the passages he underlined so as to return to them later—such as, "There is a low exactitude, that of photography and of casting", "The most beautiful subjects can be found before you: they are those you know best" and "If your talent is new, you will at first have but few partisans and swarms of enemies"[49]—had a lasting impact. Building on his compositional skill honed through many years of drawing, Mao Xuhui also discovered a series of new images in the foreign films he watched. He was fascinated by the novelty of these films that featured people of different colours and creeds. Their visual arrangement on screen, as well as their words and actions, came together to form an image one was tempted to paint. Mao Xuhui depicted the characters and scenes of various films from memory, including the Soviet film *How the Steel Was Tempered*, the French film *Le Silencieux*, the Mexican film *Corazón salvaje*, the Yugoslavian film *The Bridge*, the Japanese film *Kimi yo Fundo no Kawa o Watare* and the British film *Death on the Nile*. Mao Xuhui and his fellow painters were

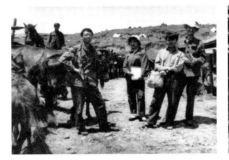
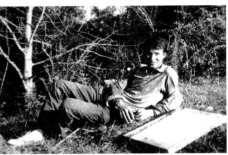

During the summer holiday of his first year in university, Mao Xuhui went sketching in Lijiang with classmates, summer 1978. From the left: Zhang Xiaogang, Chen Xiaoyan, Zhang Chongming and Mao Xuhui

During his university years, Mao Xuhui went to Jiangchuan County in Yunnan to draw, 1978

Classmates from the 1977 art class of Kunming Normal College visited the five hundred Arhats statues inside the Qiongzhu Temple in the western suburbs of Kunming, toured the mountains behind Qiongzhu Temple and took a group photograph, autumn 1978. Mao Xuhui is the person standing in back row, first from the right

39 | Experience

most drawn to exotic films with unfamiliar stories and characters who possessed markedly different dispositions from Chinese people. During this period, Zhang Xiaogang also made many sketches of scenes from films. From around 1978 to 1980, the image of the Westerner became something young painters wanted to capture. Their many years learning drawing at school, as well as the plein-air pencil sketches they had been doing since 1977 and the colouring they added later from imagination, all laid the groundwork for their future artistic practice. For many years, they frequently went out to draw landscapes. In May 1979, Mao Xuhui and his classmates went to the Gushan Brigade in Jiangchuan County's Jiangcheng Commune to draw. He was now capable of sketching everything he saw with ease, as though he were completing a school assignment. In the August and September of their summer holidays, he travelled with Zhang Xiaogang, Ye Yongqing, Yang Yijiang and a few other classmates to Nuohei Village, which was part of the Haiyi Commune in Shilin County's Guishan region. Nuohei Village is a mountain village that is home to the Sani people.[50] In the early 1950s, Huang Yongyu, a painter of the previous generation, travelled to what was then Lunan County, experiencing the local way of life in the villages around Nuohei and creating a series of woodcuts to illustrate the native Sani people's long narrative poem *Ashma*. This woodcut series became famous throughout China and many writers and artists would later travel to the region to make their art, including such Yunnan painters as Yao Zhonghua and Ding Shaoguang, who often went there to paint. The geography and cultural history endowed the region with an enduring allure for artists that continued to exert its influence decades later on Mao Xuhui and his classmates who, drawing on their knowledge of Western art history, described it as their "Barbizon". Nie Rongqing travelled numerous times with the painters to Nuohei Village and wrote:

> *Located in the mountainous karst landscape, the Sani village contains medieval-looking stone farmhouses and tall, narrow, lopsided towers for roasting tobacco, which bear a passing resemblance to European rural churches. Between the houses are cobblestone streets worn away by generations of footsteps. Surrounding the village is the karst topography of the black-rock mountain range. The red earth blots the land between the mountains and the village like red dye upon which the plant life grows and adds to the picture a complex hatching of branches and stems. Every morning, each family's flock of sheep follows the sound of the bell hanging from the neck of the leading sheep to make its way up the cobblestone paths into the mountains to look for grass. In the evening, tipsy men take the women they've set their sights on into the night, the women by turns resisting and submitting, as the scraping of shoes on cobblestone can be heard in the darkness. Aside from the occasional announcement from the village committee blaring from the loudspeakers, everything in this village seems to exist apart from our age. Sani people are a branch of the Yi people. Sani men are firm and upright by nature, and they enjoy bullfighting. The women are dark and beautiful, and they enjoy embroidery and dancing. The tenor of life here is markedly different from that of the Han Chinese.*
>
> *. . .*

They arrived in Nuohei Village in the evening. Guishan is most beautiful on summer evenings. The colours in the sky were resplendent, the red earth looked as if stained with blood, and you could just about make out the walnut trees at the village entrance as the silhouettes of their branches danced gracefully in the wind. Dressed in Ashma attire, the Sani girls spryly brought the sheep flocks back from pasture as the chiming of sheep bells reverberated into the distance. They were struck by the beautiful mountain village before them.

Mao Xuhui led the way, letter of introduction in hand, looking for the brigade leader to ask that they provide food and accommodation for some art academy students hoping to experience local life. The village was very poor and couldn't support so many people, so the brigade leader assigned the visitors various houses across three production teams where they could eat, after which they would sleep in the village warehouse. Ye Yongqing and Zhang Xiaogang slept on a big crate. The villagers worked until late and it was eight or nine in the evening by the time dinner was served. Being so poor, Nuohei had almost no lighting and the scene resembled Van Gogh's The Potato Eaters. *Most of what was eaten was in fact potatoes and a mixture of maize and rice, which was mostly maize. There was barely any meat, but there was maize wine. The locals were very good-natured and told them, "We ain't got much in the way of hygiene or food, but booze we've got plenty!" So they lived like the Sani people, following them into the mountains at daytime to paint. In the evenings, they sat around the fire pit roasting potatoes, drinking maize wine and telling the locals the news about Mao Zedong's passing and Hua Guofeng's becoming Chairman. After they were solidly drunk, they would hold a rock in one hand and a flashlight in the other and return to the warehouse to sleep. The village had lots of dogs who would attack strangers. These students were outsiders, so they always had to carry a few rocks in their rucksacks to fend off the dogs with.*[51]

Although Guishan would play an important conceptual role in Mao Xuhui's artistic career, at this stage it was just another place that many other artists liked to paint. Mao Xuhui was still following in the footsteps of others, either trying to recreate the Russian style or regarding the landscapes before him through the lens of the plein-air school. He was yet to find his own Guishan. However, as Nie Rongqing has pointed out, "When they first arrived in Guishan, they felt they had found something poignant in the earth and life of the place, which would lead them to return to it countless times in their artistic careers."[52]

During his time at university, it was less his training in drawing fundamentals that most influenced Mao Xuhui than the constant stream of information he received from art magazines and news from Beijing, the exhibitions of foreign artists taking place in Kunming, the discussions he had with friends and classmates about art, the books continually being published about Western philosophy and art, and of course the experiences he and his fellow art lovers had travelling around the country.

From 6 June to 25 August 1980, Mao Xuhui, Zhang Xiaogang, Ye Yongqing, Wu Jun, Liu Yong and He Lide—Mao Xuhui's future wife—used their summer holidays to travel to the cities of Chongqing, Dazu, Wuhan, Nanjing, Wuxi,

Suzhou, Hangzhou, Shanghai and Beijing. Mao Xuhui wrote about the long journey they took, which serves as an early record of what he experienced and learned through his travels. In a blue art logbook, he describes their itinerary and financial situation throughout their journey. He even included the tickets they bought from the various tourist sites they visited, such as the Nanjing Museum, the Jiangsu Art Museum, the Zhejiang Exhibition Hall, Yue Fei Temple and the Central Academy of Fine Arts Exhibition Hall (now the CAFA Art Museum). On 8 July, he sketched the scene of the Jiangbei docks in Chongqing with a fountain pen, writing the following words about how he felt:

A round trip from Chaotianmen to Jiangbei cost only eight cents. Naturally, these docks were fresh, interesting and varied for those who had never seen the Yangtze River. I had no idea how to express these things.

The entry next to one of his sketches of the Chaotianmen Docks reveals the increasingly sombre temperament of this young student:

This is the magnificent view from Chaotianmen's west dock. Take it all in and listen to the deep hum of foghorns, and your thoughts are taken to distant journeys. The vast river and its restless flow create such an indescribable ambience.

In Dazu, he sketched many Buddhist statues in pencil or fountain pen. Next to dozens of his drawings were written measured reflections on the object depicted, demonstrating that his interest in these traditions can be traced back to his youth. On 11 July, appended to a pencil sketch of a Guanyin statue in the Bei Mountains in Dazu, Mao Xuhui wrote of his understanding of Buddhism and art:

"Buddha" is the truly enlightened, and Guanyin comes second only to Buddha. In the vernacular of common Sichuanese people, they have "seen through it all".
The Dazu Rocking Carvings are quite successful in employing the language of plastic arts. With the development of forms and techniques like clay sculpture and casting, rock carving art had clearly declined by the Ming Dynasty.

After visiting Dazu, the group finally left Chongqing and Mao Xuhui described his mood at the time. Despite his simple writing style, we can see how his state of mind was unconsciously giving rise to a distinctive cultural disposition as he became increasingly aware of society and human nature:

On the morning of 18 July, we boarded the riverboat and set sail. The outline of the mountain city and the Chaotianmen dock gradually faded before my eyes and disappeared in the pale steel grey fog, dissolving into the unbounded atmosphere unique to the ancient state of Ba.[53] Everything was indistinct and gentle and faintly imbued with a sense of the ethereal. Looking ahead, the Yangtze River was muddy, and its swift water, swirling like always, accompanied our boat towards a grey, unfathomable expanse. I stood at the stern, watching the riverboat

stir up foam that bubbled with the rapid currents, leaving behind turbulent traces. As soon as the boat left the dock, it entered the vastness of the rapid Yangtze River current like a light canoe. As I stood on the deck, my hands gripping the railings, and gazed at the surging water and mountains on both sides, all kinds of thoughts filled my heart.

The boat made its way past Wan County, the Three Gorges, then Haikou, and finally Nanjing, the ancient city rich in historical legend, where the Yangtze River Bridge, Dr. Sun Yat-sen's Mausoleum, the Purple Mountain Observatory and the exhibitions in the Nanjing Museum left a distinctive impression on the travellers. After that, it was Wuxi and Suzhou, which Mao Xuhui described as having "stunning canal scenery", borrowing Marco Polo's phrase to describe them as "the Venice of China". In Hangzhou, they went to the Zhejiang Academy of Fine Arts,[54] where fellow Yunnan artist Shang Ding, famous for his 1974 painting *Continuous Fighting* (*Lianxu zuozhan*), was carrying out his postgraduate studies. Shang Ding showed the young group artworks by the school's postgraduate students as well as the assignments completed by students from the classes of 1977 and 1978. This was an art academy with a rich history where they were able to see the composition exercises Quan Shishan carried out while studying in the Soviet Union,[55] the oil paintings of the school's former teacher Eugen Popa[56] and the copperplate engravings of British painter William Hogarth. It was exhilarating for these art enthusiasts to encounter the originals of works they had previously only seen printed in the pages of books and magazines.

On 31 July, they took the train from Hangzhou to Shanghai and by 1 August they were already attending an exhibition in the Oil Painting and Sculpture Studio at the Shanghai Painting Academy. Here they saw oil paintings of Chen Yifei and Yu Xiaofu. Chen Yifei had already received nationwide acclaim for his works *Trailblazer* (*Kailu xianfeng*) and *The Destruction of the Jiang Dynasty* (*Jiangjia wangchao de fumie*). The elevated perspective, yellow-grey tones and attention to detail in *The Destruction of the Jiang Dynasty* were admired by oil painters throughout the country and provided a novel sensory experience for viewers in an age in which most art still conformed to Jiang Qing's "red, light, bright" aesthetic framework. They only spoke with Chen Yifei for a few minutes, but the brief conversation was something they would always remember.[57] Yu Xiaofu's oil paintings of historical figures were also well known at the time and Mao Xuhui described his work as "really intense, bold and uninhibited". Through the introduction of someone from Sichuan who worked at the Shanghai Federation of Literary and Artistic Circles named Zeng, they visited Yan Wenliang. The old painter

is over eighty. He looks old and it's difficult for him to walk, but he is talkative and warmly welcomed us, remembering each of our names. We looked at the oil paintings and still lifes he made in the late 1920s to 1930s whilst abroad, as well as his more recent landscapes. They were all depicted with considerable depth and delicacy. Despite being quite small, the paintings were profound and rich. The warm reception we received from the old master touched all of us.

A few days later, on 4 August, they took the train from Shanghai to Beijing. The most important item on their itinerary in the capital was to visit the "Contemporaries Oil Painting Exhibition" (*Tongdairen youhua zhan*), which featured works by Wang Huaiqing, Sun Weimin, Sun Jingbo and Chen Danqing. This exhibition of paintings by "contemporaries" was hosted by the China Artists Association and most of the exhibiting artists were students who had attended the Central Academy of Fine Arts High School. Because of the Cultural Revolution, many of them had been unable to pursue their studies at the Central Academy of Fine Arts in the 1970s, but they had continued to study Western art to the extent that the situation permitted. The exhibition opened on 16 July 1970 in the Central Academy of Fine Arts and all the featured artworks were a departure from formerly mandated social realism and political themes. After the exhibition, Mao Xuhui and the others went to visit Yuan Yunsheng and Sun Jingbo at the Central Academy of Fine Arts. The airport mural Yuan Yunsheng had painted earned him considerable fame when the question of whether nude figures were appropriate for such a public setting sparked widespread debate. Mao Xuhui wrote of their encounter with Yuan Yunsheng:

On the morning of 8 August, I arrived at the Central Academy of Fine Arts at nine and visited Yuan Yunsheng to look at his paintings. Yuan had long hair and was polite. He showed me his latest paintings on small dishes, nearly a hundred of them, all improvised: human bodies, animals, abstract lines and combinations of colours. They were beautiful. He said that the primary focus of one's student years was to learn to discern the good paintings from the bad and to find one's own path, and it wasn't imperative to develop a style. Thematic works don't always have to follow a specific technique; they can also be expressed through abstract language. The figurative can convey the abstract because these two elements are often intertwined in a work. Any method is just a means. Nowadays students face no significant ideological constraints; they can be easily liberated, yet they often feel a sense of emptiness and deficiency.

That noon, they saw the Central Academy of Fine Arts' "Collected Oil Paintings Exhibition" (*Yuancang youhuazhan*), which included many imitations by such Chinese artists as Luo Gongliu, Xiao Feng, Quan Shanshi, Lin Gang and Wu Zuoren of famous oil paintings, including Russian works like Surikov's *Boyarina Morozova*, Repin's *Ivan the Terrible and his Son Ivan*, and Serov's *Girl with Peaches*, as well as pieces by Titian, Rembrandt, Paul Gauguin, Paul Cézanne, Vincent van Gogh and Pierre-Auguste Renoir. They also saw original oil paintings by Wu Zuoren, Dong Xiwen and Chang Shuhong. On 11 August, Mao Xuhui visited the Military Museum of the Chinese People's Revolution, where he saw a series of names familiar to the art world from the Cultural Revolution: He Kongde, Chen Yifei, Wei Jingshan, Zhang Wenxin, Shen Yaoyi, Gao Hong, Tang Xiaoming, Lin Yong, Wei Qimei and Chen Beixin. Although during the Cultural Revolution these artists had produced numerous paintings about the revolution and Communist Party history, which employed realist techniques and depicted the standard literary and political themes of the time, they had nonetheless endeavoured on a technical level to prioritise the

expressive potential and subtlety of the medium. For these students of oil painting, these artworks acted as the models they had once sought to emulate in their studies.

Mao Xuhui wrote in his journal about all the places they visited in Beijing, from the exhibitions and art academies to the Great Hall of the People, the Badaling section of the Great Wall of China and even the alleys around Wangfujing. The novelty of everything in Beijing filled these students from the southwest of China with wonder. On 15 August, they took a train back to Kunming, a journey which at the time took three days and two nights.

At least for Mao Xuhui, this trip provided a veritable feast of artistic ideas to learn from. It wasn't so much the time they spent or the number of places that they visited than the freedom they experienced, not only the freedom to go wherever they wanted but the unrestrained and dynamic social and artistic environments they encountered, which would have been hard to imagine prior to 1978. They saw a lot of artworks that before this trip they would have had little opportunity to see, and the older generation of painters they met provided them with artistic ideas that would have been hard to come by before. After enrolling in university in the spring of 1978, this group of young students born in the 1950s were fortunate enough to start receiving news from the world beyond. In the words of the Christian God, "Blessed are ye!"

The moment when ordinary people's fortunes started to improve could be said to be the downfall of the Gang of Four in October 1976, which saw a general easing of the repressive atmosphere everyone had been under for so long. However, for those who were gradually developing the capacity for independent thought, the true blessing arrived on 11 May 1978 when the *Guangming Daily* published the famous editorial, "Practice is the Sole Criterion for Testing Truth". This official article legitimated all the scepticism people had about the past. The political faction behind this article did not seek to link the problems it identified to broader questions about political institutions or democratic liberalism. Their sole purpose was rather to exploit a discussion about "truth" to discredit the actions of the Gang of Four during the Cultural Revolution, thereby regaining the authority over truth for themselves. Nonetheless, for most people it was a clear signal: the revival of human nature had become a possibility. On 11 August, Shanghai's *Wenhui Daily* published Lu Xinhua's story *Scar* (*Shanghen*), and from 28 to 30 October, it published *In the Silence* (*Yu wushengchu*), a play about the April 1976 Tiananmen incident. This meant people could discuss publicly their doubts about the political nature and serious consequences of the Great Proletarian Cultural Revolution, and from there their belief in the existence and value of human nature. Prior to this, if the notion of "human nature" was not denied altogether, it was criticised as a part of the corrupt thought of the bourgeoisie, a situation that left no room for discussions on the subject. However, the internecine struggles within the party had changed everything. On 15 November, the Xinhua News Agency reported that the Beijing Municipal Party Committee had reassessed their judgment of the 1976 Tiananmen incident, designating it a "revolutionary event". On 16 November, the same agency reported that the Central Committee had decided to annul all "rightist" labels throughout the country.[58] On 18 December, the Communist Party of China convened the third plenary session

of the 11th Central Committee and two days later announced to the nation that they would stop using Mao Zedong's political slogan "class struggle above all" and instead replace it with "prioritising building the economy" as a guiding principle. In an authoritarian country, the orders of the governing party must be carried out fully and unconditionally, and in this case the order conformed with the wishes of most of the population. Chinese society was about to undergo a conspicuous transformation.

Although *Art Magazine* (*Meishu*), the official magazine of the China Artists Association, resumed publication in March 1976, it was only in March 1979 that the association formally returned to work.[59] The second edition of *Art Magazine* that year published Zhou Enlai's 1961 "Speech at the Forum on Literature and Art and the Conference on Feature Film Production" (*Zai wenyi gongzuo zuotanhui he gushipian chuangzuo huiyishang de jianghua*). The motivation behind the inclusion of this almost twenty-year-old speech was to provide a legitimate basis for the art world's pursuit of a less restrictive creative environment. Prior to this, Zhou Enlai had been subject to critique by the Gang of Four. Now, his speech arguing that people should take note of the nature and laws of art opened the door for further discussion about breaking free from the aesthetic strictures of the Cultural Revolution, which could be seen in the abstracts of essays published in the same issue. Famous sculptor Liu Kaiqu contended in "Things Should be Done According to the Laws of Art" (*Yao an yishu guize banshi*) that art should not be restricted by political criteria, and in "Democracy Will Not Be Bestowed Upon Us, It Must Be Fought For" (*Minzhu yao zhengqu, buneng kao ci'en*), the main supervisor of the Artists Association[60] Jiang Feng argued for greater creative freedom for artists. The conclusions and themes of all the articles included were in this vein. In June, the *World Art* (*Shijie meishu*) journal, published by the Central Academy of Fine Arts, presented the first of many instalments of Shao Dazhen's "Introduction to the Schools of Western Modern Art" (*Xifang xiandai meishu liupai jianjie*). This simply written introduction was an inspiration to young students hoping to understand Western modern art and its contents would stay with them for some time. People quickly started using more Western theoretical concepts to discuss artistic questions.

Mao Xuhui began buying and collecting the *Art Magazine* in 1979 and to this day still owns a bound volume of all the issues published that year. From 1979, articles that demonstrated the capacity for critical thought were already beginning to appear, such as the second issue's "Formal Beauty in Painting" (*Huihua de xingshimei*), written by Wu Guanzhong, and the seventh issue's "Why I Painted *Why*" (*Weishenme hua* weishenme), written by Gao Xiaohua. The first of these essays advocated abandoning the notion of art as a vehicle for political ideas and literary allegories, sparking a national debate about artistic themes, styles and free thought, while Gao Xiaohua's defence of his own artwork, *Why* (*Weishenme*), demonstrated a capacity for artistic critique. Although his painting still adhered to established themes, its grey tones and sober mood constituted an attempt by this student of the Sichuan Fine Arts Institute to depict the state of desperate confusion of a Red Guard taking a rest from violent struggle, thereby "accusing, exposing and criticising Lin Biao and the Gang of Four for their crime of inciting people to 'Attack by the Pen and Defend by the Sword'. Let the next generation forever remember the lesson from this bloodshed—never must

such a historical tragedy take place again!" Looking at these words from April 1979 today, they might appear to lack theoretical weight, but the painting they were written to defend, with its exposure of the "darker sides" of the Cultural Revolution, would become one of the most important works of "scar art" (*shanghen meishu*).[61]

One of the most subversive events to rock the painting world would take place at the Sichuan Fine Arts Institute. It began when the illustrated story *Maple* (*Feng*) in the eighth issue of *Picture Stories* (*Lianhuan huabao*) 1979 shocked its readers by portraying how in an age that sought to smother human nature, blind political faith could destroy young bodies and loving relationships. This was a work from the art world that echoed the literary world's *Scar* and the theatre world's *In the Silence*. Its creators (Chen Yiming, Liu Yulian and Li Bin) attempted to offer a truthful representation of the political reality of the Cultural Revolution. They did not exaggerate or provide grotesque renderings of those who had fallen from political grace. They rather sought to do "[their] best to truthfully depict the purity and sincerity of that era's youth who are as endearing as they are pitiable; to use shape and colour, to use naked reality, to tear asunder the most beautiful thing in this young generation's lives for all to see".[62] At the national fine arts exhibition held in March 1980 in celebration of the thirtieth anniversary of the founding of the People's Republic of China, Cheng Conglin's *A Snowy Day in 1968* (*1968 nian ri xue*), Gao Xiaohua's *Why* and Wang Hai's *Spring* (*Chun*) received awards. In January 1981, Luo Zhongli's *Father* (*Fuqin*) received first prize in the "National Youth Fine Arts Exhibition" (*Quanguo qingnian meishu zuopin zhanlan*). Later in August, the National Youth Oil Painters Forum was convened in Beijing. At this time, the work of some students at the Sichuan Institute of Fine Arts was beginning to exert collective influence under the name "scar art". The term "scar" was clearly borrowed from the title of Lu Wenhua's story and its meaning was clear to everyone. These paintings exposed the serious political problems that had previously blighted the nation. Many extolled the human nature that was so nearly extinguished at the time, such as Wang Hai's *Spring*, Wang Chuan's *Goodbye, Little Path* (*Zaijian ba, xiaolu!*) and He Duoling's *Spring Breeze Has Awakened* (*Chunfeng yijing suxing*).

Mao Xuhui had begun collecting images since 1974, and in 1982 he was still in the habit of sticking assorted paintings, old pictures and photos he came across in various magazines or prints in a scrapbook called "Drawing Materials". Aside from images of early Soviet and European paintings, plaster casts and human figures, he also included popular oil paintings produced by Chinese artists in the 1970s, such as Chen Yifei's *The Destruction of the Jiang Dynasty*, Pan Jiajun's *I Am a Petrel* (*Wo shi haiyan*), Shang Ding's *Continuous Fighting*, Chen Yanning's *Barefoot Doctor* (*Chijiao yisheng*), Zhou Shuqiao's *Willows in the Spring Breeze* (*Chunfeng yangliu*) and He Kongde's *Gutian Meeting* (*Gutian huiyi*). When Mao Xuhui and his friends were preparing to travel and see more of the world, he was already aware of the burgeoning scar art phenomenon, which is evident from his inclusion in his scrapbook of Wang Hai's *Spring*, Cheng Conglin's *A Snowy Day in 1968*, Gao Xiaohua's *Why* and Luo Zhongli's *Loyal Soul* (*Zhonghun*).[63]

After 1978, Mao Xuhui constantly collected materials on Western modern art as magazines increasingly began to introduce readers to the subject.

47 | EXPERIENCE

In the Xinhua Bookstore on Shanghai's Huaihai Road, Mao Xuhui bought a copy of Herbert Read's *A Concise History of Modern Painting*. This work, published in Chinese by the Shanghai People's Fine Art Publishing House in October 1979, became one of the few art history books popular among young artists at the time because of the author's very systematic approach to introducing the history and artistic ideas behind Western modern painting. Mao Xuhui was beginning to be drawn to artistic thought that required a deeper understanding and critical thinking, and he devoured these books with great enthusiasm.

Read's *A Concise History of Modern Painting* became popular amongst young artists and those with an interest in modern art. Readers were fascinated by the artistic ideas and formulations it contained, but it also posed a challenge for those trying to understand it. Part of the reason for this was the sentence structure of the translated text, which was very different from what people were used to, but more fundamentally, it was because Chinese people were still unfamiliar with the philosophical background and historical context of modernist art, which meant that people struggled to understand and accept some of the ideas in the book. This is why modernism in China came to be widely understood in terms of formalism, and also why so many artists yearned to contemplate artistic questions from the perspective of Western philosophy and history. Mao Xuhui underlined many passages that intrigued him or provided him with insight. He was quick to discover that it was precisely philosophical thinking that made art easier to understand and revealed the reasoning behind its apparent arbitrariness. Mao Xuhui circled the following line by Read in *A Concise History of Modern Painting*: "The whole history of art is a history of modes of visual perception." However he understood the Chinese term "modes of visual perception" at the time, it is clear that a recognition of the importance of artistic change was beginning to form. The book finishes with the following passage:

The old model is the one made inevitable by the event that founded modern Western society as we know it, segmented into divided fields of activity: the French Revolution. The bourgeois order set up the academy system that was to divorce one field of life from another, to separate scientific analysis from philosophical speculation, technology from science and science from art. The rest is modern man's alienation, his inability to relate spirit and material, or to comprehend the totality of his world. In this divided world, art still stands as an activity without predetermined confines. When this open brief is accepted negatively, it leads to the dead-ends and the triviality that have characterised much of recent art. Taken as a challenge, it could forge a new and expanded concept of art as an interdisciplinary activity, bridging fields of knowledge and linking man's polarities: his intuition and his intellect; chaos and order.[64]

Mao Xuhui drew a wavy line under the last sentence and wrote a large exclamation mark beside it. On the very last page he wrote, "Expand the concept of art."

The return to China of essays introducing the Western modern art movement beginning with impressionism can be seen as early as 1979 with art historian Wu Jiafeng's essay "Reconsidering Impressionism" (*Yinxiangpai zai renshi*), published in the second issue of that year's *Social Science Front* (*Shehui kexue*

zhanxian). The author combines an assessment of Chinese art prior to the arrival of impressionism, philosophical discussion and his personal opinions to put forward his view on the legitimacy of impressionism in China. In his circuitous and obscure prose, he sought simply to argue that as an artistic movement, it contained cultural value to be studied and learned from. Only those familiar with the political history of China since 1949 will understand why this old art historian still felt the need to mount a defence of impressionism at this time. In the mid-1950s, the art world had discussed the question of the legitimacy of the impressionist style, but the Anti-Rightist Campaign[65] that shortly followed quickly meant it was categorised as bourgeois art and subject to criticism. In 1979, after the defeat of the Gang of Four, impressionism was brought up again as an academic case study in artistic freedom, in order to lay the foundation for the return to China of further Western modern artistic movements, such as late impressionism, fauvism, expressionism, abstract art, futurism, cubism and surrealism.

On 8 September 1980, Mao Xuhui and his classmates went on a trip organised by the school to the Tibetan region of Dêqên. The Tibetan lands, people and scenery reflected the trend for depicting rustic, untouched lifestyles that arose in response to Chen Danqing's *Tears Flooding the Autumnal Fields* (*Leishui saman fengshoutian*, 1976) and his "Tibet Series" (*Xizang zuhua*, 1980). Chen Danqing's work, particularly the "Tibet Series", completely departed from the allegorical and political themes of the past, to the extent that those more familiar with earlier thematic works could only consider his paintings unfinished. At this time in China, it was a subversive idea, the value of which lay in human nature and the authenticity of spiritual life.[66] This approach to painting, which did not make use of stories or even themes, was an important stage in Chinese artists' abandonment of the aesthetics of the Cultural Revolution or Soviet social realism. Its import and influence were quickly accepted by the Chinese people. The trip to the primarily Tibetan region of Dêqên provided an opportunity for these students who wanted to follow Chen Danqing or the "life-stream" movement.[67]

Dêqên is Tibetan for "Joy and Peace", which perhaps explains why it is often called the "Town of Song and Dance", and Mao Xuhui and his classmates indeed sketched many images of Tibetan dance performances on their trip. However, the school did not permit female students to go with them to Dêqên because the region was at an altitude of 3,400 metres and underdeveloped. Unlike his travels to cities across China in July and August, Mao Xuhui did not have his girlfriend He Lide by his side, which meant his mood at the time was markedly different. During his time in Dêqên, he wrote a lot about what he saw and experienced there, but from the diary entry he compiled the night before departing, we can see the morose state of mind of this third-year art student:

> *Oddly, for the past few days, I have been hearing the old English folksong* Auld Lang Syne *(also known as the farewell song sung to bid farewell). The lyrics evade me, but the melody never fails to strike a chord in my heart. Music truly is a magical singer; it sings the unspoken, profound emotions hidden in the depths of people's hearts with beautiful melodies.*

I'm about to part with her again. I'm going to Dêqên and she's off to Ruili. Two months of the countryside, no meetups or letters. This is a great test for my frail emotions.

Here, Mao Xuhui describes the difficulty and pain he experienced in anticipation of his pending separation from his girlfriend. This was a time when he was increasingly influenced by the emotional journeys of protagonists in foreign love films, such as *Ai to Shi* (even if his own experience was far removed from the characters in that Japanese film).

The train departed Kunming in the morning of 8 September, and Mao Xuhui and his male classmates began their arduous trip to Dêqên. He watched villages, fields and hilltops pass by through the window and noticed how poor and underdeveloped such remote regions were. He also gazed in wonder at the "flashes of gold" on the peak of Cang Mountain at dawn and the towering mountains on either side of Jinsha River. The hills, grasslands and the streets of Shangri-La bustling with Bai, Yi and Tibetan people appealed to Mao Xuhui who described it as "a feast for the eyes". This is very much the psychological response of many artists who travel to Tibetan regions to paint. On 13 September, in the Diqing Guesthouse where they were staying, Mao Xuhui in his diary of his impression of Tibetans:

Tibetans are truly exciting people: free-spirited, vigorous in their physiques, unrestrained, exotic. They have unique customs and vibes and are completely different from other ethnic groups.

Among the nomadic Tibetans in Shangri-La, some are from Sichuan and others from different counties. They live where sunlight and grass fields are. They need no bed or house, and tents are their homes. What a liberating life! Despite hardships and ruggedness, the freedom to roam around is a rare happiness.

Under the intense sunlight of the plateau, their skin has acquired an iron-like sheen. They enjoy drinking and singing. Drink and song are the greatest pleasures of the free-spirited.

On the vast grasslands, herds of yaks graze to their heart's content on the food that nature provides them, while shadows of clouds fall on the undulating mountains and smoke rises from the Tibetan "homes". What a picturesque view of the plateau! The vast, deep, sonorous and primitive atmosphere brings the mind calmness and tranquillity. Enjoy this light of the plateau! It surpasses the famous Ten Scenes of the West Lake, the Classical Gardens of Suzhou and the shimmering waves of Lake Tai.

Here is where true beauty is found, entirely natural without pretence. It is intense yet harmonious, rich yet simple, a totality that is constantly changing. It is primitive, yet it is the most beautiful.

We are entering Dêqên tomorrow. I can't contain the waves of excitement in my heart!

On his first day in Dêqên, he also wrote:

On the snow-capped mountain, a Tibetan woman bursts into song. The folk song she sings is in such harmony with everything around here. Her melodious voice shows her love and admiration for the plateau. (14 September)

The excitement and interest revealed in these entries are similar to those expressed by other artists who travelled through the southwest of China around this time, such as He Duoling, Zhou Chunya and Zhang Xiaogang; they also reflect the attitude of Chen Danqing when he painted the "Tibet Series". Mao Xuhui believed that he could feel what made the Tibetan regions special, what made them so different from the Three Gorges and other scenic spots and historical sites he had visited during his summer holidays. If he were to express all this in music, he might have chosen a symphony to sing the praises of the mountains, forests, clouds, snowy peaks and "the vigorous beauty of those born on the plateau, the sunlit grasslands, and those pastoral scenes". These words suffice to explain why the paintings he completed after visiting Dêqên, *Highlands* (*Gaoyuan*, 1980) and *Drinking Tea* (*Hecha*, 1981), made such use of rich colour to depict the Tibetan scenes there.

However, on his second day, Mao Xuhui's entry revealed a completely different emotional response from that of Zhang Xiaogang and Zhou Chunya when they visited the Tibetan regions:

Looking at this world of mountains, I feel people are too lonely in places like this. Nothing is revealed. It is such a vast world, yet everything seems dead, so silent that even distant birds' chirpings can be heard. There's no human in sight, only scattered Tibetan houses and terraced fields at the canyon's lower end, but they are too tiny and faint.

It takes much effort to move around here. Travelling from the top to the foot of the mountain requires a day's work, with risks and considerable physical exertion. Even the most intelligent would become dull having lived long in these mountains. I really want to get out of here. It lacks the warmth of human presence. One feels too inferior here.

I returned to the county town with such feelings. The town, which I found unpleasant yesterday, is dirty and dusty, yet the presence of a crowd comforts me.

A few days later, on 20 September, he even wrote:

As soon as you step out it's all mountains; your eyes are filled with mountains. I'm starting to feel a bit scared. Yes, the mountains are majestic, spectacular, imposing and robust, but they can also leave eerie and terrifying impressions on people.

This is a far cry from the attitude of an optimistic naturalist. Mao Xuhui discovered that he found it hard to adapt to being without someone to talk to. At this stage, Mao Xuhui was yet to extrapolate his feelings to broader considerations about society and history, but this emotional temperament, his sensitivity to human existence, would serve as the basis for his further study of modernism. But for now,

he could only directly express what he felt as an individual: "Today I really need her by my side. I feel unwell, and my mood is quite gloomy."

Aside from a few gratifying encounters—for example, the scenery (which he occasionally described as a "natural masterpiece"), the friendliness of the Tibetan population, and Tibetan song and dance—his diary entries during this journey are filled with complaints about the remoteness and backwardness of the region, the difficulty of travel (during one journey he even wondered if his life was in danger), and the local villains and swindlers he engaged with. His writings frequently reveal the profound sense of loneliness he felt:

I feel so lonely. A month has passed. Another entire month of this lonely life awaits. Here, it's impossible to find someone to confide in. Though everyone's friendly, every day feels like a solo battle, interacting with Tibetans who don't speak my language and sitting in front of the silent mountains. (3 October)

It was all he could do to spend his time either painting or pining for his girlfriend. He often dreamed of her by his side: "Last night was so blissful; I dreamed of her" (30 September), "The nights here are freezing, and every night I wake up a couple of times because of the cold. Each time, all I can think about is you, as I try to numb myself back to sleep" (6 October). He even copied down sections of a few foreign love poems that featured in the magazines available at the local Cultural Centre, "to help me describe the lack and longing I feel" (19 October). He applied the feelings expressed by foreign poets to his own emotional state in the belief that everyone felt longing and love in the same way. This state of mind meant time passed very slowly. He did not know to whom he should talk about it, so he ended up talking with himself. This is part of the reason he turned to writing at a young age:

Art, love, how wonderful, how exhilarating. They are the meaning of life (at least for me). I agonise and toil for art; I yearn and suffer for love. Lately I find myself more mature. I know how to cherish the brilliance of love that sparkles above me. I have tasted the pain and loneliness of separation. I realise that I can't do without this beautiful feeling of love. Yet, it saddens me to think about the partings to come, like the melancholy of pondering the inevitable demise of life. (19 October)

On 28 October, Mao Xuhui described his team's journey to Lijiang. The opening and conclusion of this entry are as follows:

It's time to leave, time to leave the plateau, the formidable plateau, and I didn't say goodbye. Based on my recent experiences and emotions, I'm reluctant to say we'll meet again.

. . .

I have reached my utmost limit this time in western Yunnan.[68]

Towards the end of 1981, Mao Xuhui and his classmates majoring in oil painting organised the "Small Grass" (*Xiao cao*) exhibition in Yuantong Mountain, and the works on display were mostly their paintings of Shangri-La. Featured in the exhibition was an original piece by Mao Xuhui entitled *Highlands*, the dense and rich colour and composition of which clearly drew from the "native painting" (*xiangtu huihua*) style, particularly Chen Danqing's "Tibet Series". The influence of scar art and native painting at this time was far-reaching, and the dense, rich tone it inspired was not simply a stylistic approach but a result of the philosophy behind these movements. Scar art prompted a consideration of history, whereas native painting hoped to revive the concept of authenticity by presenting a truthful depiction of the land and its inhabitants. Mao Xuhui approved of both these tendencies. Until 1981, his cultural understanding was still confined to the contents of *Art Magazine*, literary works and the few programmes he saw for foreign exhibitions. It was difficult for his visual imagery to transcend the boundaries of his experience and knowledge, which meant that even such artworks as *Autumnal Mountain Village* (*Shanzhai qiuse*), which featured in the "Yunnan Celebration of the Sixtieth Anniversary of the Communist Party of China Fine Artworks Exhibition" (*Qingzhu Zhongguo gongchandang chengli liushi zhounian Yunnan sheng meishu zuopin zhanlan*) in June 1981, and *Drinking Tea*, which featured in the "Yunnan Ethnic Minorities Fine Artworks Exhibition" (*Yunnan sheng shaoshu minzu meishu zuopin zhanlan*) in November of the same year, were primarily informed by the native painting style. The original *Autumnal Mountain Village* has been lost, but even the remaining colour drafts for this work reveal the enduring influence of the plein-air school, which by way of its mood and brushwork recalls the oil paintings of the Cultural Revolution: brusque and sparse brushwork with sharp contrasts in colour that richly recreate the effects of light. *Drinking Tea* is markedly different, its theme and mode of expression very similar to those of Chen Danqing: dense and candid with little emphasis on brushstrokes. The sketches and watercolours that remain from this time bear the traces of native painting's influence. Less concerned with

CREATING ART AS A STUDENT

elegant brushwork and variations in colour, even his watercolours seem intent on recreating the density of an oil painting, while his pencil sketches clearly form the preparatory stages for a dense and austere final product. Mao Xuhui was profoundly affected by what he saw of Tibetans and their lifestyles in Shangri-La, Dêqên, and Chen Danqing and the native painting trend prevented him from moving beyond the visual intensity of the Tibetan regions. However, this would change in September 1981, when Mao Xuhui travelled to Xishuangbanna and the scenery and colours he encountered there would transform his formal approach to painting.

It is difficult for people today to comprehend the sense of confinement and oppression felt by the generation who lived through the Cultural Revolution. Toward the end of the 1970s and the beginning of the 1980s, professors and professionals engaged in art criticism or art history research were still reluctant to speak out. Political changes seemed to bring the possibility of alleviating this mental pressure, but one still had to be wary of publicly expressing opinions contradicting the tenets of the Cultural Revolution. In his defence of impressionism, the art historian Wu Jiafeng had needed to make ingenious use of the language and concepts familiar to the powers that be and avoid saying anything that directly contradicted the official narrative. Artists, on the other hand, are perhaps more emotional creatures than critics. The painter Wu Guanzhong's essay "Formal Beauty in Painting", which emphasised the importance of form, made waves in the art world. People who had lived through the Cultural Revolution were very aware that affirming the importance of form divorced from content was to espouse bourgeois aesthetic values. Not only would such a view not be accepted by officialdom; it was bound to be subject to vociferous criticism. A passage from Wu Guanzhong's essay illustrates the problem:

I was drawing in the fields in Shaoxing when I came across a small pond. A night of easterly winds had curled the red duckweed and green algae into a motif that recurred over the surface with the rhythm of poetry; upon this was a haphazard scattering of rapeseed flowers whose yellows set off the darker hues of their reflections in the water. I was carried away by the secluded beauty of the scene and didn't want to leave. But if I were to paint this "art without a title" would it not be subject to a torrent of abuse?! I was pondering this question on the way back when I suddenly came up with an ingenious idea: if I were to paint a group of workers and a red flag far away in the background and name the piece "The East Wind Touches All Ashore", that would surely be enough to steer off any criticism! The next morning, I rushed back to the pond with pochade box in hand, only to find the westerly wind from the previous evening had destroyed the pond's poetry. The red duckweed was there, so too the green algae and yellow flowers... The content was the same, but its arrangement and relations were different; its form had changed. It had lost its rhythm, its beauty! I didn't want to paint it anymore![69]

Wu Guanzhong's emphasis on form was so insistent and unequivocal that it led him to understand artistic methods in almost evolutionary terms. Of nineteenth-century French realism's influence on some Chinese painters like Chen Danqing, he wrote:

54 | Creating Art as a Student

Beauty, formal beauty, is a science that can be analysed and dissected. Lectures in Western art academies often include analysis of formally innovative works and compositional techniques, but here in the art academies of China such discussion remains off-limits. That young artists remain so ignorant about this discipline is astounding! It is worth noting that the Western art world is no longer content with exhibiting nineteenth-century French landscape paintings. Why in an age when we have sent satellites into orbit are we still only able to present the Western steam engine![70]

This essay by Wu Guanzhong came from a series of talks he began to give in 1978 at various art academies while he was painting in the southwest of China. In April 1979, he gave a talk at the Fine Arts Department of Southwest Normal Academy that mostly discussed formal beauty, and the school requested a copy to publish in its academic journal.[71] Earlier in the spring of 1978, Mao Xuhui had heard a talk given by Wu Guanzhong in the Yunnan Provincial Library and was impressed by the latter's emphasis on form. The "Yunnan painting school" (*Yunnan huapai*) led by Jiang Tiefeng and Ding Shaoguang also attached great importance to lines and form, which chimed with Wu Guanzhong's aesthetic theory. The decorative images they created were very different from the realism people were used to, and the influence of these Kunming artists exerted was such that they were later referred to as the Yunnan painting school. Furthermore, their preference for formal inventiveness, intense colours and exaggerated shapes seemed to closely resemble modernist art, at least in contrast to the literary and realistic paintings of scar art and native painting. Yao Zhonghua, a Yunnan painter who graduated from the Central Academy of Fine Arts, described how after the Cultural Revolution, many artists from Beijing and other parts of the country travelled to Yunnan to paint, of whom two of the most memorable figures were Wu Guanzhong and Yuan Yunsheng:

Wu Guanzhong was sixty at the time, full of energy and passion, travelling to places like Shilin, Xishuangbanna and Lijiang. In the arid heat of the dry season in Xishuangbanna, he often painted until sunset, so that by the time he got home and ate it was already nine in the evening. We took him to see the former site of the National Art College in Anjiang Village, and he was even more taken by what he saw, the history of the place reappearing before his eyes. Zhu Danian and Yuan Yunsheng each completed huge murals that would appear in the newly constructed Capital Airport, Song of the Forest *(Senlin zhi ge) (ceramic) and* Water Festival–Song of Life *(Poshuijie–shengming de zange), both of which had a huge impact across the country. Yuan Yunsheng stayed for more than two months in a Dai[72] family bamboo house in Mengding where he produced a large number of beautiful sketches.[73]*

However, Kunming was still yet to produce art that had an impact on a national level. Yao Zhonghua remembers the development of Yunnan oil painting at the time:

Around the end of the 1970s and the beginning of the 1980s, the literary and art world was teeming with new ideas and trends, such as "scar literature",

the affirmation of "formal beauty", "small, bitter, acerbic", "local colour fever", Western modernism, post-modernist trends, commodifying tendencies, and so on. Some of these trends had a big impact on art in Yunnan, others less so. There was little reaction to the scar movement in Yunnan (including in literature), whereas depicting native life at the frontiers and a decoratively inclined emphasis on formal beauty were very popular. The reason for this was not that people from Yunnan had no spiritual "scars" to give voice to, but rather that the art world in Yunnan had for some time considered the "ethnic quality of the frontier regions" to be a defining part of their artistic culture. However, many artists and writers never truly understood this "quality" and often only paid attention to its superficial properties, decorating their works with their predilection for the exotic. This served to diminish their thematic awareness and conceal their work's absence of content and mediocrity of technique.[74]

Wu Guanzhong and Yuan Yunsheng were clearly examples Mao Xuhui hoped to emulate.[75] For this restless young student, their artistic style and ideas were the direct point of reference for his acts of artistic rebellion. In 1979, Yuan Yunsheng produced a mural for Beijing Capital International Airport, *Water Festival—Song of Life*, which incited widespread controversy. This formerly rightist painter had depicted the contorted naked bodies of women in a decorative style. Its abstract, twisted and symbolic elements were not difficult for people to understand, but the artist had clearly engaged in free creation that drew from Western artistic styles and trends. Mao Xuhui saw in Yuan Yunsheng's work a departure from the rigid dogma of realism, opening up the possibility for a liberated artistic language. In line with the customs of the Water Festival,[76] the bodies of people bathing were naked. To get past the official censors, the drafts Yuan Yunsheng provided them with included sketch lines that gave the impression the bathers were clothed, but when he completed the mural, he removed the superfluous lines to reveal the women were in fact nude. The general director of the airport mural project at the time was national party leader Li Ruihuan[77] who, concerned about political repercussions, informed Deng Xiaoping. Yuan Yunsheng recounts, "Comrade Xiaoping saw it and said, 'I think it's fine.' And so, *Water Festival* was exhibited." However, the people had been politically repressed for some time and were not accustomed to seeing nude women in an airport mural, so Yuan Yunsheng had no choice but to drape the three nude women in transparent gauze: "Viewers could still see the nude women through the gauze, or they could lift up the gauze to get a glimpse of what was underneath, so in the end they covered the bodies with wooden boards." One is reminded of the fate of Michelangelo's *The Last Judgment*. The criticism and scepticism levelled at the airport mural became increasingly intense, resulting in frequent suggestions by leaders from the official Artists Association to remove it.[78] Two years later, Yuan Yunsheng spoke at an academic forum organised by the Beijing Artists Association and the Beijing Oil Painting Research Group and said, "The development of society demands that artists give full expression to their artistic individuality and self."[79] This was clearly a provocation for Mao Xuhui who was unconsciously drawing a connection between the formal beauty championed by Wu Guanzhong and Yuan Yunsheng, as well as the decorative style of his

teacher Ding Shaoguang's paintings of local Yunnan scenes.[80] It is possible that Mao Xuhui understood the nebulous concept of formal beauty to be identical to the modernist style on display in Beijing's "Stars Art Exhibition" (*Xingxing meizhan*), held in November 1979. However, at this time, as an art student at school, he was still unsure as to how to proceed as an artist. From July to September 1981, Mao Xuhui made another trip to Beijing where he visited Yuan Yunsheng and met the Stars Art Group artists Ma Desheng and Huang Rui. His experience there, as well as what he read in his recently purchased copy of Li Zehou's *The Path of Beauty: A Study of Chinese Aesthetics* (*Mei de licheng*), published by Cultural Relics Press in 1981, cemented the importance of terms like "form" and "beauty" in his mind. Around 20 August, Mao Xuhui left Beijing for Shanxi province, where he saw Taiyuan's Jinci, Datong's Yungang Grottoes and the murals in Yunchang's Yongle Palace. At the beginning of September, he arrived in Shaanxi, where he visited the historical sites and museums of Xi'an, the Qianling Museum in Xianyang and Hua Mountain. He also travelled to Luoyang in Henan where he visited the Longmen Grottoes. As with during his previous travels, he kept up the habit of writing a diary. Aside from recording the sights he encountered, his earnest writings consisted primarily of contemplations about life and art, offering a day-to-day account of the subtle changes occurring in his artistic understanding. In Kunming on 23 July, the day before he set off on his journey, he wrote:

> *Though the train is not a ship sailing on the sea, braving the wind and riding the waves, I still fantasise about everything. More importantly, I need to think about some questions calmly. What is love? What are emotions? What is the human instinct, and what constitutes human contentment, desires, dreams and pursuits?*

On the train he wrote of what love meant to him:

> *Love is sunlight, air, the azure sky, pure white clouds, the breath of the sea and skylarks in the mountains. It's an oasis in the desert, a song on the wasteland and the snow lotus on the icy mountains.*
> . . .
> *Love is a storm, thunder and lightning; it possesses the same boldness, fervour and uncontrollable power as the sea.*

He also wrote of the physical conditions on the train:

> *I feel this carriage is becoming more and more like a prisoner's cage: stifling, hot, overcrowded. The weary passengers, myself included, are a group of prisoners exiled to penal colonies. We sit at the same spot, eating, sleeping, drinking water, reading and entertaining ourselves, unable to take a single step away. We have to wait in line to pee. The window is our only place to breathe fresh air and look at the sky and the earth. Our daily routines are completely disrupted, and we don't know when to eat or sleep. Routines have no meaning here. Everything is quiet endurance. The suffocating carriage confines your movements and your only option is to learn to pass*

out. It's now half past ten in the evening, the train has been moving for a full 24 hours, and we've been prisoners for the whole day. There are people under every seat: not dirt, not luggage, but living and breathing people. What I hate is that I can still feel things. (25 July)

It was far from a pleasant journey, and a stream of unconscious feelings and ideas frequently rose to the surface of his mind. After arriving in Beijing, he was still in this frame of mind as he contemplated life.

How can one control life with reason, rules and simple formulas? That's not life because people dare not have emotions there. There are no waves, expansion, scenery, lightning, or thunder. No one understands the song of a nightingale or the call of a cuckoo bird. Art does not emerge there: no Picasso, Matisse, or Modigliani, no painting, surely no serenade, no hope for a Beethoven or Mozart, no poetry, no Whitman, Heine, or Baudelaire. There's no love, only the graves of love and the suffering of Jesus Christ, that medieval agony, human ignorance and time. There is Rodin's The Gates of Hell *but no love, no exuberance of love, no roses or lovely lilies. . . (28 July)*

He arrived in Beijing on 27 July. On 2 August, he visited the Badaling section of the Great Wall of China, the Ming Dynasty Tombs, the New Summer Palace, the Old Summer Palace and the Yanjing Restaurant. On 3 August, he went to the Central Academy of Fine Arts to book an appointment to see their collection of paintings. On 4 August, he met with He Lide and Mu Zhiying. On 6 August, he wrote of his impressions of Beihai Park: "Waves roll on the celadon green Beihai. Birds chase each other above the water; are they playing or flying anxiously? I stand on the shore, gazing at the leaden, heavy, vast sky, longing for the storm or a clear blue sky."[81] After that, they began to pay visits to local artists:

On 7 August, I finally reached Ma Desheng's home at noon. It took me much effort, and I had to ask a girl at the community office to find Ma's place. I saw some of his woodcut works, which emphasised monochrome, contortion, abstraction and intellectual depth. They were warm and exuberant, and they sought to convey a sense of eternity, the love between mother and son, and the pain and repression people feel. Ma used his own language to talk to the world. He's unwell and in poor health but filled with passion for life. One senses only the presence of the spirit in such an individual. Only the spirit, thoughts and a creative urge are left within (reminds me of Jiuba).
Passion and feelings alone are not enough; one also needs reason.
On the morning of 8 August, I went to the academy and, in the afternoon, visited Huang Rui's home.

Chen Danqing said art belongs to the artist and is not about serving the people. Artworks concern only the selected few. Also, many things in society don't serve the people, especially those more practical matters directly related to people's lives.
Chen's Shepherdess *(Muyangnü) and his portraits of female bodies left a strong impression on me.*

58 | CREATING ART AS A STUDENT

At Huang Rui's place, I saw many of his paintings. They were all painted on framed canvas and depicted Beijing's courtyard houses, streets and the Democracy Wall.[82] He'd recently been working on some colour blocks and paper cut-outs from photos. He was in contact with some French artists and had taken a collection of coloured photos of his paintings. The photos were great, and some were even better than the originals. His colours were representative of the local flavour of Beijing, with subtle variations in the grey tones. His house was covered with notes saying, "Not entertaining guests" and "No conversation longer than 10 minutes". He seemed diligent. I read several issues of the Hong Kong magazine Observer. *There were several articles introducing the "Stars Art Exhibition" artists, as well as audience comments and review articles. Many focused on Wang Keping. There were also portraits of the authors.*

The group from Kunming went to see Yuan Yunsheng in the role of students paying their respects. On 15 August, the day before they were to go to the Central Academy of Fine Arts, they went to see Yuan Yunsheng's airport mural: "In the morning I went to the international airport to see someone off. I saw the restaurant and murals. The murals, *Water Festival—Song of Life* and *Nezha Conquers the Dragon King* (*Nezha nao hai*), were indeed impressive."

At seven in the evening, I arrived at the Central Academy of Fine Arts. Many students came too. Yuan Yunsheng's place was packed, and we all stood outside the door to listen. He had just returned from archaeological expeditions to Dunhuang, Maijishan, Datong, Longmen and Xi'an. He talked about his views on archaeology: "You need a basic understanding, but you can choose and take whatever you need afterwards."

He preferred works from the Northern Wei and Sui dynasties because he thought they were free, imaginative and rugged, even though the ruggedness was a result of the passage of time. He felt there was no need to find out what they looked like in the past. What was wrong with accepting the way they are now? The passage of time had made them amazing and modern.

He thought works from the Tang Dynasty were not as free as those from Northern Wei, but they still displayed the solemnity and grandeur of that era, the magnificence of the golden age. He didn't mention anything after the Tang Dynasty.

He said Luoyang had many majestic and valuable relics, but they suffered heartbreaking destruction. It was depressing to hear that valuable things were lost to ignorance.

He praised Xi'an endlessly and spoke of the unparalleled design and grandeur of the mausoleums. They feel so modern, and nothing in the world compares to them.

He mentioned that things at Maijishan were very special, distinct from other grottoes.

Mao Xuhui made sketches of the cultural artefacts and grottoes he saw in Taiyuan, Xi'an, Xianyang, Luoyang and Changsha. These records helped him

understand traditional art, which fascinated him. He had nothing negative to say about what he saw. He shared what he had learned in a letter to Zhang Xiaogang on 17 November:

This trip, from Beijing to Datong, Taiyuan, Mount Hua, Yongle Palace, Xi'an and Luoyang, crossing the Yellow River, Yangtze River and Wei River, traversing the northern plains, cave dwellings, the Loess Plateau and poplar trees, as well as encountering the splendid ancient art, the stone carvings and stele forest at the Tomb of General Huo Qubing, left me in awe. I am starting to realise many things I had not paid much attention to. Our ancestors left us more than just Uniform Colour in Simple Outlines and Eighteen Traces.[83] What I've learned the most from this trip is how to observe and study these things.

On 16 September 1981, Mao Xuhui went to Xishuangbanna to draw, travelling to the "beautiful" Ganlanba, Menghai, Aini Village in Nannuo Mountain and the Botanical Gardens in Xiaomengyang. The purpose of this trip was to create materials for his graduation art project. The ambience, colours and forms on display in Yunnan's south were very different from those in the Tibetan regions. In the letter he wrote to Zhang Xiaogang on 17 November, Mao Xuhui described his life and mental state in Xishuangbanna:

I immersed myself in this subtropical jungle. I only had a month so it was hard to find quiet moments to paint. I let loose and roamed everywhere, trying to take in all of Xishuangbanna. I moved through the thick greenery all day, and scenes of primal simplicity and the tranquillity of human life unfolded before my eyes. Life had a slow, peaceful rhythm. Listening to the local language was a pleasure; I couldn't understand it and didn't want to. Yet, from those tones and rhythms, humanity's most basic, pure emotions and interactions were laid bare. Coming here is a rare pleasure when you're tired of the noise and chaos of urban life. Mothers carrying children on their backs, mothers watching over cradles, mothers breastfeeding under coconut trees, even the "maternal love" of the kind-hearted buffalo and white horses was so very touching. People were in such peace and harmony with Nature, dreaming sweet dreams under Areca palms. On riverbanks, alongside herds of cattle, geese and ducks, carefree people dipped in the water naked and floated on it. Sunlight abundant, trees tranquil: it was like a fairy tale.

What Mao Xuhui experienced in Xishuangbanna had little to do with native painting or the artistic style of Chen Danqing. This was the point perhaps when a preference for formal beauty began to take root in his mind.

Mao Xuhui's works in Xishuangbanna departed from his previous painting style and, like the art of Wu Guanzhong and Yuan Yunsheng, as well as the Yunnan artists Jiang Tiefeng and Ding Shaoguang, acquired a flat, decorative tendency that made use of bold, simple colours. One of his watercolour drafts resembles Yuan Yunsheng's *Water Festival*, and he built on a sketch he made to produce a piece with relatively refined brushwork entitled *Beautiful Ganlanba*

(*Meili de galanba*). In short, with his work in Xishuangbanna, he had left behind the weighty tone of native painting, the solemn tenor of which was nowhere to be seen in his new works. His focus on form and colour sometimes led his compositions to tend toward the abstract, such as with *Menghai Dusk* (*Menghai huanghun*), and the arrangement of forms in *Drawing of Xishuangbanna, Aini Mountain Village Water Pipe* (*Xishuangbanna xiesheng, aini shanzhai shuiguan*) appears very calculated, forming a striking contrast with his piece from the Tibetan highlands, *Shangri-La, Dusk* (*Zhongdian, huanghun*). Not long prior to this he had used bleak colours to paint figures with a sense of weight and depth, but he could no longer continue to paint this way in Xishuangbanna.

By constantly visiting new places, reading and encountering different local cultures, Mao Xuhui was broadening his visual horizons and stimulating his reflections upon the language of art. Different artistic styles and approaches were coming into conflict within his mind, such that he did not know how he ought to proceed in his painting. In November he wrote a letter to Zhang Xiaogang lamenting the fact that the techniques he had been learning at school could not be applied to the scenes he saw in Xishuangbanna:

> In this dreamlike world, light and green enchantment overwhelmed everything. I was caught off guard and almost couldn't paint. Over three years of basic training seemed impoverished and pale here. In this transcendent and unexpected state, I could only allow myself to get intoxicated and lacked the strength to express anything. We must have endured so much deception before coming to Xishuangbanna. Only Gauguin, the French artist, captured the characteristics of the primitive tribes in the subtropics. Of course, his art goes beyond that, with his mysterious and unfathomable imagination and inner desires.

Mao Xuhui's personal repertoire of artistic practices now offered him a variety of different paths: the plein-air school, his academic training, native painting, formal beauty and European post-impressionism.[84]

Mao Xuhui continued to seek possible directions for his own creative practice in the works of Western masters. He was constantly exploring the art journals he bought, like *World Art*, *Literature & Art Studies* (*Wenyi yanjiu*), *Meiyuan*, *Literature & Art Collected Essays* (*Wenyi luncong*) and *Translations of Works on Art* (*Meishu yicong*), searching in magazines and books for images and texts he could use. He continued to write notes and copy passages that impressed him, which in the artist's own words was a means of study that undoubtedly improved his language abilities. One book that had a profound influence on him was Ilya Ehrenburg's four-volume *People, Years, Life*, which he copied extensively from in the first half of 1981.[85] He started reading and copying passages from the book when he borrowed it from the school library in June 1980. Mao Xuhui was profoundly moved by its criticism of and reflections upon works by such modern artists and writers living in Paris as Amedeo Modigliani, Pablo Picasso, Vladimir Mayakovsky, Aleksey Nikolayevich Tolstoy, Boris Pasternak and Marina Tsvetaeva. Mao Xuhui discovered that the book "mentioned almost all 20th-century European artists living adventurous lives in

Paris". "The names of those artists, when lined up, constitute the most brilliant part of modern art history." He even thought a more fitting title for the book would be *People, Years, the Art of Life*. He said the book "opened my eyes to the kaleidoscope of modern art, revealing how it manifested in things and events of that era as well as the personal lives of artists. The questions became much easier to understand". The book's detailed account and analysis of the state of Soviet literature and art after the October Revolution caused Mao Xuhui to reflect upon such questions as the relationship between art and political power, art's social function and the value of art:

The success of the revolution only established a workers' regime but didn't solve the ideological problem. Art was reshaped into propaganda, and truly talented artists faced exclusion and even persecution. How close this is to what happened in our reality! Aren't we witnessing every day a batch of shoddy propaganda swallowing up people's spiritual world? The authorities promote the phoney and the mediocre, while genuine life is put aside and neglected. The so-called artists rarely care about the immediate reality. While the conflicts and confusion of existence accumulate, art steers a dilapidated boat and chants over and over a high-spirited tune. This prolonged dominance of falsehood over real existence is truly disgusting. Where lies the value of art?! What is the true societal function of art?! People need art because it is so different from politics. Sadly, art as a political tool has become a matter of course, poisoning and fooling people's aesthetic capabilities. Perhaps consciously or unconsciously, painters find themselves marching into the ranks of that spiritual executioner, among them the old, middle-aged, and even my peers.[86]

He discovered another artistic world in the pages of *People, Years, Life*. Ehrenburg referred to a range of events and materials in his descriptions of different poets, writers and, in particular, painters, but his true focus was always their inner life and world, which he sought in this book to reveal to the reader. Mao Xuhui came to know these artists and their work from another perspective, for example in this passage Ehrenburg wrote about Modigliani:

His painting is not the arbitrary product of his imagination—it is the artist's insight into a world comprised of a particular combination of innocence and wisdom. When I use the word "innocence", I of course do not mean immaturity, innate mediocrity or feigned vulgarity; I understand innocence as an original sensibility, a kind of intuition, an inner beauty. . . Despite their various shapes and sizes, Modigliani's models share a common trait: what unites them is not the technique of old or a means of external expression, but the artist's attitude to being in the world.[87]

Mao Xuhui saw in these words an understanding of art that was completely different from that of the plein-air school. He saw what was unique about artists like Modigliani, whose work was not impressionist yet was also seen by enthusiasts of Cubism as a "relic of the past" (in the words of Ehrenberg's analysis). What he read departed from the expressive approach of Russian painters like Repin and Surikov and was clearly completely different from the explanatory methods

taught by painters in the Soviet school. After reading this book, Mao Xuhui began to take note of the demands of the heart, another transformation in his cognitive approach to art that naturally played a role in his uncertainty about how to proceed with his graduation project.

Looking through Mao Xuhui's notes from this time, it would appear that there was no systematic logic to the art-related texts he was reading: *Matisse on Art*, *Corot on Painting*, *The Philosophy of Art*, *Conversations with Picasso*, *Cézanne's Writings*, *The Philosophical Foundations of Modern Art*, *Van Gogh's Letters*, *Kandinsky Quotations*, *Remembering Modigliani* and *On the Two Aesthetic Forms in Objective Reality*.[88] In 1982, Mao Xuhui borrowed from Zhang Xiaogang a copy of *The Tragedy of Genius* (*Tiancai zhi beiju*), written by Taiwanese author Lai Chuanjian. Mao Xuhui copied extensively from the book that provided introductions to such artists as Rembrandt, Honoré Daumier, Edgar Degas, Odilon Redon, Gauguin, Van Gogh, Henri de Toulouse-Lautrec, Edvard Munch, Maurice Utrillo, Modigliani and Chaïm Soutine. This was a time when Western philosophical works were beginning to appear in Chinese bookstores, and Mao Xuhui made records of the ideas that most interested him, including introductions to existentialist, late symbolist and futurist literature. The poetry of Guillaume Apollinaire and Mayakovsky also appears in his notebooks. He was particularly attracted to their more passionate pronouncements and copied the following passage from a letter written by Van Gogh to his younger brother Theo: "All I can do is make my paintings speak. . . I have risked my life for my work, and it has cost me half my reason, but only you truly understand me."[89]

Mao Xuhui's reading, experience and painting experiments speak to the excitement he felt when he received any information that filtered through to him from the Western art world. It was almost too much to take in, and he seemed unable to apply all the ideas he had acquired to his own much less complex experience. He still hadn't developed a personal response to what he had learned from books and magazines about artists, writers and thinkers. He was aware that he was still making sense of things, and this conflicted state of mind would manifest in his graduation project.

Mao Xuhui did not keep any complete images of his graduation project. The work had a thematic composition, as can be inferred from the title *Lancang River* (*Lancang jiang*), and appears ambivalent in its use of expressive techniques and styles. Combining the techniques of native painting with decorative composition and muted colours, he vacillated between the weighty tones of native painting and the emphasis on form his work acquired in Xishuangbanna. Although he had a good grasp of different modernist styles, he did not know how to approach his own creative practice, and as a result, he considered the project a failure from the beginning. On 23 December, the month in which he ought to have completed the project, he wrote a letter to Zhang Xiaogang expressing his frustration and musings:

You've embarked on a new sprint and you're firing up. After a period of hesitation and deliberation you tread the path of art determined and it has made me agitated. I don't want to be left behind. Such stimulation is truly marvellous, and I find myself envisioning and fantasising about what to paint tomorrow. Yes, what will

I paint? Sometimes I feel like there's a desert in front of me and there's no trail to follow. Perhaps it's not a desert but there are just too many Kuafus [90] and masters ahead. Before me lies a rich, colourful and surreal panorama. Since the 19th century, the footprints left by countless modern masters often left me in awe and longing. Where is our language?

. . .

Since receiving your last letter, I've painted only five oil paintings with two still in progress. No accomplishment apart from two or three landscapes. I don't have much time left in school, and there's only a week left before they set up the final exhibition. Fortunately, I no longer care about anything. I'll paint until the day I leave school, however much and whatever it is I manage to paint. In any case, I'll try to live up to God and my own conscience. These paintings are all impressions of Xishuangbanna, but the images are modest. Fortunately, they clearly expose many of my weaknesses and what I am.

. . .

Four years of student life have passed in the blink of an eye, four years of ignorance, credulity, hesitation and wandering. So much blind obedience and confusion. From Repin to Picasso, what a difficult process of understanding. However, there are still many incomprehensible things ahead. It's not something that can be completely understood in one go. But the belief in becoming a worker inspires me to look to the future. Each person has their own life and experience, which is never the same as anyone else's. Let each person speak their own words, preferably in their own language. Let each person complete their work according to their beliefs. Cézanne expressed his hopes among apples, pots and tablecloths. In Arles, Van Gogh passionately expressed his enthusiasm. Gauguin spoke of his troubles in Tahiti. You, in the hot wind of the grassland, experience its vast and profound love. As for me, merely reminiscing about the green dream of Xishuangbanna doesn't console my restless soul. What should I do? Where is my love, passion and wisdom? I ponder in agony!

This was Mao Xuhui's response to a letter he had received from Zhang Xiaogang on 16 December. Zhang Xiaogang, who was studying at the Sichuan Fine Arts Institute, was also working on his graduation project. He had expressed similar sentiments in his letter and shared with Mao Xuhui his ideas about art. However, because a series of his paintings had recently been acknowledged by the editor of *Art Magazine*, his mood was completely different from that of Mao Xuhui. He seemed to have moved from a state of anxiety to one of gratification:

I'm just beginning the ninth paintings in the series The Flock of Goats Wandering into the Distance *(Yangqun yuanqu),[91] and everything is proceeding relatively smoothly. Prior to this, I had drifted away from my true feelings and felt almost defeated, losing my confidence to paint. For this reason I went to Nanchong to relax for a few days. Seeing the Yangtze River obstinately and continuously flowing, watching the ships ploughing through the currents, and hearing the boatmen's strong, visceral work-songs made me realize once more that the most reliable course of action was to rely on my own strength.[92]*

Art is my God. It is at heart a religion. Faced with that "theophany", that vague light that often manifests itself in the soul, I can let go of everything; I have no interest in those distracting notions we use to show off with. I think that as long as I have the spirit of Kuafu within me, then I'll never tire of pursuing that sacred sun. Van Gogh, Gauguin and Cézanne are the three Kuafus I worship above all. . .

When I put my oil paintings together and look upon my wall of engravings, they sometimes astonish even me. Where did this strength come from? I remember how before I travelled to the grasslands, I often felt dejected and lethargic because of some indescribable blockage inside me, which produced frequent moments of self-doubt. Thank you, the grasslands! Thank you, that dry wind! Caught in its deep and vast warm currents, I felt it produce in me an irrepressible love. Just like Jane Eyre, I had "discovered God"! I believe that as long as magma is churning beneath the earth's surface, it will always find the right opening to be its volcano. Is the strength of art not the eternity we receive from precisely this kind of "eruption"?

. . .

I have some news to share with you. The editor of Art Magazine *came to our school at the beginning of October, saw my works, and apparently expressed interest. Recently I received a telegram asking me to send them some photos. Only later did I find out that they wanted to publish my paintings alongside an article discussing my art. Before now I was the only one who knew nothing about it. I still haven't quite recovered from the shock of this huge news. . . Of course, practically speaking, I mostly hope this has a positive effect on the job I'm assigned after graduation.*[93]

Since the 1980s, these two art fanatics have written each other letters to encourage one another, seek solace in their solitude and ponder questions of their own artistic practice. Their artistic understanding and values have always remained very similar,[94] but Zhang Xiaogang kept pristine pictures of his graduation project, whereas only a couple of sketchy black-and-white photos remain of the work that so disappointed Mao Xuhui. Shortly afterwards, on 27 December, Mao Xuhui wrote a short letter to Zhang Xiaogang:

School life is coming to an end. The final judgment will be announced on the 10th of next month, and on the 15th, I'll be expelled from the school gate. What fate awaits? I don't have time to think about it in detail. My only desire is to have a studio, a true dream! Art, only art can save the soul!

In January 1982, after graduating from the Oil Painting Department of Yunnan Arts University, Mao Xuhui was assigned a post at his former place of work, the Jinbi general merchandise store at the Kunming General Merchandise Company, where he would be responsible for display window design and promotion.

65 | CREATING ART AS A STUDENT

[1] The Chinese version was published under the same title: *Lermontov Poetry Collection* (Shanghai: Shidai Publishing House, 1951). Mao Xuhui discovered this old book through a colleague in 1972. Although with the arrival of the Cultural Revolution in 1966, books from the Soviet Union were mostly labelled revisionist (espousing feudal, capitalist or revisionist ideas) and thereby criticised or burned, many of these works nonetheless continued to be secretly circulated and read. Lermontov was not a poet of the Soviet era but during the Cultural Revolution he was not considered a proletariat poet either—like writers such as Maxim Gorky were—so his writings were also prohibited. (Translator's note: The English-language version featured here comes from *The Demon and Other Poems*, a selection of Lermontov's poetry, trans. from the Russian by Eugene M. Kayden [Yellow Springs, Ohio: The Antioch Press, 1965].)

[2] Translator's note: The character *xu* means "the brilliance of the rising sun" and *hui* means "radiant" or "to shine".

[3] Translator's note: The Guomindang, or the Chinese Nationalist Party, governed China from 1911 to 1949 before fleeing to Taiwan. Although the Communist Party's victory over the Guomindang and its subsequent rule over the mainland officially began with the establishment of the People's Republic of China in Beijing on 1 October 1949, the city of Chongqing was only liberated later that year on 30 November.

[4] Translator's note: Historically, many marriages in China were the result of arrangements made by relatives or matchmakers. It is notable therefore that Mao Xuhui's parents chose one another freely.

[5] The Cultural Revolution, formally known as the Great Proletarian Cultural Revolution, was a political movement launched without any legal basis by Mao Zedong in May 1966. Its objective was to prevent the "restoration of capitalism". Mao's aim was to eradicate all his opponents within the party and to use mass mobilisation on a national scale to engage in political struggle with all supervisors in leadership positions both inside and outside the party. The Cultural Revolution affected all Chinese urban and rural areas and continued until 1976, which meant it had a huge and deleterious effect on the political, economic, social, cultural, ethical and moral constitution of the country. The primary cause of the Cultural Revolution was the lack of institutionalised limitations on individual power, which meant the aspirations of a single person trumped those of party, nation and people. The Cultural Revolution taught those who came later how the country's political institutions ought to be changed to avoid a single individual ever being able to wreak such harm on a nation and its people.

[6] This quote comes from *Chronology of Mao Xuhui*, unpublished, which was written by Mao Xuhui and his assistant. (Translator's note: Big-character posters were handwritten posters with large characters that anyone could write and publicise. They were often mounted on walls in public spaces to communicate popular political sentiment. Etching on wax paper involved placing a piece of wax paper on a backing board and incising characters on it with a steel pen. The etched wax paper could then be used to print multiple copies. It was a difficult skill to master and was used in the dissemination of various materials, from political pamphlets to school examination papers.)

[7] During the Cultural Revolution, anyone could be labelled an enemy in this way. The practice was frequent and almost without legal basis.

[8] Translator's note: Struggle sessions were gatherings during which those accused of being class enemies were publicly denounced. Nominally conceived to eliminate any traces of bourgeois thought, they often became ritualised spectacles during which people

were subject to humiliation, beatings and torture.

[9] The "Violent Struggle" refers to the vicious conflicts that took place between different political factions after the Cultural Revolution began in May 1966. Most of the participants were students and workers.

[10] From *Chronology of Mao Xuhui*, unpublished.

[11] Translator's note: The revolutionary operas were a series of shows that were similar in style to Peking Opera but replaced the traditional stories of emperors, kings and beautiful women, which were considered bourgeois or feudalistic, with tales of revolutionary struggle.

[12] Translator's note: We were unable to identify the songs from the Maluku Islands, Romania and Russia, so the titles given in these instances are direct translations from the Chinese.

[13] Mikhail Lermontov, *The Demon and Other Poems*, p. 17.

[14] Translator's note: The English versions of these poems featured here come from *Heinrich Heine: Complete Poetical Works*, trans. Edgar Alfred Bowring (Hastings, East Sussex: Delphi Classics, 2016), eBook.

[15] *A Selection of Humanist Essays by Bourgeois Writers and Artists from the Renaissance to the Nineteenth Century* (*Cong wenyi fuxing dao shijiu shiji zichan jieeji wenxuejia yishujia youguan rendaozhuyi renxinglun yanlun xuanji*) was compiled by the Peking University Western Languages Department and first published by the Commercial Press Shanghai (*Shangwu yinshuguan*) in November 1971.

[16] Translator's note: The related passages included in this Chinese-language collection of European humanist writings come from Dante's *Convivio* and Boccaccio's *Decameron*, but the lines Mao Xuhui recorded in his notebook were not direct quotations from these texts but titles the Chinese editors gave to each passage summarising its central idea. As such, we have translated them directly from the Chinese as opposed to referring to the original source.

[17] Translator's note: *The Notebooks of Leonardo Da Vinci*, trans. Jean Paul Richter (New Delhi: General Press, 2018), eBook.

[18] Translator's note: *The Oxford Shakespeare: The Complete Works* (Oxford: Oxford University Press, 2005).

[19] Translator's note: Joshua Reynolds, *Seven Discourses on Art* (Moscow: Dodo Press, 2009). The first quote is the title of this extract as it appears in *A Selection of Humanist Essays by Bourgeois Writers and Artists from the Renaissance to the Nineteenth Century*, which is a summary provided by the Chinese editors of Reynolds' transcript that incorporates parts of his text.

[20] Mikhail B. Khrapkovsky was a famous Soviet art educator and student of Ilya Repin. (Translator's note: There appears to be no English translation of this book.)

[21] Translator's note: The "Three Great Revolutions" refer to the suppression of anti-revolutionary forces after the establishment of the Communist People's Republic of China, the war of resistance against the USA in Korea, and the land reform movement.

[22] These two events became well-known throughout China and had a direct impact on university admissions and the teaching practices of schools and universities. After the publication of his letter, Zhang Tiesheng was admitted to the Animal Husbandry Department of the Tieling Academy of Agricultural Sciences, became a member of the Communist Party, and in 1975 was appointed to the Standing Committee of the National People's Congress, before assuming the role of Vice-Secretary of the Tieling Academy Party Committee. With the end of the Cultural Revolution, Zhang's political position was weakened and he was sentenced to fifteen years in prison. After 1976, Huang Shuai was subject to political discrimination. Her mother was criticised, while her father was taken into custody, placed under

investigation and expelled from the Communist Party and public office. These two cases are a clear illustration of the extent to which people were affected and manipulated by China's political system and ideological environment.

[23] Translator's note: We were unable to find English titles for these paintings, so these are direct translations from the Chinese.

[24] Kassil's young adult novels were very popular in the Soviet Union. During the Great Purge, his brother Joseph (also a writer) was accused of being an active participant in an organisation of anti-Soviet terrorists plotting to overthrow the government and was executed by firing squad in January 1938. On 21 June 1970, Lev Kassil died of a heart attack while watching the World Cup final between Brazil and Italy. Many of his works were translated into Chinese.

[25] Translator's note: We were unable to locate a copy of the English version translated by Susanna Rosenberg (Moscow, Foreign Languages Publishing, 1952), so the passage featured here is a direct translation of the Chinese.

[26] In February 1974, Jiang Qing organised an exhibition at the National Art Museum of China and the Great Hall of the People showcasing 215 works by ten artists (including Feng Zikai, Li Kuchan, Wu Guanzhong and Huang Yongyu). These artworks were identified as "Black Paintings" because they supposedly sought to "oppose the Party, oppose socialism, and oppose Mao Zedong Thought". The Jiang Qing faction used the political means at their disposal to smear the artists, arbitrarily interpreting the words, colours and symbolism of the paintings through the established political framework. For example, Li Keran had depicted a landscape in dark ink, which was said to be an attempt at using the colour black to tarnish the mountains and rivers of socialism.

[27] Li Xiangrong, "The Plein-Air School Under Dappled Clouds" (*Caiyunxia de waiguangpai*) included in the *Enjoy Art, Read Books* (*shang yi, du shu*) feature of the *Kunming Daily*, 28 June 2004. Earlier, in 2003, while teaching at Yunnan University, Mao Xuhui launched a research project into the Kunming art scene of that time in which he also used the term "plein-air" school (*waiguangpai*) to refer to this group of landscape painters.

[28] During the Cultural Revolution, so-called "cow demons and snake spirits" were those designated "class enemies". The nature of their supposed crimes was not always explicit, but they were considered to be enemies of the party, nation and people, and as such had to be constantly monitored. They had to accept the frequent psychological and physical attacks and curtailments on their freedom administered by "the masses". Most of them were former capitalists, landlords, businessmen, Guomindang members, or intellectuals who had expressed opinions about or dissatisfaction with the Communist Party. They had no legal standing in society.

[29] I.e. landlords, rich farmers, counter-revolutionaries, bad influencers and right-wingers.

[30] Mao Xuhui, "City and Suburbs—A Study of Kunming's Plein-Air Painting" (*Chengshi yu jinjiao—kunming waiguang huihua yanjiu*), *Dianchi Literary Monthly* (*Dianchi*), no. 12, December 2012.

[31] Ibid.

[32] Li Xiangrong, "Kunming Painter Brother Pei" (*Kunming de Peishi xiongdi huajia*), in the *Enjoy Art, Read Books* (*shang yi, du shu*) feature of the *Kunming Daily*, 17 May 2004.

[33] Translator's note: "May Fourth" refers to the iconic student protests that took place that day in 1919. The protestors came out onto the streets to express dissatisfaction with China's weakness on the world stage, which was thought to be caused by the nation's inability or reluctance to modernise. The May Fourth protests are considered a key event in China's political evolution during the twentieth century.

34 Mao Xuhui, "Deep-Seated Memories" (*Shencang de jiyi*), *Spring City Evening News* (*Chuncheng wanbao*), October 2003.

35 Yao Zhonghua, "A Survey of Yunnan Oil Painting", in *Art, Life, Past* (Kunming: Chenguang Publishing House and Yunnan Fine Arts Publishing House, 2005); "Artistic Marvels in the Red-Earth Highlands", in *Yilin Stroll* (Beijing: Beijing University Press, 2015), p. 7. (Translator's note: Kunming is the capital city of Yunnan province, which lies in the southwest of China and has been referred to as the "red-earth highlands".)

36 He mentions Sha Lin and Jiang Gaoyi in "A Survey of Yunnan Oil Painting".

37 Mao Xuhui, "City and Suburbs—A Study of Kunming's Plein-Air Painting". In his essay "Deep-Seated Memories" (2003), Mao Xuhui also writes this: "In those years, a group of plein-air painters were active in Kunming, with Haigeng being one of their main locations. Almost every time I went to Haigeng, I would encounter some painters with their easels set up or their pochade boxes strapped to the back of their bicycles. Facing the waves of the 'ocean', under the blue sky and white clouds, they would manipulate colours and painting knives, capturing the sparkle of sunlight on the lake surface and treetops, and casually chat with onlookers during their painting sessions. Many Kunming residents, including myself, got to know oil painting in such settings."

38 A friend of Mao Xuhui, the collector Nie Rongqing, writes: "Kunming's Nanping Street was influenced by French culture coming from Vietnam in the early twentieth century and American culture from the American troops stationed there during the 1940s, which left a rich colonial legacy in the form of Western-style architecture and various stores selling general merchandise, watches and books. There even used to be a club for the Flying Tigers American Volunteer Group. The street is lined with lush French wutong trees and was once the commercial centre of Kunming, its Champs-Élysées. Baoshan Street lies parallel to Nanping Street and was also a commercial centre in which every building was two stories tall with a shop sign above the door. The general merchandise store's single workers dormitories in which Mao Xuhui lived was in the middle of this street." Nie Rongqing, *Colors of the Moat: Kunming Artists in the 1980s* (*Huchenghe de yanse: 20 shiji 80 niandai de kunming yishujia*) (Beijing: People's Fine Art Publishing House, 2015), p. 38.

39 With the beginning of the Cultural Revolution in 1966, Deng Xiaoping lost all political standing. On 5 January 1975, the CPC Central Committee published that year's "No. 1 Document" appointing Deng Xiaoping as the Vice-Chairman of the Central Military Commission and Chief of General Staff for the People's Liberation Army. From 8 to 10 January, during the second plenary session of the 10th Central Committee of the Chinese Communist Party, Deng was appointed Vice-Chairman of the Central Committee and member of the Politburo Standing Committee. From 13 to 17 January, in the 4th National People's Congress, Deng Xiaoping was appointed First Vice-Premier. In 1976, from late March to Qingming festival in early April, large numbers of students and other citizens travelled to Tiananmen Square to place flowers on the Monument to the People's Heroes in memory of Zhou Enlai. Many poems expressing dissatisfaction with political leaders were distributed, and on 4 April, around two million people had congregated there, defying an order from Beijing prohibiting the action two days earlier. On 5 April, the mourners were forcibly cleared from the square and more than two hundred people were arrested. The episode was quickly named "The Tiananmen Square Anti-Revolutionary Incident" and Deng was accused of covertly inciting the mourners. According to Mao Zedong's wishes, Deng was stripped of all his titles within and without the party but kept his party membership. From 16 to 21 July 1977, after the downfall of the Jiang Qing-led Gang of Four the previous year in October, the third plenary session of the 10th Central Committee decided to reinstate Deng as member of the Politburo Standing Committee, Vice-Chairman of the Central Committee, Vice-Chairman of the Central Military Commission, Vice-Premier of the State Council and Chief of General Staff for the People's Liberation Army.

40 Mao Xuhui's diary, 3 October 2015.

41 Translator's note: Dazhai is a village in Shanxi province which became famous in the early 1960s for the diligence and productivity of their agricultural commune. Mao Zedong's directive to "Learn from Dazhai in agriculture" established Dazhai as an agricultural model to be emulated throughout China. A similar directive concerning industrial production and based on a city in the Northeast was also issued: "Learn from Daqing in industry."

42 Translator's note: The sent-down youths were young people during the Cultural Revolution who had received a certain level of education and as such were sent down to the countryside to learn from the peasants.

43 According to the Gaokao examination all students would take the same university entrance exam. Students' family backgrounds would not play a role in their admission: "Everyone is equal before their grade." This meant that everyone had the opportunity to study at university. On 21 October, the *People's Daily* and China National Radio announced the news that the Gaokao was to be reinstated and institutions of higher education would resume regular teaching. During the Cultural Revolution, some students from worker, peasant or military backgrounds, having passed a political screening process, could be recommended for higher education without taking the exam. The aforementioned Zhang Tiesheng was a particularly well-known example.

44 Pavel Chistyakov was an art educator and professor at the Saint Petersburg Academy of Arts who established his own pedagogical system for art education. His systematic method for teaching drawing techniques was the primary point of reference for art instruction in China in the 1950s and 1960s. It mostly emphasised the importance of perspective and the anatomy of the painting subject. It was a pedagogical method based on modernist formalism, advocating a systematic process of observation, understanding and expression, as well as emphasizing the importance of three-dimensional bodies over lines in drawing. Chinese teachers and students alike are very familiar with the importance he placed on the "five tones"—black, white, grey, highlights and reflections. His method was both scientifically rigorous and a means of artistic expression, providing a kind of scientific method for recreating depth on the canvas. The Chistyakov system influenced such painters as Repin, Valentin Serov, Surikov and Vasily Polenov.

45 The Peredvizhniki group was founded in 1870 by Moscow painters Grigoriy Myasoyedov and Vasily G. Perov and received recognition from such Saint Petersburg painters as Ivan Kramskoi. Fifteen artists signed their names on the group's constitution when it was first established, including Perov, Kramskoi, Myasoyedov, Ivan Shishkin and Nikolai Ge. The group did not limit their activity to Moscow and Saint Petersburg, but rather went out into the provinces to exhibit their work, which is why they were called Peredvizhniki, meaning "Wanderers". In October 1871, they organised their first exhibition in Saint Petersburg and for the next 53 years before they disbanded, they exhibited their work almost every year in a different part of the country. Some of the most famous names in the history of Russian painting were members, including Repin, Surikov, Viktor Vasnetsov and Nikolai Yaroshenko. They advocated the artistic thought of Nikolay Chernyshevsky who said that "beauty is life" and opposed the Westernisation of Russian art in favour of emphasising native characteristics. They thought their responsibility as artists was to reflect the life and struggles of the people and uphold a spirit of democratic realism. The Peredvizhniki association ended in 1923 having survived for 53 years, during which it organised 48 exhibitions all over Russia that were warmly received by the wider population. Its most representative figures include Kramskoi, Repin, Surikov, Perov, Konstantin Savitsky, Yaroshenko, Alexei Savrasov, Shishkin, Vasnetsov and Isaac Levitan.

46 Konstantin Maksimov was a Soviet artist who was a professor in the Oil Painting Department of the Surikov Academy of Fine Arts in Moscow. He was the painter and educator who had the biggest impact on Chinese art education in the 1950s. On 17 February 1955, Maksimov arrived in Beijing in the role of oil painting instructor and education consultant for the Central Academy of Fine Arts. From 1955 to 1957, he trained a batch of teachers and students. His artistic thought, which emphasised structure and plein-air painting, had a huge influence on Chinese painting. After 1949, China had few pictures to offer from which students could learn oil painting, let alone original works from Europe. Maksimov often painted alongside his students, familiarising them by his example with the physical properties and expressive techniques of oil painting. He also taught lessons outdoors. By formulating his pedagogic approach in terms of overall schema and details, Maksimov's teaching rarely departed from the Soviet rubric. As such, his oil painting class acquired a relatively comprehensive and systematic Soviet art education. He also assisted the Central Academy of Fine Arts in formulating its oil painting curriculum. Some of his more famous students include Feng Fasi, Jin Shangyi, Hou Yimin, Zhan Jianjun, Wang Chengyi and Yu Changgong.

47 Nie Rongqing, *Colors of the Moat*, p. 71.

48 Even the first edition of the Chinese copy of *Rodin's Theory of Art* (*Luodan yishulun*) (Beijing: People's Fine Art Publishing, 1978) included a "Publication Notes" section with the following passage, written to pre-empt criticism directed at the publishers by government inspection bodies: "Certain sections of *Rodin's Theory of Art* promote the idealist theory of 'natural genius' and such ideological notions as aestheticism and individual struggle, which all bear the mark of the writer's era and class. Rodin's thought is riddled with contradictions, which are reflected in his artwork. His pessimistic, negative outlook reflects the mental state of much of the bourgeois, petit-bourgeois and intellectual classes at the end of the nineteenth century . . . Rodin's artistic activity and the contradictions in his theory show us once again that the capitalist system hampers the proper development of art."

49 Translator's note: The Chinese book *Rodin's Theory of Art*, while based on *Rodin on Art and Artists: Conversations with Paul Gsell* (New York: Dover Publications, 2012), contains an extra essay, Rodin's "Testament", which is the source of the quotes featured here. The English text is translated directly from the French, which is in the public domain and widely available online.

50 Translator's note: The Sani people are a branch of the Yi people, an ethnic group mostly situated in the southwest provinces of Yunnan and Sichuan.

51 Nie Rongqing, *Colors of the Moat*, pp. 80–83.

52 Ibid., p. 83.

53 Translator's note: Ba was an ancient state during the Zhou Dynasty over two thousand years ago that included present-day Chongqing and eastern Sichuan.

54 Established in 1928 by Cai Yuanpei and Lin Fengmian, it changed its name in 1993 to the China Academy of Art.

[55] Quan Shishan is a painter who was admitted in 1950 to the Hangzhou National Art College (later called East China Branch of the Central Academy of Fine Arts, then Zhejiang Academy of Fine Arts, and finally the China Academy of Art). In 1954, the school recommended him to study oil painting in the Ilya Repin Leningrad Institute for Painting, Sculpture and Architecture where he trained under Andrei Mylnikov and others. He came back to China in 1960 and returned to his alma mater, the Zhejiang Academy of Fine Arts, where he continued to teach for the rest of his career. Amongst his most famous works are *Unyielding Heroism*, *On the Jinggang Mountains*, *Loushan Pass* and *Revisiting the Jinggang Mountains*, which were included in the collection of the China Revolutionary Museum (which merged in 2003 with the China History Museum to form the National Museum of China). In the 1960s, his style was widely admired by young students of oil painting. (Translator's note: We were unable to find official English translations for the paintings mentioned here and have therefore offered our own.)

[56] Eugen Popa was a famous Romanian oil painter, engraver and art educator. He graduated from the Fine Arts School in Bucharest under the tutelage of Camil Ressu, before travelling to France to further his studies. He later held the post of professor at the Fine Arts School in Bucharest and Vice-Chairman of the Romanian Artists Association. As part of the cultural agreement between China and Romania, he accepted an invitation from the Chinese Ministry of Culture to teach oil painting at the Zhejiang Academy of Fine Arts, where he stayed from 1960 to 1962. In comparison to Maksimov, Popa was more interested in playing with form than realistic representation, which was at odds with the political climate and cultural requirements in China at the time. As a result, he has not received the same level of praise as Maksimov.

[57] Nie Rongqing writes in *Colors of the Moat* (p. 101): "They arrived in Shanghai and went straight to the Oil Painting and Sculpture Academy to visit Chen Yifei. A misty drizzle was falling as they arrived at the entrance to the academy and they saw a studious looking man in a white shirt pushing a bike as he walked past. It was Chen Yifei. Zhang Xiaogang went straight over and said, 'We're art academy students. We've come to see you and your artworks.' Chen Yifei convivially called them under the awning to shelter from the rain. Unfortunately for the visitors, Chen Yifei was travelling to America the next day and he had packed away all of his paintings, which meant they wouldn't be able to see his artwork. The students were in awe at Chen Yifei's success as an artist but could only stand there and watch as he left the academy. No one would have suspected that many years later, when Chen Yifei had returned from America, these young students would have become artists of great influence. Before his passing, Chen Yifei travelled to Feijia Village in Beijing to visit Zhang Xiaogang at his studio. Zhang Xiaogang brought up their brief in encounter in Shanghai years before, but Chen Yifei had no recollection of it."

[58] Translator's note: This act, literally called "removing the rightist hat", differed from "rehabilitations" or "reassessments" of previous figures or incidents in that it did not retroactively negate the previous judgment. Removing the rightist hat did not imply that someone had been erroneously labelled a rightist, only that he or she would not continue to be designated as such.

[59] The first item of an article entitled "Summary of the 23rd National China Artists Association Managing Director's Enlarged Meeting", in *Art Magazine*, no. 3, March 1979, was: "The China Artists Association formally returns to work."

[60] Translator's note: Established in July 1949, the China Artists Association is an official institution run by Chinese artists under the supervision of the Communist Party of China. It organises exhibitions, hosts academic exchanges, and produces a variety of art-related publications. Headquartered in Beijing, the association oversees a network of regional branches at the provincial and city levels. A regional branch, for example in the city of Kunming, might be described as the "Kunming Artists Association" and will operate as a subsidiary to the national-level China Artists Association in Beijing. In China, the term "Artists Association" is often used as a general term to refer more broadly to this network of institutions.

[61] Translator's note: When Lu Wenhua's short story *Scar* was published in *Wenhui Daily* in 1978, it gave rise to a literary genre referred to as "scar literature", which was characterised by sentimental portrayals of the injustices suffered by intellectuals and other class enemies during the Cultural Revolution. It inspired a series of paintings concerned with similar themes, which were collectively called "scar art".

[62] Chen Yiming, Liu Yulian and Li Bin, "Some Thoughts About the Creation of Illustrated Story *Maple*", *Art Magazine*, no. 1, 1980.

[63] The scar art images Mao Xuhui collected were pictures he bought from the exhibitions he attended. The most famous artworks included in these exhibitions were printed in black and white to be sold or used for promotional purposes and were a far cry from the colour prints with which we are familiar from contemporary exhibits. In October 1980, photos of this sort were sold at the "Sichuan Young People's Exhibition" (*Sichuan qingnian meizhan*).

[64] Translator's note: Herbert Read, *A Concise History of Modern Painting* (New York: Praeger, 1975), pp. 323–24. The essay that features this quote was added to this enlarged and updated third edition of the book. It was written by Caroline Tisdall and William Feaver at the request of Read's son Benedict.

[65] Translator's note: The Anti-Rightist Campaign took place from 1957 to 1959 and sought to purge the party and the country at large of "rightist" elements. It is seen as the defining moment that transformed China into a one-party state.

[66] Chen Danqing completely abandoned the officially mandated themes popular in painting at the time. He explained his artwork as follows: "I want to make people see that there is fiery, unbridled life miles away in the mountains. If you saw the herdsmen in Kham, you'd be certain to think that these are real men. Every day I saw them standing in groups on the street exchanging ornaments and selling Tibetan butter with glistening eyes and solid foreheads, walking down the street as their plaited hair and accessories swung to and fro. Their weighty footsteps were majestic and steady, their presence inspired awe and admiration. Their entire being from head to toe makes them a good subject to paint. I found a way of painting that cuts to the heart of the matter. They just have to stand there and it's already a painting." *Fine Art Research*, no. 1, 1981, p. 50. Chen Danqing's attitude undoubtedly had an influence on Mao Xuhui.

[67] Translator's note: The life-stream (*shenghuo liu*) movement aimed to find beauty in people's everyday lives, which it sought primarily in remote rural regions where people lived more "primitive" lives. Some saw it as a means of returning to the purity of human nature, untouched by the complex artifice of urban life, whereas others saw it as an adventure into a different world.

[68] Looking back on his summer in the Ngawa grasslands in the Tibetan region of Sichuan with his classmate from the Engraving Department Zhou Chunya, Zhang Xiaogang wrote, "After leaving the grasslands, I forgot many details about the life I had experienced there. All that remained were the intense, rich colours of the grasslands, the pure, uninhibited character of the Tibetan people, and the lines that linked all these colours and images together . . .

I hope I will be able to accept nature with purity and innocence, the way a newborn looks at the world." *Art Magazine*, no. 4, April 1982. The responses of Mao Xuhui and Zhang Xiaogang to their time in the highlands are clearly very different.

[69] *Art Magazine*, no. 5, 1979, p. 34.

[70] Ibid.

[71] Wu Guanzhong remembers this time: "The school's academic journal said they wanted to publish it, so I wrote it up into a paper called 'Formal Beauty in Painting', but I never saw it get published. I suspect the editors had misgivings—they were afraid. However, Wu Bunai from the *Art Magazine* requested a copy and they published it right away as the leading piece." Wu Guanzhong, *Never the Smooth Path: Wu Guanzhong's Autobiography* (*Yongwu tantu: wu guanzhong zishu*) (Changsha: Hunan Fine Arts Publishing House, 2015, p. 170).

[72] Translator's note: The Dai people are an ethnic group who live primarily in Xishuangbanna in the south of Yunnan province.

[73] Yao Zhonghua, "Artistic Marvels in the Red-Earth Highlands", p. 7.

[74] Yao Zhonghua, "A Survey of Yunnan Oil Painting", p. 98.

[75] Yuan Yunsheng was an artist who studied at the Central Academy of Fine Arts before being labelled a rightist student in 1957. In 1960, as a rightist who refused rehabilitation, he was, along with the Central Academy of Fine Arts director Jiang Feng and others who were similarly labelled rightists, sent to do physical labour at the Shuangqiao farm where he shared a room with Jiang Feng, Li Zongjin and Wang Bingzhao. After graduating, he left Beijing and went to Changchun where he continued to keep in contact with Dong Xiwen, Zhang Ding and Zhu Naizheng. In 1978, he travelled to Yunnan's Xishuangbanna and the sketches he made there would serve as the basis for the mural *Water Festival—Song of Life*. In 1979, he was invited by the director of the Academy of Arts & Design, Zhang Ding, to produce a mural for Beijing Capital International Airport. Later, the Central Academy of Fine Arts established the Mural Department where Yuan Yunsheng accepted a post to teach.

[76] Translator's note: Water Festival, or Water Splashing Festival, is the name for the New Year's celebrations that take place in Southeast Asia and amongst the Dai people of southern Yunnan. The festival occurs during the hottest month of the year, and participants often splash each other with water to celebrate.

[77] Translator's note: Li Ruihuan occupied various authoritative positions in municipal departments involved with infrastructure and construction in Beijing at the time, which is why he was overseeing the project.

[78] After 1982, in the words of Yuan Yunsheng, "The airport erected a fake wall made of three boards that obscured the bathing women. In 1990, my brother Yuan Yunfu led a team of workers to coat the murals in a layer of protective solution. The fake wall got in the way so the workers, without asking for instructions, removed it, allowing the nudes to see the light of day again. The colours of this section were clearly newer and brighter than the rest of the painting. It was a truly Chinese ending to the story! In 2002, the airport underwent refurbishment, and many media organisations were concerned about the fate of the airport murals. They called for the murals to be preserved, but the airport paid them no attention. I assumed the mural would be destroyed, but to my surprise, after the refurbishments were completed, the murals were still there. What was ridiculous however was that a suspended ceiling obscured the top fifty centimetres of *Water Festival*. They had also added a large screen wall in front of Zhang Ding's mural, and in front of Yuan Yunfu's they had put an S-shaped partition that obscured almost

a third of the image. The murals were sacrificed to the refurbishment of the airport. Looking back on it now, these murals seem to act as a mirror to the various periods of China since the 1980s, reflecting the awkward situation of art at that time. You don't know whether to laugh or to cry." (Translator's note: The above Yuan Yunsheng quotes come from a conversation Lü Peng had with the artist.)

[79] *Art Magazine*, no. 3, 1981.

[80] Mao Xuhui's teacher Ding Shaoguang left Kunming and moved to the USA in May 1980. Prior to this, the painting style associated with Ding Shaoguang and Jiang Tiefeng was known as the Yunnan painting school and was influential amongst artists living in Yunnan.

[81] Translator's note: Beihai, or the "Northern Sea", is one of the three sections of Taiye Lake, which has been part of an extensive royal park in Beijing since the Ming Dynasty. Since 1925, it has been a public park.

[82] Translator's note: After the Cultural Revolution, from November 1978 to December 1979, a long brick wall on Xidan Street in Beijing started being used by people to put up big character posters expressing their discontent with various political or social issues. This wall later came to be known as the Democracy Wall, and it gave rise to the Democracy Wall Movement. The Deng regime initially adopted an attitude of tolerance but later cracked down on the phenomenon after criticism began to spread to Mao Zedong and Deng Xiaoping himself.

[83] Translator's note: Uniform Colour in Simple Outlines (*danxian pingtu*) and the Eighteen Traces (*shiba miao*) are traditional Chinese drawing techniques used primarily in simple monochrome pictures.

[84] Under the influence of post-impressionism, Mao Xuhui instinctively felt dissatisfied with the formalism he was trying to put into practice. In a letter to Zhang Xiaogang written on 17 November 1981, he wrote, "I don't think works from the likes of Jiang Tiefeng are great art. The popularity of such a style is not anything remarkable, and I have no interest in it."

[85] Translator's note: An abridged version complete with annotations by C. Moody was published under the title *Ilya Ehrenburg: Selections from People, Years, Life* (Oxford, New York: Pergamon Press, 1972).

[86] Mao Xuhui, "The Path of the Heart—A Concise Autobiography of the Heart (1956–1985)" (*Xinling zhi lu—yi fen jianyao de xinling zizhuan*), an unpublished essay written on 28 February 1989 when the artist was living at No. 2 Heping Village.

[87] Translator's note: This passage is translated directly from the Chinese.

[88] Translator's note: We were unable to identify some of these texts. In these cases, the titles were translated directly from the Chinese.

[89] We will later see similarly passionate expressions in Mao Xuhui's letters to friends. (Translator's note: There are some discrepancies between the Chinese and Van Gogh's original draft. For those parts that correspond, we consulted *The Letters of Vincent van Gogh*, trans. Arnold Pomerans [London: Penguin Press, 1996].)

[90] Translator's note: Kuafu is a giant in Chinese mythology who attempted to capture the sun. In his pursuit, he drank the Yellow River and Wei River dry to quench his thirst, but nonetheless eventually died of dehydration. He is a symbol both of vain hubris and of admirable commitment in the face of an impossible task.

[91] *The Flock of Goats Wandering into the Distance* is one of the pieces in Zhang Xiaogang's graduation project he called the "Grassland" series.

[92] Translator's note: This paragraph features in Lü Peng's biography of Zhang Xiaogang, *Bloodlines: The Zhang Xiaogang Story*, edited by Rosa Maria Falvo and Bruce Gordon Doar (Milan: Skira, 2016), p. 102.

[93] Zhang Xiaogang, *Amnesia and Memory: Zhang Xiaogang's Letters* (*Shiyi yu jiyi: zhang xiaogang shuxinji*), *1981–1996* (Beijing: Peking University Press, 2010, pp. 16–18).

[94] In an essay written in 2005, Zhang Xiaogang recalls the time: "I only really got to know Mao Xuhui after starting university. I was accepted into the Oil Painting Department of the Sichuan Fine Arts Institute, and he was accepted into the Oil Painting Department of Yunnan Arts University. After receiving our acceptance letters, Little Mao invited a few of the painting students, which included me and Ye Shuai (who was feeling down because he hadn't been accepted), to get food at a small restaurant and take a group picture at a photo studio. The photo was labelled 'Friendship Forever, Boundless Future'. Our correspondence began then and continued for twenty years (with the exception of one four-year interruption when we were living in the same city)." Zhang Xiaogang, "The Mao I Know" (*Wo renshi de Damao*), in *Mao Xuhui* (Beijing: Cheng Xindong Publishing Company, 2005).

Chapter 1

ENLIGHTENMENT

Mao Xuhui
Drawing of Yuantong Temple (*Yuantong si xiesheng*),
18 August 1973
Pencil on paper, 19.5 × 26 cm

Mao Xuhui
Shiju Train Station under the Western Mountain (*Xishan jiaoxia de shiju huochezhan*), 16 March 1975
Charcoal on paper, 23 × 29 cm

Mao Xuhui notes: "This was drawn on the first day of the training march organised by the general merchandise store militia, when we reached Shiju train station"

Chapter 1

ENLIGHTENMENT

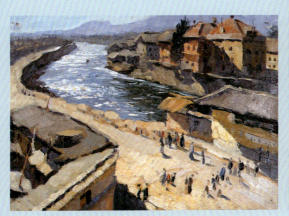

Mao Xuhui
*Looking at Panlong River from Desheng Bridge
(Cong deshengqiao kan panlongjiang)*, 1975
Oil on paper, 23 × 30 cm

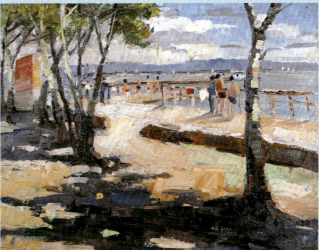

Mao Xuhui
Haigeng in Summer (Xiari de haigeng), 1975
Oil on paper, 30 × 36 cm

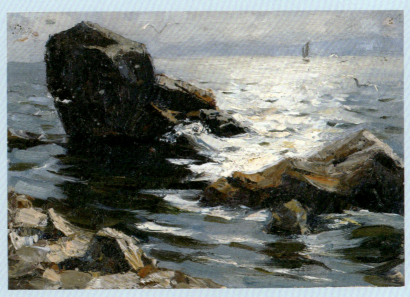

Mao Xuhui
Drawing of Haikou, Kunming (Kunming haikou xiesheng), 1975
Oil on paper, 22 × 30.5 cm
Zhang Xiaogang's collection

Chapter 1

Enlightenment

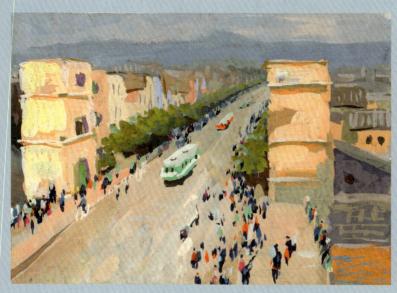

Mao Xuhui
Desheng Bridge Bridgehead, Jinbi Road (*Jinbilu deshengqiao qiaotoubao*), 1975
Gouache on paper, 13.5 × 18.5 cm

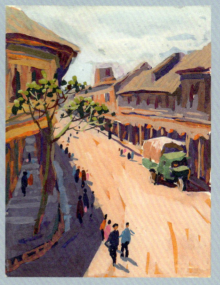

Mao Xuhui
Tongren Street Close to Baoshan Street Crossing (*Tongrenjie jin baoshanjiekou*), 1975
Gouache on paper, 15 × 11 cm

Mao Xuhui
My Office (*Wo de bangongshi*), August 1976
Gouache on paper, 21 × 28 cm

Chapter 1

ENLIGHTENMENT

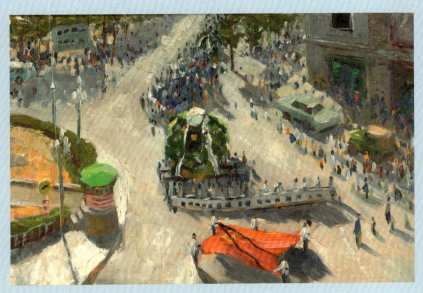

Mao Xuhui
Leader Passed Away (*Lingxiu qushi*), September 1976
Oil on paper, 27 × 39 cm

Mao Xuhui notes on 3 October 2015: "The year when Zhou Enlai and Mao Zedong passed away in quick succession, Su Xinhong and I stood on the roof of the general merchandise store watching the scene of people marching through the streets to mourn the deaths of these great figures, and we started to paint. Below us was Jinri Park and its fountain, with the general merchandise store on its right. The procession made its way from Dongfeng West Road, with Sanshi Street on its right"

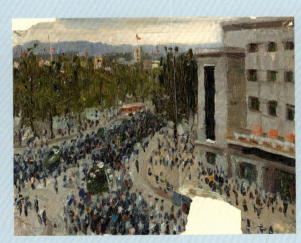

Mao Xuhui
Leader Passed Away No. 2 (*Lingxiu qushi zhi er*), September 1976
Oil on paper, 21 × 27 cm

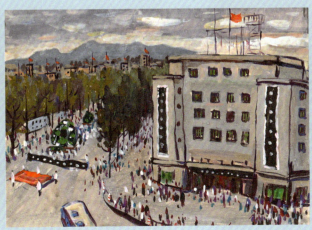

Mao Xuhui
Leader Passed Away No. 3 (*Lingxiu qushi zhi san*), September 1976
Gouache on paper, 18 × 24 cm

Chapter 1

Enlightenment

Mao Xuhui
Drawing of Jinning (*Jinning xiesheng*), 1977
Oil on paper, 18 × 24 cm

Mao Xuhui
Still Life (*Jingwu xiesheng*), 1977
Oil on paper, 52 × 39 cm

Mao Xuhui notes in October 2015: "I painted it at our house at the Bureau of Geology and Mineral Resources while taking my university entrance exams"

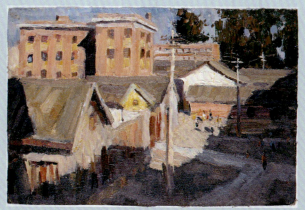

Mao Xuhui
Bureau of Geology and Mineral Resources Courtyard (*Dikuangju dayuan*), 1977
Oil on gauze paper, 27 × 39 cm

Chapter 1

Enlightenment

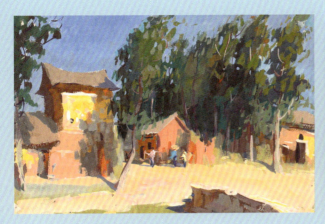

Mao Xuhui
Rural Chenggong (*Chenggong nongcun*), 1977
Gouache on paper, 27 × 39.5 cm

Mao Xuhui notes in October 2015: "I painted this when the 'Learn from Dazhai in agriculture' campaign team was transferred from Baofeng Commune, Jinning, to Chenggong. I received my university admission letter whilst working in Chenggong"

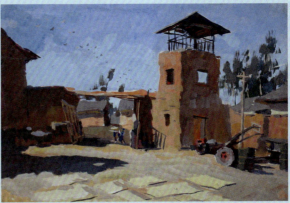

Mao Xuhui
Threshing Floor in Rural Chenggong (*Chenggong xiangcun de daguchang*), 1977
Gouache on paper, 40 × 54 cm

Mao Xuhui notes in October 2015: "In 1977, I was still in this village, working as a member of the 'Learn from Dazhai in agriculture' campaign team. Before, in 1976, I worked in Baofeng Commune, Jinning County, and during that time, I met Xia Wei and Zhang Xiaogang, who were sent-down youth in Jinning County at that time. Xia Wei was in Baofeng Commune, and Xiaogang was in Erjie Commune. In early 1977, I followed the work group to Chenggong. I then went to Kunming to take the university entrance exams and received the admission letter from Kunming Normal College"

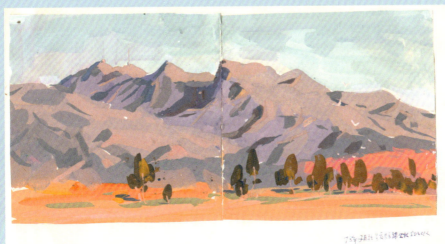

Mao Xuhui
Liangwang Mountain in Chenggong (*Chenggong liangwangshan*), February 1978
Gouache on paper, completed at Gucheng Brigade, Majinpu Commune, Chenggong

75

Chapter 1

ENLIGHTENMENT

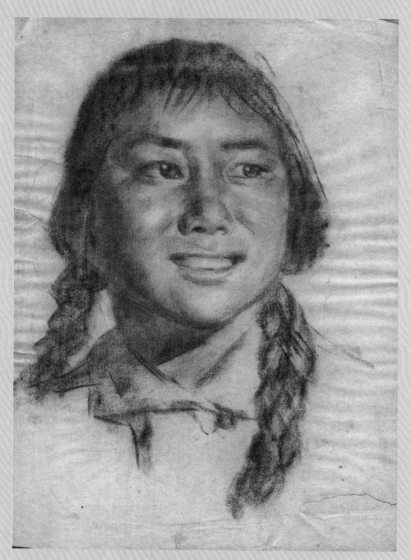

Mao Xuhui
General Merchandise Company Employee (*Baihuo gongsi de zhigong*), 1976
Charcoal pen on paper, 37.5 × 26.5 cm

Chapter 1

ENLIGHTENMENT

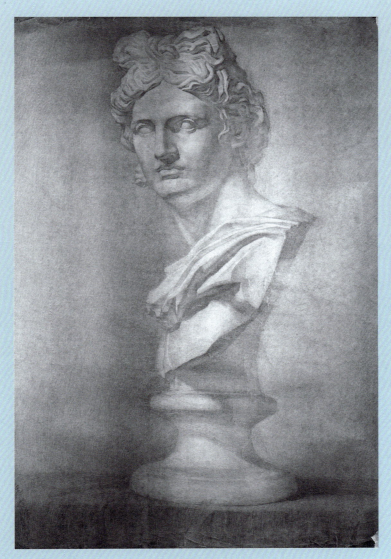

Mao Xuhui
Apollo (Aboluo) Apollo, 1978
Pencil on paper, 87 × 58 cm

Chapter 1

Enlightenment

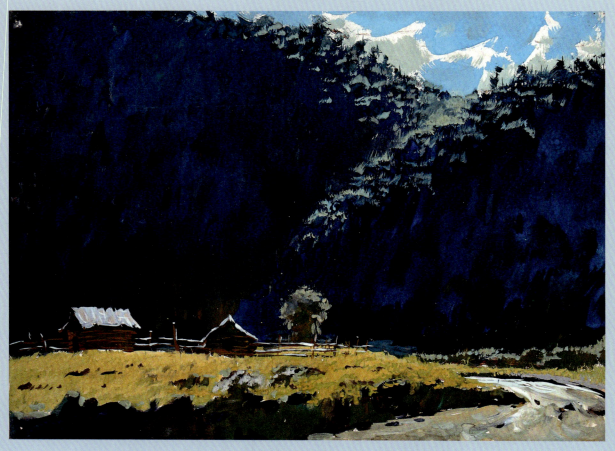

Mao Xuhui
Scenery of Lanping Forest Area (Lanping linqu fengjing), 1978
Gouache on paper, 41 × 55 cm

This is a painting from memory. The journey to the forest area was long, and the scenery along the way was all much the same. In the summer holidays of 1978, after his first year of university, Mao Xuhui went sketching in Lijiang with Zhang Xiaogang. In Lijiang, they met classmates Zhang Chongming and Chen Xiaoyan and stayed and ate at Chen Xiaoyan's mother's workplace. Influenced by Yao Zhonghua's Yunnan landscapes, he painted "big mountains and big rivers"

Chapter 1

Enlightenment

Mao Xuhui
The Old Street of Lijiang (*Lijiang laojie*), August 1978
Gouache on paper, 59.5 × 39.5 cm

Mao Xuhui
Xundian Miao Village in Yunnan (*Yunnan shanchun Xundian miaozu cunzhai*), 1978
Gouache on paper, 25.5 × 43 cm

Chapter 1

ENLIGHTENMENT

Mao Xuhui
Terraced Fields in Yunnan (Yunnan titian), 1978
Oil on paper, 44.3 × 37 cm
Zhang Xiaogang's collection

Mao Xuhui
Threshing Floor of Haimen Brigade, Jiangchuan County (Jiangchuan haimen dadui de daguchang), 1978
Gouache on paper, 24.5 × 51 cm

Chapter 1

Enlightenment

Mao Xuhui
Two Paintings of Tibetan People Going to the Market in Dêqên, Shangri-la, Yunnan (Yunnan Zhongdian Deqin zangmin ganjie tu), 1980
Crayon on paper, 26 × 51 cm; 24 × 50 cm

Mao Xuhui
Tibetan Houses in Dêqên, Shangri-la, Yunnan (Yunnan Zhongdian Deqin zangmin minju), 1980
Oil on paper, 39.5 × 36 cm

Mao Xuhui
Drawing of Shangri-la, Yunnan (Yunnan Zhongdian Deqin xiesheng), 1980
Oil on paper, 37.5 × 44.5 cm

Mao Xuhui
Shangri-la Snow Mountain (Zhongdian de xueshan), 1980
Oil on paper, 38.5 × 77 cm

Chapter 1

ENLIGHTENMENT

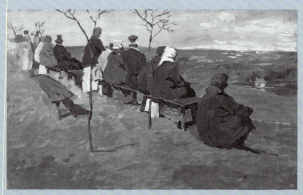

Mao Xuhui
Memory of the French Film Le Silencieux
(*Faguo dianying chenmo de ren de jiyi*), 1978
Gouache on paper, 21.5 × 23.5 cm

Mao Xuhui
Copying Soviet Paintings (*Linmo sulian huihua*), 1978
Gouache on paper, 35.5 × 54 cm

Mao Xuhui
Memory of the British Film Death on the Nile
(*Yingguo dianying niluohe shang de can an de jiyi*), 1978
Gouache on paper, 14.5 × 25.5 cm

Mao Xuhui
Memory of the Japanese Film Manhunt
(*Riben dianying zhuibu de jiyi*), 1978
Gouache on paper, 20 × 30 cm

Mao Xuhui
Memory of a Yugoslavian Film (*Yi bu nansilafu dianying de jiyi*), 1978
Gouache on paper, 29 × 35 cm

Chapter 1

Enlightenment

Mao Xuhui
Memory of the Soviet Film How the Steel Was Tempered (*Sulian dianying gangtie shi zenyang liancheng de jiyi*), 1978
Gouache on paper, 38 × 27 cm

Mao Xuhui
Memory of the Yugoslavian Film The Bridge (*Nansilafu dianying qiao de jiyi*), 1978
Gouache on paper, 24.5 × 36.5 cm

Mao Xuhui
Memory of the Mexican Film Corazón salvaje (*Moxige dianying lengku de xin de jiyi*), 1978
Gouache on paper, 31 × 24 cm

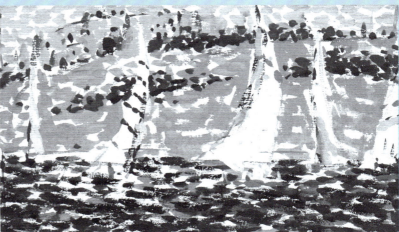

Mao Xuhui
Memory of the British Film Death on the Nile (*Yingguo dianying niluohe shang de can an de jiyi*), 1978
Gouache on paper, 14.5 × 25.5 cm

Chapter 1

Enlightenment

A sketch drawn by Mao Xuhui at Chaotianmen Dock in Chongqing, during his summer vacation field research trip from 6 July to 25 August 1980

During his summer vacation field research trip from 6 July to 25 August 1980, Mao Xuhui toured the Three Gorges by boat. This is a sketch of the docks and scenery of the Three Gorges he drew while on board

Chapter 1

ENLIGHTENMENT

The canal scene at Wuxi Renmin Bridge drawn
by Mao Xuhui on 25 August 1980

On 22 August 1980, Mao Xuhui depicted the scene of boat docks along
the canal, where boats served as homes, at Suzhou Renmin Bridge

During his summer vacation field research trip from 6 July to 25 August
1980, Mao Xuhui wrote about his trip to Beijing and his visits to veteran
artists Yuan Yunseng and Sun Jingpo in Beijing

Chapter 1

Enlightenment

Gao Xiaohua
Why (Weishenme), 1978
Oil on canvas, 107.5 × 136.5 cm
National Art Museum of China, Beijing

Cheng Conglin
A Snowy Day in 1968 (1968 nian ri xue), 1979
Oil on canvas, 196 × 296 cm
National Art Museum of China, Beijing

Chapter 1

Enlightenment

Luo Zhongli
Father (Fuqin), 1980
Oil on canvas, 215 × 150 cm
National Art Museum of China, Beijing

He Duoling
Spring Breeze Has Awakened (Chunfeng yijing suxing), 1981
Oil on canvas, 96 × 130 cm
National Art Museum of China, Beijing

Chen Danqing
*Tibet Series: Mother and Son
(Xizang zuhua: mu yu zi)*, 1980
Oil on canvas, 51 × 75 cm

Chen Danqing
Tibet Series: Into the City No. 2 (Xizang zuhua: jincheng zhi er), 1980
Oil on canvas, 70 × 45 cm

Chapter 1

ENLIGHTENMENT

Chapter 1

ENLIGHTENMENT

From 18 to 29 September 1980, Mao Xuhui sketched in the Dêqên area of Shangri-la, Yunnan

Chapter 1

ENLIGHTENMENT

Mao Xuhui
Highlands (Gaoyuan), 1981
Oil on canvas, 88 × 117 cm

Mao Xuhui
Drinking Tea (He cha), 1981
Oil on canvas, 62 × 109.5 cm

Chapter 1

ENLIGHTENMENT

Mao Xuhui
Beautiful Ganlanba (*Meili de ganlanba*), 1981
Gouache on paper, 43 × 112 cm

Mao Xuhui
Drawing of Xishuangbanna, Aini Mountain Village Water Pipe
(*Xishuangbanna xiesheng, aini shanzhai shuiguan*), 1981
Gouache on paper, 30 × 54 cm

Chapter 1

ENLIGHTENMENT

Mao Xuhui
Shangri-la, Dusk (*Zhongdian, huanghun*), 1981
Watercolour on paper, 15 × 22 cm

Mao Xuhui
Xishuangbanna (*Xishuangbanna*), 1981
Gouache on paper, 31 × 70 cm

Chapter 1

ENLIGHTENMENT

Mao Xuhui
Drawing of Xishuangbanna, Menghai Dusk (*Xishuangbanna xiesheng, Menghai huanghun*), 1981
Gouache on paper, 44 × 31 cm

Chapter 1

Enlightenment

Mao Xuhui
Highlands (*Gaoyuan*), 1980, and *Morning Tea* (*Zaocha*), 1980
Oil on cardboard, 78.5 × 108.5 cm

Mao Xuhui
Drinking Tea, draft (*Hecha, caogao*), 1981
Sketch on paper, 56 × 96 cm

Mao Xuhui
Drinking Tea (*Hecha*), 1981
Watercolour on paper, 39 × 63 cm

Chapter 1

ENLIGHTENMENT

Mao Xuhui
Autumnal Mountain Village, draft (Shanzhai qiuse, caogao), 1981
Oil on paper, 44 × 54.5 cm

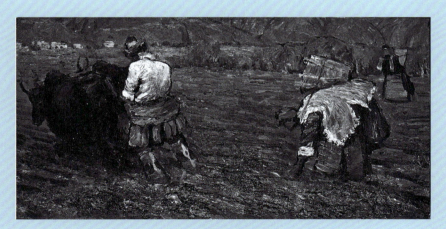

Mao Xuhui
Farming (Gengzhong), 1980
Oil on paper, 24 × 48 cm

Chapter 1

Enlightenment

On 22 August 1981, Mao Xuhui sketched at the Yungang Grottoes in Datong, Shanxi, during a field research trip

On 23 August 1981, Mao Xuhui sketched at the Huayan Temple in Datong, Shanxi, during a field research trip

On 29 August 1981, Mao Xuhui sketched at the Lintong Musuem in Xi'an, during a field research trip

On 29 August 1981, Mao Xuhui sketched at the Tomb of Sima Jinlong in Datong, Shanxi, during a field research trip

On 31 August 1981, Mao Xuhui sketched at the Banpo site in Xi'an, during a field research trip

On 31 August 1981, Mao Xuhui sketched at the Xi'an Banpo Musuem, during a field research trip

Chapter 1

Enlightenment

On 2 September 1981, Mao Xuhui sketched the stone carvings of Maoling Museum at the Limin Hotel in Xianyang, Shaanxi, during a field research trip

On 3 September 1981, Mao Xuhui sketched at Yongkang Mausoleum, Xianyang, Shaanxi, during a field research trip

On 6 September 1981, Mao Xuhui sketched at Luoyang Museum, Henan, during a field research trip

Mao Xuhui and his graduation project *Lancang River* (*Lancang jiang*), winter 1981

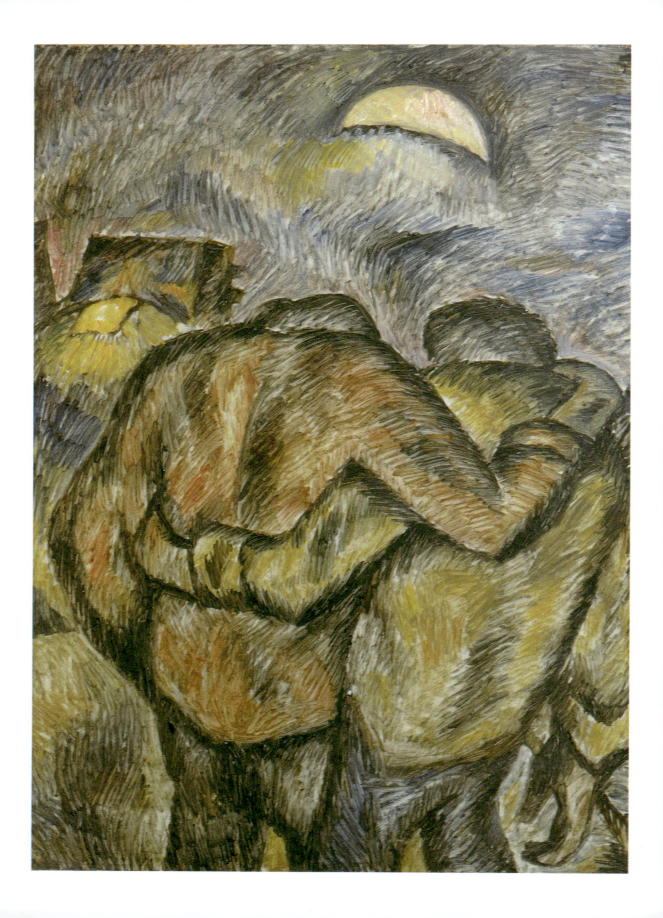

Chapter 2

THE TUMULT OF YOUTH

Still that wineglass
Still that red wine
Still that pitch-dark night
Still those tender songs
Are they all here, my friend
Ah the cabin by "the Seine River"

Still that face
Still that angle
Still that bitterness
Still those dreams
Those who have left will not return
Those staying remain together
Ah the cabin by "the Seine River"

Still that lamp
Still that stubbornness
Still that hour
Still that tender song
We keep the incoming
We wait for the absent
Ah "the Seine River..." the cabin

Mao Xuhui (1982)

Mao Xuhui wrote the poem *Ah the Cabin by "the Seine River"* in November 1982, almost a year after graduating from the Yunnan Arts University. He had married his classmate He Lide two months after finishing university, and in March travelled to Guishan with Zhang Xiaogang who was yet to find a job after graduating from the Sichuan Fine Arts Institute. For Mao Xuhui, this trip to Guishan marked a turning point in his artistic practice. In contrast to his previous trip, he no longer regarded the rural ethnic minority region through the lens of the plein-air school and instead saw the simple nature of his surroundings through his own eyes, producing for the first time a series of works that depicted his own Guishan. A comparison of his paintings from this period with his previous depictions of Guishan reveals a different expressive technique. In 1979, Mao Xuhui was still immersed in his studies of Soviet painters and their visual understanding. He even copied passages from Konstantin Maksimov's speeches about oil painting techniques. The Soviet artist's personal perspective on art united his various accounts of what he had learned from experience and practice, and he always advised Chinese students to grasp the world as it really is before deciding how to depict it. However, he also warned students not to simply "copy what you see". For example:

If the bodies in a painting, its background and clothing, can be brought into harmony, then that work has exhibited some of the characteristics of oil painting. However, objects that exist in nature do not simply exist in harmony; there are also elements of conflict and contrast. You should be able to see the conflicts between the warmth and cold of an object's colours (the differences in warmth-cold relations, the complex elements of warmth and cold that exist in a single object) and be able to give them expression. Everything has its own colour; nothing is without colour. Sometimes there are vibrant colours; at other times the colours are more neutral. Not everyone can see the difference, but every colour exists in relation to the body it inhabits.[1]

FROM GUISHAN TO THE SEINE

Page 98
Mao Xuhui
Strolling by the Moat after Drinking (Jiuhou manbu zai huchenghe bian), 1982
Oil on board, 67 × 62 cm

However, having encountered modernist texts and images, Mao Xuhui was no longer interested in these surface visual phenomena. His decision to abandon his previous painting approach both informed and was informed by the habit he had maintained since 1980 of transcribing pertinent extracts he encountered that detailed the careers and insights of modernist artists. Although his inability to settle on a specific mode of expression caused his final graduation project to be a failure, the work revealed an indecisiveness on the part of the artist, a sign that he was beginning to break free from the influence of the plein-air school and native painting. If formalism would not meet his requirements as a painter, he was sure to find the seeds of a personal artistic language in his new life experiences. Of course, his attempts to move on from his former painting methods were at this stage still grounded in the theoretical. Although his vacillations between different styles prohibit us from seeing an obvious expressive approach in his final art project, his graduation thesis *On Paul Cézanne* (*Tan Baoluo Saishang*) reveals this young artist's decisive break with the Chinese mainstream at the time.

Mao Xuhui says he first came across Cézanne in the book *A History of Impressionist Painting* (*Yinxiangpai huashi*): "Back then I was overwhelmed by Monet, Pissarro, Sisley, Renoir and Degas, captivated by their splendid, vibrant colours and intense sense of light. When I saw the awkward, rugged self-portrait of Cézanne, I felt uneasy. I couldn't understand why he was also regarded as one of the greatest painters." However, in 1981, Mao Xuhui in no uncertain terms: "Now, what overwhelms me the most are not Monet's *Impression, Sunrise*, Degas's dancers, Pissarro's peasant women, Sisley's harbours, or Renoir's theatre boxes, but Cézanne's still lifes: his apples, tablecloths and pottery."[2] In his graduation thesis he writes:

Cézanne passed away on 22 October 1906, over half a century ago, yet it is only now that we come to know him and his art. How pathetic! Many of our concepts are still those of the past, so we feel uneasy and shocked to find no features of classicism, romanticism, realism and impressionism in Cézanne's paintings. At first glance, his paintings appear stiff, clumsy, laboured and lifeless. No wonder the Parisian audiences and critics reacted with relentless ridicule back then. But through all this unsightly "awkwardness" that challenges outdated perspectives, we feel the vitality and profundity in his art. The great unity of form and colour, the meticulous and compact structuring and the solid and definite forms create a sense of eternity and grandeur. Everything is painted with such solemnity and dignity; his painting is like a pyramid built with colours and forms like bricks and tiles. Whether it's the apples, the tablecloths, the portraits, the landscapes and the bathing women he painted, you distinctly feel that none of it is merely a crude imitation of nature but rather a meticulously crafted world arranged by an artist; it's not the portrayal of nature's shell, but the expression of its internal structure. What a pure language of painting, full of sincerity and strength, hope and confidence, and an indomitable will to create art.

Now we can see why the Guishan Mao Xuhui saw in 1982 was different from what he painted in those Sani villages in 1979. The bright, shining colours are gone, and the formerly imposing and beautiful scenery has given way to

a gloomy, primeval dreamscape in which awkward and crude-looking houses, trees, fences and stone-stacked walls are depicted in short, thick brushstrokes, reducing the entire composition to a psychologically disturbing plane without a sense of depth or perspective. This is no longer the plane of decorative patterns and blocks of colour, but a world of shapes that unsettle or startle the mind of the viewer. Some of the trees and houses are outlined in thick, dark hues, which are imbued with a powerfully affecting psychic force. The simultaneous influence of Van Gogh, Gauguin and Cézanne are clearly present in this work. In these landscape pictures, Mao Xuhui has drawn from the emotional turmoil of Van Gogh, the primitivism of Gauguin and the crude brushwork of Cézanne to produce a new Guishan, a Guishan that emerges from his very soul. In fact, Zhang Xiaogang, who accompanied Mao Xuhui to Guishan, also produced works in a similar vein on this trip, albeit with a more delicate and nervous character. We can also see from the sketches Mao Xuhui produced that he viewed the object of his perception very differently—no longer a precisely delimited body nor a decorative arrangement, and a far cry from his sketches in the Tibetan regions or his use of colour in Lijiang.

In February 1982, Mao Xuhui went back to the General Merchandise Company, a place he was fed up with and didn't want to be anymore. He wanted to teach at an art academy, but he knew that his disappointing graduation project would not provide him with the cultural capital he needed to carry on in the school as a teacher. His formal artistic training had failed to significantly change his destiny, and he found little to satisfy his inner restlessness and yearning for freedom. As a result, he succumbed to more dissolute habits and began drinking and smoking heavily. He began to acquire a tendency toward psychological mimesis, exhibiting signs of depression, anxiety and a generalised "suffering", inspired as he was by the terms he read in modernist books or the stories he encountered of the lives of Western artists. Furthermore, his girlfriend He Lide had been assigned a job in Qujing, a small city far away from Kunming, which only made him more receptive to the Western modernist notion that human life is a tragedy. His conception of society and his own predicament began to stray even further from orthodox views. In February, Zhang Xiaogang returned to Kunming after university feeling similarly despondent because he was unable to find a satisfactory job. Although the publication of his graduation project *Coming Storm* (*Baoyu jiangzhi*) in the pages of *Art Magazine* in February 1982 had made Zhang Xiaogang the object of envy and admiration amongst his friends and classmates, it had not allowed him to stay on at the Sichuan Fine Arts Institute as a teacher. He arrived in Kunming and waited for any opportunity that might come his way. His birthday fell on 22 February and, in their melancholy state, Mao Xuhui and Zhang Xiaogang spent the evening in the latter's house with saké and fava beans, seeking comfort in their shared suffering. In the hope that it might help her find work in Kunming, thereby changing the lovers' current situation, Mao Xuhui and He Lide registered their marriage. However, for Mao Xuhui, who sought above all to become a bona fide artist, the most important thing in his life was still painting, which is why shortly after his marriage to He Lide, he travelled once again to Guishan with Zhang Xiaogang. The large number of sketches and materials he produced on this trip would become an important source for his "Guishan" (*Guishan*) series.

For Mao Xuhui, with his ambitions of being an artist, graduating from art academy must have felt like entering a state of suspension. He had deepened his understanding of art but, having finished school and entered the quotidian world of work, he was at a loss. On 8 March, after his trip to Guishan, Mao Xuhui took a train to Chongqing on his own, an impulsive decision the origins of which were obscure even to him. As the place of his birth, the city must have had a certain nostalgic allure, but the primary reason for his travelling to Chongqing to clear his thoughts was the Sichuan Fine Arts Institute, which was esteemed throughout the country, and friends like Zhang Xiaogang who had lived or were living there. Mao Xuhui could sense that this trip had none of the feelings of excitement and joy associated with his former travels. Gazing through the grimy train window at the dim light reflected from the river on the evening of 3 March in Chongqing, Mao Xuhui felt mentally exhausted, a feeling that was somewhat assuaged by hearing the Sichuan accent and seeing the local girls, which awoke in him happier, more cordial feelings. The next day, he went to the Sichuan Fine Arts Institute in Huangjiaoping.

Chongqing is truly a grey expanse, with faint blue mist and a stirring melancholy, deep yet indistinct. The dry weather of Kunming: fierce wind rolling dust, the sky vibrant and blue. The spring arrives eagerly and ferociously. Here, it's quite the opposite: the transition from winter to spring takes place quietly, with tenderness.

During his time in Chongqing, Mao Xuhui kept a record of his feelings and his ceaseless ruminations. At the Sichuan Fine Arts Institute, he attended the "National Higher Art Academy Student Artworks Exhibition" (*Quanguo gaodeng yishu yuanxiao xuesheng zuopin zhanlan*) and the "Sichuan Fine Arts Institute Visits Beijing Oil Painting Exhibition" (*Sichuan meiyuan fujing youhuazhan*). Despite the widespread interest in native painting, Mao Xuhui was relatively non-plussed by the exhibitions in which he perceived little that was new or exciting. He wrote of his impressions of the artworks by students at the Sichuan Fine Arts Institute that had received high praise:

Luo Zhongli has churned out some thirty oil paintings, a series of displays of the life of Sichuan farmers, in one go. They are filled with many vivid, clever details and even brutal realism. They are down-to-earth but a bit outdated, too. I have yet to think much about things like this. Gao Xiaohua's work is similar: a series of portrayals, quite skilled, but it feels like something is missing; what, though, I can't put my finger on. Cheng Conglin's portraits of four classmates and a few artists today— the warm tone of the one portraying Xiaogang was nice. Overall, though, they are not ideal. The four small works by Yang Qian: one depicts a small corner and another a tiny heart. I am fond of Hope *(Pan) and the one depicting a goat being fed. They, too, show good technique, but they also feel somewhat "foreign" and lack a little austerity. However, painting such a simple and ordinary corner and making it into something is not easy. Xiaogang's* The Flock of Goats Wandering into the Distance *"excites me. There's a soul-captivating charm to the tone, composition and shapes. If I had money, I'd buy this painting first.*

Mao Xuhui noted his indifference to the traditional Chinese paintings in the exhibition and expressed interest in the contents of an evening seminar that discussed Soviet modern paintings, large-scale mixed-media artworks and murals, but he was now predominantly concerned with the "open realist" ideas of Ehrenburg—"memories of war and the pursuit of form; against the cult of the individual"—as well as painters who, unsatisfied with the status quo, explored new creative paths, such as Yevsey Moiseyenko, Savitsky and Tetyana Yablonska.

Life is composed of a series of incidental events. It was but an unfocused artistic drive that had brought Mao Xuhui to the place of his birth, so he had no specific purpose or plan. On 11 March, he visited the reference room at the Sichuan Fine Arts Institute High School, where he watched a series of videos on "The Beauty of Japan", "Decoration and Craftsmanship at the Academy" and the art of Michelangelo, Rodin and Gian Lorenzo Bernini. He watched a forty-minute version of *Carmen* and was fascinated by the opera's emotional tenor: "The opera *Carmen* is full of passion, portraying the life of the lower classes. It has a wild, untamed Spanish flavour, but with a strangely moving beauty, like a Gypsy woman. When I heard the line, 'Love is a rebellious bird', it brought tears to my eyes."

His recalls the narrative style of Hermann Hesse's Bildungsroman *Peter Camenzind*, a book Mao Xuhui had read. Beneath the surface of Mao Xuhui's record of quotidian events simmers a powerful sense of unease:

In the afternoon, I arrived by the riverside of Lijiatuo with Liu Yong, Ye Shuai and Xiao Zhiqiang. The colours of the riverbank, the large colour blocks, the ambiance, the lines, and the grey and hazy sun . . . The factories and chimneys spat out black fumes by the ferry dock on the shore. In this busy and misty riverside, I couldn't quite say whether I was happy or joyful; I found everything before my eyes beautiful and special. Compared to Kunming, it had a more complete melancholy that quickly brought to mind people and things of the past. Standing on the sand I was not overly excited but calm. With the big batches of grey-green hue merging with the river, standing on the expansive riverbank felt like standing in front of a marvellous stage as vast and profound as the land depicted by Millet, accompanied by the sound of steam whistles echoing from the swaying boats in the river. I strolled through this expanse, thinking how liberating it would be if life's path were this open and free and I could go anywhere I pleased. Yet I stood there like a tied-down bird. There was a faint grief in my heart, even repressed pain deep within. Perhaps I see society too clearly, and with that clarity comes too much despair, which replaces all the beautiful thoughts and dreams I once had about life. I feel so burdened. Who could possibly understand why I've come here again? Who could know the weight I carry within? Yet I can confide in no one, nor do I need to, because what am I in the minds of others? I looked at the pebbles beneath my feet. I wanted to regain some innocence and move my attention to these natural handicrafts, but I realized that what's lost in a person is much harder to find again, for life isn't like these pebbles that one just picks up at will. It's as if I've become a person without choices; the opportunities are choosing me instead. Nonetheless, I have carefully chosen my pile of stones. What memories will they leave for me, these stones imbued with multiple meanings?

I took a ride back to the art academy and stopped by a small eatery on the street to fill my stomach. In this little joint, you could have a meal for just a few bucks: two bowls of dumplings and a bowl of noodles, or a piece of fagao [steamed cake], a youtiao [fried breadstick].

Before I knew it, I was smoking more cigarettes than usual.

The petite local girls on the street had a certain charm, at least to me, perhaps because of their fair and plump faces.

There was another lecture that night in that shabby, chilly auditorium. Shao Dazhen from the Central Academy of Fine Arts was to give a talk on "Western Modernism."[3]

Modernist works encompass both abstract and figurative art.

Just as the slides were about to start, the power went out. Meeting adjourned.

The moon was particularly beautiful that night, either a pale or more saturated orange, and the night was not dark but purple and grey-blue. Such nights were meant for lovers, brought to earth for love. The soft and peculiar radiance was scattered for love, yet there I was, alone, heart full of desire, which I could only restrain with reason. All those moments of sweetness and beautiful dreams no longer belonged to me while my love was somewhere far away, so distant. Watching this great moment fading away, all you could do was sigh for life and feel lost and estranged. This tranquillity faintly stirred up time past, and I dared not chase after these sparks of memory. I had never been at ease in my past travels and often wandered around with a broken and shattered heart. Here, I felt the loneliness of fate and the melancholy of life more and more. What is there to remember? Forgetting the past is a blessing, yet before me lay nothing but emptiness and loneliness.

"La Rotonde"[4] *I imagined did have a certain allure, filled with waitresses with wondrous smiles, friendly and not sharp-tongued. The drinks may be cheap, but they can lighten the mood. At least there were lights there; in student dormitories, you won't even find a candle. Not to mention the tempting flower within, so young and charming.*

I stumbled back drunk, and my body felt lighter. The streets and the Yangtze River were asleep, and only a few pedestrians and couples drifted in the night mist. Everything, including my heart, became simple. I vaguely remember that I climbed the gate of the academy. I had gone to sleep when Xiaogang came over in the dark. He spoke of his work, his longings, his worries and what remained of his hopes for the future. My mind was blank, dealing with him with a tired brain. I couldn't see his face, only the glow of his cigarette that flickered as he spoke to himself incessantly.[5]

The eleventh passed like this, in darkness, in fatigue.

The twelfth was the last day, yet I didn't feel the need to stay any longer and had the strong urge to go back, and once that feeling arose, it was unstoppable. Going back, there was only going back; that's how I could get things started. My greatest gain was a kind of pressure, the fear that if you don't produce something, you'll appear insignificant and inevitably be discarded.

I went to the exhibition one last time. Only Lu Yi's work left an

impression, strong in form but lacking in flavour. Sichuan artists indeed stood out. Luo Zhongli's paintings simply couldn't be looked at for long: they seemed diseased, as if an illness prevented one from getting close. Somehow, Yang Qian's work was approachable and somewhat innocent. Xiaogang's work appeared a bit too simple; Cao Conglin's too hasty. Lei Hong's Watching the Sun *(Kan taiyang) was appealing, but the rest seemed obscure, even ridiculous. Some paintings were simply unpleasant no matter how you looked at them, and it felt unnecessary to exert energy on such things. The paintings by the teachers seemed even more pitiful. Such exhibitions only boost one's confidence.*

I went to the resource centre at noon to look at the art catalogues. There was an admission fee of one yuan, but after some pleading and expressions of devotion to art, the gatekeeper let me in for free.[6]

I freely browsed the large-sized complete collections, the Japanese Sansai, the American Connoisseur, *photography albums and the* Japanese Monthly Art Magazine. *The works of Van Gogh and Cézanne still held that shocking power, but many masters' works barely interested me; artists like Kandinsky, Klee, and Dalí left me cold. I adored Picasso's Blue Period. Paintings by Bonnard and Matisse felt distant, and Japanese paintings seemed overwhelmingly sensual, too stimulating, with so many beauties and nude figures only offering sensory pleasure and arousal.*

My head started to ache: migraine from a bad cold. In the end, every time I flipped through a page, my eyes would sting as if stabbed by an intense light. Realising opportunities like these were rare, I continued to browse desperately, but eventually I felt dizzy and had to leave. My body was weak; I had only read for three hours.

Returning to the city, I once again felt the unique contours and undulations of this mountain city, the land where my ancestors grew up. And I took this place as my hometown and cherished it. Coming back here was like returning to my mother's side, where I felt a carefree tranquillity that could not be found elsewhere. I knew my grandfather was waiting for me, as well as all my older and younger cousins and their spouses. My life there would be a settled, secular life. I could take it easy and go wherever I wanted because it was home.

The streets of the mountain city, with their composition and grey tone—I couldn't get enough of it. I gazed at them from the tram; I strolled along the riverbank. I stood at Lianglukou and gazed at the Yangtze River Bridge, holding the rail and counting the steps, watching the misty river and the reflection of boats, the run-down houses, and the brand-new buildings. Observing the streets here, one could look up or down: interesting juxtapositions, intersections and arrangements everywhere in grey and subdued colours, with beautiful ashen shades, thin shadows and faint sunlight. The air was damp, and there were no dazzling colour patches. Many beautiful girls adorned the streets, and I longed for them, though I realised that I had aged considerably: on my face almost no hint of youth, no confidence evoked by those faint traces. Instead, I was plagued by feelings of inadequacy, failure and loneliness. I'm a wanderer with no harbour nor destination, drifting with my fate; I don't know whether I'm moving forwards or backwards, with the current or against it. I don't know why I came to Chongqing so determined and hastily. Was it some kind of calling? Perhaps it provided me with an opportunity for introspection, prompting

me to calmly reflect on my past university life; my happiness upon enrolment and the tranquil times in the academic environment were all replaced by a faint melancholy.

. . .

Morning, 14 March

I survived another night, finally reaching home today. I wanted to get off at Qujing, but many things put me off, and I have found myself becoming more and more rational. This is how society grinds down each and every one of us, smoothing out the edges of passion and sensibilities until we are all like the stones by the riverbank: almost identical in smoothness and size. I don't understand why people insist on being different from one another. You want to use this surname, while they want to use that surname, and everyone looks different. I don't see the point of it all. Why can everyone else tolerate this misfortune, yet I can't? I refuse to become just another pebble. What's in it for me? Self-worth? Who will ever recognise me?

Shuicheng is behind me now, it's eight in the morning, and we've reached Meihua Mountain station. We may be getting close to Yunnan. A bunch of dirty and tired-looking men boarded the train, their faces etched with the deep wrinkles of bare survival. Is that the symbol of hard work and bravery? To me it's sickening. This is the misfortune and degradation of man. There's nothing worthy of sympathy here. Being tortured into a state like this only to maintain one's instincts is just repulsive.

I've almost finished Byron's biography on the train. True poets are all masters of self-expression, sincere and candid, loathing hypocrisy. These are essential elements of artistic creation. If we were to deny the existence of the self, I doubt we would have sculptures by Michelangelo or Rodin's The Gates of Hell, *nor would we have Van Gogh or Cézanne, and modernism would never have emerged. People would always remain mired in ancient religions and legends, perpetually in a state of ignorance. Without the independent thinking and toil of artists, without their unique sensibilities and acuity, our lives would be dull and uninspired.*

There is an irresistible freshness and joy to early mornings, the sunlight bright and innocent.

This young girl in pink reminds me of the waves on the lake, so fresh and clear. Youthfulness emanates from every gesture of hers. Meanwhile, I can only quietly contemplate life, seeing everyday existence with wearied eyes. Who wouldn't want to preserve that innocence and purity? Yet, time doesn't spare us. Even this girl, in another ten years, will she still be as captivating as she is now?[7]

Mao Xuhui's trip to Chongqing was part of his process of contemplating how to carry out his art. His mind was awash with thoughts and contradictions, which reflected his need for new creative possibilities. So too did the narrator of Hesse's *Peter Camenzind* continuously ponder his *raison d'être* and how he ought to face up to his future, and Mao Xuhui copied a passage from the novel in his notebook:

I began to understand that suffering and disappointments and melancholy are there not to vex us or cheapen us or deprive us of our dignity but to mature and transfigure us.[8]

In truth, his drawings of Guishan in early March marked a turning point in Mao Xuhui's career of which he himself was perhaps not immediately aware. An irreversible transformation was taking place in his style that clearly revealed the expressive tendencies of his character.

In early April, Mao Xuhui took a train to Beijing with his wife He Lide and friend Wang Jiandian. He wrote in his notebook: "On 13 April, I saw in the National Art Museum of China the *Japanese Prints* exhibition for which I bought the exhibition catalogue, and also saw *500 Years of Masterpieces: Armand Hammer Collection*. There I saw for the first time original paintings by such Western masters as Michelangelo, Raphael, Rembrandt, Rubens, Ingres, Corot, Millet, Monet, Derain, Degas, Sisley, Renoir, Pissarro, Moreau, Boudin, Gauguin, Van Gogh, Chagall, Picasso, Modigliani, Andrew Wyeth and Ensor." For these young artists who were born in the 1950s, to see original works by Western masters was an incredible luxury. Before attending the exhibition, Mao Xuhui wrote of an excitement that was hard to put into words:

I went to the museum on the morning of the 11th and first bought the Japanese Prints *exhibition catalogue. I had this sense of urgency, as if a grand curtain was about to rise, revealing the true appearances of the masters I had long been familiar with. I tried to calm myself down so that excitement wouldn't diminish the impact of this novel experience; it was of great importance to me. I was like a devout believer, quietly praying to God in crucial and important moments, asking Him for acute sensitivity, wisdom and self-restraint to spare me from great inner turbulence. It was so mysterious, like the night, the sea, the moment the sun bursts out. I felt so humbled yet so fortunate, still young, not yet verbose, able to meet the works of the masters in such a country, in such a fervent state, having long yearned for this moment, my heart withering and facing the end of the world. I was like a wanderer, a grain of sand tossed by fate, a lone ark deserted at sea, a dried heart.*

Mao Xuhui included in his notebook small sketches of and written reflections upon the works that most interested him at the exhibition:

No. 65 Raphael (1483–1520), Italy
Study for the Fresco The Prophets Hosea and Jonah
(Partial) Goose quill pen, brown wash, heightened with white gouache and squared for transfer with charcoal, blind stylus and red chalk.

No. 83 Jean-François Millet (1814–1875), France
Peasants Resting, *Chalk drawing*
Tan paper (the colour of kraft paper). A peasant couple sits under a tree. The man, sitting on a wooden cart (a wheelbarrow), a pipe in his mouth, takes out tobacco from the jacket pocket on his knee, while the peasant woman supports her head with her left hand, sitting on the grass, in the shade of the tree. Distant village. Pale green fields. Extremely ordinary, natural, peaceful, without any pretence, unexpectedly simple.

No. 12
View of the Cathedral of Mantes (c. 1855–60), Oil painting on canvas
Doubtless, Corot's paintings inspired the impressionist masters because he entered nature earlier, lived in harmony with it earlier, observed it with his own eyes earlier, and stepped out of the studio into Nature's embrace earlier.

His notebook includes similar passages on works by masters like Rembrandt, Giambattista Tiepolo, Jean-Baptiste Greuze, Théodore Géricault, Gustave Moreau, Peter Paul Rubens, John Singer Sargent and Monet, which speak to the spiritual nourishment and profound pleasure the experience provided this devout believer in art. However, it was the Modigliani painting *The Maid* that impressed him in a way that would soon have a direct impact on his work.

Mao Xuhui had eagerly studied all he could about European art history through his extensive perusal of magazines and picture albums, but when the original works finally appeared before his eyes, it nonetheless added another dimension to his comprehension of Western art. Merely taking pleasure in the aesthetic, it seemed, was not enough to furnish him with a path to pursue as a creator of art. When Mao Xuhui attended the "German Expressionist Oil Painting Exhibition" (*Deguo biaoxianzhuyi youhua zhanlan*) at Beijing's Cultural Palace of Nationalities on 14 April, the works by groups like Die Brücke and Der Blaue Reiter, as well as the metropolis-inspired pieces of German expressionists more generally, profoundly inspired him:

Mao Xuhui in front of the poster for the German Expressionist Oil Painting Exhibition, Beijing Cultural Palace of Nationalities, 14 April 1982

At the Art Museum, paintings from the Armand Hammer Collection evoke a sense of tranquillity and archaic elegance, yet once you step into the hall, you won't get a moment of peace. It's impossible to be calm here; instead, you are met with waves of intense tremors and fierce, uncontrollable emotions. Rationality has no place here; these artists unleash emotions onto the canvases with sincerity and honesty, free from the restraints of tradition. Emotions have replaced technique; emotions have triumphed over techniques. True art, be it classical, impressionist, or expressionist, shares a common goal: to convey to the audience beauty, passion, ambiance and emotion. It seeks not to captivate the audience through brushstrokes, space, colour, or composition! Though each artist employs different techniques, the emotional palette inevitably alters one's perception. It inevitably influences and may even subconsciously dictate the method by which an artist expresses their emotions.

Mao Xuhui was particularly interested in the language of expressionism, which differed from

that of classicism and even impressionism. Prior to this, he was clearly familiar with post-impressionism and the French fauvists through printed reproductions and had started to experiment in his paintings with modes of expression that belonged to neither impressionism nor realism.

A preference for rich and dense painting, acquired from scar art and native painting, as well as his travels in the Tibetan regions, found its fulfilment in the paintings of artists like Georges Rouault, albeit in a very different form: spurning realism while retaining the gravity of its style. The work of three post-impressionist painters would replace native painting as the model Mao Xuhui hoped to emulate; Van Gogh, Gauguin and Cézanne prompted this young Chinese painter to turn his focus respectively to passion, primitivism and nature. In his paintings of Guishan, he even made use of small blocks of colour in a deliberate attempt to recreate Cézanne's understanding of natural structure. However, deep down, Mao Xuhui had little interest in form or natural structure, and Rouault's crude, obscure and gloomy style provided the direction in which he would begin to experiment. Before his trip to Beijing, Mao Xuhui had painted some gouache works on paper, the thick outlines of which demonstrate he was already following in the footsteps of Rouault. However, only after he had seen the paintings at the Beijing expressionist exhibition did he begin to see clearly what his own painting language would be. After returning to Kunming, he sketched on the back of a painting of the woman he had recently married—a painting that happened to be in the style of Rouault—a scene of two youths by the banks of the moat at night.[9] His brushwork is reassured and relaxed, despite the night-time setting, in contrast with the dense colour and thick, powerful outlines of his earlier gouache works. The reddish moonlight is reflected in the moat alongside which two men, who seem to have already had a few rounds of drinks, are making their way home with their arms around one another. Perhaps it depicts a real meeting between Mao Xuhui and Zhang Xiaogang, drinking together to relieve their inner malaise.

Mao Xuhui worked close to the dormitory for the Kunming Song and Dance Ensemble, where Zhang Xiaogang got a job as a set designer in the first half of 1982. This young man who craved freedom finally had the opportunity to move out from his parents' place and live independently in the workers' dormitory. This space that lay beyond the reach of parental control became a place for these youths "infected with bourgeois thought and lifestyles" to drink and chat about life and art. These gatherings of young men and women, during which they recited French poetry, listened to Western music and discussed philosophical questions, frequently involved raucous singing and often came to an end only when the participants had passed out drunk. The European art tradition that so enthralled them was the reason the history and legends of modernist artists in Paris seemed so sacred and captivating for these Kunming youths. They read Charles Baudelaire, discussed Friedrich Nietzsche and shared their impressions of Claude Debussy and Igor Stravinsky. They yearned for Europe, France, Paris, Montmartre. They were so enamoured of the bohemian lifestyles of those in the French capital at the turn of the century that they longed to see in Kunming another Paris, or at least in the moat that surrounded the city their own Seine. They wanted to imagine their world as a re-embodiment of Paris, a

recurrence of the environment that gave rise to all those quasi-mythical European artists. Mao Xuhui's poem *Ah the Cabin by "the Seine River"* (*A, "Sainahe" bian de xiaowu*), written in November 1982, is a true portrayal of the lives of Mao Xuhui and his friends at this time. The "little room" is none other than Zhang Xiaogang's Kunming Song and Dance Ensemble dormitory on the banks of the Panlong River. At the end of the poem, Mao Xuhui wrote the following explanatory note:

This is not the Seine River of Paris, nor is it Parisian melancholy. It's just an insignificant river and some insignificant sorrow. Yet this cabin, albeit small, is noteworthy, for it is seething with an air reminiscent of the fervour and romance of Montmartre in early 20th-century Paris. The painful contemplation of fate, devout explorations of art, as well as deep sympathy and understanding, countless blue dreams and Platonic fantasies—all of these pervade the light of this humble abode.

In the same month, he also produced a painting of this little building on the banks of their "Seine" (i.e., Panlong River), the warped streets, bridges and buildings that he frequented with Zhang Xiaogang and others. These young artists began to turn their attention from the idealised authenticity of the accommodating countryside to the more sensual authenticity they were beginning to perceive in the bleak metropolis. Whether in their new roles in various organisations or roaming aimlessly through the city's streets, these young graduates discovered that the unforgiving political regime of the past had given way to a different kind of harshness—that of night, indifference, incoherence, emptiness and confusion about the future. There was thus a huge difference between Mao Xuhui's understanding of the city and its environment and that of the previous generation of painters. The city was no longer to be depicted in impressionist tones that pleased the eye; it rather increasingly resembled a mentally oppressive space.[10] In the past, Mao Xuhui's notes had consisted mostly of passages from classical masters like Da Vinci, Jean-Auguste-Dominique Ingres and Ilya Repin, but as he read more texts about Western modernism, particularly Ehrenburg's *People, Years, Life*, as well as more books about Western philosophers, writers and modern artists, his outlook changed completely, particularly with regard to his own predicament and mode of being. He came to embrace ideas of thinkers like Albert Camus who argued that the world is absurd and human life suffering; he began to understand the meaning behind the passage "in a universe suddenly divested of illusions and lights, man feels an alien, a stranger".[11] As far as Mao Xuhui was concerned, the ideas he came across required no elaboration. An insightful sentence was enough to prompt him to recognise new realities and questions. It was a time of ideological renewal in China, when ideas from the West were pouring in through translated works and people were embracing liberalism, a trend that would only later be suppressed by the government in 1987. The changes taking place had a powerful impact on people's thinking, particularly amongst the impressionable youth.[12]

As early as the beginning of the 1980s, more and more Chinese translations of Western works were appearing in bookstores, including books about Western art and artists. At first, Mao Xuhui had to learn what he could from

magazines, but as books became increasingly available, he devoured all he could find about Western artists and their works. In 1982, he started recording his findings from the books he read in a separate notebook he kept specially for the purpose. He writes, "This cannot be merely a form of entertainment, a refined way of passing the time. Through my readings of the masters, I shall contemplate life." In it he wrote of Francisco Goya's life story and provided his own analysis of the Spanish painter's art. He even drew connections between the era in which Goya lived and the television series of *Anna Karenina* that was being aired at the time in China. He saw contextual similarities between the conditions faced by Goya and the characters in the Tolstoy saga: a certain extravagant opulence that was also hollow and vulgar. All the imaginings and cogitations prompted by an unending stream of text and image came together to form a text that resembles a book review. When reading about foreign artists, he attempted to discover the special quality that made them different from ordinary people. He did not keep his copy of William Somerset Maugham's *The Moon and Sixpence*,[13] which he read around 1982, but in his notes on the novel he provides an understanding of the role of the artist that verges on the theological. After reading *The Moon and Sixpence*, he wrote:

I bought the book with immense interest because it's about Gauguin. Books on such topics are much needed. Artists aren't what ordinary people imagine them to be, yet they have to endure what ordinary people go through—life, family, work, love, spouses, children—to survive, to carry on living. How can they be spared of pain and struggle? Yet they must endure what ordinary people don't experience: the spiritual longing and turmoil, the myriad impulses stirred by feverous pursuits, and motivations and actions that the world often fails to understand and deems absurd and ludicrous.

Gauguin was a name he knew well. His impression of such modernist painters of unique character and distinctive artistic inclination, which also included Cézanne and Van Gogh, instilled in him a conception of the artist as modern-day saint. The time and effort of artists were precious, their goals far removed from secular concerns; their natural gift caused them to lie in wait for their divine calling, after which they would devote their lives to art, for art was a sacred spiritual substance that transcended nature. He commented: "It requires someone who recognises its charm and is willing to embark upon its journey, spurning all else that might get in the way of this task." It was not Maugham's novel that had implanted such ideas in Mao Xuhui. They were rather the accumulated result of all the books he had read about artists, which had consolidated in him a zealous belief in the value of abandoning oneself to artistic pursuits. A child born in the 1950s, he had seen the political fervour that had taken over the city during the Cultural Revolution. Now, during a period of palpable social and political change, and having read of a different kind of fervour erupting spontaneously from the souls of artists, he was quick to believe the quasi-religious pronouncements he encountered in various texts and, like impoverished Christians awaiting salvation, accept the necessity of the suffering he faced in this world:

Artists endure painful lives, yet they are the happiest people.

Those who attain such happiness must suffer blows and torments, the intensity of which is beyond what ordinary individuals can endure. Not everyone can extricate themselves from that abyss, struggle out of the world's indifference and callousness; not everyone can trudge from darkness to light, from setbacks to success; not everyone remains steadfast in pursuit of their envisioned goals, harbouring such intense desire amid suffering, even if no one believes in their existence, no one acknowledges their worth, and despite the myriad misfortunes that befall them together, they still manage to rise from despair, continuing to thrive in their realm of freedom. They row against the current and plough all day like true labourers and farmers, yet what labourers and farmers they are![14]

He read voraciously, not only about the history and ideas of famous artists, but also those of literary writers. He tried to piece together an impression of their lives and desires from the texts that he read: Paul Éluard on the front lines in 1917 writing the poem *Duty and Anxiety* to the sounds of artillery firing; Hesse publishing his poetry collection *Romantische Lieder* in 1899 as a bookstore manager in Basel; Pablo Neruda attracting the attention of the literary world at the age of 27 with the publication of his *Twenty Love Poems and a Song of Despair* in 1924; August Strindberg, born to a family in decline and living a life of misery before becoming famous in 1879 for his satirical novel *The Red Room*; Apollinaire, the illegitimate son of an Italian officer and a Polish noblewoman; T. S. Eliot and his poem *The Love Song of J. Alfred Prufrock* (published in 1917); André Gide embracing his homosexuality after falling seriously ill during his travels in Africa; and many more. The lives and thoughts of these writers and poets invaded and agitated his spiritual world like a poison. The ideas and feelings he acquired from reading pushed Mao Xuhui towards the limits of his spiritual comfort zone, such that his encounter with original expressionist works was all it took to convince him that it was time to leap into the writhing abyss of the psyche, to use a completely liberated expressive language and to experiment with a form of painting born from the very trembling of the soul. His first forays into expressionism were with oils. In *By the Moat at Night* (*Yewan de huchenghe bian*), oceanic waves undulate across the moat's surface, upon which reflections of distant streetlights produce an emotionally stirring contrast between warmth and cold. Drawing inspiration from Rouault's stylistic approach, he also attempted to explore the relation between emotion and form, using irregular brushstrokes to disrupt the stability of outline and shape. Of course, the profiles of the two young men in the foreground retain a distinct structure, particularly the head in the middle that is composed of three visible surfaces, two of which are in shadow and sharply distinguished from the top of his head that is cast in light. A thick application of colour throughout the painting serves to maintain a depth of feeling. *Walking on Dongfengdong Road at Night* (*Zou zai yewan de dongfeng donglu*) seems to have abandoned this thick layering, choosing instead to render the surface of Dongfengdong Road with textured dabs of finely applied colour. Four young art students stroll along the road, seemingly without a specific destination in mind, perhaps in search of a place to drink or maybe heading toward Zhang Xiaogang's

dormitory by the "Seine". In keeping with the mood of these imitators of Western attitudes, everything from the cold lighting to the round moon shining in the dark sky is rich with the melancholy tone of poetry. In the oil painting *Strolling by the Moat after a Drink* (*Jiuhou sanbu zai huchenghe bian*), Mao Xuhui's use of paint is extremely thin, almost translucent, and his brushwork is light and textured, revealing parts of the canvas beneath. The painting is based on his gouache draft *Moat Beneath Moonlight* (*Yueguang xia de huchenghe*) and its composition similarly features the figures of two drunken youths—Mao Xuhui and his friend Zhang Xiaogang—leaning upon one another as they amble along the banks of the moat. However, in the finished oil painting, the two drunks have become the true subjects of the composition. In this series of works he produced after returning from Beijing, one oil painting entitled *Moat at Night* (*Yewan de huchenghe*) depicts a single person. The delicate application of colour on its smooth fibreboard surface forms a striking contrast with the dense paintwork in his previous *By the Moat at Night*. Despite the fact it depicts Kunming, the city of eternal spring, it appears to be winter, and the surface of the water is calm, almost as if everything has been frozen. The young man in the foreground gazes over to the other side of the moat, the quiet of his surroundings rendering this figure, whoever he may be, a symbol of solitude. This is a sentiment that coincides with Mao Xuhui's state of mind at the time: an anguish tainted by idealist expectation, an anguish informed by his impression of Western writers and artists.

An artistic problem was beginning to reveal itself to Mao Xuhui. He realised that the German artworks he saw hanging in the Cultural Palace of Nationalities in Beijing were clearly very different from works by the French artists he knew like the fauvists. He discovered contradictions that both excited and confused him: a desire for freedom that was also an urge to leap into the abyss, an awareness of something that seemed to be separate from society while approaching the truth that lay behind it, a spiritual world that was utopian in nature but that he was uncertain could ever truly be realised. To turn to political and philosophical critiques is of course to envisage new value systems, to cast doubt on outdated ideas and dictates, to spurn old habits of looking to official media and voices for guidance. In short, Mao Xuhui felt the strong need to search for a new world, a world apart from the scenery of the city, apart from the sparkle of light and colour, apart from considered arrangements on a two-dimensional plane. This world existed in an invisible place, a place that could only be approached through introspective exploration. This is what all the expressionist painters had been telling him: give expression to the inner world. From these German artists' works, Mao Xuhui discovered that what was important was not to depict or arrange reality, but to *interpret* it, to reveal the disorder and unrest beneath even the seemingly smoothest of surfaces. The artist should not consider the objective his or her goal, but rather ought to "sublimate the objective into the symbolic form of human emotion and expression, to form an abstract conception of the object"—lines that Mao Xuhui underlined in his copy of the programme for the German Expressionist Oil Painting Exhibition. Such texts also prompted Mao Xuhui to see the European masters with whom he was already familiar in a new light, including German painters like Dürer and Caspar David Friedrich. He realised that regardless of what these old masters

painted, or how they painted it, what we find truly arresting in their art is the "intense and painful contradiction between self and world"—, which lies at the heart of the work of expressionist artists. As such, he first came to understand Van Gogh in association with the works of expressionist painters like Munch, James Ensor and Max Beckmann as opposed to the sunny landscapes and joyful dances he saw in the works of French artists. Mao Xuhui agreed wholeheartedly with something Beckmann once wrote: "If you wish to get hold of the invisible you must penetrate as deeply as possible into the visible. My aim is always to get hold of the magic of reality and to transfer this reality into painting—to make the invisible visible through reality. It may sound paradoxical, but it is, in fact, reality which forms the mystery of our existence."[15] It is this commitment to exploring the truth beyond the empirical world while never truly leaving it behind, which meant that Mao Xuhui would never in his painting career succumb to pure abstraction.[16]

Perhaps it was his marriage to fellow student and explorer of art He Lide that led him to paint so many portraits of her in 1982. *Portrait of Girl in Red* (*Zhuo hongyi de nüzi xiaoxiang*), completed at the beginning of the year, is still densely coloured, and the young artist is consciously attentive to its structure, portraying his subject's hands in a manner that approaches realism. He completed *Self-Portrait at Dongjiawan* (*Zai Dongjiawan de zihuaxiang*) at around the same time, a piece in which the paint is applied thickly, and the natural structure is depicted in broad-stroke blocks that are predominantly grey in tone. *Portrait of Girl in Black Cardigan* (*Chuan hei maoyi de nüzi xiaoxiang*) is clearly in the style of Modigliani, but it nonetheless retains a sense of space and structure, perhaps as a result of Cézanne's continuing influence on Mao Xuhui's painting, an influence that is also discernible in the brushwork in the face of his self-portrait earlier that year. The heaviness has been toned down in *Portrait of Girl Wearing White* (*Chuan baiyi de nüzi xiaoxiang*), which was completed in July, in which the background is painted in light, textured brushstrokes. *Portrait of Girl in Turtleneck* (*Chuan gaoling maoyi de nüzi xiaoxiang*) was painted in October and is a work with a clearly expressionist bent: the subject's outline is such that she is almost reduced to a symbol, and the grey tones and brushwork resemble those of *Moat at Night*, which was completed around the same time. Mao Xuhui had totally freed himself from the clutches of all his previous influences. Summer in Kunming is not particularly hot, but the *Self-Portrait* that Mao Xuhui completed in August that year depicts the artist as if the magma in his heart is about to erupt out of him, as though the outer shell of this recent initiate of the church of expressionism were about to dissolve under the trembling, unstable brushwork. The colours are sombre, the mood agitated, and it seems that he can no longer hold back his inner turmoil and unease, his thoughts having now entered an incessantly tumultuous phase. Despite this, when Mao Xuhui attended the "Yunnan Masses Fine Art Works Exhibition" (*Yunnan sheng qunzhong meishu zuopin zhanlan*) in October, jointly organised by the Yunnan Masses Art Museum and the Yunnan Branch of the Artists Association, the oil painting of his that was featured, *Dusk Return* (*Mugui*), recalled the works of the native painting style. The reason for this was simple. It was the only style the exhibition accepted.

Mao Xuhui spent much of his time in the first half of the 1980s reading and writing. Taken together, the poems, notes and diary entries he wrote in various notebooks provide an insight into how his ideas came together over that time. The marks, colours and images that flowed from the tip of his pen form the language he used to translate his experiences and thoughts and put them to paper.

Poetry is often related to human emotion. Language and words can be considered the tools by which the poet explores his or her thoughts. If we are not researching poetry *qua* poetry, we can argue that poetry is simply the symbolic form, made up of words, that thought takes. Mao Xuhui was often gripped by a passion for poetry. Very early on, he began writing poetry with short lines, perhaps convinced that only concise formulations could express his mood with sufficient vigour. He and his friends Zhang Xiaogang and Ye Yongqing had developed the habit of using the written word to articulate their ideas about Western thought. Amongst the artists born in China in the 1950s, they were the thinkers of artistic problems, the expressers of artistic ideas and the recorders of personal art histories. Through their writings, we gain an understanding of the spiritual and intellectual evolution of this generation of artists, the quivering in their hearts and the struggles in their souls.

Poetry and love are common bedfellows. Alongside the lyrics of a Tibetan folk song he transcribed while travelling to Lijiang and Shangri-La in 1980, Mao Xuhui writes of his longing for love:

POEMS AND NOTES: THE QUIVERING OF THOUGHT

Jade Dragon's majestic presence, the clear spring of Black
Dragon Pool,
Autumn chrysanthemums at the Lama Temple, gentle breeze under
the blue sky and white clouds—
None of these can detain my heart.
The joy of reunion, the sweet whispers of meeting again,
What could be sweeter than that?

The grasslands of Shangri-La, the azure waters of Bita Lake,
The black forests, the golden birches—
No matter how enchanting they may be, they cannot sever
my longings.
Thinking of her gazing eyes, her sincere love,
What could be more touching than that?[17]

The language here is simple and straightforward, but the right to freely express one's emotions in this way had only recently been granted this generation of young people. Before 1978, this kind of writing, which departed from questions of class to recognise love in the abstract, would have seemed unhealthy and dangerous. Of course, people would only be granted the right to such self-expression after the huge political transformations at the end of the 1970s. For Mao Xuhui, writing was about thought, about revealing problems, as he wrote in a poem in 1981:

Every time I try to write
Language from my aesthetic education pours out
Still I must write
To seek solace for my spirit[18]

Western poetry and ideas could subtly change how someone thought, felt and spoke. We can see an example of such a change in the love poem Mao Xuhui wrote in February 1982:

She loves me
With a weary face
I love her
With great worries
She lowers her eyes and turns away
I can't help but feel regret in my heart
When she approaches
I hold her in my dumfounded embrace
I want to die in this kiss
I don't want to think about the past
I don't want to contemplate the future[19]

Mao Xuhui's reflections on human nature and emotion had evidently departed from the naïve naturalist lyrical style of his earlier poetry. The spiritual world had become less simple and unequivocal. Life in 1982 after graduating from university was both monotonous and charged with desire: for Mao Xuhui and his friends, love, alcohol and interrogating the life that awaited them occupied a great deal of their time and countless evenings. Sometimes Mao Xuhui thought himself a thoroughly boring person, working a regular job, sleeping in on Sundays, just another of the thousands of people rushing between traffic lights on busy city streets. He faced the endless repetition of Chinese parasol trees going from green to yellow then back to green, car-horns sounding in the streets where people shuttled endlessly back and forth, and all the tasks, already determined by those in charge, awaiting him in the office to which he walked every morning. During these times, Mao Xuhui's poems could start with a title, like *Pallid Days* (*Cangbai de rizi*) or *Memories* (*Huiyi*), or could begin unannounced, like a man talking to himself.

> *If I believe in that dream*
> *In which the devil*
> *Reaches out his dreadful fingers to me*
> *And leaves me in a cold sweat*
> *If I were to recount my dream*
> *To her exactly as it was*
> *She would be terrified*
> *. . .*
> *I go to sleep late every night*
> *I don't go off to dreamland quietly*
> *I no longer have quiet dreams*

Many of Mao Xuhui's poems have no titles. They are rather spontaneous literary outbursts of feeling:

> *Night is a solitary witness*
> *A silent poet*
> *When purple and blue stir the sky*
> *The moon emerges*
> *The world pushes us onto this stage*
> *Let it be*
> *The sky too familiar*
> *The wind all too familiar*
> *Under the clear sky of spring*
> *Memories mix with reality*
> *An illusion stretches out on the tracks*
> *On the hillside*
> *The most terrifying thing is to lose the reins*
> *I have changed*
> *The world before my eyes has changed*

Stars in the sky
Eyes on the ground
Gazing at each other
Together in the fields
She's so close to me
Like a tight-fitting coat

Later, when he was organising his poems, he included a photo taken around 1985 of him with some friends, including Zhang Xiaogang and Pan Dehai, in a rustic setting, apparently eating a basic meal. The inclusion of this photograph illustrates that Mao Xuhui's poetry and social life were connected. It was still far from a period of material abundance in China but reading opened the eyes of Mao Xuhui's circle to new possibilities. Through the biographies of Western artists, writers and thinkers, they had caught a glimpse of a new way of life, one that had been previously designated bourgeois and therefore forbidden. Through the power of imagination, they saw the sordid evenings they spent together through the lenses of romanticism and modernism. They were filled with longing and passion and never tired of trying to recreate what they understood to be the Western way of life—at least until the alcohol got the better of them and everyone passed out. Mao Xuhui wrote poems about their drunken revelries:

Let us drink another glass of wine
Sing another song
When the glass empties
When the song finishes
We will part ways
This I do not want
The night is so wonderful
Like the wine in the glass
Sing another song
My friend
Then happiness will shatter
. . .
Another drink
Another song
When the glass empties
When the song finishes
We will part ways

Mao Xuhui also included a photo of his friends drinking together at the end of his poem *Ode to Drink* (*Hejiu ge*). In short, poetry was one of the forms Mao Xuhui used to describe and document all aspects of his everyday and emotional life. He wrote of his desire for girls, expressed doubts about the possibility of eternal love, and described the frustration, loneliness, lack of direction and general confusion he frequently felt. Reading had thrown his thinking into a state of disorder and had

120 | POEMS AND NOTES: THE QUIVERING OF THOUGHT

infected his former naïve naturalism with a kind of spiritual anxiety and decay, as can be seen in his poem *Noon* (*Zhengwu*):

> *I wonder if under this colourless harsh light*
> *There are still thoughts on earth*
> *Those alleys, those suffocated walls*
> *. . .*
> *I have none*
> *The wind, the sand, accompanied by the harsh light,*
> *Threaten my gaze*
> *And bury dead dreams*
> *As if entering death*
> *I lost my existence*
> *My dying belief lost in paper-like numbness*

What was it about poetry that appealed to Mao Xuhui and made him give voice to his inner trembling, the tumult of youth, in poetic form? His interest in poetry was different from that of the generation of Chinese poets who began turning to modernist expressive forms toward the end of the 1970s. Mao Xuhui was simply a man who was hypersensitive to his own mental state. Poetry was a means of articulating everything he felt, not an expressive end in itself. As such, Mao Xuhui often used poetry to make a record of everyday affairs in his life and how he felt about them. He wrote of what he saw when, unable to sit still at work, he went walking in the streets—the bookstores, the girls, the wrinkled faces and sickly demeanours of the aged, the secluded limewashed backstreets, the scents floating from restaurants, the merchants selling jeans and sausages, the sounds of Hong Kong pop songs emerging from the alleyways, the change of the seasons, the golden sunlight sifting through the green leaves of the Chinese parasol trees, the yellow leaves falling to the ground and being trampled beneath the feet of passers-by, the newspaper he bought at the entrance to the cinema as he looked at faces familiar from childhood passing in the crowd, and so on. Eventually, when he returned to his desk at work and picked up the ringing phone, all these images and ideas continued to flow through his mind. He himself did not know "what I desire, what I know, what I'm tired of"[20] which, combined with the influence of modern poetry, led his writing occasionally to take on a neurotic, rambling character:

> *There's a flame lit in the body*
> *There's a drop of venom circulating all around*
> *There's an inevitable truth*
> *Countless pains lips cannot express*
> *Now, dreams cascade down from the forehead*
> *Flowing or drifting no longer, they coagulate*
> *Clasped between the pages of a book in a drawer,*
> *Fast asleep in a segment of a diary*
> *They can sleep, they can depart*

What the coagulation left behind is many factual vitamins
Dry, colourless wantings bitter as soil

That Mao Xuhui wrote in this way is a sign of the influence the foreign poetry he read was having on him. For some time, he had been transcribing passages written by foreign poets, including Alexander Pushkin, Rainer Maria, Mihai Eminescu, William Carlos Williams, Ezra Pound, H.D. (Hilda Doolittle), Robert Duncan, Siriman Sissoko, Lermontov and Desanka Maksimović. He paid no attention to the place of these poets in the history of literature. He simply copied down the poems he liked.[21] However, over the course of his reading, he began to approach problems in a less linear and simplistic way. Just as with his art, he looked for a new vocabulary with which to give voice to the quivering in his soul. Transcribing these texts was a way for him to meditate on the spiritual power behind poetry.

He had once expressed an instinctive longing for innocent love. However, the latest literature he had been reading inspired him to think differently, to write about the contradictions he encountered and the questions they posed. He wrote the following in his red sketchbook in the evening on 20 August 1983: "Love is nothing; only the land is essential." He saw the land as what could save life and the soul, whereas love would destroy all dignity and peace. Love devoured life, time and tears, and, on a fundamental level, did not really exist. Only the ground beneath one's feet was eternal.

Millet found the earth,
Van Gogh found the sun,
None pursue and adore
the earth as Millet
and the sun as fervently as Van Gogh
They dissolve their lives into the earth and the sun

Lines such as these illustrate why Mao Xuhui living an alienated life in the city was still willing to submit to the "First Kunming Artists Association Painting Exhibition" (*Kunming shi meixie shoujie huazhan*)[22] and the "Life of Yunnan Nationalities Fine Arts and Photography Exhibition" (*Yunnan minzu shenghuo meishu sheying zhanlan*)[23] two artworks, *Wooden Bridge* (*Muqiao*) and *Dusk Return* respectively, in the native painting style—even if the former revealed in its brushwork a certain neurotic anxiety on the part of its creator.

However, Mao Xuhui's way of looking at things had changed. His shift from a visual recorder of the outer world to a sensual perceiver of his inner world was not a straightforward one. The texts he had read in numerous magazines and books led his wording and phrasing to take on a more esoteric character:

Is it me moving, or is it the sky
Is it me, or is it the world
Vast, clamorous, beyond all imagination
The space, turbid, who is floating in it

The clouds in the sky
Are they daydreams, or perhaps God
It once said that everything revolves around us
The sun shines because of this
Leaves sway, that's the wind
My skin and blood feel
A chill, but who is it
Is warmth from the heavens
Or from the earth's spirit? The earth hasn't rotated
The sky hasn't rotated
I'm moving; nothing else moves
Houses, layers of stacked buildings
Stay put like the earth
Moving yet making no noise
Contemplating in a mysterious language
Colours are moving, air is flowing
Interweaving, chaotic, complex
Polluting the soul
The soul is moving, unseen
It is flying but cannot reach the edge
The endless, boundless expanse[24]

This kind of writing with its disjointed phrasing that lacked the coherence of more familiar expressions signified a kind of literary awakening amongst young Chinese in the early 1980s: the beginnings of an increased awareness of what it meant to be human, humanity's natural state of disorientation, and the aesthetic techniques by which to present this condition. The education to which those born in the 1950s were subject was rigid, repetitive and lacking in critical thought. They were not encouraged to think about the world in which they lived and what it meant to be human. It was not until they were exposed to Western thought that the shroud of official political rhetoric, which had always defined their grasp of reality, society and themselves, was lifted—however that exposure occurred. Mao Xuhui had deepened his understanding of the world, society and himself through his reading. He became aware of the relativity and complexity of an existence that resisted succinct explanation; he began to grasp how to transform the fixed preconceptions of the physical world into the basis for subjective thought; he realised how to break apart once rigid phrases and reassemble them to reveal worlds he had never imagined, seen or considered before. When liberated like this, thought led to a kind of spiritual activity that seemed to endlessly expand the realm of the soul. This way of thinking and experiencing the world implied that the writer needed only words to open his or her mind and no longer sought closure beyond the self—in, for example, official government doctrine. This was a process of liberation for those born in the 1950s, which was in direct contradiction with the demands and propaganda of the state.[25]

In a softcover notebook with pictures of Chinese landscapes on it, in which he recorded a great deal of information about foreign artists' views on art, Mao

Xuhui also wrote extensively of what foreign literature had taught him about how to live one's life and view the world.[26] In March 1983, he copied many passages from Hesse's *Peter Camenzind* describing the views of Camenzind—or Hesse himself— on "purely animal existence",[27] as well as his preference for playing the beast, his distaste for secular joy and pride,[28] as well as both the poetry and sympathy for ordinary things in nature that arise in his heart when he perceives that "the wind sings in the trees or that a mountain shimmers in the sunlight".[29] The sentences Mao Xuhui copied down in his notebooks sufficed to awaken associations in his mind that caused him to ponder big questions, which in turn would lead him to search for the answers in more books. Any work by a Western writer could inspire in him excitement or unease and reinforce his innate belief in an individual's unique existence and right to make art. In place of the repugnance at religious piety that Hesse exhibited in his rebellion against his father and the literary explorations of self he subsequently carried out under the influence of Friedrich Schiller, Heinrich Heine and Friedrich Hölderlin, Mao Xuhui faced an epistemological void that was growing with the rapid retreat of the formerly ubiquitous ideology and political discourse of the Maoist period. This provided the conditions under which he and his closest artistic friends were eager to embrace all Western thought. Reading was one thing, transcribing another: transcribing was a form of deep thinking. In his unconscious, Mao Xuhui equated transcription and thought, whereby the very action of copying down passages embodied an individual's decision to choose and to act. In his softcover notebook, he copied down quotations by a number of artists featured in *A Selection of Essays on European Modernist Painting Schools* (*Ouzhou xiandai huapai hualun xuan*),[30] including Cézanne, Paul Signac, Georges Seurat, Van Gogh, Gauguin, Henri Matisse, Maurice de Vlaminck, Rouault, Emil Nolde, Ernst Ludwig Kirchner, Robert Delauney, Franz Marc, Paul Klee, Wassily Kandinsky, Adolf Hölzel, Kazimir Malevich, Piet Mondrian, Fernand Léger, Beckmann, Giorgio de Chirico, Odilon Redon, Alfred Kubin and Max Ernst. Of course, he also copied from the book's preface and the introductions to each painting school, including André Breton's *Surrealist Manifesto*. He copied down passages about a wide range of painting styles and schools, apparently without

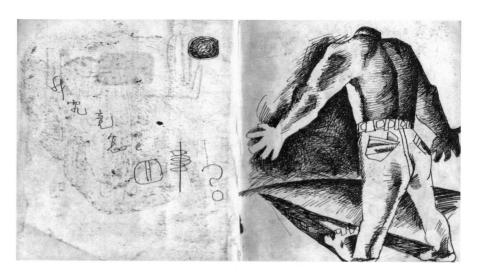

Text titled "What on earth is with me?" (*Wo jiujing zenme hui shi?*) in Mao Xuhui's 1982–83 sketchbook and diary

124 | Poems and Notes: The Quivering of Thought

regard for his own personal interests, which demonstrates that Mao Xuhui was still pursuing a comprehensive and in-depth understanding of Western modernism. He wanted to know everything there was to know.

Reading provokes a form of introspection that never rests. The life of the body can never replace the independent path of thought, although thought itself might occasionally seek nourishment from discrete actions to extend its life and versatility, to realise its own movement. In a sketchbook mostly in use from 1982 to 1983, Mao Xuhui put his endless torrent of thoughts to paper as though he were completing a kind of assignment, compelling himself to think independently and express in his own words the problems he faced. "I should learn how not to think anything; give myself some time to just think myself." Deformed images drawn in fountain pen accompany the text in his diary of thoughts. Beside a page on which he scrawled the words "What on earth is with me?" stands a burly man staring into the boundless night. . .

What exactly was it that caused his almost instinctive desire to become an artist? The notion of being an artist continued to haunt Mao Xuhui. It is known from experience that one should not limit one's future to a single path, and Mao Xuhui did indeed pose himself this question: "If I don't become an artist, then do I not become free? Is the problem not solved?" This thought only occurred to him some time after graduating art school. Prior to this, becoming an artist was all he could think about, but he knew that there were already young painters who were making an impact in the world of art. The "Stars Art Exhibition" in Beijing, scar art in Chongqing and the native painting trend that had sprung up in various cities—even in the north, where echoes of this style could be seen in paintings of the ethnic minorities in Inner Mongolia. Meanwhile, this young man in Kunming, still anxious about his art, knew full well his situation: "Many times I thought I had matured, but it turns out I am still a fool!" This line appears in his 1982–83 black-and-red-cover notebook as the title of an illustration, perhaps inspired by a movie poster, of a proud young man against a backdrop of swirling dark clouds weighing down upon the earth.

Loneliness was a common concern for young people in the 1980s in China. According to the communist education they had received, society needed

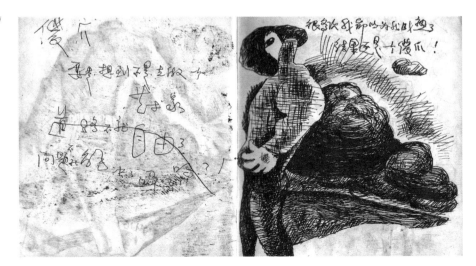

Text titled "I am still a fool" (*Wo haishi yi ge shagua*) in Mao Xuhui's 1982–83 sketchbook and diary

125 | POEMS AND NOTES: THE QUIVERING OF THOUGHT

Text titled "What shall I leave behind?" (*Wo yao liuxia shenme?*) in Mao Xuhui's 1982–83 sketchbook and diary

a spirit of collectivism. Concerns about an individual's fate, an individual's fate that was not connected with the collective fate of society and humanity at large, were considered to belong to the corrupt thought of the bourgeoisie and therefore had to be rigorously criticised until they were eliminated. However, as class struggle ceased to be the sole criterion by which political matters were judged, and Enlightenment texts from the West entered China, introducing more and more people to modernist philosophical concepts, the younger generation began to focus increasingly on questions of self and individual existence as a means of thinking through and dealing with the problems they faced. It was a time of increasing tolerance towards thinking about loneliness, focusing attention on the self and exploring one's own inner world, even to the hidden depths of the unconscious. As Mao Xuhui understood it, "Loneliness is the fate of a new life." This is how seriously he took loneliness:

> Who understands an infant's cry? Is it cold? Yes, I'm cold, and I fear the arrival of death. I might seem a jolly fellow, yet my heart still fears the cold. Is there a colder winter in this universe than solitude? I guess... not.
> Didn't you like to cry when you were little?

He continued to think about the world in this neurotic way: to be born is to require a certain value, to demand recognition, whereas to die is to have nothing to do with anything at all. But what is the life, what is the self, one ought to have? The real question was how in this society could one achieve success and leave one's mark? How could one realise one's dream and value by becoming a true artist? He realised that he still trembled in the face of his own life and future. He lacked resolution and courage. In short, he felt that after all this time learning art, he had nothing to show for it. He had not provided society with anything. He saw himself at this stage as someone with a certain amount of experience—"What's unfortunate, alas, is that I'm still alive"—but who was it that demanded he left something behind in this life? Himself? He already had a solid grasp of the important ideas a graduate in their late twenties ought to have about life: "My ambitions, my fantasies, my vulgar

emotions, my biological instincts, my heart that cannot resist temptation and yet cannot grasp what it is that tempts it. It is like being gently mocked. If there really was a God, I would surely pray to Him, tell Him about the hardships of life, share with Him my sorrows, let Him look upon my pale face, this ugly, twisted faced. My Lord. . . open Your eyes and look upon me."

It is as a result of reading, as well as thinking about what he read, that Mao Xuhui wrote in this way. Next to these lines he sketched a picture of an anguished face with a cross on its forehead and, above that, a naked man, supine, an image of hopelessness and involuntary solitude. The juxtaposition of these images presents us with a picture of a man freed from intellectual confinement only to sink deep into existential crisis, a man who has opened a Pandora's box of irrepressible anxiety. However, this state of mind would be transformed by another instinct: that urge to silently reflect upon and submit to the will of life. Life can unleash a certain instinctive energy, which incites an individual to persevere, to strive, until life becomes capable of convincing itself that love must be deployed in the fight against death:

Reflection and silence: these are the weapons of a real man, ones that cannot be taken away by anyone. They elevate us. We, the real proletarians who possess nothing, have only silence and reflection. These two stones are stacked in our hearts. We carry them through the journey of life, and we carry them into hell. Our love is eternal, singing the same song to resist the threat of death, to resist loneliness. We are seeking God together!

His thought may have been disjointed and his understanding of life full of contradictions, but Mao Xuhui still sought a more settled state of mind. He knew that people had the freedom to create and the only difference between the great masters and the mediocre was that the former had exercised that freedom. He knew that life was a disappointment, its moments of joy sparse and transient, its suffering constant, but he had no choice but to keep "waiting for Godot". What remained to him now was the task of earnestly facing up to himself and life, and finding a sincere and precise mode of expression:

Our desires, our hobbies, speech, our circumstances, the environment, and all kinds of fate, the rise and the fall, have we ever, in true seriousness, observed ourselves, studied ourselves and known ourselves? I don't know if I understand myself. So how can I understand others?

This young man, not long graduated from school, still unknown to the world, was a thinker who longed to be an artist, an explorer who searched for himself and the answers to life's questions in the texts he never tired of reading. Despite the simple language, we can see in his words the influence of the books he read. In October 1981, the China Social Sciences Press published *Sartre Studies* (*Sate yanjiu*), edited by Liu Mingjiu, which Mao Xuhui read. The book contains the essay "Self-Portrait at Seventy" in which Jean-Paul Sartre reflects upon his own life by posing

questions to himself. Mao Xuhui's own writing occasionally recalls Sartre's style. Clearly, a tendency toward self-interrogation is a trait common to many thinkers:

[H]aving relations with others in the same way as anyone else... Why would the individual have to be anonymous?

And you don't think that in a society which does not automatically legitimize its members, as the theocratic and feudal societies did, the desire for personal glory is in some way universal?[31]

Mao Xuhui underlined these lines from Sartre's text.

For Mao Xuhui, literature was of course another means of discovering the world and making sense of its rich tradition of thought. He read Franz Kafka's *The Castle*[32] at the end of 1982 and the predicament faced by the novel's protagonist K affected him in such a way that he experienced K's puzzled helplessness as his own. Like all his generation, Mao Xuhui had been assigned a future with an explicit political objective—they were to be the Inheritors of the Communist Project.[33] However, in December 1978, this doctrine was losing its potency, and a reappraisal of what it meant to be human began to guide the new educational philosophy. The question touched upon everyone, the intellectual world of every individual. Having acquired a grounding in language from primary and secondary school and enhanced one's knowledge of the humanities at university, it was now possible to use the vocabulary learned from books to interpret one's world, life and self. Those who had already encountered Western thought, particularly those who had devoured book after book from the West, could delve deep into the spiritual world of thinkers, writers and artists from faraway lands, many of whom were no longer alive, and get an understanding and feeling for the subtle truths behind their words. Therefore, Mao Xuhui was able to accompany K through the strange village where the novel is set, understanding and even experiencing all that K experienced, and seeing all that is absurd and unknowable about human life. The village—which is a stand-in for anywhere in the world—has "no need for a land surveyor". Although the mayor's rambling speech to K is full of allusions, its verbosity mostly conveys a sense of frustration and absurdity that is perhaps universal. The novel poses questions by way of its details, and the dialogue between K and the mayor in particular inspired thought in Mao Xuhui. He underlined "the ludicrous bungling that in certain circumstances may decide the life of a human being".[34] It is but a minor line in the novel, but it prompted Mao Xuhui to think about life.

In truth however, one's intellectual preferences and state of mind do not adhere to a purely abstract logic or emerge solely as a direct result of what one reads. Even an understanding of Socrates, Plato or Descartes depends on the specific circumstances and material conditions of the understander, his or her social position and everyday life. One day Mao Xuhui might contemplate how to be an artist, how to make sense of solitude and lust, how to respond to the question "To be or not to be?", how to establish one's own artistic standard (all this on 1 February 1983), then on the next day face the challenges of a particular creative

project and his daily inescapable anxiety. In a diary entry for 2 February 1983, in which he considers how to produce a satisfactory work for an exhibition organised by the Municipal Artists Association, he seems to lack confidence in his recent, as-yet-untitled work. He speculates that if he left it in his room for some time before returning to it later, he might suddenly discover something new in it. Clearly, at this time, he was still unsure about his work. However, the deadline for submitting pieces to the exhibition had come, and he realised that only by unveiling the work in public would he be able to discover others' opinions and what needed improvement. On 12 March 1983, in an apparently despondent mood, he wrote the following in his diary:

> *I'm back, back again in this old office (not the studio). As I sit down in my familiar chair, I hear the familiar street noises outside the window that used to irritate me and the sound of abacus beads next door. I stand by the window watching the bold parasol trees, the beautiful girls on the pavement and the sky above the opposite roof: everything is exactly the same as before. I've just sat down but it feels like I've never left. It's all too familiar: even the coughs of the colleague next door remain the same, the sound of phlegm falling into the fish tank has never quieted down, and there's the smell of dust in the air. As usual, the janitor has brought me a pot of boiling water.*

Here, Mao Xuhui bemoans the mentally oppressive environment and working conditions of the General Merchandise Company where he worked every day. He knew that this was real life, but such an environment could wear a person down, required patience. The freedom he had enjoyed, the open air he had breathed only a couple of weeks earlier when he had visited his relatives, now seemed like a dream, as though it had never really existed. As soon as he was in his office again, the grinding routine began once again: "Once again, you sit quietly in your chair, pick up a newspaper, drink another strong cup of tea, listen to the excited, urgent ringing of the phone, and wait for your superior to assign tasks, wait for all manner of unimaginable boredoms and numbness to fill your time, wait for those indifferent faces." For Mao Xuhui, his company and office resembled a prison. He was a prisoner who had escaped only to be captured again and brought back to his desk to stare through the window of his cell at the bustling streets outside. Such a mindset could only lead him to associate his own situation with that of mythologised artists like Van Gogh and Kafka. He believed that artists were condemned to mental oppression and suffering and that they all sought a life of uninhibited freedom. Sure enough, having complained about his job, Mao Xuhui went on to summarise his understanding of artists as follows:

> *What excites us in Van Gogh's painting is not the subject matter or the objects he depicted, but the brilliance of suffering, loneliness, pain and longing radiating explosively from his vibrant colours.*

Mao Xuhui's own feelings and situation resemble his understanding of the great Western artists—solitary figures lacking social status, misunderstood,

unrecognised, indifferent to secular matters, and so on. We can see this in his discussions of Dmitri Shostakovich's biography in which he seems to see the musician as living under similar circumstances. He saw no difference between Chinese people reciting from memory passages from *Quotations from Chairman Mao Zedong* (*Mao zhuxi yulu*)[35] and Westerners doing the same with the Bible. He believed that what he and Western artists shared was a desire for freedom and an urge to escape the strictures of doctrine. As such, he tended to agree with what he read in books from the West. He saw all repetition in life as boredom and boredom as no different from suicide. In his temperament and character, he exhibited an artistic tendency towards expressionism as opposed to rationalism. Rather than encouraging him to calmly meditate on metaphysical questions, the texts he read and the thoughts they incited only made him dig deeper into his own repressed and anxiety-riven states of mind. Throughout 1983, Mao Xuhui constantly read, thought and wrote: he read a wide range of biographies and books, thought about the meaning of loneliness and destiny, and wrote about suffering. He also attempted to provide new explanations for the great works of art and literature formerly misrepresented in the official discourse. For example, he saw in Jean-François Millet's depictions of peasants a consideration of the magnitude of piety, a respect for the purity of religion, a reflection upon death inspired by pastoral music, and not merely "a portrayal of peasant suffering". In short, the works of foreign artists, writers and thinkers caused him to clean away all his former prosaic conceptions of art. He began to regard art instead as a "worldly Christ" that "allowed people to escape suffering" (14 July 1983).[36]

In Strindberg's *The Son of a Servant*, there is the following passage: "Books contained the thoughts and experiences of all kinds of people, and he could now, unbeknownst to those around him, engage in intimate conversation with that majority of persons who were no longer living." Mao Xuhui was not an expert on literature. He simply sought answers and solutions to the problems he faced in the books that he read.

It is not difficult to imagine that a young man of his age, not long past adolescence, would be concerned with questions of love and sex. Modern art deals with the unconscious, sex and the oft-discussed topic of love. It was easy for Mao Xuhui to find the inspiration to approach such issues more freely in the books he borrowed or bought. In *The Son of a Servant*, which he bought in March 1983, he saw the protagonist Johan as a mirror image of himself. He regarded Johan's experience as his own experience, and it was through the story of Johan's various encounters growing up that he was able to discover more about himself and his possible fate. In the confusion of events that form a life, words such as love, sex and flesh are important. It is therefore clear why Mao Xuhui might underline such passages as the following, where the author discusses love:

> *Spiritual love is a complicated emotion full of falsehoods; it is fundamentally unhealthy. Pure love is a contradiction in terms if it means injecting the spiritual into the concept of purity. Love as the drive to produce offspring must be sensual if it is to be healthy. If it is sensual then one must love the other's body.*[37]

Such an argument might seem reasonably straightforward, but for those more familiar with the previous age's emphasis on chastity, seeing love not in revolutionary but sensual terms came as an epiphany, a joyous release. Indeed, for a young man born in the 1950s, the opportunity to think and talk about sex and love without a sense of shame or impropriety only came about in the early 1980s. The private aspect of sex is universal, and Mao Xuhui had long been exploring sex in his mind and paintings. He had certainly received a sort of education about "love", whether directly or indirectly, but for someone who enjoyed reading Western literature, this was only the beginning of the questions he would encounter about love and sex. It started with the artistic depictions of human figures he could vaguely make out in the faded prints of Western artworks, but later, especially in the German Expressionist Oil Painting Exhibition he visited in Beijing, he had seen a completely different way of expressing sexuality. In December 1983, the "Norway Munch Painting Exhibition" arrived at the Kunming Provincial Museum on its tour through China and provided Mao Xuhui with further insight into aesthetic expressions of the unconscious. He had taken great pleasure in the German Expressionist Oil Painting Exhibition in Beijing and realised that love and sex could be portrayed in a more direct, less narrative way, which allowed one to enter the very soul of the artist and establish with him or her a kind of spiritual resonance. In May 1983, Mao Xuhui bought a copy of Maugham's *The Razor's Edge*. He read with great interest the narrator's conversations with Isabel about love and passion, so much so that he even envisaged himself participating in these conversations himself. The narrator discusses questions of love, marriage and passion with Isabel, a woman who is in love with Larry but ends up marrying Gray. For Mao Xuhui, the crux of the matter was not that the book's narrator was perhaps Maugham himself or that the Larry character was likely based on Ludwig Wittgenstein. He was rather concerned with understanding more general questions such as the relations between women and men, money and love, sensual desire and social status—topics that the book discussed at length. He was particularly struck by some of the dialogue, such as Isabel's "You know, often the best way to overcome desire is to satisfy it", which he underlined. He marked many passages of the narrator's conversations with Isabel about sexual love, morality and passion, in which Maugham's words seemed to represent the thoughts of a young Chinese man in the process of liberating his mind:

> *Unless love is passion, it's not love, but something else; and passion thrives not on satisfaction, but on impediment.*
>
> . . .
>
> *Passion doesn't count the cost. Pascal said that the heart has its reasons that reason takes no account of. If he meant what I think, he meant that when passion seizes the heart it invents reasons that seem not only plausible but conclusive to prove that the world is well lost for love. It convinces you that honour is well sacrificed and that shame is a cheap price to pay. Passion is destructive.*[38]

Mao Xuhui seems to have acquired a certain unconscious support from these lines, which gave release to the desires that perhaps had always existed

131 | Poems and Notes: The Quivering of Thought

but were repressed under the weight of social norms. He couldn't resist writing his own thoughts and feelings in the margins of his copy of the novel:

Free will can transcend love. Only by transcending love can one attain true happiness. Because one cannot replace everything with love; it is just one part of the enormity of life, one of its passions. Any attempt to replace everything with love, any such thought or action, will meet its tragic end because it can never truly satisfy us. Not only will love be destroyed, but life will also be destroyed.[39]

However, on the previous page he also wrote, "Love is a mixture of emotion, desire, possessiveness, and perhaps even money and social status."[40] As the novel's story progressed, he discovered that the issues discussed by its characters were far from innocent and he felt compelled to record his understanding in writing: desire was not the same as love but love without desire was inconceivable. Especially when the narrator spoke of sex taking place out of habit, Mao Xuhui began to relate these ideas to what he knew of his own world:

For most Chinese people, sexual relationships based on habit constitute the entirety of their sexual life. Many are confined to this level, and their environment, their numbness and their ignorance of the world and themselves do not make them any smarter or better than swine.[41]

Mao Xuhui was less influenced by the stories in this sort of novel than he was by the ideas conveyed by its author through the deeds and words of its characters. It was the ideas implied in the novel's dialogues that set his mind in motion, filling it up with new concepts or giving release to the magma bubbling in the depths of his unconscious. This was a common phenomenon amongst Mao Xuhui and his peers during the 1980s. They began to form a new understanding of morality, social hierarchy, instinct and bestiality, crime, justice and the sacred. A series of words, which previously they had not encountered, or rarely used, or understood only in a conventional sense, began to appear in new contexts, often leaping off the page during the vivid and nuanced narration of the ups and downs of a character's fate. It was a veritable feast for hungry readers, and as they devoured all that they could, it was natural for a young person to become enchanted by images and fantasies of love. Just as Mao Xuhui gave voice to the love he felt through poetry and illustrations, he also produced liberated paintings of the female form, adorned with the petals of desire.

Nature's goddess,
If I had the fortune to meet you again
To rest my head in your curled hair
And dream
I would sleep forever
Oh, Goddess
In your eternal grace[42]

132 | POEMS AND NOTES: THE QUIVERING OF THOUGHT

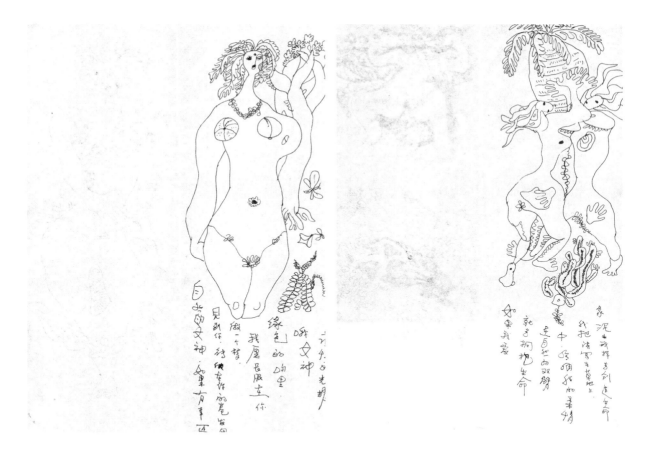

Mao Xuhui
Goddess (Nüshen), 1982
Poetry and illustrations

How were these questions about life to be asked? How were they to be understood? Everyone faces different choices as a result of their reading and experience. Mao Xuhui wanted to be an artist, not just a painter in the ordinary sense of the word, but an artist in the mould of those he knew and admired. Whatever he read or learned about artistic figures, particularly those from the West, fuelled his latent desire to become an extraordinary artist, a unique person. His pursuit of this ideal affected his attitude to family, which he considered a wall that isolated him from those around him: "It has both sheltered me from storms and denied me refreshing breezes." Therefore, he ought to live like an artist, unrestrained by society's moral codes, because artists operated according to their own law. These views on love, sex, family and desire gradually took shape as his reading and thinking continued. They would lead to a personal life and artistic career frequently affected by emotional adventure and domestic conflict.

Whereas previous exhibitions served merely as a provocation of sorts, the Norway Munch Painting Exhibition prompted Mao Xuhui to think about his personal experience. From 1982 to 1984, a combination of living apart from his wife and the uncertainty surrounding his career intensified the mental pressure and psychological conflict he was experiencing. Munch's themes were family, sex, illness and love, and his visual language struck Mao Xuhui on a visceral level. He almost instinctively accepted the Norwegian painter's expressive method. Furthermore, sexual liberation was a popular theme at the time. Mao Xuhui had sought to

transcend boundaries in his literary and intellectual pursuits, and the visual language of expressionism provided a path for liberated, even unconscious, action. When alcohol and ideas allowed him to escape the confines of everyday rationality—in the form, for example, of extramarital affairs and open interactions with the opposite sex that transgressed the moral codes of society—his response was to pick up his paintbrush or pen. He believed this was the most authentic way to live. With this in mind, we can understand why in May 1984, when things were becoming tense at home, love poems began once again to appear in his notebook:

I know
It's you
Though veiled in obscurity
So incredible
Yet equally unattainable
I know now
All of this
Can no longer be put into words
It is a floating
Seed
With its inclination
Ending its days of idle dreaming
This is the shadow
Of a drifting cloud
Creating strange illusions
Upon the May earth
This is all of you
Hyacinth
. . .
All this means more than just
Longing
Or is this just a fantasy
When all the days add up
And become memory's sofa
You will find
There are more days ahead
"Hyacinth"
I recite in silence
Like a black-robed monk
And close my heart
In the faint glow of Maria
At the intersection of the world's dimness and light
I hold a joy
Before your chest
Longing for something
Beneath your eyelids

I seek rest
Just like this
And dream again[43]

The "hyacinth" is Sun Guojuan, a painter Mao Xuhui had recently met. With an atmosphere of crisis having descended upon his marriage, he found great solace in the emotional sustenance he received from his relationship with this woman. There is no one on this earth who can tell all there is to be told or ask all there is to be asked about love, and Mao Xuhui had clearly found himself caught in a whirlpool of complicated emotion. Each of the ripples born from his romantic longing, his outpourings and expressions of love, the complex of passions within him intertwining with unorganised thought, came together to form the unfolding story of this unique soul. Not long after the lovers had plunged into the emotional depths of their romantic relationship, Mao Xuhui travelled to Chengdu and Chongqing to work. On the trains he took and in the hotels he visited along the way, he wrote letters to his girlfriend in which he expressed his thoughts and inner passions. These are the ripples of thought emanating from the emotional whirlpool at his core:

This is the dusk of May, and the fields are already green, and we say it's intense, and we part ways. This is the first time. Perhaps the freshness of the first time makes it deeper, more mysterious.

. . .

Together we have made many stories, about roses, about drizzle, about dusk, about silence. . . Thinking back now, I believe we were happy. We found happiness in this world. (Night of the 26th, on the train)

Woke up in the morning, and we were already in Xichang, Sichuan. The scenery outside the window differed little from Yunnan: red soil, green paddy fields, purple ridges and cyan mountains. Sunlight shone through the window from the east, and in the compartment sat absent-minded passengers. I was listening to Bartók's piano music while continuing my conversation with you. The scenery came alive with the lively and cheerful music of Bartók. . .

The train is rushing forward endlessly: is there distance between us now? I can't feel it. How could we be far apart? What is far? In the blue eyes of God, hundreds of metres, thousands of metres, tens of thousands of metres, hundreds of millions of metres, what does it matter? I think only our souls are the exception. They are either distant or close, and in an instant, they can be drawn really close, as if right under God's nose, and in another instant, they can fall into an abyss, moaning in despair; often, they don't even exist. Now our souls are here. They are close to God, and most of mine have been possessed by you. Sometimes, I feel it is secure, like a medieval castle, a garden of Louis XIV filled with directions and the delights of heaven. When we first met, this soul was like a haunted house, full of mystery and fear, surrounded by a dark, dense forest. Yet we boldly entered the house, opened all the doors and windows, and lit a red bonfire in the forest. In front of God, we revealed our nature, just like when He created us, singing in the Garden of Eden, bathing in the sacred sunlight under the olive tree. When we woke up from God's shelter and

found ourselves in this whirlpool of life, we were hostile towards everything. No matter what kind of waves rock the world, it is ultimately these waves that will bring mankind before God, and our souls will have walked ahead of all the waves while the body remains trapped in some bizarre current. This is our anguish today, our regret, our misfortune, but it also shows our value: we are rebels, allies, and we have betrayed the whole world and sublimated our souls—we've been saved. Were we to stand on the ground of the third wave, our souls would be even more incredible, and perhaps that would be a sacred moment, closer to the mystery of the universe.

We are such people: revolutionaries, destroyers. As the poet from the movements said, find your horizon and smash it. This is how humanity advances. The horizon is infinite, while the wave is to smash, one wave engulfing another. It is in smashing and engulfing that humanity matures. We grow up in countless betrayals and become powerful. (11am, morning of the 24th)

Sometimes I can't help but ask myself, what kind of relationship are we in? Is it demonic, a dream, something born out of nothing? Its birth is entirely accidental. We have no sense of law, no sense of morality in us, only our own laws and morality! What do we restrict ourselves by? Only what's most essential, most true in us, which cannot be obtained through habit. Our habits are only pulled together by law. Yet we rely on nature. I now realise that we are the purest people, and our way of life is that of the true people. It is not governed by any concept; it relies solely on instinct, intuition and God. Aren't people like us reliable? I think a question like this is groundless. We are independent of society, and we resist society together. The existence of society only arouses our defiance and kindles our enthusiasm to find our own personality. What remains of humanity without the existence of individuals? That is just hypocrisy, and it is the hypocrisy of this society that makes us have to betray it. Otherwise, we would also be hypocrites. (Afternoon of the 27th)

What am I? Perhaps you too have pondered this question. Perhaps everyone has pondered this question. I don't fully understand myself and am not entirely happy with who I am. Sometimes I hate myself, and I feel that I've become a burden to myself. Getting to know you, I know now that I'm a person born under the sign of Gemini; I am a child born in the summer (how sweet that sounds). I have had many dreams, some of which have come true, others have shattered, and most are just dreams themselves. Twenty-eight years—the most lively half of my life has gone by, and twenty-eight years feel like a dream today. Twenty-eight, oh you poor thing, is like a cancelled receipt. Twenty-eight years are forever gone, vanished into the vast universe. A twenty-eight-year-old man is judged a person in debt to society, yet I don't want to take any responsibility, and I am still dreaming. Twenty-eight has been considered a truly mature age, but I know nothing about the future. What I do know is that we are always passive. Happiness is a handful of fleeting comets, followed by long periods of emptiness, nothingness and numerous pains collectively known as solitude. Mostly, we're just silent. Our betrayals are forced by others. Looking back at the past twenty-eight years, those few days you lived as a human, those countless days as a dog. In these twenty-eight years, we died, committed suicide, suffocated and sold ourselves out, including our souls. Twenty-eight years, I hate all these twenty-eight years, what tremendous pressure was endured by our hearts!

I want to cry out and scream, yet everything turns into silence. Let God make the judgement! On the day of judgement, I firmly believe in the need of my soul. As the twenty-eighth year arrives, let me desire life once more! Van Gogh began to erupt with his burning soul in these years, and after ten years of eruption, he died in the fields. Life is so tenacious, yet so fragile; in ten years he climbed to the forefront of the world's masters, leaving more than a thousand masterpieces for mankind, but these ten years also pushed him into the abyss of death: he left his soul and passion to the world, this despairing world, and left the world with pain and despair. Twenty-eight, let me love life once more!

What can I do, except play the role of a clown, except be a prisoner under the lamp; what can I do, a devilish self, except run around in the maze of fantasy; what can I do, in this mediocre life, in the maddening disquiets, in the facades that had to be maintained, what can I do? I should act, I often urge myself, but action is difficult, if we were in the American West in Chicago, on the ranches of France, what inconvenience would there be to act? But we have no Seine River here, no Rhine River, only the white nights that swell our nerves; we have nothing, only our own souls; we have lonely rivers, silent rivers, rivers of tears. . . . (Night of the 30th)

Aside from the endless romantic talk and stream of impressions, we can also see considerations about life and art scattered throughout Mao Xuhui's love letters, emerging abruptly from and yet entwined with his more emotional prose, which is sometimes full of joy and excitement, other times dejected and pessimistic. Today people might ask what are the trials artists of Mao Xuhui's generation faced that impel us to sympathise or empathise with them? What secret does a glimpse into his highly personalised and private inner world reveal? Mao Xuhui's reading and writing show us the answer to these questions. When a wide range of Western thought was translated into Chinese characters and began entering the minds of Chinese readers, it transformed their knowledge of the world, society, humanity and the soul. By examining the books Mao Xuhui read, the passages he underlined in red or blue ink and the notes he scribbled in the margins in pencil, we discover that the spiritual origin of his rebellion against society was a yearning for something he had failed to consider before: the freedom and rights humans deserve. The experience of loneliness comes from a desire for human creativity. Nietzsche was a guide for those who cast doubt upon God and authority more generally. The end of the Cultural Revolution and the arrival of Western ideas into China was bound to galvanise anyone who longed for a space for independent judgment, independent living and independent thought. At least the adventure of life would no longer be confined to mass political movements or the endlessly reaffirmed concept of class struggle. The people were waking up. They were beginning to understand that they were real human beings, with flesh and blood, with moments of joy, sorrow and loneliness. Some of them were realising the possibility, their God-given right, to channel their hopes and ideals into the sacred cause that is art without being subject to the whims of some external power. Van Gogh was naturally a model to whom Mao Xuhui and his friends turned. They found the mad and legendary figure of Van Gogh as he appeared in the novel

Lust for Life both inspiring and exhilarating. They discussed the letters Van Gogh wrote to his brother Theo, reciting from them as if they were gospel. Nietzsche, Schopenhauer, Freud, Camus, Kafka and Hesse are only a few of the innumerable thinkers, artists and writers they read. It was texts by these figures from the Western tradition that replaced the officially sanctioned reading lists of the past. These young artists were so enthralled by these Western texts and so convinced of their value that they frequently shared and exchanged them. During the 1980s, helping each other buy cultural materials from abroad, such as books or cassette tapes, became a common practice among young literature and art enthusiasts.[44] However, the significance of these texts far surpassed their role as sources of inspiration and influence. The reason for the insatiable appetite of people like Mao Xuhui for Western books was that on a fundamental level these texts prompted them to focus on their situation and fate, humanity and the world, and the value of the individual. A sensitivity to life and consciousness of humanity was awakened deep in their hearts. The questions faced by the human, the individual, the solitary life, were suddenly under scrutiny. It left a profound impact on this generation of artists and would become the basis for their personal adventures in life, as Mao Xuhui wrote in a letter to his girlfriend:

Danish philosopher Søren Kierkegaard posed the following question to himself in 1835: "What I really lack is to be clear in my mind what I am to do, not what I am to know. The question is about understanding oneself and recognizing what God wants me to do; it is about finding a truth that is true for me, finding an idea for which I can live and die." The forefather of existentialism realised the value of the individual as early as the last century. He repeatedly emphasizes the "I", "I", "I"; he believes that the individual is crucial. Because, just like us, he lived in a time that neglected the uniqueness of individuals and valued public opinion when a true person was seen as insignificant dust. Modern individuals are "lost" in the crowd, clueless the second they are separated from it. For long we have been aware of this and have tried to break free from this collectivism that engulfed our individuality. This is why we have come together and created a different way of life, and this path continues. We have not only chosen our own path in life but have also chosen art as our religion. Our view of life and art are intertwined, and we can tolerate a life devoid of thought and choice no longer.[45]

In short, Mao Xuhui was influenced by the ideas and stories he read and seemed to find a means of satisfying his inner and unconscious desires in books. Locating the precise causes for his behaviour, the people and things that impelled him to act the way that he did, will always be difficult, but one thing is for sure: Western texts, images and music clearly served to provoke and excite his mind. On 8 May 1985, Mao Xuhui wrote a long confession on the blank page at the end of the last chapter of Maugham's *The Razor's Edge* where he explained why he was so obsessed with reading these novels. On an unconscious level, he seemed to intuit the profound impact the stories and characters in these novels from Paris, London and New York would have on his art and life.

Integrity is based on honesty. I think every great novelist possesses this basic virtue, which means their works provide us with assistance or companionship in our contemplation of life. The morality of literature lies precisely in this. Though everything is fictional within these complex and vast narratives, the author's serious reflections and examinations of life, the world, and society are revealed. This is what's truly moving. Sometimes, the author doesn't state it directly, otherwise it'd become a textbook. They reveal the acting forces behind the fate of various characters, the atoms and particles, the fundamentals, and discuss some ordinary yet sharp issues with their readers. If we have difficulties expressing ourselves or dealing with real life, we can still resonate with the work. This is a connection between minds; it is honest. Here we see the souls and actions of "the characters", and at the same time, we begin to see the value and absurdity of our souls and actions. Anyway, it provides our spiritual lives with a clubhouse, a field, a beach, or even a palace, except that the hall is only established in the relationship between you and the book, and there are no real pastors and idols in the physical space.

ne day in 1982, Mao Xuhui completed a watercolour on paper in his office at the general merchandise store on Jinbi Road called *Office Window* (*Bangongshi de chuangkou*). The sunlight through the window fills the room with an ambient light that makes the crumbling wall appear bright and rich in colour. Instead of warm yellows, golds and oranges, the light outside the window is depicted with dabs of paint reminiscent of blue skies and white clouds, a palette that reappears on the illuminated sections of the curtains, albeit in slightly cooler tones. The brushwork is relaxed and free in this work of unrestrained expression, a piece of visually pleasing tonal contrasts in which even the brushstrokes depicting light reflected off floorboards are imbued with a certain precise beauty. Mao Xuhui clearly developed this aesthetics by studying the technique and approach of the plein-air school. Mao Xuhui spoke often of his "office", which is frequently the subject of his paintings. He produced numerous sketches of this room, many of which contain a single figure, sometimes himself, such as the ink wash on paper drawing *Man by the Window* (*Chuang qian de nanren*), the charcoal pencil sketch *Reading* (*Dushu*), or the sketch in fountain pen of his friend entitled *Portrait of Xia Wei* (*Xia wei xiaoxiang*). He made these sketches as though he were writing entries in a diary, and they form a record of the young man's complex and restless response to his surroundings. The books he read were changing him by the day but, as he always complained, the environment in which he lived remained monotonous and dull. If you open a map of Kunming, the city in which Mao Xuhui lived, you will see that the General Merchandise Company he was so fed up with was only a short distance from the dormitories in Dongjiawan where he went home to sleep every evening. Not far from the offices where he worked is Xunjin Road, which is very close to the Song and Dance Troupe dormitories where his friend Zhang Xiaogang lived. If we add Dongfeng Road, which lies parallel to Jinbi Road, and Heping Village where he would live after being transferred to the Kunming Film Company in March 1984, we get a rough idea of the horizons of Mao Xuhui's world at this time. It was in this small space that he and his friends lived their lives, drinking, discussing art and getting lost in the city's streets. It is why themes like Dongfeng Road, Desheng Bridge, Dongjiawan and his office window keep recurring in his writing and artworks.

In August 1983, Mao Xuhui worked in the art department of a television series for Yunnan Television that was shot in Shilin.[46] On this trip, he produced a

"CORPOREALITY"

series of drafts that would inform his "Corporeal" (*Tiji*) series.[47] A sketchbook labelled "Human Body, Corporeal" contains several abstract, spatially structured human forms that would form the drafts for his oil painting series "Corporeal".

"Corporeality" (volume) was a standard concept familiar to most students of art, a topic that would inevitably arise in their art academy education. In early 1981, Mao Xuhui had already produced a series of sketches of human bodies that had a rich sense of corporeality. Such sketches were an indispensable part of the curriculum, and like most of his classmates, Mao Xuhui carried out these assignments according to the teacher's instructions. However, the corporeality of the human body had always appealed to Mao Xuhui on an unconscious level as an expressive means to visualise the body's sexuality, vitality and desire, and not merely as a physical object to be accurately rendered. Unlike his classmates, he had already been profoundly affected and inspired by expressionism and impressionism. Many of his drafts and sketches, whether monochromatic or in colour, revealed the influence of expressionist impulses and visual forms. An expressionist calligraphic[48] tendency was evident in compositions he completed as early as 1981. Some of his improvised fountain pen and pencil sketches exhibit a character that verges on the neurotic. As he began to depart from realism and gain a better understanding of modernist art, it was easy for him to be drawn toward formal analysis and an emphasis on distorted or even abstract forms.

In February 1981, many young artists took note of a special issue of the UN-published *UNESCO Courier* magazine that focused on the art of Picasso. At this time, no other artist could galvanise and excite young Chinese artists quite like Picasso. This artist who was born in Spain and lived in France had already achieved mythic status amongst young artists in China because of the novelty of his cubist artworks and unique life story. Alongside Van Gogh, he was the person who attracted the most attention amongst young Chinese artists. His visual language was particularly revolutionary because he deconstructed the subjects of his painting—be they inanimate objects or human beings—and reassembled them as he saw fit. With the exception of his Blue and Rose Periods, as well as his later years, Picasso always emphasised the importance of form. On the cover of this particular issue of *The UNESCO Courier* was his coloured *Seated Woman* (1937, oil on canvas, 100 × 81 cm), a portrait of Marie-Thérèse Walter, one of Picasso's lovers. It is true that Walter appears as "the personification of delicacy and tenderness",[49] but the depiction of her face is far from realist. In portraits like this, Picasso liked to paint his subject's face in profile, with both of their eyes on the same side, while spatially reorganising their body, adornments and surroundings to produce a distorted or even abstract image. This was of course the result of Picasso's experimentations with cubism, the fruits of a constant evolution that began when, inspired by African wooden sculptures, he transformed a natural image of nude women into a painting altogether more abstract, *Les Desmoiselles d'Avignon* (1907). This formal conception, this apparent liberation of aesthetic form, was bound to affect Mao Xuhui. He was particularly moved by *Guernica* (1937) and even drew a grid on top of the printed picture, a standard technique for artists hoping to sketch a copy of an image. He seemed to believe that a work like *Guernica* must be a product of strength and

Chinese-language issue of the *UNESCO Courier*, no. 8, February 1981, cover

Chinese-language issue of the *UNESCO Courier*, no. 8, February 1981, pp. 42–43

passion, the result of the love all humanity shares, just as the writers of *The UNESCO Courier* put it: "Bearing in mind the creative process that produced it, its message seems to be that [human] coexistence can only be achieved by deploying the same strength and passion with which Picasso achieved a coherent work of art. The name of that passion is love, for it was love for those who had suffered, for those who had been so brutally destroyed, that drove him to paint his most immortal work."[50] Mao Xuhui seemed to approve of this statement because he underlined it in red.

This sort of text undoubtedly had a strong influence on Mao Xuhui who sought in the modernist artworks he encountered manifestations of the principles described in Western literary, philosophical and artistic texts. He seemed to believe that these deformed images of life were a particular form of visual testimony to the love of which these texts often spoke—even those images of figures in the midst of war crying out in despair. It was images and texts like these that transformed Mao Xuhui's conception of art. His grounding in the theory of humanism convinced him of the validity of modernist art. If the thematic mood of *Guernica* was the cruelty of violence and war, then Picasso's *Joie de Vivre* (1946), which featured in the same issue of the *Courier*, presented an image of peace and love. In the essay analysing the latter painting, Mao Xuhui again found an affirmation of many of the principles that so appealed to him: joy, freedom, harmony and living life to the full.

An artist's sensitivity is closely related to the visual, which can often lead to a kind of subconscious psychological transference. For example, feelings associated with a scene of the Mediterranean could be transferred to Xishuangbanna, a place with which Mao Xuhui was more familiar, where the vibrant purity of colour illuminated by the region's abundant sunlight caused his paintings to acquire a flat and decorative quality. Mao Xuhui had always been aware of the power of free expression afforded by the canvas; Western modernism merely opened his eyes to greater possibilities in terms of deconstructing form. A pencil drawing completed by Mao Xuhui in 1982 entitled *Rhapsody No. 1* (*Kuangxiangqu zhi yi*) is very reminiscent of Picasso's style and could almost be seen as a tribute to Picasso's *Joie de Vivre*. In *Portrait of a Sitting Woman* (*Zuozhe de nüzi xiaoxiang*), another charcoal pencil drawing completed in 1982, we can see the influence of Picasso's depictions of figures in profile and Matisse's decorative arrangements. The 1983 charcoal pencil drawing *Picasso's Mistress* (*Bijiaosuo de qingfu*) displays Mao Xuhui's interest in Picasso's

visual deconstruction of surface and profile, as well as the latter's approach to incorporating and decomposing visual forms in his art. In 1983, Mao Xuhui painted two oils in the style of Picasso. Having first drawn a draft in pencil, he went on to realise his understanding of the approach on canvas. Picasso's deconstruction of naturalistic forms fascinated Mao Xuhui for some time. He spent much of 1982 returning to the question of how to break free from naturalistic depiction, and he frequently sought the answer in the relationship between the outlines of one or two human faces. He even used the word "cubism" in the titles of his experiments in this direction: *Cubist Figure* (*Litizhuyi de renwu*) and *Cubist Portrait* (*Litizhuyi de xiaoxiang*). However, Mao Xuhui's formal interests would soon move from "cubism" to "corporeality".

As we have learned from his understanding of the many poems and books he read, love and eros were themes that had always intrigued him. We have also seen how he had a natural sensitivity to the corporeal insofar as it evoked desire. The sketches of human figures and still-life oil paintings he completed as a student already reveal something of his understanding of the corporeal—something characterised by heft and a muscular suppleness. In some of his explorative drafts, we can see that he was increasingly interested in incorporating the corporeal into his experiments deconstructing form. A 1982 fountain pen drawing entitled *Human* (*Ren*) shows that he even approached depictions of the human face from the perspective of the corporeal. The implicit motive or point of departure for his fascination with the corporeal was of course his perception of love and sex, perhaps involving memories of personal experience. For example, in the draft he created for *Love No. 2* (*Ai zhi er*), Mao Xuhui places emphasis on the breast in the middle of the embrace, while in his notebook, he portrays the relationship between Adam and Eve, dissects the *corpus* of Venus, and reminisces on the voluptuous bodies of impressionist paintings. His formal obsession with the corporeality of the body caused him to broaden the horizons of his understanding of form, which quickly led him to abstract composition. The themes that interested him are evident from what he wrote in the blank spaces of these abstract compositions, be it phrases like "A feeble loner destroys himself for love" or the titles he gave them, like *Perishing Love, Memory* (*Xiaoshi de ai, jiyi*) or *Congealed Love* (*Bei ninggu de ai*). At the same time, experience told him that the movement of two bodies embracing one another could stimulate the imagination to conceive of limitless repetitions and transformations to a body's structure. As such he began to modify the relations that arose between different parts of the body as a result of their position and size, causing some of them to proliferate on the canvas to the extent that the whole composition took on a strongly abstract character, for example in *Boundless Love* (*Wujin de ai*). This way of understanding and vivisecting the body led to the draft *The Corporeality of Love* (*Ai de tiji*). In this work, we can vaguely make out various parts of the human anatomy, the disembodied limbs emerging from the pulsing mass of intertwining male and female bodies, but they have been arranged by the artist in such a way as to create a completely abstract structural grouping. Although the human eye can piece together the original bodies of which it consists, clearly the artist is more interested in presenting the abstract structural relations between these limbs moving through time than returning to that illusive notion of the intact body. In doing so, he is able to depart further from previous

143 | "Corporeality"

requirements regarding the portrayal of physical objects, thereby freeing himself to incorporate any form or effect into the visual logic of his compositions without being confined to the horizons of pre-existing visual experience.

For Mao Xuhui, 1981 was a year characterised by anxiety about his graduation from art academy. He was well aware of the aesthetic preferences of the academy, which led him to conclude that at this time, when freedom from the political and ideological strictures of the past finally allowed for the emergence of different artistic ideas, he nonetheless had to limit the themes and styles of his artistic output to the representative approaches of native painting (an aesthetics that originated amongst painters from Sichuan) or the decorative style (which arose from the Yunnan painting school). As such, while naturally anxious to complete his graduation project, he still spent any spare time he had experimenting in notebooks, on paper or on canvas with imagistic forms inspired by what he saw in magazines, books and artistic publications from abroad. To consider the body unencumbered by the natural laws that once confined it, thereby allowing for new interpretations of form and symbol, allows the painter to tend toward a more unrestrained artistic practice. In the fountain pen composition *Night* (*Ye*), human bodies in motion have been completely replaced by abstract, round blocks of varying sizes which entwine and penetrate one another in a way that is undoubtedly related to sexual memories or phantasy. Such works demonstrate that Mao Xuhui sought an artistic method that conformed thematically to deep, subconscious desires while departing visually from purely descriptive imagery. He was beginning to approach a total liberation of form. However, once form had been completely destabilised by this corporeal movement, desire and unconscious drives turned to lines and outlines to imbue once again the corporeal with vitality. We can see such irrepressible drives and unconscious desires in Mao Xuhui's *Sea* (*Dahai*) and *Earth* (*Dadi*), two Chinese brush drawing drafts completed in 1982. *Sea* is a graphic illustration of these uncontrollable desires, while the subjects of *Earth* are corporeal bodies with considerable weight that, throbbing with living impulses, resemble thunder tumbling down from the sky or souls bursting forth from the earth. In other words, formally speaking, these corporeal beings are restless, as can be seen in the 1983 fountain pen and pencil drawing *The Rising and the Disintegrating* (*Zheng zai shengteng he wajie de*). In this draft, the corporeal is no longer an offshoot of the human body but an independent and agitated explosive force. When Mao Xuhui went to Shilin to draw, he was struck by the sense of mystery in the place's natural environment, which caused him to copy a quote by Albert Einstein in his notebook while he was working as part of the film crew there: "The most beautiful thing we can experience is the mysterious. It is the source of all true art and science. He to whom the emotion is a stranger, who can no longer pause to wonder and stand wrapped in awe, is as good as dead."[51]

Having completed a few sketches of Shilin, he began to feel in the quiet and peaceful forest of stone an eternal force imbued with mystery.

The eternal silence.
They are the strong ones, standing in boundless solitude, silent, never garrulous under the clear sky.

Sketchbook dated January to August 1983, including sketches and notes of Shilin landscapes

Where did they come from? Are they exiles, cast out? They for sure didn't come to Earth to be mere decorations, to become money-making servants. Can humans understand? Humans only think that everything can be used to make big money, everything can be sold for profit, and God has given humans a chance to make money. This is humanity.

They are indestructible...

This is what he wrote in the blank space around a fountain pen sketch he made of the Shilin stone forests in which he perceived a mysterious life force. The act of psychological transference, whereby one's feelings are projected upon a natural object, is naturally often accompanied by a tendency to see oneself in the now spiritual object. In Mao Xuhui's case, it gave rise to an internal impulse and spiritual process that meant the drafts he made in his sketchbook could very quickly be transformed into oil paintings. However, the corporeality Mao Xuhui painted was evolving, from a kind of formal deconstruction to an uncanny organism moving unbridled through space. The corporeal was now full of energy, capable of metamorphosing and even constructing a mysterious, ever-expanding space for itself. Most of Mao Xuhui's "Corporeal" oil paintings were completed in 1984. Although some were based on drafts, many of these oil paintings could not be confined to preliminary sketches and took shape spontaneously on the canvas. The expressionist style on display in the "Corporeal" series came closer than ever to expressing Mao Xuhui's self, with its irrepressible, instinctive calligraphic quality and preference for deformity. In producing these oil paintings, he did not accurately replicate the arrangements on his drafts but rather completed them guided by the unquenchable impulses in his soul. The most important works in this series are *Corporeal in Motion* (*Yundong zhong de tiji*), *Ever-Expanding Corporeal* (*Hai zai pengzhang de tiji*) and the highly expressive *Red Corporeal* (*Hongse tiji*).

The "Corporeal" series was completed while Mao Xuhui was working for the General Merchandise Company and living at his dormitory in Dongjiawan. From the beginning of 1982 to March 1984—when he was transferred from the general merchandise store to the art department at the Kunming Film Company where he would work designing posters—Mao Xuhui spent all his time either in his office or the Dongjiawan dorms reading, painting and thinking about art. There was no drama in his life to speak of. Only his evenings drinking and discussing art with friends seemed to him to escape the monotony of everyday life. Just as they made the moat in Kunming their Seine, so too did they want to inject what they read about Europe into their own lives and art, hoping that with the help of their imagination, and under the influence of a great deal of alcohol, they might be able to produce new dreams for art and the future. However, the truth was that the tedium of everyday life, the lack of material conditions and the general dearth of modern artistic spirit in their social environment limited the scope of their artistic activity. Mao Xuhui and his friends had but a very limited space within which to search for limitless possibilities. Mao Xuhui produced a great deal of small sketches of a solitary man slumped in his office and staring out the window at the world outside, an allegory for his inner longing for a less confined world. Through the window he watched people walk by,

145 | "CORPOREALITY"

the scenes of Desheng Bridge and the Xunjin Street junction, the streetlights leading down Dongfeng Road towards Dongjiawan, friends from the office or his dormitories, and so on. On the other hand, Mao Xuhui as a person at this time was defined almost entirely by parties, booze, music, discussions about philosophy, religion, art and girls, and the abyss of his emotional life. Not only did this impel him to turn to books in search of a larger spiritual space and the means to expand his intellectual horizons, but it also led him to find emotional release in his artistic practice. It was in this frame of mind that he completed *Red Corporeal*, as his friend Nie Rongqing writes:

Mao Xuhui's "Love" (Ai) series and "Red Corporeal" (Hongse tiji) series are in some way each a record of two different states of his life. This is especially true of the "Red Corporeal" series, which he completed in a single week during which he barely slept or interacted with friends, instead painting his art in a state of manic exuberance. He could feel the potentially lethal effect this was having on him, he could see the redness in his eyes, and he even began to hear non-existent voices—he understood his mind was on the brink of collapse. Then one day Zhang Xiaogang and Pan Dehai, thinking it strange they hadn't seen Mao Xuhui for so long, rode their bikes to the film company and saw the entire "Red Corporeal" series, this bursting forth of unchecked emotion. Zhang Xiaogang, intuiting that continuing at this rate would be no good for Mao Xuhui's mental health, suggested that they go out for a drink. With that, the "Red Corporeal" series came to an end. Mao Xuhui never went back to it. He was no longer in that state of mind and so that particular creative process came to an end. If he had been left to continue painting that day, perhaps Mao Xuhui today would be a painter from another spiritual world.[52]

In the summer of 1983, Mao Xuhui painted a picture of a summer's day on Xunjin Street—*Xunjin Street in Summer (Xiari de xunjin jie)*—in which two women are standing opposite one another, the atmosphere between them apparently preventing them from speaking to each other. Having suffered a year living apart from his wife, during which he frequently became acquainted with new women, he was perhaps feeling anxious about a choice he faced. Disorder and mental turmoil are common in one's youth, but for Mao Xuhui, they were the necessary and exhilarating results of his spiritual transgressions and were therefore mental states to which he seemed almost willing to succumb. By the end of the year, the mental turmoil had engulfed him, but changes in his life and work environment seemed to have a regulating effect on his state of mind. In a letter written to his wife He Lide on 24 February 1984, he calmly informs her that his transfer to the film company will soon be completed, and it is now time to find a way to transfer her from Anning back to Kunming.[53] He spends much of this letter discussing artistic and academic questions, for example what he has learned from Saul Bellow's novel *Humboldt's Gift* about the death of the poet and the predicament of the intellectual. He also calmly discusses family affairs and even describes his own emotional state:

When I left work this noon, I saw a young mother holding an infant waiting for the bus at the route five bus stop. The infant was wrapped in a veil, and in

the sunlight, it looked beautiful. If I always rely on intuition to feel the outside world, there are many touching things.

This month I saved forty yuan and received two payments for my articles. The cupboard is indeed very convenient. The room is starting to boil, the dreadful summer. Is it possible to get the sixth issue (the last one) of World Literature *from 1983? I've received the first issue of this year's* Foreign Literature.

I cleaned the magnetic head of the cassette recorder with detergent, and the sound was much better. I didn't even have this basic knowledge in the past.

Caught another rat. Under the cupboard, it must have struggled for two days on the adhesive board, because I had forgotten about it. There seem to be more rats, though. Everyone is struggling to survive.

In short, after Spring Festival in 1984, especially after his transfer from the general merchandise store to the film company and the birth of his daughter, Mao Xuhui, who had been the cause of considerable concern amongst his friends regarding his mental health, seemed to have, for the moment, regained a certain composure. After all, he must have felt that working in the art department of a film company had at least somewhat elevated his professional status as an artist and would provide him with more opportunities and possibilities to paint.

ntil 1984, the network of exhibitions in China remained firmly in the hands of the official Artists Association. As intricately structured as any government organisation, its vast bureaucratic web spread from the national-level China Artists Association to artists associations at the provincial and regional levels, and further on to municipal- and county-level organisations, all of which, naturally, state funded. Any artist who wanted to participate in an exhibition organised by the Artists Association had to meet its political and artistic standards and requirements.[54] Although it ceased to function completely between 1966 and 1976, it was able to resume activities after the downfall of the Gang of Four when Jiang Feng, who had been formerly labelled a "rightist", re-emerged to assume the role of Chairman.[55] Based on his assessment of the new political environment, and along with other officials in the Artists Association like Hua Junwu, Jiang Feng used the power of the organisation to ensure artworks in the scar art and native painting traditions originating in Sichuan were exhibited in the "5th National Fine Arts Exhibition" (*Di wu jie quanguo meizhan*) organised by the Ministry of Culture and the China Artists Association in February 1980. He also promoted the "Symposium on Oil Paintings by Young Artists" (*Qingnian youhua chuangzuo zuotanhui*, August 1981) and the "Oil Painting Exhibition of the Sichuan Fine Arts Institute" (*Sichuan meishu xueyuan youhua zuopin zhanlan*, 19 January to 7 March 1982), which undoubtedly encouraged young artists who had only just graduated. For some time the exhibitions and events organised by the Artists Association formed the horizon of possibility for young artists in China hoping and striving to exhibit their work. This is the main reason why, when the Yunnan Artists Association issued a call for submissions to the "6th National Fine Arts Exhibition" (*Di liu jie quanguo meizhan*) in 1984, Mao Xuhui and his friends continued to place so much hope on their artworks being accepted. After all, there were no opportunities at the time for young people to participate in independent exhibitions. When they heard about the "Celebrating the 35th Anniversary of the Founding of the People's Republic of China Yunnan Fine Arts Exhibition" (*Qingzhu Zhonghua renmin gongheguo chengli sanshiwu zhounian Yunnan sheng meishu zuopin zhanlan*) organised by the Yunnan Department of Culture and the Yunnan branch of the Artists Association, as well as news that the 6th National Fine Arts Exhibition was soliciting submissions, Mao

FINAL PURITY

Xuhui and his friends put aside any scepticism they might have had and began working on their submissions.

Of course, Mao Xuhui understood the requirements of the Artists Association and had no intention of submitting his "Corporeal" series. However, just as with his graduation project a few years previously, he faced the problem of how to create work that would be accepted by officialdom. It was reasonably easy for Mao Xuhui to return to tried and tested topics and methods, namely depictions of the purity of rural life and human nature, artistic themes he held in high esteem. Acquainted with this approach through the landscape paintings of the Barbizon School, Van Gogh's *The Potato Eaters* and Gauguin's *Tahitian Women*, he had long developed a comprehensive understanding of this form of artistic expression. Like most sensitive young artists of the time, he realised that it could help him break free from the shackles of official political frameworks and traditional Soviet methods, thereby opening up an artistic path towards spiritual freedom. As early as 1980, the native painting style of such oil painters as Shang Yang and Chen Danqing had already had a profound influence on the younger generation of artists. Furthermore, the experience and achievements of Mao Xuhui's previous two trips to Guishan had already provided the young artist with a rich source of material to work from. Mao Xuhui had realised that scar art and the native painting movement to which it gave rise were already largely accepted by the Artists Association, and as such, by producing artworks in this vein and according to these methods, he might have a chance of having his works exhibited. Four years earlier, artworks by students from the Sichuan Fine Arts Institute had been included in the 5th National Fine Arts Exhibition. Naturally, the main objective of Mao Xuhui and his friends was to follow in their footsteps by having their works exhibited in the sixth edition, and they encouraged one another in their pursuit of this goal. In early 1984, Mao Xuhui had moved into the dormitory-cum-workshop of the Kunming Film Company at 2 Heping Village in Panlong District (now Guandu District), a move he believed had fundamentally transformed the conditions under which he could paint. In May, his daughter Maotou (later renamed He Jing) was born, which naturally brought him great joy. Irrespective of their duration, such moods were always able to propel Mao Xuhui through his artistic work, which in this instance was creating art based on the sketches he had made at Guishan.

Mao Xuhui worked on these artworks for almost half a year. Unlike the oil paintings he made during his visit to Guishan with Zhang Xiaogang in the spring of 1982, he adopted a more traditional creative process of preparing small drafts before completing the final picture. All the works he produced for the exhibitions organised by the Kunming Artists Association and Yunnan Artists Association were based on drafts, including *Guishan Collection: Red Earth Road* (*Guishan zuhua: hongtu lu*), which was included in the exhibition organised by the Yunnan Artists Association in July, and *Guishan Collection: Mountain Village at Dusk* (*Guishan zuhua: shancun huanghun*), which was included in the exhibition organised by the Kunming Artists Association in October. The final stage of Mao Xuhui's process was the application of colour, which simply served to finalise the picture by adding that visual dimension only colour can provide. However, for Mao Xuhui, the function of sketches was not limited to a stage in the process of producing a finished oil painting. He was

always thinking about how to mine previous sketches for material that could be transformed into formal works in the future. *Mountain Village at Dusk* is an example of a piece Mao Xuhui completed from drawings he made in his sketchbook in 1983. It contained many drawings of women whom Mao Xuhui placed in a pastoral natural landscape, often with a goat next to them to accentuate the rustic purity of nature. In this sketchbook, images of Guishan are interspersed with those of women from Western artbooks, which shows he frequently associated images of women with notions of life, nature and purity. Next to the draft for *Mountain Village at Dusk*, Mao Xuhui drew a naked woman apparently questioning the sky above her. He writes:

If you don't understand it, then it's better not to understand anything at all. The more you know about the world, the more pain you'll feel. Let your soul sleep: immerse it in distant and tranquil reveries. Sing for fantasies rather than for this world. Love, love the ordinary things rather than people. Reach your hands to the sky, the earth, and the fields, and offer your heart to them. There, you receive more than you give: that is the truth.

This seems to be a time when Mao Xuhui was able to ponder questions calmly. He took what he knew about Adam and Eve, myths of women in untouched natural environments, the scenes of mountains and goats he personally saw and experienced, and the appearances of fields and shepherds, and channelled it all into a yearning for purity, a fantastical dreamscape approaching the ideal of art. *Mountain Village at Dusk* was completed not long after *Red Corporeal*. Its tonality evidently approaches that of Millet. The people, goats, trees and even plants have a magisterial, sacred quality about them, painted as they are by an artist with a profound love for nature. Mao Xuhui's pastoral paintings are imbued with his inner anguish and religious fervour for the mystery of nature, which means his depictions of nature and people differ a great deal from the lyrical portrayals of someone like Jean-Baptiste-Camille Corot. Everything appears solid and still, but in a different manner from the work of Cézanne. Irrespective of the latter's influence on Mao Xuhui, and despite the contemplative force that emanates from the dynamic, awkward Sani shepherdess depicted in coarse brushstrokes and resembling a statue, the tree behind her is full of life as it grows in the background, its sturdy trunk, thick branches and dense leaves forming a striking contrast with the spindly metropolitan figures that populated some of his previous paintings. He adored nature because he saw in it the life, well-being and vigour he longed to see. The enigma of nature's abundant vitality lingers longer in the heart of the artist than it does in the mind of the ordinary person because the latter barely considers this sort of question. Even Guishan and dusk themselves pose problems to an artist who cannot help but ponder them. It is in the process of thinking through this confusion that the artist provides us with purity and vitality in the form of images that are hard to come by in the metropolis.

Perhaps there was too much of Western classical art's influence in those voluptuous human figures. Furthermore, one would never see nude women in the rustic villages near Guishan. So Mao Xuhui turned to the vast number of sketches he had made of Guishan in the hope of creating as true a portrayal as

possible of the simple purity he had perceived and come to understand there. Not only is there a small coloured sketch of *Guishan Collection: Red Earth Road*, there is even a larger draft that resembles a finished product. The style in the final version is reminiscent of Gauguin or Henri Rousseau, and the whole painting feels more consciously stylised than previous works, especially *Mountain Village at Dusk*. It has a stiffness that resembles that of medieval paintings and the artist seems to have incorporated too many themes and expressive approaches into his creation, a tendency we also see in a work that was not selected for the exhibition, *Guishan Woman* (*Guishan funü*, 1984), although this artwork has a more primitive flavour.

In any case, Mao Xuhui saw Guishan as another means of re-examining "authenticity". The phrase "return to nature" makes us think of French painter Rousseau and that lyrical poet of natural images Corot—Mao Xuhui himself said that Corot's paintings reminded him of Guishan, but in terms of spiritual temperament, Mao Xuhui more resembles Millet. He would continue to produce paintings of Guishan at various stages of his career. Guishan and the metropolis continued to simultaneously inspire contrasting responses in the artist's mind. We will soon see that although he saw in nature something sacred in the religious sense, what the sheep, trees, stones, houses and shepherdesses really came together to provide was a kind of sanatorium for a young man tormented by the red-brick walls, asbestos tiles, advertising boards and noisy machinery of the modern metropolis. Nature was a bed, a place of comfort where one could rest and feel one's pain being gradually eroded away.

Guishan was indeed an idyllic bed that enthralled the artist:

The redder the soil, the greener the grass and trees on it. We sat on the grey stone seats protruding from the red earth, much like Henry Moore's bronze sculpture King and Queen *on the hills of Yorkshire. We gazed at the drifting clouds and the expansive land nestled between two conical mountains, our minds void of thoughts. We listened to the wind pushing the sound of the forest into the valley, rattling the sensitive nerves of the sheepdogs. Flocks of black goats and grey-white sheep, heads bowed, casually grazed on tender grass and green leaves. The shepherds occasionally called out while farmers ploughed the fields, guiding their yellow oxen and iron ploughs up and down the uneven hills in the valley. All of this created a picture of ancient survival, an image of farming and herding in Eden. Though in Eden Adam and Eve didn't farm; they simply ate the fruits of the trees, leisurely and content. However, the scene before us more closely matched my imagination of Eden, where survival came through labour. This labour differed fundamentally from the intense, overworked operations of mechanical and electronic civilizations. It stemmed from a natural instinct and simple hopes.*

We can now see why the artist populated his natural scenes with voluptuous nudes.

The arrival of industrial civilisation brought with it a plethora of writers and artists in whose work we can see a similar state of mind. Indeed, it is a state of mind in thrall to utopianism, which in such times possesses an acutely critical

character. It is important to note that aside from the vulgar and cheap products of modern civilisation, the most central object of its critique was the painful, infuriating and emotionally damaging hostility between people that was the result of traditional cultural and social problems. Understanding this helps us see why Mao Xuhui drew a visual analogy between the gaze of the shepherdess and that of the goat. People living in nature are necessarily pure, and what purity is more authentic than the purity of animals? In the early twentieth century, the German artist Franz Marc had posed the question: "How does a horse see the world, how does an eagle, a deer or a dog?"[56] However, Mao Xuhui's fascination with the goat's gaze was not the result of some cultural idea that had been transmitted to him but rather an instinctive reaction and revulsion to urban life.

In *Guishan Collection: Woman and Horse* (*Guishan zuhua: nüren he ma*), Mao Xuhui condenses nature into an oneiric vision in which a local woman from Guishan walks with a branch symbolising life in her arms and a white horse not far behind her. The background contains only blue sky and red earth, which form an almost abstract relation with one another. Nature appears before us in its most distilled form in this lyrical work, the symbolic meaning of which is presented as a dreamlike scene of earth and branch, animal and woman. The artist has provided us with a clear and accessible expression of his view of life. Unlike the protagonist of Hesse's *Peter Camenzind*, Mao Xuhui prefers the red earth beneath his feet to the clouds in the sky: "The red earth contains all dreams. The red earth itself is dreams—dreams of the Earth; dreams full of love and passion." It is the red earth that provides support for the insecurity in the artist's soul: "I have this feeling that neither our flesh nor our souls can leave the Earth as they please." That there are no white clouds in the blue sky of this painting is not surprising. The immaculate animal forms such a striking contrast with the blue sky that the addition of a white cloud floating aimlessly above would be superfluous. Like the red earth below, an untainted sky is better able to evoke a dreamscape in the lyric mode.

Purchased by Zhang Zhen, a Shanghai poet who has since moved to Sweden, *Guishan Collection: Encounter on Red Earth* (*Guishan zuhua: hongtu shang de xiangyu*) is a portrayal of the purity of Guishan shepherdesses that has an idolatrous quality. Mao Xuhui has centred the two women in his composition such that they occupy most of the canvas. Furthermore, the two figures are positively statuesque in their bearing, which aligns with the artist's intention of capturing a sense of the eternal in his renderings of nature and those who inhabit it. We saw a similar decision to present authenticity and eternity through the portrayal of ethnic minorities in Chen Danqing's "Tibet Series", in which one could almost smell the scents of butter tea and sheepskin in the artist's depictions of Tibetan herdsmen. However, Mao Xuhui felt that Chen Danqing's oil paintings had still failed to capture something essential, that eternal quality within nature and people. It was based on this that Mao Xuhui was finally able to express his view that Chen Danqing was "a second-rate Millet, thrice removed". Such an assessment reflects Mao Xuhui's natural preference for basic form as opposed to realistic detail in his search for a means of expressing "authenticity" and "eternity".

Guishan Collection: Remote (*Guishan zuhua: yaoyuan*) shares the lyric-poetic quality of *Guishan Collection: Woman and Horse*. Interestingly, we

could choose to see the figures in this painting as none other than the two women in *Guishan Collection: Encounter on Red Earth*. We discover that the artist has overlooked the individual features of the figures he paints, choosing instead to retain only the basic appearance of the clothing worn by the Guishan people. Of his "Guishan" paintings, *Guishan Collection: Remote* is one of the most richly poetic in character, which is why it contains a relatively complete set of natural symbolic objects: a mountain, a tree, a goat and clouds. The comparatively bright use of colour implies that perhaps the artist's mind was so completely immersed in his own drifting pastoral fantasy as he completed the work that the ambiguous effect often produced by the mysteriousness of nature barely registered with him.

One could almost describe *Mother Red Earth: Calling No. 2* (*Hongtu zhi mu: zhaohuan zhi er*) as a pantheistic work, or perhaps an anthropomorphism of nature. Mao Xuhui combines the properties of earth with those of human flesh, giving full expression to the idea that God is nature. All things are born, grow and eventually return to nature. Nature gives humans life and as such humans' final home is the nature that gives rise to all things. But what does this expression of the naturalism of life mean? Is all that is restless and discomfiting on the canvas merely a pictorial representation of the unending cycle of life? In truth, what this painting really embodies is an inner state of increasingly irrepressible panic. Our mother, the mother of all life, is undoubtedly worthy of praise, but the "Calling" of "Mother Earth" is so deafening that we cannot help but recoil from it. In 1985, Mao Xuhui painted a piece titled *Red Human Body on Red Earth* (*Hongtu shang de hongse renti*) in which the Son of Nature bounding across the canvas appears so consumed by frantic mania that we can only regard him as a terminally ill monster. It is therefore clear, with a piece like *Mother Red Earth: Calling No. 2*, that the pathologies of life have seeped into Mao Xuhui's art, a feature we will see become more pronounced in his later works.

The "Guishan" works appear at various points in Mao Xuhui's career and can be seen as sporadic expressions of his true disposition that remains with him throughout. As a body of work, it reflects one aspect of his contradictory state of mind.

There was evidently something strategic in Mao Xuhui's choice of Guishan as his subject matter. He was aware of the aesthetic tastes of the Artists Association at the time and sought to produce work that would be thematically acceptable without sacrificing his own artistic views and principles. However, although the exhibitions organised by the Artists Associations for Yunnan province and Kunming city each featured one of his paintings, neither Mao Xuhui nor his companions—Zhang Xiaogang, Ye Yongqing, Pan Dehai—had works selected by the 6th National Fine Arts Exhibition.

On 28 February 1984, Mao Xuhui wrote a long essay recording his thoughts about life and society, in which he analysed how and why society for an individual is so complex and difficult to navigate. He concluded by writing:

Being an outsider means no longer being bound by societal values. Outsiders have transcended life; though they may seem pitiful on the surface, they are just spectators of society. Perhaps they stay closer to the principles of life, closer to nature, closer to the God people once believed in and the heaven people longed for.

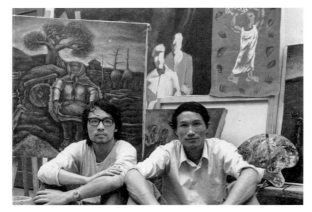

Mao Xuhui (right) and Zhang Xiaogang (left) at Mao Xuhui's Studio, 2 Heping Village, 1984

Mao Xuhui at Kunming Film Company dormitory, 2 Heping Village, 1984

Society is nothing but the actualisation of hell; society is hell. To be someone who has escaped from hell, isn't that wise?[57]

This was written around the time Mao Xuhui moved from the General Merchandise Company dormitory in Dongjiawan to his new accommodation with the Kunming Film Company at 2 Heping Village. It gives a genuine insight into the thoughts of this young man who maintained his contemplative attitude as the confrontations he faced at work, in society and at home continued to weigh down on him, exacerbating his anxiety. He now fully understood the ideas of figures like Rousseau, the reason Gauguin had gone to Tahiti, and the lives of the Sani people who went out to work at sunrise and returned home to rest at sunset. However, material reality had forced upon him difficult choices about his life and art going forward. His dreams of participating in the 6th National Fine Arts Exhibition had come to nothing. He and his friends could not make sense of how the social "mass organisation" that was the Artists Association really worked. They had not considered, nor did they want to consider, why people like Jiang Feng had been able to use their power in 1979 to welcome a completely new artistic phenomenon and make it a core part of the organisation's work. It was in fact a political act, a negation of the Cultural Revolution that had just come to an end, but now that the political situation and people involved had changed, young artists were not going to be given a similar opportunity again. Perhaps one's sense of honour is innate, but Mao Xuhui and his companions had not received the same honour from society as the creators of scar art had a few years before them. Time had passed and the political and social environment had changed. The artistic questions of the age could no longer be aptly understood or engaged with by devoting oneself to historical truth (scar art) or advocating a return to human nature (native painting). If they wanted to hold on to their artistic ideals, Mao Xuhui and his friends would have to think of another way.[58] Problems like this rarely come one at a time and Mao Xuhui's mind once again began to enter a state of turmoil:

> *Summer rain moves towards autumn*
> *Is love also like this?*
> *The rain falls again and the heart feels cold*
> *If this is the last time to confide in you*
> *If this is the last time*
> *Raindrops would turn into tears*

About love
A full page has already been written
If I know a truth or thousands of them
What does it prove?
Love is just love

Because of maturity, death approaches
And from reliability come numbness and negligence
We fall asleep on the couch of love
When dreams turn away
Pain has already landed

Because of the pain you have to console it
Rethink pain all over again
Love is a flying bird
You cannot grasp it in your hands[59]

This poem was written after it had become clear to Mao Xuhui that his work would not be included in the 6th National Fine Arts Exhibition. From 1983 to spring 1984 he had perhaps been overwhelmed by his emotions, but the change of living environment (his new job and accommodation) and family situation (the birth of his daughter) had served to regulate his mood and lifestyle, as did all the effort he channelled into producing an artwork for the 6th National Fine Arts Exhibition.[60] In the poem, the present object of his love remains unsaid, but we can see that deep down he is preparing to bid farewell to the love that consumes so much of his energy. Even if the stability of his marriage still hung in the balance, his tears now lacked their former fervour. As the artist knew, love was simply a bird. She had flown away, and the pain of another bout of anxiety was about to arrive—despite the fact a new chapter in his romantic life had already begun.

[1] Translator's note: This was apparently copied down on the first page of Mao Xuhui's 1977–82 notebook and comes from an article by Maksimov, translated into Chinese, titled "On Oil Painting" (*Guanyu youhua*). However, it is not known where Mao Xuhui copied it from.

[2] All quotes from this paragraph come from Mao Xuhui's graduation thesis, 1981, unpublished.

[3] Shao Dazhen, a professor of art history at the Central Academy of Fine Arts. He studied in the Soviet Union in his early years. After the third plenary session of the 11th Central Committee in 1978, Shao was among the first to introduce Western modern art to China (published in *World Art* in 1979). He was the editor-in-chief of the official magazine of the China Artists Association, *Art Magazine*, until he was dismissed in the aftermath of June 1989.

[4] A reference to a famous bar in Paris frequented by modern artists like Picasso.

[5] In March 1982, Mao Xuhui was already working at the Jinbi Road general merchandise store, while Zhang Xiaogang was travelling around Kunming in search of employment opportunities. It appears that, in early March, Zhang Xiaogang returned to Sichuan Fine Arts Institute hoping to be reassigned. Unsuccessful, he then went to the ferry port. After spending a day there, he returned to Kunming.

[6] Gao Xiaohua, author of the important scar art painting *Why*, later recalled looking at foreign art catalogues as a student in the Sichuan Fine Arts Institute library: "Speaking of looking at materials and art catalogues, it reminds me of the commotion caused by the arrival of the oil painting class of '77 into the Sichuan Fine Arts Institute. Due to the upheaval of the Cultural Revolution, the institute had very few decent domestic and foreign art catalogues left when it reopened its doors. Consequently, viewing art catalogues became a 'privilege', something students naturally did not have the qualifications for. How could the self-proclaimed exceptional students of the class of '77 tolerate such 'discrimination'? So, I organized a 'petition' campaign: we first put up big-character posters, then went on strike, refusing to attend classes or meals. In reality, our purpose was very simple: we wanted to learn and improve; we wanted to look at art catalogues and materials! . . . And so, the school opened the library. I remember queuing up with immense joy and a sense of victory, waiting to take turns looking at the art catalogues. It felt so blissful! According to the school's new regulations, we had to wear special gloves when looking at the catalogues, and we were repeatedly reminded not to tear or damage them." Gao Xiaohua, "Scar Painting in Chinese Modern Art History" (*Zhongguo xiandai meishushi zhong de "shanghen huihua"*), in *Recollections and Statements* (*Huiyi yu chenshu*), edited by Lü Peng and Kong Lingwei (Changsha: Hunan Fine Arts Publishing House, 2007), p. 160.

[7] From Mao Xuhui's personal notebook, with a red plastic cover, bearing the inscription on the title page:

"Commemorative Album of Yunnan Province Literary and Artistic Creation Programme Rehearsal and Performance Conference, 1974, Kunming."

[8] Translator's note: Hermann Hesse, *Peter Camenzind*, trans. Michael Roloff (New York: Farrar, Straus and Giroux, 1969), p. 100.

[9] Translator's note: The Panlong River skirts around Kunming's old city centre and is therefore sometimes called the "moat".

[13] The plein-air school's conception of the city can be seen in the following retrospective description: "The beautiful scenery of old Kunming was the eternal pride of the city. Some young local painters wanted to provide an interpretation of these beautiful Kunming scenes through their 'little landscape paintings'. Panlong River, which runs through the city, was jokingly called 'Kunming's Seine' by local painters. As you travel along the river, the scenes that can be painted are even more beautiful. The river enters the city from the north, its moss-covered stone banks, the domed caves where people collect water, the dripping steps that lead to the river's surface and the irregular arrangement of mud and old wooden housing that overlook the river all forming a picturesque muddle until you reach Desheng Bridge, after which they give way to a few buildings in the French style. The plein-air painters were obsessed with painting Zhuji Bridge, Furun Bridge and Desheng Bridge, with the two sand-coloured watchtowers on its west side. These were scenes they never tired of painting." Li Xiangrong, "The Plein-Air School Under Dappled Clouds", in the *Enjoy Art, Read Books* feature of the *Kunming Daily*, 28 June 2004.

[11] Translator's note: Albert Camus, *The Myth of Sisyphus* (London: Penguin Books, 1975), p. 13.

[12] Nie Rongqing writes in *Colors of the Moat: Kunming Artists in the 1980s* (*Huchenghe de yanse: 20 shiji 80 niandai de kunming yishujia*) (Beijing: People's Fine Art Publishing House, 2015), pp. 155–57: "For Zhang Xiaogang and Mao Xuhui, 1983 was a year characterised by booze. When they met up, the main item on the agenda was invariably drink, which they needed not simply to relieve their despair but also to provide excitement. The euphoria they experienced from alcohol seemed to transcend everything else. When they got off work, Mao Xuhui and Zhang Xiaogang drank together, usually without much in the way of food except for perhaps a bag of fava beans or peanuts. The more they drank and chatted together, the more animated they became. Often, a friend might turn up during a drinking session and, having gone off to buy another bottle and some peanuts, would join them. After a while, perhaps they'd be joined by someone else. If there were a lot of people, they'd spread newspaper on the floor and sit in a circle smoking and drinking together. Occasionally Mao Xuhui would play some Russian folk songs or old tunes on the guitar. The sober ones would sing as they held basins for their drunk friends to vomit in. It was all very bohemian. Sometimes they'd listen to songs Zhang Xiaogang had edited on his own tape recorder—a skill he had picked up at the Song and Dance Troupe and he continues to enjoy to this day."

[13] The earliest Chinese translation of this book was published on 1 November 1981 by Foreign Literature Publishing House in Beijing.

[14] From the pastel-patterned notebook labelled "1981–83".

[15] Translator's note: Max Beckmann, *On My Painting* (London: Tate, 2003).

[16] To this day, Mao Xuhui still retains a copy of 1982's fifth issue of *Foreign Literature and Art* (*Waiguo wenyi*), published by Shanghai Translation Publishing House. This small-format bimonthly magazine featured an article on Beckmann translated by Du Dingyu entitled "Max Beckmann: The German Painter Persecuted by the Nazis" (*Beishou nacui pohai de deguo huajia beikeman*). (Translator's note: Original unknown.)

Black-and-white prints of Beckmann's paintings were included on the front and back covers, both inside and out. For the vast majority of young artists in China during the 1980s, the poor-quality black-and-white pictures printed in the pages of magazines were the primary means by which they could encounter Western artworks. This magazine was one of Mao Xuhui's earliest points of access to Beckmann's paintings. In the notebook with photos of landscapes in it (in which he started writing in November 1982), Mao Xuhui also copied down some of Beckmann's thoughts from *A Selection of Essays on European Modernist Painting Schools* (*Ouzhou xiandai huapai hualun xuan*), edited by Walter Hesse, trans. Bai Zonghua (Beijing: People's Fine Art Publishing House, 1980). (Translator's note: This selection of essays was translated from *Dokumente zum Verständnis der modernen Malerei* [Hamburg: Rowohlt Verlag, 1956].)

[17] Loose pages from his notes while travelling in Shangri-La, Lijiang and Dali (October 1980).

[18] The hardcover "Art Diary" (1978–81), which he shared with his father.

[19] "Sketchbook" (1982–83). All the following unreferenced quotes of Mao Xuhui's poems are from this sketchbook.

[20] Ibid.

[21] Mao Xuhui copied several foreign poems in a hardback, red-spined, chequered notebook. He used this notebook from 1982 to 1984, which meant that there was a clear modernist tendency to the poems he chose, such as Émile Verhaeren's *La plaine*, Paul Valéry's *The Graveyard by the Sea*, William Butler Yeats' *Sailing to Byzantium*, Rilke's *Sonnets to Orpheus*, T. S. Eliot's *The Love-Song of J. Alfred Prufrock*, and Ezra Pound's *Portrait d'une Femme*.

[22] Held by the Kunming Federation of Literary and Art Circles and the Yunnan Masses Art Museum in February 1983.

[23] Jointly held by the Yunnan Cultural Bureau, Yunnan Masses Art Museum, Yunnan Branch of the Artists Association, Yunnan Branch of the Photographers Association and Cultural Palace of Nationalities in April 1983.

[24] The blank-covered blue notebook (November 1983 to February 1984).

[25] The political environment after December 1978 was one that tended to avoid ideological controversy. However, as Western texts and images continued to enter China by way of various media like books, films and the news, people became increasingly aware of and sympathetic to Western thought. The change taking place in Mao Xuhui's views as he read and copied from Western books is representative of the obsession with Western culture shared by many of the youth at this time, which they manifested in their daily lives and interactions with one another. During the Conference on Theoretical Work held in early 1979, the Communist Party of China had already attempted to relax former leftist ideological taboos. However, it was also at this time that they announced the Four Cardinal Principles which had to be adhered to: the principle of upholding the socialist path, the principle of upholding the dictatorship of the proletariat, the principle of upholding the leadership of the Communist Party of China and the principle of upholding Mao Zedong Thought and Marxism-Leninism. It was not long before ideas were appearing amongst the populace that upset the party leadership, including such slogans and organizations as "Demand Human Rights" and "Democratic Conference". On 20 April 1981, the *People's Liberation Army Daily* (*Jiefangjun bao*) published an article called "The Four Cardinal Principles Must Not Be Violated—A Review of the Film Script *Bitter Love*" (*Si xiang jiben yuanze burong weifan—ping dianying wenxue juben "kulian"*), which attacked said literary work for reflecting upon history in a way that "denigrated the socialist system". Deng Xiaoping agreed, arguing that, "It is

true that the effects of this kind of text and so-called 'democratic' activists are similar." Phenomena like this alarmed party leadership and, on 12 October 1983, Deng Xiaoping told the second plenary session of the 12th CPC Central Committee, "There are still many problems in the spheres of literature, art and theory, considerable disorder, especially the phenomenon of spiritual pollution. Soldiers on the ideological front should be engineers of humanity's soul, but there are some who are running counter to the demands of their contemporaries and the people, who pollute the souls of the people with their unhealthy thought, unhealthy artworks and unhealthy performances. The essence of spiritual pollution lies in the promulgation of the various corrupt and decadent ideas of the bourgeoisie and other exploiting classes, as well as the spreading of distrust in the socialist-communist cause and leadership of the Communist Party. Two particularly prominent problems right now are humanism and the theory of alienation." Deng was referring here to philosophical circles analysing and reappraising Western thought, particularly Marxist theory, in a manner that contradicted the orthodox interpretation. Two prominent thinkers engaged in such pursuits were Zhou Yang and Wang Ruoshui. Later, on 31 October 1983, the Xinhua News Agency published an opinion piece entitled "The Struggle against Spiritual Pollution" (*Xiang jingshen wuran zuo douzheng*). However, these internecine struggles and superficial campaigns did little to influence the younger generation's zeal for learning about Western thought. In fact, the campaign to "eliminate spiritual pollution" had petered out by spring of the next year.

[26] Mao Xuhui started using this softcover notebook in November 1982. His last entry is dated 18 June 1983.

[27] Translator's note: Hermann Hesse, *Peter Camenzind*, p. 22.

[28] In a poem written in "Sketchbook" (1982–83) around the beginning of 1983, Mao Xuhui wrote the following lines: "If one accepts there is sin/Then the first sinner is God/Admit the bestial, oppose the divine/See eyes in the trees/See sadness in the ripples/See lust in the storm." These words recall Hesse's conflicts with and rebellion against his father.

[29] Translator's note: Hermann Hesse, *Peter Camenzind*, p. 115.

[30] This book was originally published in December 1980, but the copy Mao Xuhui has is from the second printing that came out in 1983. The note on the inside cover shows that Mao Xuhui only bought this book in September 1983. Clearly, Mao Xuhui must have previously borrowed the book from friends or the library before transcribing large parts of it to help him understand and remember its contents better.

[31] Translator's note: Jean-Paul Sartre, *Life/Situations: Essays Written and Spoken*, trans. Paul Auster and Lydia Davis (New York: Pantheon Books, 1977), pp. 28–29.

[32] The Chinese version was based on Willa and Edwin Muir's English translation and was published by Shanghai Translation Publishing House. Mao Xuhui's copy was the second printing published in June 1982.

[33] Translator's note: *We Are the Inheritors of the Communist Project* was a popular Chinese song released in 1960.

[34] Translator's note: Franz Kafka, *The Castle*, trans. Willa and Edwin Muir (New York: Alfred A. Knopf, 1959), pp. 77 and 43.

[35] Translator's note: Often referred to as the Little Red Book, the *Quotations from Chairman Mao Zedong* (sometimes written "Mao Tse-tung") summarised Mao Zedong's thoughts on various topics in a concise form that was easy to read. It was for some time the most widely read book in China.

[36] This quote, and the unreferenced quotes that precede it, come from the notebook labelled "1981–83".

[37] Translator's note: The two Strindberg passages

quoted above come from his autobiographical novel *The Son of a Servant*, Claud Field's 1913 English translation of which is in the public domain. However, the English translation takes great liberties with the text, whereas the Chinese version is far more faithful, and there is little correspondence between the two. Unable to read Swedish, we have opted to translate directly from the Chinese: *Nüpu de erzi*, trans. Gao Ziying (Beijing: People's Literature, 1982), pp. 293 and 121.

[38] Translator's note: This quote and the quote above come from William Somerset Maugham, *The Razor's Edge* (London: Penguin Books, 1992), pp. 160 and 170.

[39] In Mao Xuhui's copy of *The Razor's Edge*, the top margin of p. 194.

[40] Ibid., the top margin of p. 192.

[41] Ibid., the bottom margin of p. 193.

[42] This poem appears on the first *Goddess (Nüshen)* sketch, 1982.

[43] This poem was provided by the painter Sun Guojuan.

[44] For example, Mao Xuhui wrote in a letter to Zhang Xiaogang on 7 June 1984: "I'll be back by the time you receive this letter. I bought you a collection of Van Gogh's letters, entitled *Dear Theo* (*Qin'ai de ti'ao*). I also got a few other books and art catalogues, but I wasn't able to buy many because of money constraints. In Chengdu, Yang Qian recorded a few tapes for me, all works by modern composers. You don't have any of these pieces so I'll finally have something to offer in that regard." The practice continued into the early 1990s, as can be seen from a letter Zhang Xiaogang wrote to Mao Xuhui on 4 December 1990: "I'm glad I finally received your letter. I went to the post office yesterday and got the copy of *A German Requiem* you sent. I just listened to it twice in quick succession, and now as I'm writing to you, I'm listening to it for a third time. This is exactly the kind of classical music I've been dreaming of. How shall I put it? As soon as I started playing the tape, I heard a voice in my heart: 'Only old Mao truly understands me.'"

[45] 23 May 1985, provided by Sun Guojuan.

[46] Translator's note: Shilin, or "Stone Forest", is about 90 km from Kunming and consists of a set of tall limestone formations arising vertically from the ground like trees.

[47] Translator's note: A direct translation of the original term used here is "volume" or "bulk". It featured prominently in the Chistyakov art pedagogic system, under which many Chinese painters learned their craft, and designated the sense of volume of an object that painters ought to recreate in their artworks. In the 1980s, however, the term began to depart from this predominantly geometric meaning. As well as referring to volume, heft or bulk, it also acquired connotations of materiality and texture, in contrast to the general trend toward abstraction and dreamlike phantasy perceived in the development from realism to impressionism, expressionism and cubism. This focus on materiality did not entail a return to representative realism, but rather oftentimes involved an injection of the weight and texture of the material world into nonetheless non-representative or abstract compositions. It is also important to note that the first artworks to give prominence to this quality did so in their depictions of the human form, which emphasised the mass and tactile quality of human bodies in a manner that could be sensually or sexually suggestive. As such, the concept came to acquire connotations of bulk, tactility, materiality and carnal desire in contrast to ethereality, phantasy, idealism and abstract principles. The last of these contrasts, between abstract principles and carnal desire, was particularly appealing to young artists adapting to a period of relative cultural and social liberalism after the Cultural Revolution. Bearing all this in mind, as well as the fact that the Chinese word contains the

character for "body", we have decided to translate the term as "corporeality".

[48] Translator's note: Brushwork plays a central role in Chinese calligraphy and when practised capably can channel the calligrapher's spiritual and emotional state. Modern Chinese art theorists have noted a similar tendency in Western modernist schools like expressionism, and as such the term "calligraphic" can be used to describe paintings that exhibit a certain emotional tenor through their brushwork.

[49] Translator's note: *The UNESCO Courier*, December 1980, p. 3.

[50] Translator's note: *The UNESCO Courier*, p. 18.

[51] Translator's note: Albert Einstein, *Living Philosophies* (New York: Simon & Schuster, 1931), p. 6.

[52] Nie Rongqing, *Colors of the Moat*, pp. 181–83.

[53] He writes in the letter, "I went to the film company today and asked around. The power struggle continues but perhaps not for long. I think we can still get a transfer. I don't want to leave Kunming." Mao Xuhui explained that since he did not want to leave Kunming and work in Anning, transferring his wife He Lide from Anning to Kunming was of the utmost priority. Only then could the couple finally leave their life of separation behind them. Although He Lide had left Qujing after being assigned a job in Anning, which was far closer to Kunming, it still had not solved their basic problem.

[54] The China Artists Association was founded in 1953. According to its constitution, its function is to organise artists "to create works of high ideological and artistic quality so as to inspire enthusiasm for labour and combat amongst the people". The constitution also stipulated that the association would "organise artists to study the art theories of Marxism-Leninism and socialist realism, to study the policies of the party and government, to learn from social life, and to adopt critical and self-critical methods in order to constantly reform and improve the thought of artists". The Artists Association ceased its activities when the Cultural Revolution broke out in 1966. It was only in August 1978 that the Preparatory Group of the China Artists Association was established and then, in March 1979, with the convening of the 3rd National China Artists Association Directors' Enlarged Meeting and Third General Members Assembly, that it formally resumed its functions as the Artists Association. The new constitution written on 9 November that year did not fundamentally differ from that which had preceded it. The organisation continues to exist as a propaganda organ for the party.

[55] A woodblock artist in his early years, Jiang Feng participated in Shanghai-based left-wing artists movements and Lu Xun's Creative Print Movement. After arriving in Yan'an in 1938, he became the director of the Fine Arts Department of the Lu Xun Academy of Fine Arts. In 1949 he was elected Vice-Chairman of the China National Art Workers Association, before assuming the role of Vice-Director of the Central Academy of Fine Arts in 1951, and in 1953 became Vice-Chairman of the China Artists Association. However, in 1957, he was labelled a "rightist". In 1979, he took up the post of director of the Central Academy of Fine Arts and was elected Chairman of the China Artists Association. With his return to the art world, Jiang Feng provided active and practical support to the scar art movement and the "Stars Art Exhibition".

[56] Translator's note: Franz Marc, "How Does a Horse See the World?", in *Theories of Modern Art. A Source Book by Artists and Critics*, edited by Herschel B. Chipp (Berkeley and Los Angeles: University of California Press, 1996), p. 178.

[57] Mao Xuhui's blue notebook labelled "October Eighty-Three *Mao*". (Translator's note: The word "Mao" appears in the original in English.)

[58] In *Colors of the Moat* (p. 190), Nie Rongqing provides his insight into the psychological blow dealt to these young artists when their works were not selected for

the national exhibition: "None of the works submitted by the artists from China's Southwest, including Zhang Xiaogang, Mao Xuhui and Ye Yongqing, were accepted by the '6th National Fine Arts Exhibition' held in 1984. Several influential artists from all over the country were also overlooked. It was an important moment for that generation of young artists who realised that they no longer had the luxury of relying upon the 'National Fine Arts Exhibition' as a means of showcasing their art and changing their destiny. Mao Xuhui still believes this was all a result of fate, that if their works had all been accepted, the revolutionary '85 Art Movement might not have taken place. Artists were getting tired of competing with countless others for limited opportunities, which was the main reason they began to put on their own exhibitions. Many new ideas were beginning to take shape in Kunming, ideas that would eventually lead to the 'New Figurative' Exhibition organised by Mao Xuhui. Zhang Xiaogang and Pan Dehai."

[59] Mao Xuhui's decoratively patterned notebook. Most of the entries date from February to May 1984, but this poem was written sometime later, around the late summer of 1984. Many of the poems and texts that precede it relate to love and emotional life.

[60] In *Colors of the Moat* (pp. 179–81), Nie Rongqing describes Mao Xuhui's mental state at this time: "On the one hand, there was the complex emotional entanglement of family life, and on the other there was the spiritual nourishment of his extramarital affair that felt like a cleansing spring breeze. He entered a state of conflict characterised by both an inability to give up on his romantic relationship and intense philosophical speculation. It was at this time that Mao Xuhui's daughter He Jing (Maotou) was born. At first, he was resolutely opposed to the mundane life that awaited him, but when little Maotou was born, he was struck by the joy this little life brought. For many years, whenever I saw him and Maotou together, he was always the picture of tender fatherly love. In 1984, the Party Secretary at the Kunming Film Company was He Jiajia, a man with a great respect for true talent who used his connections to transfer Mao Xuhui from the general merchandise store to the film company to work. Having spent the previous year oscillating between drunken exuberance and sober introspection, Mao Xuhui spent 1984 producing some of the most important works of his artistic career."

Chapter 2

THE TUMULT OF YOUTH

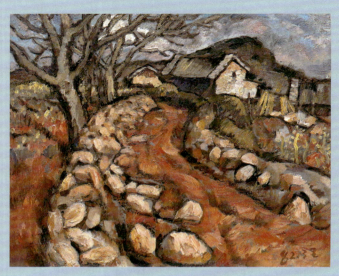

Mao Xuhui
Drawing of Guishan (*Guishan xiesheng*), 1982
Oil on paper, 43 × 53 cm

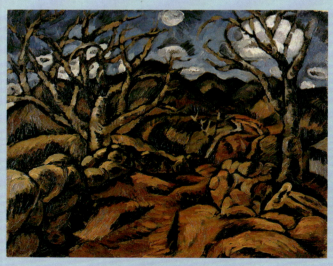

Mao Xuhui
Drawing of Guishan (*Guishan xiesheng*), 1982
Oil on panel, 43 × 55 cm

Chapter 2

The Tumult of Youth

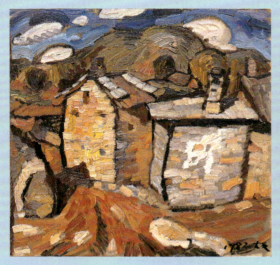

Mao Xuhui
Drawing of Guishan (*Guishan xiesheng*), 1982
Oil on paper, 44 × 45.5 cm

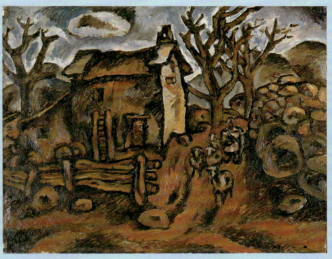

Mao Xuhui
Drawing of Guishan, Village Gate (*Guishan xiesheng, cunkou*), 1982
Oil on paper applied to panel, 40 × 50 cm

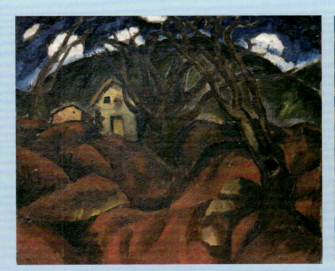

Mao Xuhui
Drawing of Guishan (*Guishan xiesheng*), 1982
Oil on paper applied to panel, 43 × 48 cm

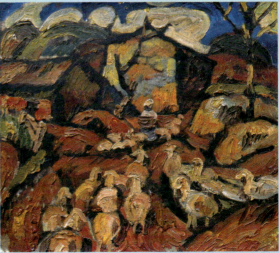

Mao Xuhui
Drawing of Guishan (*Guishan xiesheng*), 1982
Oil on paper applied to panel, 44 × 50 cm

Chapter 2

The Tumult of Youth

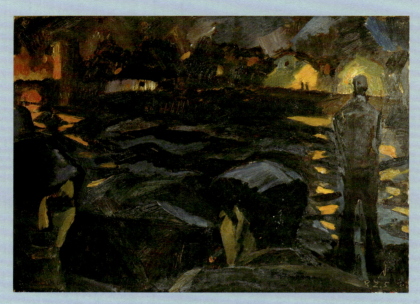

Mao Xuhui
By the Moat at Night (Yewan de huchenghe bian), May 1982
Oil on paper, 39.5 × 55 cm

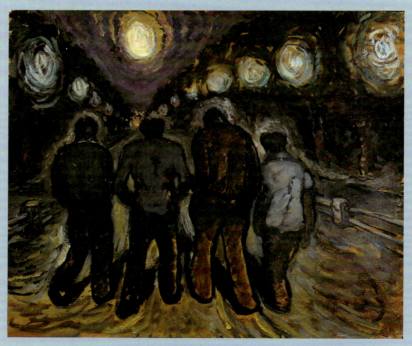

Mao Xuhui
Walking on Dongfengdong Road at Night (Zou zai yewan de dongfeng donglu), 1982
Oil on paper, 47 × 54 cm

Chapter 2

The Tumult of Youth

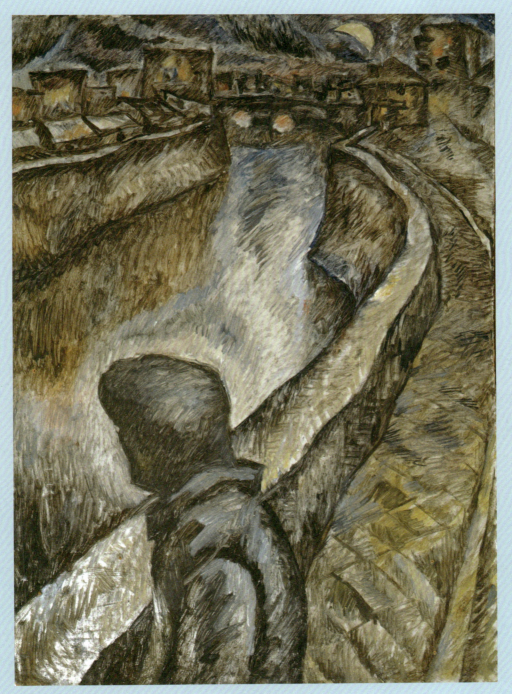

Mao Xuhui
Moat at Night (Yewan de huchenghe), 1982
Oil on board, 60 × 42 cm

Chapter 2

The Tumult of Youth

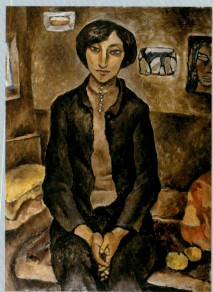
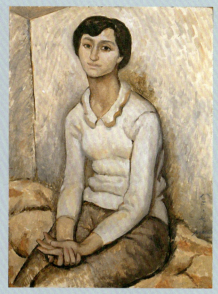
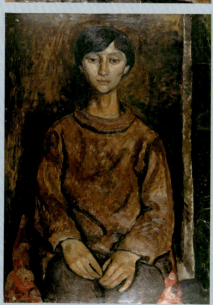
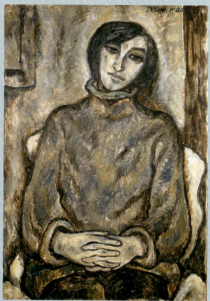

Mao Xuhui
Portrait of Girl in Black Cardigan (*Chuan hei maoyi de nüzi xiaoxiang*), 1982
Oil on cardboard, 78 × 55 cm

Mao Xuhui
Portrait of Girl in Red (*Zhuo hongyi de nüzi xiaoxiang*), 1982
Oil on canvas, 88 × 61 cm

Mao Xuhui
Portrait of Girl Wearing White (*Chuan baiyi de nüzi xiaoxiang*), July 1982
Oil on fibreboard, 72 × 50 cm

Mao Xuhui
Portrait of Girl in Turtleneck (*Chuan gaoling maoyi de nüzi xiaoxiang*), October 1982
Oil on paper applied to fibreboard, 54.5 × 39.5 cm

Chapter 2

THE TUMULT OF YOUTH

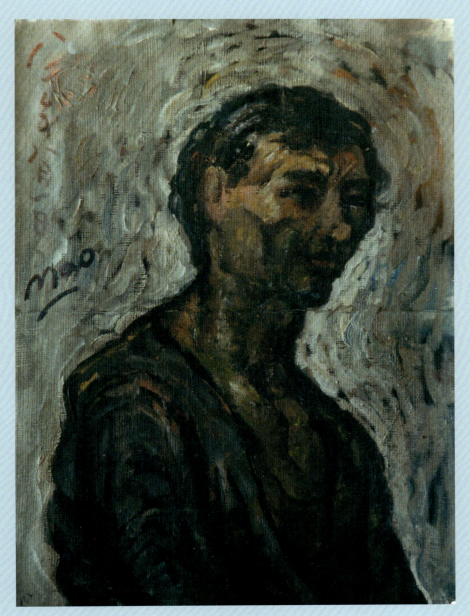

Mao Xuhui
Self-Portrait (*Zihuaxiang*), 1 August 1982
Oil on canvas, 54.5 × 39.5 cm

163

Chapter 2

The Tumult of Youth

Mao Xuhui
Half Moon (*Ban ge yueliang*), 1982
Gouache on paper, 29 × 19 cm

Mao Xuhui
Moat Beneath Moonlight (*Yueguang xia de huchenghe*), 1982
Gouache on paper, 29 × 19 cm

Sketch drawn by Mao Xuhui with Desheng Bridge along the Panlong River in Kunming, 1982

Sketch drawn by Mao Xuhui with the landscape along the Panlong River in Kunming, November 1982

Sketch drawn by Mao Xuhui with the landscape along the Panlong River near Desheng Bridge in Kunming, 15 November 1982

Chapter 2

The Tumult of Youth

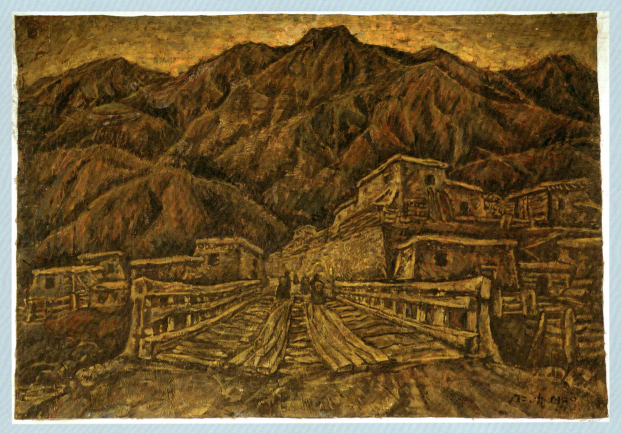

Mao Xuhui
Shangri-La Wood Bridge (*Zhongdian muqiao*), 1982
Oil on canvas, 78 × 108 cm

Chapter 2

The Tumult of Youth

Mao Xuhui
A Corporeal (Yi ge tiji), 1984
Oil on canvas, dimensions unkown

Chapter 2

The Tumult of Youth

Mao Xuhui
Ever-Expanding Corporeal (*Hai zai pengzhang de tiji*), 1984
Oil on cardboard, 77 × 103 cm

Mao Xuhui
Four Corporeals (*Si ge tiji*), 1984
Oil on paper, 76.5 × 105 cm

Chapter 2

The Tumult of Youth

Mao Xuhui
Two Corporeals at Night (Yewan zhong de liang ge tiji), 1984
Oil on paper applied to fibreboard, 79 × 105 cm

Mao Xuhui
Corporeal in Motion (Yundong zhong de tiji), 1984
Oil on paper applied to fibreboard, 79 × 105 cm

Chapter 2

The Tumult of Youth

Mao Xuhui
Red Corporeal (*Hongse tiji*), 1984
Oil on paper applied to fibreboard, 79 × 105 cm

Chapter 2

The Tumult of Youth

Mao Xuhui
Desheng Bridge (Desheng qiao), 1982
Gouache on paper, 26 × 35 cm

Mao Xuhui
Dongjiawan Street Lamps (Dongjiawan de ludeng), 1982
Oil on paper, 34 × 44 cm

Mao Xuhui
Dongjiawan Twilight No. 1 (Dongjiawan de huanghun zhi yi), 1982
Oil on paper, 31 × 43 cm

Mao Xuhui
Dongjiawan Twilight after Rain (Dongjiawan zhi yu hou de huanghun), 1982
Oil on paper, 44 × 31 cm

170

Chapter 2

The Tumult of Youth

Mao Xuhui
Xunjin Street Crossing (*Xunjin jiekou*), 1982
Oil on paper, 39 × 39 cm

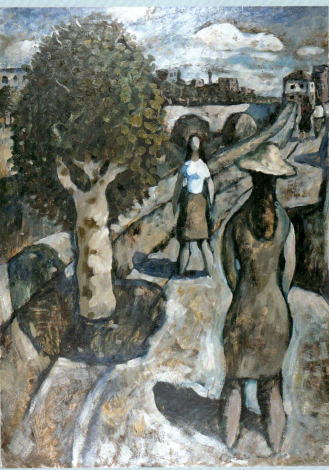

Mao Xuhui
Xunjin Street in Summer (*Xiari de xunjin jie*), 1983
Oil on paper, 78 × 54 cm

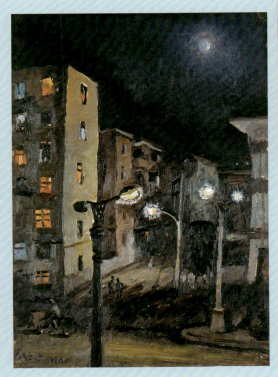

Mao Xuhui
Dongjiawan at Night (*Yewan de dongjiawan*),
June 1982
Oil on paper, 54 × 39 cm

Chapter 2

The Tumult of Youth

Mao Xuhui
Office Window (*Bangongshi de chuangkou*), 1982
Watercolour on paper, 57 × 40 cm

Mao Xuhui
Portrait of Xia Wei (*Xia Wei xiaoxiang*), 1982
Fountain pen on paper, 27.5 × 19.5 cm
Drawn at the office of the Jinbi Street general merchandise store

Chapter 2

The Tumult of Youth

Mao Xuhui
Female Body Sketch (*Nü renti xiesheng*), 1981
Oil on canvas, 60 × 85 cm

Chapter 2

The Tumult of Youth

Mao Xuhui
Rhapsody No. 1 (Kuangxiang zhi yi), 1982
Pencil on paper, 18.5 × 36.5 cm

Mao Xuhui
Portrait of a Sitting Woman (Zuozhe de nüzi xiaoxiang), 1982
Charcoal pencil on paper, 26.5 × 19 cm

Mao Xuhui
Picasso's Mistress (Bijiasuo de qingfu), 1983
Charcoal pencil on paper, 39.5 × 14 cm

Chapter 2

The Tumult of Youth

Mao Xuhui
Cubist Figure (*Litizhuyi de renwu*), 1982
Fountain pen on paper, 27 × 38.5 cm

Mao Xuhui
Cubist Portrait (*Litizhuyi de xiaoxiang*), 1982
Charcoal pencil on paper, 39.5 × 27.5 cm

Mao Xuhui
Human (*Ren*), 1982
Fountain pen on paper, 20 × 23 cm

Chapter 2

The Tumult of Youth

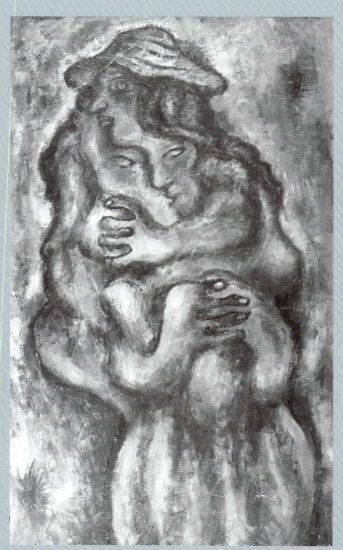

Mao Xuhui
Love No. 2 (Ai zhi er), 1983
Oil on paper, 96 × 55 cm

Mao Xuhui
Love (Ai), 1983
Charcoal pencil on paper, 27.5 × 20 cm

Chapter 2

The Tumult of Youth

Drafts of *Venus* (*Weinasi*) and *Adam and Eve in the Garden of Eden* (*Yadang he xiawa zai yidianyuan li*), in the red-covered sketchbook dated February to November 1982

Exercises of voluptuous female forms in the red-covered sketchbook dated February to November 1982. A study of Edgar Degas' work

Chapter 2

The Tumult of Youth

Draft of *Perishing Love, Memory* (*Xiaoshi de ai, jiyi*), in the red-covered sketchbook dated February to November 1982

Draft of *Congealed Love* (*Bei ninggu de ai*), in the red-covered sketchbook dated February to November 1982

Mao Xuhui
Boundless Love (*Wujin de ai*), 1982
Fountain pen on paper, 20 × 27 cm

Chapter 2

The Tumult of Youth

Mao Xuhui
The Corporeality of Love (*Ai de tiji*), 1982
Charcoal pencil on paper, 10 × 29.5 cm

Mao Xuhui
Night (*Ye*), 1982
Fountain pen on paper, 20 × 27.5 cm

Chapter 2

The Tumult of Youth

Mao Xuhui
Sea (*Dahai*), 1982
Calligraphy brush and ink on paper, 16 × 52.5 cm

Mao Xuhui
Earth (*Dadi*), 1982
Calligraphy brush and ink on paper, 16 × 53 cm

Chapter 2

The Tumult of Youth

Mao Xuhui
The Rising and the Disintegrating
(*Zheng zai shengteng
he wajie de*), 1983
Pencil and fountain pen on paper,
19.5 × 9 cm

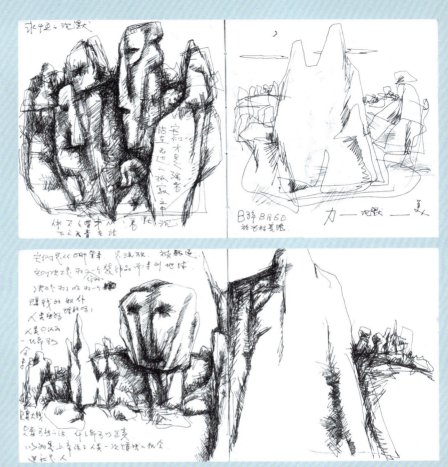

In August 1983, Mao Xuhui sketched and made notes
on the landscapes of Shilin

Chapter 2

The Tumult of Youth

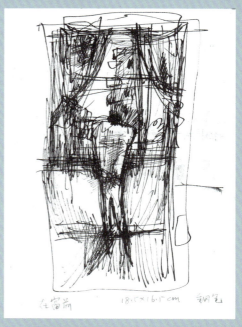

Mao Xuhui
Man by the Window and Man under the Sun (*Chuang qian de nanren he taiyang xia de nanren*), 1982
Ink wash on paper, 24 × 39.5 cm

Mao Xuhui
The Reader and the Observer by the Window (*Kan shu de ren he kan chuang wai de ren*), 1982
Fountain pen on paper, 24 × 39.5 cm

Mao Xuhui
By the Window (*Zai chuang qian*), 1982
Fountain pen on paper, 18.5×16.5 cm

182

Chapter 2

The Tumult of Youth

Mao Xuhui
Self-Portrait by the Window of Dongjiawan Dormitory
(*Zai dongjiawan sushe de chuang qian de zihuaxiang*), 1982
Fountain pen on paper, 18.5 × 16.5 cm

Mao Xuhui
Reading (*Dushu*), 1982
Charcoal pencil on paper, 54 × 38.5 cm
Now at Jinbi Store

Mao Xuhui
Kunming Street View (*Kunming jietou jijiang*) (top); *The Intersection of Desheng Bridge and Xunjin Street Crossing* (*Deshengqiao xunjin jiekou*) (lower right), 1982
Fountain pen on paper, 27.5 × 39 cm

Mao Xuhui
Woman Cycling on Dongfeng Road (*Dongfenglu shang qiche de nüzi*) (left); *My Office at Jinbi General Merchandise Store* (*Jinbi baihuo shangdian wo de bangongshi*) (right), 1982
Charcoal pencil on paper, 21 × 27.5 cm

Chapter 2

The Tumult of Youth

Mao Xuhui
Desheng Bridge (Desheng qiao), 1982
Fountain pen on paper, 18.5 × 16.5 cm

Mao Xuhui
Jinbi Road at Night (Yewan de jinbi lu), 1982
Fountain pen on paper, 18.5 × 16.5 cm

Mao Xuhui
Dongjiawan Street Lamps at Night (Dongjiawan yewan de ludeng), 1982
Fountain pen on paper, 18.5 × 16.5 cm

Chapter 2

The Tumult of Youth

Mao Xuhui
East Dongfeng Road at Night (Yewan de dongfengdong lu), 1982
Ink wash on paper, 27 × 29.5 cm

Mao Xuhui
Nighttime Street Lamps Outside the Window (Chuang wai yewan de ludeng), 1982
Calligraphy brush and ink on paper, 23.5 × 39.5 cm

Chapter 2

The Tumult of Youth

Mao Xuhui
By the Window: Twilight (Zai chuang qian: huanghun), 1982
Fountain pen on paper, 18.5 × 16.5 cm

Chapter 2

The Tumult of Youth

Mao Xuhui
Women by the Window and Nighttime Street Lamps (*Chuang qian nüzi he yewan de ludeng*), 1982
Charcoal pencil on paper, 28 × 39 cm

Mao Xuhui
Man under Street Lamps (*Ludeng xia de ren*), 1982
Charcoal pencil on paper, 28.5 × 39 cm

Chapter 2

The Tumult of Youth

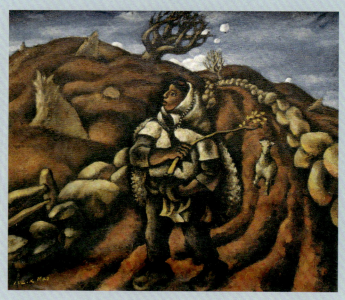

Mao Xuhui
Guishan Collection: Red Earth Road (Guishan zuhua: hongtu lu), July 1984
Oil on canvas, 80 × 90 cm

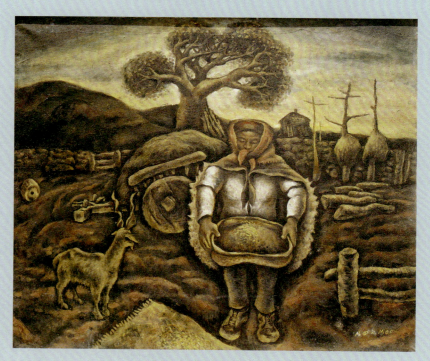

Mao Xuhui
Guishan Collection: Mountain Village at Dusk (Guishan zuhua: shancun huanghun), July 1984
Oil on canvas, 90 × 110 cm

Chapter 2

The Tumult of Youth

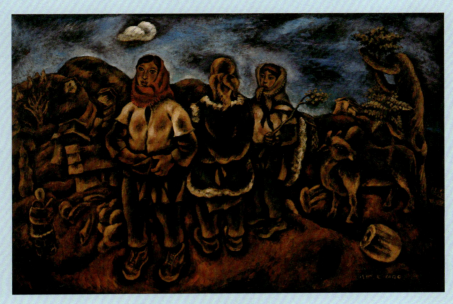

Mao Xuhui
Guishan Woman (Guishan funü), July 1984
Oil on canvas, 85.5 × 128.5 cm

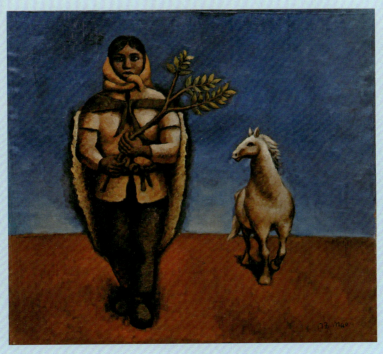

Mao Xuhui
Guishan Collection: Woman and Horse (Guishan zuhua: nüren he ma), 1985
Oil on canvas, 86 × 90.5 cm

Chapter 2

The Tumult of Youth

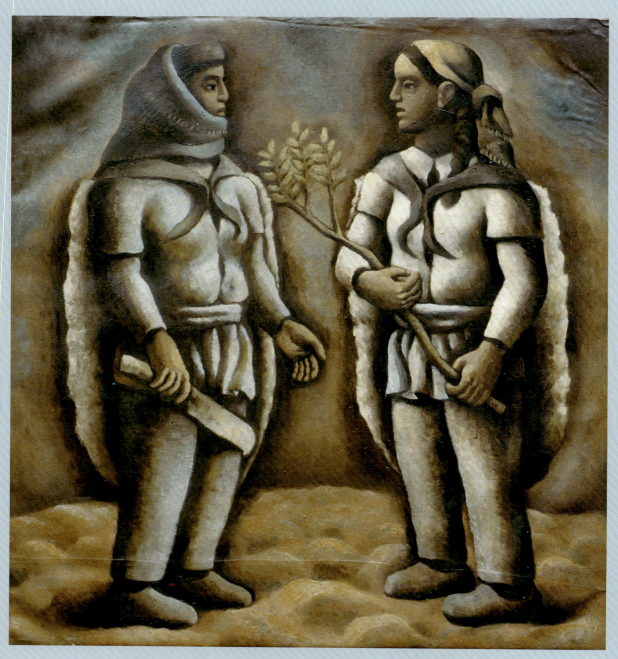

Mao Xuhui
Guishan Collection: Encounter on Red Earth (Guishan zuhua: hongtu shang de xiangyu), 1985
Oil on canvas, 100 × 80 cm

Chapter 2

The Tumult of Youth

Mao Xuhui
Guishan Collection: Remote (*Guishan zuhua: yaoyuan*), 1985
Oil on canvas, 110 × 87.5 cm

Mao Xuhui
Mother Red Earth: Calling No. 2 (*Hongtu zhi mu: zhaohuan zhi er*), 1986
Oil on paper, 78 × 108 cm

Chapter 3

THE NEW FIGURATIVE AND MODERNISM

This is how the world ends
Not with a bang but with a whimper.

T. S. Eliot[1]

Narcissus and Goldmund by Hermann Hesse, translated by Yang Wuneng, published by Shanghai Translation Publishing House, August 1984, 1st edition, 1st printing

Page 192
Mao Xuhui
David and Venus
(*Dawei yu weinasi*), 1986
Collage and watercolour on paper, 27.5 × 19 cm

The character Narcissus, who represents a spirit of purity, reverence for reason and dedication to the religious cause, is placed by his author Hermann Hesse in a fictional medieval monastery, which is also the site to which his counterpart Goldmund, the passionate explorer, eventually returns to contribute what remains of his life to religion. Goldmund and Narcissus represent different parts of human nature, two of the most important tendencies one can find in a person. These seemingly distinct aspects of the human spirit are visible in both classical and modernist art; they form the inner need and desire for completeness that defines what it means to be human. However, life does not bestow perfection upon everybody. To those who yearn above all for freedom and complete liberation, like Mao Xuhui and his friends, the figure of Goldmund was naturally the more appealing of the two. The ability to speak freely and a natural curiosity about the unknown had freed these young Chinese artists from the confines of their former world, and they sought further liberation through travel and exploration. In October 1984, Mao Xuhui bought a copy of Hesse's *Narcissus and Goldmund*, a novel that had a twofold impact on Mao Xuhui—affecting both his life and his art.[2]

Of course, Mao Xuhui's new understanding of life did not begin with *Narcissus and Goldmund*, but the novel clearly reinforced and reaffirmed the insights he had gained about life from reading other Western texts. An individual's experiences were in themselves meaningless, but if one saw them in the light of universal ideals, one could connect the insignificance of the individual to the qualities of greatness. This was what Hesse wanted to say through the fates of the characters in his story. Goldmund's hopes and desires were already clear to him when he first entered the monastery. He already held the abbot, and especially his

A GOLDMUNDESQUE JOURNEY

assistant Narcissus, in loving esteem and awe. Since the essence and meaning of Narcissus' life was to serve the spirit, he was responsible for guiding the students towards sublime spiritual goals. Goldmund, on the other hand, was a young man full of vim and vigour for whom "going to the village"—to court village girls—was a huge temptation and an irresistible part of human life, even if it violated the rules of the monastery and was punished severely. The act of slipping out of the monastery at night with his classmates was almost instinctual to Goldmund whose contradictory psychological state in these moments Mao Xuhui understood only too well.[3] He saw in the novel a depiction of his own inner problems. Perhaps he believed that he was destined to walk Goldmund's path of passion and love, the path that followed love's lure into the dead of night. He too had to leave the monastery and experience the secular pleasures and pains of life on the road before he decided whether to return. Stories like this provided a reference point for his mode of life. He and his friends, in the prime of youth, lived and acted in a Goldmundesque manner. The question now was how art, his own art, could achieve transcendence.

The sunlight against the church's ceiling drew Goldmund's eyes to the affectionate, evocative and compassionate wooden statue of the Virgin Mary, an image that struck him in all its perfection. Through the priest's introduction, he went on to work as an apprentice to Master Niklaus, the man who carved it. The study of art, the young man thought, might inject a little of the sublime and valuable into his life of dissipation. But when Goldmund observed the head and working hands of Master Niklaus, he was surprised to discover, as he pondered artistic creation, an image of his friend Narcissus take shape—"this image was without flaw or contradiction, although it too bore many lines and recalled many struggles"[4]—a vision of which he now felt compelled to create a lifelike representation. The function of art alluded to here was clear to Mao Xuhui: artists ought to endow their personal experience with a sense of the sublime, the eternal even, a line of thought that connects love, the transience of life, death and all such questions that incessantly emerge from the heart. Mao Xuhui understood how Goldmund truly saw the world, which is why he underlined these lines describing the latter's revelation:

He thought that fear of death was perhaps the root of all art, perhaps also of all things of the mind. We fear death, we shudder at life's instability, we grieve to see the flowers wilt again and again, and the leaves fall, and in our hearts we know that we, too, are transitory and will soon disappear. When artists create pictures and thinkers search for laws and formulate thoughts, it is in order to salvage something from the great dance of death, to make something that lasts longer than we do.[5]

This meant that for the sake of art, for the sake of something that lasts longer, he had to abandon that which was second only to love in importance, namely, freedom. This was a kind of inner torment, a spiritual state of suffering, a form of agonising self-restraint that was necessary to attain the sublime. Hesse had told him that art was the union of spirit and flesh that led humans from tangible objects to the most arcane of abstractions. Of course, art could also return from the realm of pure thought to the physical world of flesh and bone. Art brought the soul and body

together as one. It was a knowledge of life itself, a rationalisation of basic instinct, the most essential science of what it meant to be alive. It was this understanding of art as directly related to life that aside from informing Mao Xuhui's ardent and longstanding interrogation of the meaning and function of art, inspired all aspects of his artistic practice. Throughout his career he would always see his art and life as inextricably linked, a unified whole. This mode of thinking and state of mind meant that the evolution of Mao Xuhui's art was always bound to tend toward the vocabulary of expressionism and its emphasis on the calligraphic and contingent.

The trials depicted in literary texts are not as concrete and distressing as those experienced in real life. Towards the end of May 1984, while he was working on his submission for the 6th National Fine Arts Exhibition, Mao Xuhui travelled to Chengdu and then Chongqing to attend a country-wide film poster exhibition. Nothing about the journey captured the imagination of this young Kunming artist born in Chongqing. Unlike his trip to the city in 1982, when he visited the Sichuan Fine Arts Institute and attended various exhibitions, this time he found the whole ordeal utterly dull. He realised that he was no longer a dynamic and positive subject freely observing a new place but had rather become an impotent and insignificant being disappearing into the depths of an urban labyrinth. He made a couple of sketches at Chaotianmen and drew a lost and solitary figure staring out over the Mountain City.[6] In one picture, he looks through the window at the drizzle and architecture, likely in a state of ennui, because next to it is written, "Apart from one's own simple existence, what is there? Only the soul is free; the body is but a sacrifice." The tone of such remarks might be the result of the books he read rubbing off on him however, because even in this despondent mood, flickers of poetry emerge:

It's raining again
I think of the rain in Beijing, on Chang'an Avenue, the rain of Xi'an,
under the ancient bell tower—I met similar rain in Luoyang. The rain in Chengdu is
transparent, whereas the rain in the mountain city is as heavy as lead
What remains is the rain in the spring city
Music played by the hands of Chopin
It's raining again
. . .
A cluster of dreams opens up like an umbrella

As before, Mao Xuhui made a record of his mood and thoughts about art and life while travelling, writing of his concerns and unending dreams. His visit to Chongqing in June was short and far from extraordinary. In comparison to what Goldmund had experienced in Hesse's novel, there was no drama to speak of. Like Goldmund, Mao Xuhui had noted the girls he saw on his journey, but once the city of Chongqing had become tedious to him, even its female inhabitants seemed to lose their charm. In a letter to Zhang Xiaogang he complained about his trip to Chongqing:

I didn't plan on writing a letter at first. Travelling around has been so
exhausting, and there isn't much worth talking about. Every day I want to come back.

There's not a single place for me here in Chongqing. For some reason, this time in Chongqing, I'm repulsed by the city, including the chicks here, no feelings, no appeal. Under the scorching heat, I could only eat liquid or semi-liquid food daily. Thinking about it, the five days in Chengdu were such great days. Being with Yang Qian was so pleasant and freeing. We talked about art, music and chicks. Beer and rabbit meat came together, and we spent an entire night in a drunken stupor at the Hua Xi restaurant (an underground restaurant). Chengdu chicks are crystal clear and elegant, with skin so unbelievably white. I feel too out of place by comparison. In Chongqing, they even call me "African fish". There's no way around it; when it comes to skin, we feel inferior.[7]

In the Sichuan Fine Arts Institute, Mao Xuhui chatted with Ye Yongqing over a drink. He had met Ye Yongqing long ago while learning from the plein-air school,[8] but this time the artists seemed to speak at cross purposes. Perhaps their personalities and interests were too different, but later Mao Xuhui wrote in a letter, "I don't think there's anything to talk about with him." He knew that Zhang Xiaogang was trying hard to get a transfer to the Sichuan Fine Arts Institute to work as a teacher, and so he offered his opinion on the subject. He told him he didn't think the institution was a good fit, even claiming he would find it "suffocating to stay here one more minute". As far as Mao Xuhui could see, the Sichuan Fine Arts Institute was not the vibrant place it had been from 1979 to 1981; it had become a lonely environment lacking anyone who could really understand his artistic pursuits: "Sure, I understand why you wanted to go back. It's precisely because I understand that I feel people like us are very unfortunate. I feel sad for us. I can't see much of a future there. Maybe they offer the best conditions: the studios, catalogues, exhibition halls, celebrities, travel opportunities . . . But behind all this glamour is the emptiness of the soul, the emptiness of humanity and the emptiness of emotions. One will only fall even faster there."[9]

In 1984, China was yet to offer young artists any opportunities aside from the shared aspiration that their artwork might achieve success in the exhibitions organised by different levels of the Artists Association. However, the ideological ambience and outdated aesthetics that pervaded the official art organisations, as well as the messages one received from all corners of society, implied there was little hope for success. Mao Xuhui's mood as he awaited news about whether his artwork would at least be exhibited, let alone receive an award, was mostly characterised by anxiety and unease. Of the works he had created, he saw in the "Corporeal" series the work most in line with his psychological state, but he and his companions strategically sought to repress their wayward inclinations in order to produce warm, pure and poetic paintings that conformed to the "native" tendency preferred by exhibition organisers. Examples include the works Zhang Xiaogang hoped to submit, having not long recovered from a serious illness, titled *Evening Wind* (*Wan feng*) and *Mountain Daughter* (*Shan de nüer*), as well as Ye Yongqing's *Sani Sisters of the Shepherd Village* (*Muyang cun de sani jiemei*). The pastoral quality on display in these paintings was part of the artists' strategy to appeal to the tastes of the judging panel, a desperate attempt to produce the kind of tender, poetic works that tended to feature in these exhibitions. These circumstances induced

in Mao Xuhui a profound anxiety and while in Chongqing he felt particularly on edge. The most pressing concern was the fact he had to wait before returning to Kunming and completing the painting he hoped to submit, but more generally he was in a mood of anxious anticipation about what fate awaited him. It was hard for him to maintain a sanguine disposition as he considered the artistic struggles and dreams he and his companions shared. Those evening gatherings with friends or his walks by Kunming's "Seine" imagining what his future might bring were occasions characterised more by happiness and joy. But now, telling his friends how he felt, he seemed melancholy and frightened:

I arrived in Chongqing on my birthday. At dusk, I strolled along Linjiang Road alone, and the maroon Yangtze River was humming with muffled steam whistles. The mountain city began to reveal its character: thousands of lights twinkling in every corner. Yet I felt that it was hell, and products from the early industrial revolution grotesquely swelled here: piles of houses, people and lights. . . My sense of self was greatly threatened, and every alley, every stairway and every building seemed our enemy. Such forms of construction were deeply unsettling. This is a city on the brink of destruction. Only nature is eternal: fields, the red earth, hills, and white sheep. . . It's been twenty-eight years. I think of all kinds of things in the past, and the people, and a melancholy haunts me. I think of those grand ambitions, and as a person who has lived for twenty-eight years, I am indeed ridden with anxiety. I think of love, of eternal tranquillity, of my nature, of the Seine River, of those who have gone before us, and of my wife and daughter. [10]

Sure enough, in the end, the works produced by Mao Xuhui and his friends did not make it into the 6th National Fine Arts Exhibition, which only inspired more disappointment and a desire to set out on a journey and roam free. This is why the novel *Narcissus and Goldmund* resonated with Mao Xuhui, filled him with such excitement, and why he repeatedly wrote poems about love in his diaries and elsewhere.

Mao Xuhui was still contemplating these questions in April 1985 when he wrote down his ideas about solitude on the last page of his copy of *One Hundred Years of Solitude*. His understanding of solitude might have differed from what was described in the philosophical and literary texts he read, but he and his friends had at least been familiar with the concept for some time. *One Hundred Years of Solitude* further cemented the word "solitude" in the minds of these young people born in the 1950s. Mao Xuhui recognised the individual reality of solitude, the fact that no one could share his concerns about art and life, so when he read the novel by Gabriel García Márquez and discovered once more something that resonated with his experience of life, something that affirmed the objective reality and intellectual legitimacy of solitude, especially at a time when he was struggling to find others around him whose views about art and life aligned with his own, it was as if this great work of literature had graced his existence with a kind of understanding and care he found it difficult to come by in his everyday life. As such, he was only too keen to record his views on the last page of this novel.

This lonely fate might be a profound awakening for humanity. Who can say this destiny ended with the demise of the Buendía family? Not only does it have a second chance here on earth, but it might even be our reality today, our fate today, our confusion and unease, astonishment and pain. In an atmosphere of indifference that lacks understanding, empathy, comprehension and trust, one cannot find a better or more apropos fate than solitude.

Nothing miraculous took place in Mao Xuhui's life. The everyday affairs of his circle continued to revolve around reading, painting, drinking and listening to music. But existence is concrete, dependent upon the physical. It makes higher demands of life, craves recognition from society for the products of its labour, but Mao Xuhui in 1984 was merely an art worker in a film company.[11] His friend Zhang Xiaogang had travelled to Shenzhen in an attempt to get involved in the new wave of capitalist construction taking place in this rural town in Guangdong but, unable to adapt to the rules of this new game, didn't stay long before returning to Kunming. Mao Xuhui comforted his friend and they discussed the possibility of starting their own renovation company in Kunming, but this too ended in failure. Mao Xuhui bought *One Hundred Years of Solitude* in 1985, and the words he wrote on the last page were simply a record of his situation and mental state. He was not resigned to his lot, but nor did he have any faith in the necessity of future success. He merely lay in wait for a vague possibility:

The revelation of this vicious cycle of lonely fate offers a glimmer of possibility for humanity to escape it. But let us not forget, it is only a possibility.

By 1985, the short-lived "eliminate spiritual pollution" campaign had come to an end,[12] but even at the beginning of 1984, when the movement was still in full swing, Deng Xiaoping did not stop advancing economic reforms. Having observed what was happening in the special economic zones of Shenzhen and Zhuhai, he told the nation on 24 January, "The development and experience of Shenzhen proves that our policy of establishing special economic zones was correct." This endorsement of market economics led to the decision by the CPC Secretariat and State Council in March to loosen economic restrictions on fourteen cities up and down the coast of China, which expanded their economic autonomy in the hopes of attracting foreign investment. Previously, such measures would have been opposed and criticised for promoting non-socialist economic forms. In June, Deng Xiaoping reassured Hong Kong's business community that after 1997, when sovereignty over the territory would be transferred from Britain to China, Hong Kong's relationship with the mainland would be one of "one country, two systems", which implied that a capitalist system was going to be incorporated into a socialist country. After the huge National Day parade on 1 October, Deng Xiaoping announced: "The main task now is to systematically reform those aspects of the economic system that impede our progress."[13] In January 1985, wages in state-run enterprises were pegged to efficacy, dealing a blow to the socialist principle of "to each according to his needs". In June, the People's Liberation Army retired a million soldiers, the government withdrew from people's communes throughout the countryside, and township and village governments were established. These measures had a direct influence on how people lived, worked and thought. As a result of his economic reforms, Deng Xiaoping featured on the

THE FIRST NEW FIGURATIVE EXHIBITION

front cover of *Time* magazine in January 1986. This was the historical context that allowed young people like Mao Xuhui and Zhang Xiaogang, dissatisfied with their work and until now deprived of the economic means to transform their situation, to join or even establish their own private companies.

The energy and vitality within artistic and cultural circles manifested in various ways. The 1984 CCTV[14] broadcast of the Hong Kong serial *Huo Yuanjia* marked the beginning of a rapid influx of television shows, music and popular culture from Hong Kong. In January 1985, Hu Qili attended the Fourth General Meeting of the Writers Association of China on behalf of the CPC Central Committee and said: "Creative work must be free" and "We should be resolute in guaranteeing this freedom for writers". This new political and cultural climate was being transmitted to every city in China through official media, both written and broadcast.

Ever since December 1978, liberalism had started to spread throughout the country. In 1980, Central Academy of Fine Arts graduate Yao Zhonghua, at the suggestion of some friends, founded the Shen Society, Kunming's first free art group. The "First Shen Society Painting Exhibition" (*Shenshe shoujie huazhan*) was held that summer in the Yunnan Provincial Museum.[15] The exhibition's manifesto read:

The Shen Society was born with the arrival of the 1980s, in the Geng-Shen Year of the lunar calendar—the Year of the Monkey. The gold monkey is the embodiment of sincerity, the pursuit of truth, loyalty, wisdom, courage, dynamism, the ideals of the people, and as such we choose to adopt it as the symbol of the Shen Society. Only with the spirit and qualities of the gold monkey can our generation, on the tortuous path that lies ahead, live up to the great responsibility history has conferred upon us. We are well aware that without breakthroughs in theory, there will be no creative innovations in practice. Everything is meaningless posturing if it is without a bold commitment to exploration and action that is fearless of the consequences. The essence of art is creation. Without creation, art is death. The measure of style is the personal; the soul, endlessly honed and probed, is the root of painting. It is for this that we must study, think, learn from one another, and create.

Although the works in this exhibition still had a serene, decorative quality, there was clearly a desire shared by those involved for free expression. These were views that could only be expressed so openly because of the relatively relaxed political atmosphere at the time. Yao Zhonghua was someone young art students like Mao Xuhui had wanted to emulate during the early years of their studies, but when they saw in this exhibition the intense colours on *hanji* or *gaolizhi* [16] paper paintings of Yao Zhonghua, Jiang Tiefeng, He Neng, Pei Wenkun and Liu Shaohui, they quickly lost interest.[17]

However, the Shen Society, as the earliest art group of its kind in Kunming since 1949, set an example to radical artists in the city. The artworks it exhibited and the intrepid spirit of its members would influence the next generation of young artists. Michael Sullivan, a scholar familiar with Chinese art, wrote the following in his book *Art and Artists of Twentieth-Century China*:

Another group founded in 1980 that also had a short life was the *Monkey Year Society* (*Shen she*), so named because 1980 was the year of the monkey. It was formed in remote Kunming by artists whose work often featured the minority people of the Southwest. In the following year ten artists from the Southwest, prominent among them Liu Ziming and Yao Zhonghua, earned national recognition by being granted a show at the China Art Gallery, although the Artists Association, presumably reluctant to acknowledge their independent origin, did not mention the name Shen She. Several of these Yunnanese painters, among them Jiang Tiefeng and Ding Shaoguang, followed Huang Yongyu in painting thickly on both sides of tough Korean paper (*gaolizhi*), which gave their color added depth and brilliance. These "Modern Heavy Color Painters", as they called themselves, were inspired not only by contemporary Western art but also by the tradition of Chinese decorative art, by the Dunhuang wall paintings, and by the batik designs and rich embroideries and jewelry of the southwestern minorities.[18]

China's institutional structure means that political and cultural information spreads unevenly throughout the country, and Kunming's location meant that in the period immediately after 1978 it would receive a smaller share of opportunities than cities that were richer in political and cultural resources. In the world of art, following the artistic activity of such groups as the Nameless Painting Society (*wuming huahui*, Beijing), Grass Painting Society (*caocao huahui*, Shanghai) and New Spring Painting Society (*xinchun huahui*, Beijing), as well as events like "Shanghai Twelve Painting Exhibition" (*shanghai shi'erren huazhan*, Shanghai) and "Stars Art Exhibition" (Beijing), modernism was soon to appear in the work of a wide array of artists and the groups they organised. In 1983, art that featured in Xiamen's "Five People Modern Art Exhibition" (*Wu ren xiandai yishu zuopin zhan*) and Shanghai's "'83 Experimental Painting Exhibition" (*'83 shiyan huazhan*) completely subverted official aesthetic standards. By 1984, the Northern Art Group (*beifang yishu qunti*) was established in the northern city of Ha'erbin. Its members proclaimed in its manifesto that they wanted to "establish a new conceptual world" with their artistic activity, ambitions that far surpassed those of the native painting style and the early stages of modernism. Taking advantage of China's new liberal atmosphere in the reform and opening up period, young artists in 1985 seemed even more audacious in their attempts to kick-start their powers of imagination. This was the year that modernist art groups like Jiangsu's New Wild Painting Society (*xinyexing huapai*), Quanzhou's BYY Painting Society (*BYY huahui*), Lianyungang's Space Art Base (*taikong yishu jidi*) and Shandong's Luxinan Art Group (*luxinan yishu qunti*) began to appear. Furthermore, modernist art exhibitions began to take place in multiple cities, of which some of the most influential were the "Jiangsu Youth Art Week—Large Modern Art Exhibition" (*Jiangsu qingnian yishu zhou—daxing xiandai yishu zhan*) and "'85 New Space Exhibition" (*'85 xin kongjian huazhan*). In May of that year, in the "Advancing Young Chinese Artists Exhibition" (*Qianjin zhong de zhongguo qingnian meizhan*) held at the National Art Museum of China in Beijing, Zhang Qun and Meng Luding's painting *New Era—Apocalypto of Adam and Eve* (*Zai xin shidai—yadang yu xiawa de qishi*) became a symbol of the new artistic era: a more open and liberal

age had begun. The modern art emerging from various cities across China was a result of the political and economic changes that gave people a shared sense of possibility. Given the means—a little funding, some space, others with similar views and the creative urge—young people from all over the country would spontaneously get together to publish a manifesto or put on their own exhibitions. This was why there were so many new groups and exhibitions to be found in numerous cities throughout China in the years leading up to 1985.

For Mao Xuhui and his friends, on the other hand, no opportunities had materialised by the end of 1984, let alone any miracles. One day in December, Zhang Xiaogang, who was working in Shenzhen at the time, sent Mao Xuhui a greeting card in which he told his friend, "I have seen, heard, felt and experienced too much. In a word, it's miserable here. It is not a place for making pure art. All conceptions will change. I'm coming back to Kunming for Christmas. I bought you something nice." The bustle of Shenzhen did not seem to have diminished Mao Xuhui's friend's love of art. Meanwhile, in Kunming, Mao Xuhui had completed *Red Corporal* and his "Guishan" series, but his art remained unrecognised by officialdom, misunderstood by audiences and unexhibited by art institutions. As a result, he and his friends continued to live wounded lives that involved "smoking and drinking vast quantities".

In early 1985, Zhang Long, a friend who had travelled to Shanghai to study in the Fine Arts Department of East China Normal University, returned to Kunming for the holidays. When he saw the paintings of Mao Xuhui, Zhang Xiaogang and Pan Dehai he was "excited. He thought the paintings in Shanghai were too weak, too sweet; they lacked life".[19] Zhang Long said that as soon as he returned he would get in contact with a Shanghai gallery about the possibility of exhibiting their work, and sure enough the Kunming artists did not have to wait long for his news. In a letter sent on 20 March, he told them he had found a Shanghai painter who was willing to put on a group exhibition with them. Collaborating with an artist local to Shanghai, he pointed out, would make it easier to promote the event. The Kunming artists would be free to decide which paintings to exhibit and were also to choose between two venues, the Xuhui District Cultural Centre or the Jing'an District Cultural Centre ("Whatever works", Zhang Long wrote). They eventually settled on the Cultural Centre in Jing'an District. As for the paintings, Zhang Long told Mao Xuhui and Zhang Xiaogang that each of them could provide fifteen pieces, but he added, "A couple of Zhang Xiaogang pieces from each period, although preferably fewer of the 'spooky' ones. The same goes for Mao Xuhui—preferably not so many 'sexy' ones." By the "spooky" paintings, he meant Zhang Xiaogang's "Ghost" (*Mogui*) series, which he produced after an extended period recovering from illness in hospital in 1984, and by the "sexy" paintings, he meant Mao Xuhui's 1983 "Corporeal" series. These two series were important parts of Zhang Xiaogang and Mao Xuhui's output, the results of their embarking on a new artistic stage. Zhang Long's suggestion reveals that such "spooky" or "sexy" artworks were still difficult for Shanghai audiences to accept at the time. The "Guishan" series alone was likely to shock them. Zhang Long brought up the example of Feng Guide to describe the kind of art Shanghai viewers preferred, saying that his art "satisfied everybody".[20]

204 | THE FIRST NEW FIGURATIVE EXHIBITION

Prior to this, organising an exhibition had always seemed like a fortuitous, one-off possibility to these young Kunming artists, but when the opportunities for exhibiting work started increasing and everyone began seriously contemplating how best to organise an exhibition, questions and issues concerning the function of art seemed to become increasingly consequential. This was, after all, their first chance to exhibit their work on their own terms, and in a metropolis like Shanghai. The prospect galvanised the artists from Kunming, especially Mao Xuhui, who took the initiative in ensuring all the paintings were sent to Shanghai by early May. At this time, they were yet to settle on a name and theme for the exhibition. The artist Hou Wenyi, who was to be participating in the exhibition, sent Zhang Xiaogang, Mao Xuhui and Pan Dehai a letter on 15 May. She told them the artworks had arrived and although the size of the space limited the number of pieces that could be exhibited, afterwards they could try to put on a second or third exhibition. The main problem they faced now was promotion. They had to find a way to attract the interest of relevant magazines so the event would receive sufficient coverage. Other difficulties the artists might face, and about which Zhang Long had been concerned from the start, were also highlighted in Hou Wenyi's letter:

As for the Shanghai situation, to put it simply, the city is a huge black hole. It swallows up everything, from rubbish to gold, without offering a reaction. The cultural climate is not good. A few young men and women in fashionable clothes might, like little dogs, view us with curiosity or reverence. This is probably the best possible outcome. As for that group of people who call themselves artists or painters, their pitiful jealousy and frightening standards will serve as our second course. If we do not wish to make ourselves ill, we are best to avoid the third course altogether, which is to say we do not want to invite any unwanted trouble like a visit from the Public Security Bureau or a premature exhibition ban. Shanghai is a place where high culture mixes freely with high stupidity. Politically speaking it is extremely conservative, and the situation recently has become somewhat delicate. For this reason, Zhang Long and I think that this time it's best not to exhibit any works that are excessively sexual or contain explicit depictions of sex. Shanghai is a good stage. It is also, for better or for worse, the biggest city in the country and a window to the outside world. We have to take it easy.[21]

In truth, the words "sex" and "sexy" don't really do justice to Mao Xuhui's art. Works like *Red Corporeal* are undoubtedly an expression of unconscious forms, but this is a far cry from ordinary Chinese audiences' understanding of "sex", let alone "sexy". Audiences in China were not yet accustomed to the vocabulary of expressionism and although Mao Xuhui's expressionist works were direct emanations from the soul, they were completely different from what most people associated with the sexual and erotic. In the end Mao Xuhui still brought his "Corporeal" series to the Shanghai exhibition, while Zhang Xiaogang's "spooky" paintings did not touch upon any sensitive political issues at all. The question of the exhibition title also came up in Hou Wenyi's letter and her discussion of it sheds light on some of the questions being considered by artists at the time:

205 | THE FIRST NEW FIGURATIVE EXHIBITION

As for the title of the exhibition, I've always wondered whether it would be possible to call it the "New Figurative (xin juxiang) Painting Exhibition" or the "New Figurative Art Exhibition". One reason for this is to distinguish it from the new wave of exhibitions all calling themselves "modern", a word that is ambiguous, theoretically feeble, and functionally mostly imitative. We might be amongst their ranks, but we should try to make the first step and declare our views, even if they are not yet mature.

It is hard to say what made Hou Wenyi affirm: "The abstract school is dead", but what is certain is that abstract paintings that had previously appeared in Shanghai by artists like Li Shan and Zhou Changjiang did not go on to make waves in China's modernist movement. Hou Wenyi believed that the works in this first Shanghai exhibition shared a certain "unity", but she did not go on to explain what that unity was. Perhaps she noticed that most of them retained certain concrete forms, which inspired her to lean into people's habits of associating the figurative with realist or representative art: "Let them get a taste of *our* realism!" Of the five artists featured in the exhibition, Pan Dehai's work was the most abstract in style, a result of the emotional tempest the earth forests[22] of Yunnan had set off inside him after his arrival in Kunming as a recent graduate from China's Northeast. After graduating from high school, Pan Dehai lived as a sent-down youth in the countryside near Inner Mongolia where he would sketch the rural scenery and labourers. He graduated from the Fine Arts Department of Northeast Normal University but the mystique of the southwestern province of Yunnan brought him to Kunming where he was assigned a job teaching at the Yunnan Geological Bureau Middle School. This was the school where Mao Xuhui's mother happened to work, so it was not long before the two had gotten to know one another. This was how Pan Dehai became a figure in Kunming's modernist movement.[23]

Pan Dehai began by using expressionist brushstrokes to articulate how he felt, those hazy impressions that intermingled with the outlook on life and vision of the world he had acquired from books. When he heard about Yuanmou County and its mysterious earth forest landscape, it was as if a voice beckoned him that he could not refuse. "I was working as an art teacher at the school affiliated with the Geological Bureau. In my first semester working there I heard about the earth forests in Yuanmou County, so I went with a friend who did photography. I just wanted to have a look. I had no idea it would have such a profound impression on me, that it would have such a huge impact on my early artworks."[24] The colours, shapes and apparent barrenness of the earth forest struck the perceptive, young Pan Dehai whose sense that this natural formation "symbolised what felt raw and primal about life" led him to use a more abstract vocabulary in his early paintings. In his notes written at the time, Mao Xuhui wrote that Pan Dehai "ran off to the earth forests and discovered his Holy Land. That bare, desolate, melancholic beauty. There was nothing there. But for him there was everything." He produced "painting after painting of red earth forests, grey earth forests, white earth forests, until finally even the earth forests disappeared, leaving behind only disquiet and rhapsody". In such 1982 works as his abstract "Untitled" (*Wuti*) and "House" (*Fangwu*) series, we can see that when Pan Dehai's experiments with abstraction are not informed by calligraphic or symbolic abstract structures, their

focus is the geometric relations in natural objects, which reflects how he understood abstract art at the time. However, it was nature itself that allowed him to embrace the visual language known as "abstraction" with such confidence. He saw nothing abstruse or esoteric in abstract art. On the contrary, he saw in it a true means of giving concrete expression to his inner world. Towards the end of 1982, he started his "Earth Forest" (*Tulin*) series. The bright light refracting off the towers of clay provided him with the conditions to fully explore his abstract visual language. He emphasised the texture of the earth forests beneath sunlight, the abstract relationships that formed between separate structures; he sought abstract contrasts between the blue of the sky and the clay's red. Clearly, Pan Dehai was less interested in abstract forms than he was in the specific contours of his own emotional state. His compositions revealed the passion he felt in the process of painting for the mysteries of nature and life. In 1983, while he was producing the abstract "Earth Forest" series, he was also reading an eclectic range of books. Sometimes he would make a record of his thoughts, which could be direct responses to what he had read or broader meditations on art. Like Mao Xuhui, he also liked to use words to articulate his understanding of art:

In the chaos, exploring, following one's heart and entering the natural. The natural is simultaneously a reflection of the self and an unconscious integration of the external. It is where fresh artistic sensations are born, like how amongst a billion cells, a few might suddenly change.

There is another half of everything we see, perhaps the bigger half, that lurks unseen behind things and excites me more than what's on the surface. The surface can only tell us one side of things, and even if what it shows us is alluring, it's unlikely to be the whole truth. I feel as if there is something restive inside me that resists the visual experience the external world forces upon us. These

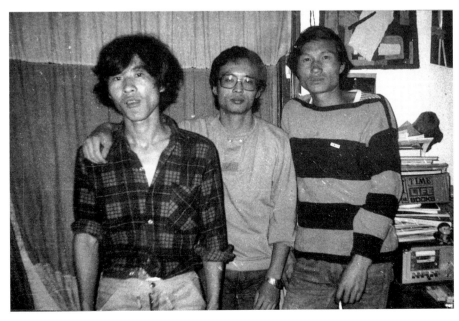

Mao Xuhui (right), Zhang Xiaogang (middle) and Pan Dehai (left) discussing exhibition plans at the dormitory of the middle school affiliated with the Kunming Bureau of Geology and Mineral Resources, 1985

surface phenomena are lifeless, monotonous; one gets the unmistakeable feeling that one is being fooled or deceived.[25]

Evidently, it was Pan Dehai's conception of art that allowed him to find kindred spirits in Kunming. He was naturally an important participant in the Shanghai exhibition.

Zhang Xiaogang was busy with work projects at the time. His lack of success in Shenzhen, coupled with his general temperament, meant he did not seem particularly excited about this unexpected opportunity to exhibit his art. The exhibition was undoubtedly a good thing, but he did not have the time and energy to devote himself to the preparatory work, choosing instead to submit to Mao Xuhui's arrangements. He felt completely differently from his friend about the exhibition. He saw it simply as a chance to let his works "see a little light",[26] whereas Mao Xuhui regarded it as an important historical turning point. As a result, although the letters sent by Zhang Long and Hou Wenyi were sent to the Kunming artists as a group,[27] it was Mao Xuhui who took the initiative in organising and coordinating exhibition affairs. In the essay "Recollections about the New Figurative Exhibition and the Southwest Art Research Group", Mao Xuhui recalls that time:

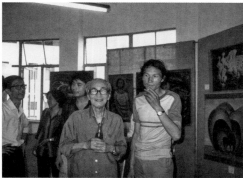

Group photograph of artists participating in the First New Figurative Exhibition, in front of Shanghai Jing'an District Cultural Centre, June 1985. From the left: Pan Dehai, Mao Xuhui, Zhang Long, Xu Kan, Hou Wenyi

Mao Xuhui and veteran painter Guan Liang aginst the background of Mao Xuhui's work at the First New Figurative Exhibition, June 1985

Mao Xuhui viewing Zhang Xiaogang's work with the audience at the First New Figurative Exhibition, June 1985

He [Zhang Long] suggested that everyone go there for an exhibition, and he would be responsible for arranging the venue, but they would have to fund it themselves. So they had to make money quickly. They got together with some others and started a decoration company, doing renovations and drawing design plans, but after much hustle, it didn't turn out to be very profitable. With little money earned, a telegram came from Shanghai: the venue was secured. They had to act quickly. The money they had saved was not enough, and they had to borrow. Pan [Dehai] borrowed 600 yuan, Mao [Xuhui] borrowed 300 yuan, and Zhang [Xiaogang] borrowed 200 yuan. The works of these three filled eight large crates, and it took two tricycle trips to move them to the train station. Since it was an express shipment, over 400 yuan was spent on shipping fees. Pan and Mao took leave and rushed to Shanghai while Zhang was stuck in Kunming. There were many specific tasks to handle: painting advertisements, printing invitations, placing ads, transporting and hanging the paintings, and setting up the exhibition space. . . They did these things all by themselves. They sneaked into the East China Normal University art student dormitories or classrooms at night and stayed there. Every day, they had to avoid the school guards' questioning. Pleasant times at night were spent at the school cold drink shop sipping Jazz coffee. As for people from Shanghai participating in the exhibition, aside from Zhang Long, there was Ms Hou Wenyi. She graduated from the Zhejiang Academy of Fine Arts in 1982. After graduation, she was

assigned to some place in Hunan and "struggled" there for several years. She had only recently secured a job at the Shanghai Research Institute of Culture and History. She was broke too... She suggested "New Figurative" as the exhibition name, and everyone agreed intuitively... When the exhibition was about to open, Hou brought in a sculptor, a Zhejiang Academy of Fine Arts graduate named Xu Kan. He didn't contribute much money to the exhibition, so they asked him to buy some paint for the advertisements. Finally, the exhibition opened on 12 June 1985 at the Shanghai Jing'an District Cultural Centre. A young girl brought a bouquet. The exhibition hall charged 30 yuan per day, and the ticket revenue did not go to us. That day, many people came, including various figures from Shanghai's art world, both old and young. This included the now-deceased Mr. Guan Liang and Mr. A Da. The exhibition hall was bustling and packed with people. It was a medium-sized exhibition hall with 120 works displayed, very crowded, with many metal sculptures placed in the aisles. We got through that day with continuous handshakes and introductions. People generally felt the exhibition was very stimulating.[28]

On 12 June, the exhibition that Hou Wenyi suggested be called "New Figurative" opened in the Jing'an Cultural Centre in Shanghai. This Zhejiang Academy of Fine Arts graduate also drafted the exhibition's manifesto:

Art [a:t] noun, the presentation, by way of various materials, of humanity's great, intense and compassionate spiritual activity. New Figurative art can also be described as organic. It denies everything that is decorative or claims to be artistic.

Its chief characteristics are its pursuit of the real, its passion, its strength.
It is about shaking the soul above all, not pleasing the eye. It is not a game of colours and shapes.

Wisdom, colours, images, captions, words... These are all merely means, servants, the servants of the great faculties of emotion and reason.

Mao Xuhui (right) in front of his work with Zhang Long (left) at the First New Figurative Exhibition, June 1985

Mao Xuhui demonstrating the T-shirt on which an audience member wrote "dumbasses" at the First New Figurative Exhibition, June 1985

209 | THE FIRST NEW FIGURATIVE EXHIBITION

New Figurative Art is high-capacity.
Figurative as a concept is not in opposition to abstract or any other word.
The New Figurative movement is only in opposition to the antiquated past.
Art is never abstract. (by Hou Wenyi)

The featuring artists that appeared on the exhibition invite were Hou Wenyi, Zhang Long, Mao Xuhui, Zhang Xiaogang, Pan Dehai and Xu Kan.

1985 was the year that a wide range of artistic groups and exhibitions appeared one after another in cities all over China, most of which accompanied by texts expressing similar sentiments. Although these groups might have phrased things differently, they shared a common desire for the liberation of thought and the pursuit of true art. One did not have to understand the elaborate philosophical thinking and ideas behind these introductions and manifestos. They were all simply words selected from Western texts to articulate how people felt, their shared desires, combined into the kinds of sentences that would get everyone excited. Not long later in 1986, Mao Xuhui wrote a defence of the New Figurative Exhibition. What his defence shared with the ideas espoused by other groups was the conviction that art had to be freed from "its subservient role as a simple tool in service of politics. No longer will it sing the praises of icons. It will be open to everyone".[29] Regardless of the content of its manifesto, what was most important about the New Figurative Exhibition was that it realised the participating artists' desire to freely express their art. The New Figurative was part of the broader historical phenomenon that was the artistic New Wave of the mid-1980s. As one might imagine, the wild brushstrokes, deformed shapes and intense colours on display were not to everybody's tastes. Mao Xuhui remembers discovering amongst the visitors' messages one that simply read, "a bunch of dumbasses." He immediately posed for a photo with it held up to his chest. Mao Xuhui had brought the main pieces from his "Guishan" and "Corporeal" series to Shanghai. There was an expressionist tendency to most of the other artworks. Zhang Xiaogang brought both the "Grassland" (*Caoyuan*) series he made for his graduation project and the "Ghost" series he created after coming out of hospital. Only Pan Dehai's paintings resembled abstract compositions. The exhibition certainly left its mark on Shanghai audiences and not a few were inspired by the artworks on display. A couple of the older generation of Shanghai artists also attended the opening, including Guan Liang and Ada, which was a great encouragement for the younger artists.

On the last day of the Shanghai exhibition, the Chinese-born, Swedish-national poet Zhang Zhen suggested they continue the exhibition in Nanjing and even contributed 150 yuan to the project. With the help of friends in Nanjing, the New Figurative Exhibition once again opened its doors on 16 July at the Nanjing Health Education Centre, featuring this time the poems of Zhang Zhen. The artists put up a sign indicating the attendance price was one yuan, despite scepticism about whether anyone would pay attention, on the off chance that their dwindling funds might be supplemented by visitors agreeing to pay. They even sold coloured photographs, appealing to the audience in Nanjing for financial support every day the exhibition was on.[30] Having come up against all the miscellaneous

Mao Xuhui (left), Hou Wenyi (middle) and Pan Dehai (right) at the entrance to the First New Figurative Exhibition's Nanjing stop at Nanjing Health Education Hall, July 1985

specific tasks that arise when organising an exhibition, Mao Xuhui wrote a letter to his girlfriend Sun Guojuan in Kunming apologising for the fact that he had not been able to write her love letters as readily as he had before. The exhibition had been taking up too much of his time and energy:

> Not writing letters is cruel. Many a time, I picked up pen and paper and felt too overwhelmed by everything. I haven't had a moment that truly belonged to me except for brief periods of sleep.
> I have to think and deal with the consequences of my actions. I have to give my all for my actions. Unintentionally, I have become the "leader" of this collective action. I have to find a rope, buy a nail, deal with a dazed spectator, meet new colleagues and handle invoices, introduction letters, tricycles, bus stations, food, the heat, watermelon, soda, encouragements, gratitudes, curses, shipments, pleas, indifferences, advertisements, explanations, arguments... I'm a bit at a loss. I've pushed my abilities to the limit, but things still seem to be in a mess. I can say I'm afraid to think about Kunming, to think about the past. Here, every day, you have to be tense and work hard for the exhibition, for art, for people, for yourself, for the past.
> Even now, I don't know how to express (deal with) it.
> I just want to finish the exhibition as soon as possible and go back to Kunming to rest.[31]

The New Figurative Exhibition might seem like a contingent event: after a companion expresses interest in the work of some Kunming artists, they find a gallery in Shanghai, come up with an impromptu title and, with the support and encouragement of some friends, manage to get together the funds to put on an exhibition. However, the ambience of a historical period can sometimes cause a series of serendipitous incidents to align and consolidate into an event with a certain necessity, propelled by a shared dream. For those passionate young artists and theorists, 1985 was a year with historical significance. In January, *Currents of*

211 | THE FIRST NEW FIGURATIVE EXHIBITION

Thought in Art (*Meishu sichao*) was founded, the Hubei radical art magazine in which Mao Xuhui would later publish his full introduction to the New Figurative. June saw the launching of the *Art News of China* (*Zhongguo meishubao*), which would go on to report on the newest trends in Chinese art. In July, young Nanjing University of Arts graduate Li Xiaoshan published an essay in the *Jiangsu Painting Journal* (*Jiangsu huakan*) entitled "My Views on Traditional Chinese Painting" that would trigger debate throughout the art world. His pronouncement that traditional Chinese painting was no longer relevant provoked widespread discussion about the future of Chinese art. In October, Nanjing painter Ding Fang, who had discussed modern art with Mao Xuhui during the New Figurative Exhibition, organised a large-scale exhibition in Jiangsu Art Museum with fellow Nanjing artists Guan Ce, Shen Qin, Ren Rong and Xu Yihui entitled "Jiangsu Youth Art Week", which included an array of surrealist works that shocked local audiences. November saw the arrival of a new Hubei journal on modern art entitled *Painter* (*Huajia*), and the "Rauschenberg Overseas Culture Exchange" (*Laoshenbo zuopin guoji xunhuizhan*) opened in Beijing on 18 November, broadening Chinese artists' conceptions of modernist art. Finally, in December, the "'85 New Space Exhibition" opened in Hangzhou, identified by critics as the first example of a shift from modernism to postmodernism in China. These modern art groups from cities throughout the country all seemed to emerge in the space of two years, from 1985 to 1986, and they used every possible form to express their artistic ideas, from exhibitions to academic discussions and articles published in journals. In the National Seminar on Oil Painting in April 1986, this artistic period was described as the "'85 Art Movement" by the critic Gao Minglu, who was attempting to unify all these various modern art currents. With that, the New Figurative exhibitions that took place in Shanghai and Nanjing were incorporated into a single comprehensive art movement.

efore Chinese art's New Wave had crested, Mao Xuhui was still in a state of anxiety and unease. The end of the exhibition had left him dispirited. The parable of Hemingway's *The Old Man and the Sea* had him questioning once more the reason he painted and exhibited his work. What was life about? On 10 August, having returned from Nanjing to Kunming, he wrote an essay about "a primordial anguish" that haunted him. He and his friends spent every day rushing through life; they fretted about various things and yielded to the allure of art, but in the end all that awaited them was death. What was the point of all this? He did not believe it was art as such, because lurking within all art was also life: "This vast and microscopic world feels like a huge mountain towering within us and tempting us to scale its peaks. It exists beyond our consciousness. It confounds me, perplexes me. I keep experiencing and discovering it, but I still can't articulate what it is. Perhaps when I can, it will be when I'm facing the end of my life." He believed that he painted and put on exhibitions because it was, at heart, what he wanted to do. It was both a way of proving his existence and a means of better understanding himself, a process of self-discovery: "The hidden body emerged from the black hole, clothed in a jacket, naked otherwise, liberated from all the violence of thoughts. It revealed flesh and blood from the smoke of concepts and screamed out of the absurdity of life. It showed me that it is a part of the world, albeit small, even pitiful at times, but it conforms to the logic of nature, the eternal form of nature. Each appearance shocks me and knocks me to the ground. I am speechless, unable to withstand a single blow." He wrote that he lived in the trap of civilisation, which was useless and empty: "[I am still far] from my goals, far from the other shore, far from the soul. . . I cannot put it into words."[32]

THE NEW FIGURATIVE CONTINUES

Although he was exhausted by the time he got back from Nanjing, and had been feeling strangely despondent since his return, the exhibition nonetheless seems to have awoken inside him a deep-seated desire. He felt that there was a self lurking within him that yearned to burst out from the murky depths. It was not a self that could be controlled by the embodied self, but its existence was inseparable from it. It was only through the embodied self that it could manifest as part of the actual world. This lurking self was a real, living thing, and the unspoken objective of the artist as a person of flesh and bone was to give it expression. Only then could the embodied self make its way to the other side and coincide with the authentic soul. Reading Freud had become a necessity for most young people at the time, but the unfamiliar linguistic form these texts took once they were translated from German, French and English into Chinese led many readers to consider a rational understanding of the ideas within of secondary importance. For those artists who yearned to give expression to their chaotic inner world, almost any concept that came from Western texts was enough to stimulate their imagination and spark associations in their minds. This approach to Western thought was a result of these artists' mercurial and restless inner drives, which it simultaneously served to satisfy. They could not be blamed for responding to these texts in this way because at this time all concepts and terminology pointed one way: towards the liberation of the self. Mao Xuhui was one of those who sought a total liberation of the self. When he read these translated works or discussed Western thought with friends as the effects of alcohol took hold, he began to reshape his world and draw a sharp line between himself and the popular artistic styles and attitudes of the past. It was this Dionysian tendency that guided his spiritual life after the New Figurative Exhibition, a tendency that was no less intense in his moments of sobriety than it was during his drinking sessions with friends.

In September, he sent a rambling letter to Zhang Xiaogang, who had started teaching part-time at the Sichuan Fine Arts Institute, in which he reminisced about the evenings they enjoyed together with friends in Kunming. However, the New Figurative Exhibition had awoken something in him that pushed back against returning to the tedium of everyday life. In the letter, he expressed his desire to do something big:

Your letter sounds like you're fucking drunk. Since you left, I haven't had a drop and have fallen back into a calm swamp. Every day, I jump from one book to the next, from novels to poetry, movie scripts and magazines, and then I go and get milk.

The memory of the "Seine River" has, since its inception, seduced countless people, not just seduced but also corrupted and intoxicated them, and then they go and dance disco.

The red nights of the "Seine River" swaying, a mix of the moon and youbao.[33]

The history of the "Seine River" is no less than that of the real Seine River, the French Seine, the birthplace of the devil.

It still flows there, but its climax has passed. It has become a legend, a future reading for the next generation, an inspiration for the lousy writers to write their

The Moon and Sixpence, or "The Moon and the Seine", "The Moon and the Devil", "The Moon and Disco" and "Moon and White Water".[34]

> We will have to create another history. Plans about drinking on the beaches of Hawaii and New York, for instance, about the question of chicks of different races, and many other cases. . .[35]

Mao Xuhui remained in a frenzied state. He was not content to rest on his laurels now that the exhibition was over. A combination of instinct and all the ideas he had accumulated during the previous few years of reading and introspection made him want to continue promoting the New Figurative and begin using it as a platform to organise more exhibitions and academic events. With the help of Hou Wenyi's introduction and encouragement, Mao Xuhui sent his thoughts about art and some photographs from the New Figurative Exhibition to *Art Magazine* editor Li Xianting. Ever since the scar art movement and the Stars Art Exhibition, Li Xianting had been an active proponent of new art, publishing a wide range of artworks and essays in support of the new movement. It was because of Li Xianting that Zhang Xiaogang's *Clouds in the Sky* (*Tian shang de yun*) featured in *Art Magazine*. Publication in this preeminent official art journal was the highest form of recognition available at the time and was the best indicator of a young artist's creative potential. Mao Xuhui naturally remained hopeful he could attract the support of this famous critic. However, by mid-March 1986, the end of the first month of the lunar calendar, Mao Xuhui was yet to receive a response from Li Xianting. His dreams yet unsatisfied, he began to feel the repetitive drudgery of domestic life:

> Every day is a repetition, just like the sky of Yunnan is still azure, and the weather is still dry. Every minute I want to do something exciting, I always end up bored stiff. I don't know how long this life will last, and when will we find liberation in life?! When will people be able to let go and do what they truly want, all in, without any concerns? As of right now, I don't see that happening. Everything lives inside me, yet I want to express it. Here, every minute and every second of time feels prolonged; every moment it mocks the frailty of life, the frailty of desires, and the frailty of Mao Xuhui. In this lack of "romance" and "creative release", one can only become more and more ordinary. I hope this situation ends soon. God knows, deep inside, we have already travelled very, very far. [36]

Clearly, Mao Xuhui was depressed by the fact that by spring of 1986 a path for further artistic development for him and his friends was still yet to reveal itself. However, around the beginning of March, when Gao Minglu travelled to Shanghai from Beijing, Mao Xuhui received some news from Hou Wenyi about the New Figurative Exhibition that once again piqued his interest. Gao Minglu was not only an editor at *Art Magazine*; he also worked at *Art News of China*. Like Li Xianting, he used his influence at these two publications to promote the new modernist art movement. Hou Wenyi told Mao Xuhui to get in contact with Gao Minglu as she was busy preparing to travel abroad.[37] On 12 March, after sending him a letter and photographs, Mao Xuhui received a reply from Gao Minglu:

215 | THE NEW FIGURATIVE CONTINUES

Comrade Mao Xuhui,

Hello!

I received the letter and photographs. Two will be published in the fifteenth issue of Art News of China *and we'll try to get something published in* Art Magazine *too.*

I was very interested in the photos I saw of the artworks by young artists from Yunnan and Shanghai that were exhibited in the New Figurative Exhibition. Would it be possible for you to tell me a little more about the exhibition's purpose and aims, as well as some information about the artists? If there are any other members interested in discussing things, feel free to put them in contact with me. Please be open and candid about your ideas. There are two reasons for this. Firstly, I will be giving a talk at the National Oil Painting Art Conference in April on the creative theory and practice of young artists, which will involve presenting and discussing artworks. Secondly, it would be good to publish your works in a timely manner. I would appreciate your active assistance and hope to hear a reply from you shortly.

I'll leave it at that. Happy spring!

Gao Minglu

12 March 1986

This letter was a momentous piece of good news for Mao Xuhui and provided a goal towards which he could channel his restless drives that until now had lacked a suitable object. He believed that with Gao Minglu's support, his artistic career might be able to break free from the confines of Yunnan and make waves on the national stage, allowing the art and ideas of the New Figurative movement to have a broader impact. He quickly responded to Gao Minglu with a long letter that, aside from including the first 1986 issue of *Yunnan Fine Arts Dispatch* (*Yunnan meishu tongxun*), which featured Mao Xuhui's essay "New Space for Art and the Mind" (*Yishu yu xinling de xin kongjian*), also described in detail the New Figurative Exhibition and his own ideas about art.

In Yunnan Fine Arts Dispatch, *I discussed some of my thoughts, which are basically new ideas from the last few years. They mainly express a sense of rebellion and scepticism. Without these two elements, creativity is just an empty word. Man exists as a thing in itself, and in this, everyone is equal and has their own value; the important thing is to find some forms to express this existence. Some choose politics, some choose football, while my colleagues and I choose art—canvas and palette. This requires art to be something closely related to life, and this life is human because only humans have the ability and wisdom to create art, through which they express their views, feelings, hopes, fantasies and personal characteristics—instincts and courage.*

Organising exhibitions at our own expense and effort is a way of being responsible for ourselves. You accumulate many feelings and insights in this world and seek to express them through the language of painting, hanging up paintings one after another until they fill the room, left to their own devices. Does society need this kind of thing at all? Do other people need them? Or do they contain something

that transcends you? Others' evaluations prove that there is a commonality to many things. The transcendence of spirits leads to our dialogue with society. If a work is imbued with life, then the work and its greater existence are something worth fighting for. This is why we organise exhibitions.

. . .

For various reasons, the authorities won't organise exhibitions like this. I can't blame them; society doesn't know you yet. The only way was to do it ourselves. In line with the trend early last year for starting a business, I also found some work and earned 500 yuan. Other colleagues contributed money or effort as they could, and those without money borrowed. At the time, it was simply a matter of money: money could rent us a venue, and that's the reality of society. We worked hard for some time—contacting the exhibition hall, printing invitations and advertisements, shipping artworks—every part, every detail had to be done by us personally. Taking action became the highest principle. Of course, as always, we couldn't have done it without the help of friends: my high school classmate Liu Tiejun, who now works at the Beijing Broadcasting and Television Department, my classmate Wu Yue from Fengliu Yidai *magazine in Nanjing, the entire editorial staff of the* Chunsun *newspaper in Nanjing; Tang Guo, Yang Gang, Gao Huan, the Swedish-Chinese poetess Zhang Zhen and her husband Magnus Fiskesjö; Wu Duan from the Graduate Students' Association of Nanjing University; and the students from the Fine Arts Department of East China Normal University. . . The list goes on. They all helped us with our exhibitions in Shanghai and Nanjing. The exhibition cost nearly 3,000 yuan, most of which was paid for by those participating, with help from friends. The exhibition was successfully held at the Shanghai Jing'an District Cultural Centre and the Nanjing Health Education Hall. We had more than 3,000 visitors, and opinions about the exhibition were very intense, which I cannot elaborate on here.*[38]

Sure enough, during the "National Oil Painting Art Conference" (*Quanguo youhua taolunhui*), which took place that year from 14 to 17 April, the New Figurative was incorporated into Gao Minglu's academic presentation, entitled *The '85 Art Movement* (*'85 meishu yundong*), under the section "Intuitivism and Mystery". Gao Minglu also mentioned Mao Xuhui by name: "Author of the New Figurative Exhibition Mao Xuhui (from Yunnan) and his companions have produced a series of paintings of deformed and swelling corporeal bodies in motion. For them this reflects humanity's primal and bloody nature, a synonym for life. He remembers something Bunin[39] said: 'Art is the prayer, the music and the song of the human soul.' Accordingly, they believe that art is the soul shaking the soul, and all external forms are merely the soul's symbols, signs of the soul's 'gnosis."[40]

The National Oil Painting Art Conference was held by the Oil Painting Artistic Committee of the China Artists Association. It seems that during this period that valued freedom of thought, this official institution had recognised the importance of openness to new ideas, which aside from leading to many young artists and critics being invited, including Zhu Qingsheng, Gao Minglu, Shu Qun, Zhang Peili and Li Shan, also meant that Gao Minglu was granted the opportunity to give an academic talk entitled *The '85 Art Movement* in which he presented hundreds of slides of

artworks by modern artists that sent ripples of shock through the audience. In his presentation, Gao Minglu united the different modernist currents taking place in various cities across China into a single artistic movement, which itself was seen as part of a broader historical project for cultural enlightenment stretching back to the May Fourth Movement. He wrote: "1985 saw the latest iteration in a programme for cultural change that began with the May Fourth New Culture Movement", "The '85 Art Movement's aims are to reflect upon tradition and examine the previous artistic age (the previous movement) in the light of the renewed impact of Western culture on the nation of China since opening up to the world. Its purpose is to modernise Chinese art." He mentioned various styles including scar art, aestheticism, life-stream and affected naturalism, but he argued that these previously novel forms had "made peace" with official art ("the idealist-realism that over the last thirty years has become the norm") during the 6th National Fine Arts Exhibition. He argued that this ostensibly diverse artistic landscape set the scene for the '85 Art Movement, which implied that there was a certain historical inevitability to the modernist art movement since it arose as a result of specific cultural-historic conditions. This is how contingent incidents can be transformed into a historical event, how the apparently happy accident of the New Figurative Exhibition could be incorporated into a broader modern artistic trend that characterised the whole era. Gao Minglu identified two currents in this trend, "rationalism" and "current of life", the latter of which he said was exemplified by the New Figurative Exhibition. This line of thought naturally led many radical artists to feel their work was of historical significance.

Gao Minglu's talk at the National Oil Painting Art Conference was considered a success,[41] igniting the passion of many of the younger attendants and leading to the decision to organise a national event in Zhuhai showcasing slides of Chinese modern art. Prior to this, northern artist Wang Guangyi, who had been assigned a job at the Zhuhai Academy of Painting, which was about to open its doors to the public, had expressed hopes that the academy's future would be closely linked to China's modernist art movement. After obtaining the approval of *China Art News* and the Zhuhai Academy of Painting, they swiftly organised a conference entitled "Youth Art Wave Large-Scale Slide Exhibition and Conference" (*Qingnian meishu sichao daxing huandengzhan ji yantaohui*).[42]

In February 1986, Mao Xuhui and Sun Guojuan travelled to Guishan together. In comparison to previous trips, the drawings he made there were more stripped back, the objects depicted less distinct, and the works in general more concerned with the artist's feelings. Mao Xuhui had painted a few oil portraits of Sun Guojuan. Their relationship had started in 1984 and would continue on and off until the latter half of 1987. Although Mao Xuhui was always contemplating human emotion in a general sense, jotting down his reflections on love in the abstract in his notebook, a new chapter in his romantic life was bound to disturb his regular emotional state.

By May, Mao Xuhui had still not received the essential news he was waiting for. What's more, the emotional problems at home were clear for all to see and he decided to take a trip to Chongqing to clear his mind. He went to the Sichuan Fine Arts Institute and stayed in Ye Yongqing's dormitory, a place that was dubbed

"Sunlit Courtyard"[43] by a group of young teachers who had become friends since working at the academy. Mao Xuhui's stay there left a profound impression on him. Back in Kunming, reminiscing about his time in the Sunlit Courtyard chatting and discussing art with Zhang Xiaogang, Ye Yongqing and others, he decided to write Zhang Xiaogang a letter:

> In the carriage, I refused to talk to anyone for the entire journey, which only deepened the suspicions of those around me. I sensed their unease. I lay on my bunk, reliving the happy times at the Sunlit Courtyard from head to toe, lying there for countless hours. I silently rejoiced in having such memories, which I call understanding life's happiness. I miss everyone; happiness is just that simple.

This was around the time that the situation at home deteriorated even further, causing Mao Xuhui to feel isolated and upset. He believed his family, "no longer exists. I simply walk towards the ruins, the home I built and now, by my own hands, have destroyed. I committed this crime". At times like these, being with friends helped alleviate his inner turmoil. He said, "I would love to record a tape of everyone talking, but I'm worried that I'd lose the ability to express myself in front of a tape recorder." He thought about the companionship and warmth he felt in the Sunlit Courtyard:

> I've always liked that low bed I sleep on. It's been a long time since I hummed or sang, and I had no interest in it, so Xiaogang said my guitar was not as good as it once was, which is true. When a person stays constantly in an environment that contradicts their inner feelings, their nature only plays a pathetic role. In a space without resonance, one's nature can only remain confined within one's heart. How can you strum and sing?! You either rebel, destroy, do annoying, foolish things, or belittle your self-respect; either way, you find no place to escape. Only in Taohua Hill, at the Sunlit Courtyard, amidst the green foliage, did I realise that I wasn't as bad or dull as many had imagined. Something tinged with fantasy revived within my body and emerged from the night. My guitar hadn't deteriorated to the point of being unlistenable; everyone can attest to this, and so can the leaves of Taohua Hill.

We can see that with his family on the brink of falling apart, Mao Xuhui turned to his friends for comfort and warmth.[44] However, having left his friends on Taohua Hill, he entered an abyss and began a descent to the emotional depths from which he appeared to himself a pitiful good-for-nothing. It was a state of melancholic self-loathing he would often describe in his letters. What he needed was a force from outside to bring about change.

This force arrived on 8 June when Mao Xuhui received a letter from Gao Minglu inviting him to attend the Youth Art Wave Large-Scale Slide Exhibition and Conference in Zhuhai. Gao Minglu explained that the aim of the event was to bring together and present the artworks of young art groups all over the country in a slideshow. Furthermore, representatives from each of the groups would attend and discuss organising a nationwide modern art exhibition in Beijing or Shanghai. The main co-ordinator of the slideshow was Zhuhai Academy of Painting's Wang

Guangyi, who was already a well-known figure at the time. He was a founding member, along with such "comrades-in-arms" (a favourite phrase of his at the time) as Shu Qun, Ren Jian and Liu Yan, of the Northern Art Group, which even before putting on any exhibitions had established a name for itself amongst young artists and critics with its manifesto. Now Wang Guangyi wanted to bring more young artists into the fold to further boost the New Wave art movement. Having received the materials for the slideshow, Wang Guangyi wrote the following in his succinct reply to Mao Xuhui:

> Dear Brother Xuhui,
> Slides received, worry not.
> We will be inviting you to the opening ceremony for the slide exhibition in Zhuhai, which will take place around 10 August.[45] Please make sure you're free. Your invitation will be sent to you on 25 July. Expenses for travel to Zhuhai will be covered by your place of work. The rest—food, accommodation and the like—will be taken care of by the Zhuhai Institute of Painting. Does that sound alright? Looking forward to seeing you!!
> In August, all the renowned figures from the world of young art will gather in Zhuhai. It's going to be a momentous event!!
> Yours hastily yet sincerely,
> Wang Guangyi
> 9 July 1986

As a member of the Northern Art Group, Wang Guangyi remained committed to the ideals he and his friends had previously espoused, namely, the transformation of the conceptual world through art. It was in fact because of the force of their philosophical ideas and manifesto that the group became so influential.[46] In "The Spirit of the 'Northern Art Group'" ("Beifang yisu qunti" de jingshen),[47] people discovered a platform that differed from that of the artists of the Southwest and their concern with the inner world of the individual:

> First of all we would like to declare to the public: the "results" you see before you are not the "culmination" of "creation". Like everything humans do, they are merely acts. The only difference is that the aim of these acts is to establish a new conceptual world in which all the traditions of humankind have disappeared—a new, solid, eternal, immortal "world" will thenceforth be built.

The manifesto even provided the criteria by which to judge whether a work of art had value:

> The principal criterion is whether it presents us with sincere ideas, which is to say, whether it reveals the power of human reason; the noble qualities and sublime ideals of human beings.

This criterion, reminiscent of Kantian or Hegelian absolutism, did not conform at all to the general ethos of Mao Xuhui and his friends, and in particular

220 | THE NEW FIGURATIVE CONTINUES

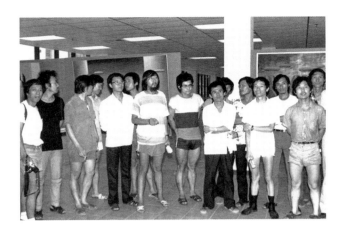

At the Zhuhai Conference in Guangdong, August 1986. From the left: Wu Shixiong, Li Shan, Gao Minglu, Zhang Peili, Wang Guangyi, Ding Fang, Shu Qun, Zhou Yan, Cao Yong, Mao Xuhui

their idea of the birth of a "Northern Civilisation" that would replace all previous culture hardly resonated with artists from the South. However, differences of opinion did not affect their shared goal of combining forces by using an art event to bring together artists from all over the country. This was why the main organisers of the slide exhibition wanted a representative from the New Figurative to attend. It was also the reason Mao Xuhui was so excited by the prospect.

It took Mao Xuhui five days to reach Zhuhai. He first went to Guangzhou where he "saw the tall buildings, huge hotels; it was like being in another country". Mao Xuhui's reaction illustrates the contrast between an inland city like Kunming and the thriving coastal city of Guangzhou. There was a huge difference in material conditions. On 15 August, Mao Xuhui arrived in Zhuhai and met with Wang Guangyi, noting that the standard of the dormitories in the Zhuhai Academy of Painting was equivalent to the accommodation normally allocated to officials at the department and bureau levels of government in inland cities.[48] At Wang Guangyi's home, they drank, danced and "partied all night". Mao Xuhui helped them write advertisements and slogans, and noticed:

> Nearly all staff from Art News of China came, and a bunch of so-called authorities and celebrities like Hua Junwu, Zhan Jianjun, Shao Dazhen and Zhou Sicong all showed up. The provincial Publishing House of Jiangsu has agreed to publish a beautiful catalogue, and a certain celebrity, Fei Dawei, will take a hundred slides to the US and France. The director of the Shanghai Museum of Modern Art (newly established) also promised to hold the first "Chinese modern art exhibition" there this year. Plenty of good news. There was indeed a restless air of "active rebellion", and they invited reporters from many magazines and newspapers. It looked like they were preparing for a big event. These folks were very clear-headed, and I was only there to watch the excitement. It seemed they had done everything that needed to be done. Us Yunnan monsters can only paint; with respect to these other skills, we simply cannot compare to them.

In Zhuhai, he also wrote a letter to Zhang Xiaogang, in which he tried to tell him everything he had seen and experienced. This was just when Zhang Xiaogang was getting ready to go to Chongqing to start his trial period as a teacher at the Sichuan Fine Arts Institute, but Mao Xuhui wanted him to stay in Kunming until he got back. "We need to discuss what to do next! This time I've got to network with the ringleaders from across the country and meet some official chiefs. I have many ideas, but we can discuss them in detail when we meet!"[49] Clearly, something had triggered Mao Xuhui's desire to do something. Prior to this, all the Kunming artists knew how to do was paint, but now Mao Xuhui had discovered that to be successful one had to act on the level of society. Their first social act had been the exhibitions

in Shanghai and Nanjing. Despite being limited by the resources available to them, they had nonetheless learned a great deal from the specific tasks involved in organising and putting on an exhibition. Mao Xuhui and his friends realised that it would be difficult for them to achieve their objectives if they did not organise and carry out their artistic activities with a sense of purpose. Mao Xuhui had already returned to Kunming when, in September, he received a letter from Wang Guangyi in Zhuhai. Aside from informing Mao Xuhui that he was still working on his "North Pole" (*Beifang jidi*) series and explaining why the Zhuhai Conference materials and bulletin had yet to be sent out, he wrote: "Gao Minglu recently travelled to Hubei to give a report on the '85 Movement and apparently it was very well received. People from all walks of life are beginning to take note of the '85 Movement. This is great news for our cause!"[50]

Wang Guangyi's letter shows that the idea of a unified art movement, first proposed by Gao Minglu in April that year at the Oil Painting Research Conference, had become widely accepted. The word "movement" in particular appealed to Mao Xuhui because it evoked the very same modernist outlook he had encountered in the books he read: one that emphasised art as avant-garde.

After returning to Kunming, Mao Xuhui described the Zhuhai Conference to his friends in the manner of a preacher sharing news of a great revolution that was already raging through the country. It was time to act, to join this great artistic revolution.[51] In August, a group of artists came together in Mao Xuhui's dormitory in Heping Village to establish the Southwest Art Research Group (*xinan yishu yanjiu qunti*), which began with more members than had participated in the New Figurative Exhibition, amongst whom Mao Xuhui, Zhang Xiaogang, Pan Dehai, Zhang Long, Ye Yongqing, Deng Qiyao, Su Jianghua, Mao Jie, Zhang Hua and Zhai Wei. It was not limited to artists from Kunming and many members hailed from Sichuan or other cities. The situation in the Southwest reflected a broader phenomenon. Similar collectives were forming at a rapid rate in many cities across China because young artists were now aware that as individuals they lacked the power to compete with official organisations like the Artists Association. Only by combining forces, whether in tightly knit organisations or looser assemblages, would they be able to exhibit their work and make their voices heard in society. However, at the same time, these young artists were only too eager to form collectives. It was during this period that Ye Yongqing, who had previously come across as somewhat shy and retiring, emerged as an important figure.[52]

On 26 October 1986, the opening of Third New Figurative Exhibition—Artworks, Slides, Images, Essays (*Xin juxiang di san jie zhan—zuopin huandeng tupian lunwen*) was held in the Yunnan Provincial Library.[53] Artworks were presented in the form of slides and there was clearly a great deal of passion behind the writing of the exhibition introduction:

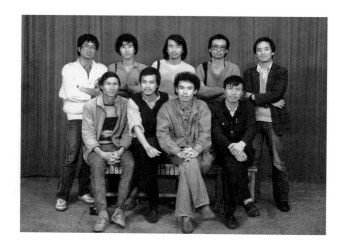

Group photograph of the main artists of the Southwest Art Research Group when it was established, October 1986. Front row, from the left: Mao Xuhui, Ye Yongqing, Su Jianghua, Deng Qiyao; back row, from the left: Zhang Long, Pan Dehai, Mao Jie, Zhang Xiaogang, Zhang Hua

Artists participating in the Third New Figurative Exhibition, Yunnan Provincial Library, 26 October 1986. Front row, from the left: Zhang Xiaping, Sun Guojuan, Yang Huangli, Li Hongyun, Mao Xuhui, Zhai Wei, Zhang Xiaogang, Pan Dehai; back row, from the left: Deng Qiyao, Ye Yongqing, Shi Anda, Zhang Hua, Ma Xiangsheng, Su Jianghua

At the Third New Figurative Exhibition, Yunnan Provincial Library, 26 October 1986. Front row, from the left: Zhang Xiaping, Wu Wenguang, Sun Guojuan, Ye Yongqing, Li Hongyun; back row, from the left: Zhang Hua, a friend, Deng Qiyao, Pan Dehai, Mao Xuhui, Zhang Xiaogang, Zhai Wei, Su Jianghua, Yang Huangli, Ma Xiangsheng

Eternity is achieved by humankind, not one individual. The world always requires some people to restore it to its original form. Each era reveals its particular mode.

If you do not realise that the apex of life is action, you will never be able to act better.[54]

The number of participating artists far exceeded that of the first exhibition. In addition to members of the Southwest Art Research Group, Dong Chao from Shandong and Ding Defu from Henan (a classmate of Pan Dehai), also had works in the exhibition.[55]

With the start of the new semester, Zhang Xiaogang began contemplating the question of how to act. Despite his innate scepticism, he had nonetheless been affected by the news from the Zhuhai Conference and the formation of the Southwest Art Research Group. He was even thinking about holding a New Figurative Exhibition at the school where he worked, and on 8 November, he sent Mao Xuhui a letter in which he wrote of his plans to hold an art event at the Sichuan Fine Arts Institute in mid-December:

Something like an art festival with the following contents: (1) an exhibition of photographs of our works; (2) a self-written, self-directed, self-performed play (which the students will organise); (3) a slideshow (with some other stuff in the pipeline); (4) academic talks (which will mainly be radicals from outside the school). We're still working on the last two items, but they'll hopefully be ready in time. The event will last three days. I finally got Wang Yi[56] *to join us, and I also grabbed a couple of student leaders. The aim is to shake up the dreary atmosphere of this place. When you get this letter, please tell Sun Guojuan, Xiaping,*[57] *Li Hongyun,*[58] *Zhai Wei, Su Yang, Ye Yongqing and anyone else in the Kunming gang to send original colour photographs to make copies of. The exhibition copies were of terrible quality. Please get back to me ASAP if they can't for whatever reason. If you or anyone else who's a good speaker can come, let me know and we'll arrange a speaking slot for you—guaranteed full audience, some of them fans of yours. Obviously, ideally all of us Kunming barbarians would come over and do an art event here, human sculpture or something. I promise it's going to be good.*

Mao Xuhui had started to act the moment he arrived back in Kunming from Zhuhai. After managing to get his work included in an exhibition held by the Yunnan Artists Association, he wrote about it to Zhang Xiaogang: "A good number of the exhibited artworks were by our brothers and sisters from the Southwest Art Research Group. The atmosphere was good. They called it a 'small milestone in Yunnan Art'." Mao Xuhui was also offered an opportunity to speak at the Yunnan Oil Painting Research Conference, which he used to present slides of artworks by the Southwest Art Research Group, introducing these radical young artists to painters in the Artists Association. The Wuhan periodical *Currents of Thought in Art* had also agreed to publish an essay he had written, which he hoped would help broaden the influence of New Figurative as a concept. But Mao Xuhui wasn't satisfied with simply publishing an essay. He sent a letter to Zhang Xiaogang asking him to speak to Ye Yongqing, who was also teaching at the Sichuan Fine Arts Institute. Ye Yongqing was taking too much time and Mao Xuhui was worried they'd miss the publication date for *Currents of Thought in Art*:

> *Ye Yongqing must have sent it too late and missed the deadline for* Currents of Thought in Art. *So, timing is crucial for action!! Of course, Ye Yongqing is in a sensitive period. What's the situation with* Art News of China? *Have you written a letter to Cai Rong*[59] *about this matter? We must try to get the front page! I have ways to deal with Chen Weihe, but since Ye has sent the package, I've written to Chen to explain. These matters are quite awkward.*
>
> *On another note, I'm in contact with* Art Magazine. *They plan to publish one of my articles in their November issue, but I don't know if any paintings will be included. I've sent copies to Gao Minglu and Zhu Qingsheng, as well as materials about the Southwest Art Research Group activities. If they decide to publish paintings, we must send some slides!!*
>
> *Zhu Qingsheng has received and archived the two photos everyone sent earlier. He mentioned that a group of graduate students, including foreign students, are very interested in our New Figurative, though nothing is concrete.*
>
> *In short, I need to have some of your slides and other materials on hand, as opportunities may arise any minute. If you've written anything recently, please send me a copy. You might also need to provide me with some slides as backups.*[60]

Mao Xuhui's excitement is evident from the tone of his letter. On 15 December, Mao Xuhui wrote another letter to Zhang Xiaogang in which he discussed the publication of an article and artworks in *Art News of China*. He told his friend that Gao Minglu had received a new batch of materials that he hoped to publish in the second issue of *Art Magazine* the following year. Furthermore, Gao Minglu, Zhu Qingsheng and others were currently working hard to organise "China's First Avant-Garde Exhibition" (*Zhongguo shouci qianwei dazhan*), a project they had first conceived during the Zhuhai Conference. He was calling on Yunnan artists to submit their best works for the exhibition, which he said was "China's entrance on the world stage!". He went on to write that New Figurative materials had been presented at the Peking University Art Week, while in Kunming, "we put on another small exhibition that

224 | THE NEW FIGURATIVE CONTINUES

attracted a lot of attention. The New Figurative is making waves everywhere". Clearly, the radical flame in Mao Xuhui's heart was burning bright. In the letter he described various events and conferences related to modern culture, including debates taking place in the world of philosophy: "A powerful essay recently came out by someone called Liu Xiaobo. I really enjoyed an essay he wrote criticising Li Zehou's aesthetic philosophy, which featured in the tenth issue of *China* (*Zhongguo*) magazine. There was a Nietzschean spirit to his approach. It was pretty extreme and when it comes to the question of life, he and I have a lot in common!" Modernist thought, together with the passion of youth, had induced in Mao Xuhui a state of irrepressible excitement. He also told Zhang Xiaogang that although his wife He Lide was to transfer from Qujing to the Yunnan Arts University to work, the two had decided to "properly separate" at the beginning of the following year. Clearly, all of Mao Xuhui's energies were being consumed by the art movement. He merely reminded Zhang, "Just don't do anything stupid with the academy leader's daughter!!"[61] Mao Xuhui's pending divorce had evidently done little to hinder his involvement in the ongoing modern art movement.

On 21 December, Mao Xuhui wrote another letter to Zhang Xiaogang telling him that in Kunming the term "New Figurative" had "become a part of the vocabulary. It's the phrase on everyone's lips. I recently participated in the Municipal Youth Federation, and only through interactions with people from different sectors did I once again realise that the New Figurative has far surpassed the art scene and other artistic concepts. The New Figurative seems to have become my nickname, just like Big Mao and Gang'r are our nicknames. We are now known by the 'well-known' and have turned ourselves into upright gentlemen. The New Figurative concept has also humorously made its way into the mayor's information system. For New Year's Day and the Spring Festival, there will be some activities for 'the youth.' Although the 'Cultural Night' event featured only thirty paintings, they once again stole the spotlight. The audience was packed. Many of the works on display were our 'second or third-rate' pieces, but they did broaden our influence and popularise our art. With our art consultations at the event, we are gaining more and more viewers. They will enthusiastically spread our 'toxicity', as to them, modern art is synonymous with the New Figurative!"[62] Mao Xuhui was in a state of frenzy he found it difficult to control. He no longer had any scruples about calculating the extent to which these past or future events might help advance his artistic career or that of his friends; he did all that he could to push the New Figurative to new heights. He cared about the week-long art festival Zhang Xiaogang was organising at the Sichuan Fine Arts Institute and even hoped Zhang Xiaogang could send him around eighty invitation letters for him to distribute to the "big names" in various spheres of Kunming cultural life.

In his response on 26 December, Zhang Xiaogang shared Mao Xuhui's buoyant enthusiasm: "The New Figurative is everywhere!!! This festival is one of the most important events this academy has seen in years! It's past eleven, I just got back from working overtime and I'm exhausted, but I just wanted to share a few words, because right now I feel so alone! Since I started working on the festival, what's boosted my courage to keep marching forward into the unknown is a series of serendipitous events. Long live serendipity! How I'd love to be back in Kunming drinking that maize wine from Guishan!"[63]

225 | THE NEW FIGURATIVE CONTINUES

At Pengjiafen Miao Village in Sandan, Kunming, January 1987. From the left: Shen Jiaming, Nie Rongqing, Zeng Hao, Cui Yahong, Mao Xuhui, Sun Guojuan

As Zhang Xiaogang devoted all his energy to planning and organising the art event he had conceived, he and his friends were unaware that a political movement was taking place in China that would throw a spanner in the works of what was being referred to as the "Fourth New Figurative".[64] For many it looked as though this modernist art event had been thwarted before it even began. Zhang Xiaogang was devastated, but Mao Xuhui seems to have been unaware of the situation at the Sichuan Institute of Fine Art a few days later when he received his invitation.[65] In any case, no public events would be held by the New Figurative or the Southwest Art Research Group ever again.[66]

The essay Mao Xuhui mentioned to Zhang Xiaogang that would be appearing in the first 1987 issue of *Currents of Thought in Art* was commissioned by chief editor Peng De and titled "The New Figurative: Presenting and Transcending the Living Figurative Schema" (*Xin juxiang: shengming juxiang tushi de chengxian he chaoyue*). Written after the Zhuhai Conference, it was a comprehensive account of the conception of art Mao Xuhui had developed over years of contemplating the subject. In the past he had been enthralled by Western books, but now he was using concepts and ideas he read to form his own philosophy of art, one that could defend and explain the artwork he and his friends created. He clearly sought to support and sustain the art produced by fellow members of the New Figurative by writing an essay rich in art theory. Gao Minglu was in the process of collecting materials related to youth art groups and organising his own ideas about the movement, but no critics with the ability to write texts defending New Figurative art had appeared in Kunming. As such, the artists involved had no choice but to do it themselves, and Mao Xuhui saw himself as the New Figurative's spokesperson.

Life is the origin of spirit and creativity. Only by emerging in a fluid manner from its specific point in space and time can it converse with the world and have the potential to change it. In this sense, art as a synonym for life and creation must first discard any purpose or function beyond itself. It is only when art emerges from the life of an individual and seeks to preserve this entity that it can spread its wings. Only once it has found itself will it be possible for it to transcend itself. When it sincerely and sensually articulates its passions and spontaneously reveals its inner self, it is bound to touch upon that "public secret" which is the secret of humanity.

The influence of Lebensphilosophie on Mao Xuhui's thinking here is evident in his use of terminology. His mind had absorbed a great deal of vocabulary

IN DEFENCE OF MODERN ART

relating to Western thought, but his task as an artist was to distil these complex ideas into formulations that served his own project. The essay was full of emotion, bursting with passion, but in his attempt to articulate artistic theories and objectives, his language and phrasing still came across as rushed, unsystematic and inconsistent. The artist had too much to say. He referenced Saul Bellow while discussing Kantian concepts and ideas. He wanted to say that art arises from the demands of life, is not subject to utilitarian and teleological requirements and belongs to no one; it springs from the deepest liberation of the human spirit but can only become manifest by way of specific symbols and forms. The Living "Figurative Schema" was Life—Creation—Form. Through it, Mao Xuhui aimed to solve the problem of the finitude of individual life by making the dream of capturing the eternal possible. This is what Mao Xuhui had written in his notes and it constituted a schema with noticeable benefits:

> *Eliminate all sense of fear.* (Zhang Xiaogang)
> *Remain fearless in the face of death.* (Hou Wenyi)

By quoting these two comrades-in-arms, Mao Xuhui hoped to convey the fact that their art was a rebellion against fate. He began by rejecting art as a tool for fulfilling one's responsibilities to life and, following this line of thought, defined the New Figurative as "a promise to life and the mind". However, Mao Xuhui reminded his readers, when life manifests in a particular artistic form the result is often a complex structure in which rationality and intuition, as well as metaphysical and instinctual thinking, live alongside one another; in which classicism, dadaism, the modern and the primitive co-exist.

> *Perhaps it's because I'm lonely that I picked up a paintbrush. I found there a language—one whereby the external and internal world can communicate—a space where I can exist.* (Zhang Xiaping)
> *The burden of the soul begins with despair. This power we call painting is not simply expressing oneself or getting something off your chest, but, on top of that, a form of control, judgment, persona, orientation, a frame of mind.* (Hou Wenyi)
> *It feels as if a passionate drive that lies beyond life itself is holding me back and shaking me awake, making me do something and not simply want to do something. It causes that powerful note of life to sound from the distant, indistinct throb of the mind. There are five canvases before you. You feel the excitement and challenge of life, that fight-to-the-death; now is the moment that verifies you, that impels you; the moment you strive to think, to do; that urgent need to do, to act, act.* (Pan Dehai)

After quoting his friends, Mao Xuhui referenced a Goethe line as it appeared in an art theory book by Zhu Guangqian called *Aesthetic Gleanings* (*Meixue shihuiji*)[67] to argue that the New Figurative was simply an assemblage of different complex individualities united by an overarching goal, which as such gave rise to "all manner of breath-taking scenes of the Living Figurative Schema". These "scenes" were both image of and testimony to our era, paths leading towards truth and the future. He went on to quote William Butler Yeats: "Man can embody truth but he cannot know it."

228 | In Defence of Modern Art

Mao Xuhui also discussed the question of form in art, hoping to explain how to recognise the specific style and expressive mode of the New Figurative. However, since he claimed that by seeing through form to the "mysteries of the spirit", content and form appeared as one, it was difficult to provide an answer to the question of how to distinguish the formal properties of New Figurative art. Mao Xuhui's analysis was based on concepts he came across in books about Western art history, including the dichotomy between figurative and abstract painting. Figurative painting, he argued, was illustrative and clear but, as a mere representation of the surface, lacked authenticity. But to what painting did this critique really refer? It seems that his use of fashionable, Western terms like "figurative" only served to obscure his point, because the art he had in mind here was probably the native painting style, an artistic approach that had been popular for many years in China and produced commercial paintings with elaborate, affected depictions of people from ethnic minorities in sheepskin coats. Mao Xuhui also criticised abstract art, which he said obstructed the mind by being overly subjective. It was this analysis that laid the foundation for the expressionist method employed by Mao Xuhui and his friends. They did not want their work to be excessively illusory because that would lack emotional authenticity. They did not want purely abstract arrangements in which one could not perceive the spiritual world. Changes could be made to the images projected on the retina, but their basic relations ought to be preserved, their inherent spirit drawn out by way of the artist's creative intuition. Such a view is reminiscent of Max Beckmann's ideas, a painter with whom Mao Xuhui was very familiar. By spurning both "realistic" and purely abstract compositions, Mao Xuhui's explanation broadened the scope for formal experimentation. Artists were free to employ a wide array of forms and symbols as they pleased. In the space between the material and psychic worlds, any formal arrangement was possible as long as the artist maintained a connection with both poles:

When it incorporates various styles and compositional elements, multiple languages, structures and dimensions, then it is the New Figurative style. When various factors intersect and interact, exclude and embrace one another, each unique and yet part of the whole, that is the New Figurative.

After this statement allowing for any possibility, Mao Xuhui quoted a passage from Herbert Read's *A Concise History of Modern Painting* to describe the New Figurative as a style "bridging fields of knowledge and linking man's polarities: his intuition and his intellect; chaos and order",[68] thereby demonstrating his views were in line with accomplished theorists of art. Finally, Mao Xuhui emphasised the importance of action, arguing that it was only through action that artists could bring about concrete results and allow the soul to achieve transcendence.

Ye Yongqing also wrote an article, but it was not completed in time to make the first 1987 issue of *Currents of Thought in Art*. In it he attempted to describe the art of the Southwest Art Research Group, which was established only a few months earlier in August 1986. He hoped to carry out a systematic analysis of the work of artists living in the frontier cities of China's Southwest, which would announce

to the world that a new kind of art had begun to develop in Yunnan that was not limited to the native cultural characteristics usually associated with the region. This essay entitled "A Brief Account of Natural Consciousness in the Paintings of the Southwest Group" (*Xinan qunti huihua zhong de ziran yishi lüeshu*) referred to many of the group's members, including Su Jianghua, Yang Huangli, Mao Jie, Zhang Xiaogang, Zhang Xiaping, Sun Guojuan, Pan Dehai, Ma Xiangsheng, Fu Liya, Mao Xuhui and Ren Xiaolin. Many of these artists participated in the slide exhibition held in Kunming, so it would not be wholly misleading to describe this text as an exposition of the New Figurative art phenomenon. Even though Ye Yongqing liked to make use of novel but ultimately ambiguous terminology whenever possible, his basic premise and aims were clear. He hoped to give an account of the relationship between the individual and nature as it appeared in these artists' work. He began by writing, "The rebirth of natural consciousness and the wide array of various intersecting intentions in contemporary painting is a result of changes in social life."[69] This implied that these artists no longer approached nature as something pure and separate from modern society, which was a conception of nature they had encountered in books and associated with Gauguin in Tahiti. Yunnan is a province with many ethnic minorities. One often sees men and women wearing traditional ethnic dress walking through the streets of the provincial capital Kunming. This was the reason for the emergence of the Yunnan painting school, one of the main characteristics of which was its preference for ethnic minority themes and images. After the end of the Cultural Revolution, many artists from all over the country (including Wu Guanzhong) saw ethnic minorities and their lifestyles as symbols of purity and simplicity, an aesthetic approach that no longer appealed to the young artists born in the 1950s. For Ye Yongqing, "nature is a social being". Although his attempt to explore this theme gave rise to many somewhat confused passages, he was clearly aware that people's understanding of nature had changed. He used a far from traditionally naturalist vocabulary to describe the work of his fellow artists in this essay, which features terms like "bewilderment", "catastrophe" (Wang Yi), "pessimism", "mystery" (Su Jianghua, Yang Huangli), "morbidity" (Zhang Xiaogang), "dread" (Li Hongyun, Sun Shifan) and "estrangement" (Zhang Xiaping). He introduced Mao Xuhui's work as follows: "In *Mother Red Earth* he chooses natural objects that are wild, rugged and yet to be conquered by humans, the union of contemplation and vista, turning to his highly contradictory ideal of life as strength to create a forceful and desolate overall style." The words of this artist yet to turn thirty didn't always roll off the tongue; his phrasing was often jarring and his meaning obscure. He concluded his description of the various artists' individual styles as follows:

> Hence the bearer of wisdom regarding the unity of nature and man—spiritual painting seeps into the souls of young southwestern painters differently, always externalised to differing extents and intensities in our works and, having accumulated over thousands of years, occurring naturally and spontaneously to our intuition. What we must endeavour to do is simply mould it into contemporary natural consciousness to intensify and sublimate it.[70]

Nevertheless, Ye Yongqing's text is full of warmth and naturalist ideals. As he tried to explain, the new natural understanding amongst artists did nothing to curb their nostalgia for a primal nature, even if they were becoming increasingly aware of various problems with nature as an idea. Ye Yongqing's view was so different from the radical art manifestos emerging from cities elsewhere in China that Zhang Xiaogang wrote in a letter to Ye Yongqing, "Today's 'radicals' are going to regard this essay as 'negative and degenerate'!"[71]

It is true that the northern artists who received Mao Xuhui so warmly in Zhuhai had little interest in how nature and natural changes set off tremors in the soul. They believed their own ideas and slogans were closer to the objectives of the youth art movement at the time. The first 1987 issue of *Currents of Thought in Art* also published an essay by Zhuhai Conference organiser Wang Guangyi, whose ideas were markedly different from those of the southwestern artists. He had no interest in instinct and intuition. A vaguely Hegelian philosophy and worldview inspired the young painters from China's North. Wang Guangyi was twenty-three before he was accepted into the Oil Painting Department of the Zhejiang Academy of Fine Arts, where he was primarily influenced by the work of Western modern artists like Van Gogh, Matisse and Picasso. He was once very much intrigued by expressionism, a style he later turned against. Perhaps it was merely a result of personal preference, but he was more drawn to classical art, philosophy and aesthetics from the West.[72] From his graduation to 1986, he worked on his "Frozen North Pole" (*Ninggu de beifang jidi*) series, the emphasis of which on cold indifference and frozen ice was clearly related to the geography and climate of the north. In a defence of his work, he interpreted this "frozenness" as an attempt to capture life's "internal drive":

Life's internal drive, this force behind culture, has truly reached its pinnacle today. We hope to "work hard to embrace the various forms of life" and establish a new, more human-centred spiritual mode that brings greater order to the evolution of life. This is why we oppose those pathological, peripheral, rococo-style arts, as well all those unhealthy things detrimental to the evolution of life, because these so-called "arts" only foster the weaker side of humanity, leading people away from health and the essence of life. The clamour of these pathological, peripheral arts threatens to drown out what healthy people yearn to hear: the solemn tragic toll emanating from the inner drive of life.[73]

Wang Guangyi also occasionally discussed art in terms reminiscent of Nietzsche's conception of tragedy.[74] This hyperbole reflected his relative dissatisfaction with expressionism, which he never explicitly identified with either China's New Wave or the artists of the Southwest. "Modernism" was synonymous with rebellious agency at the time and was adopted by all those who considered themselves rebels. Young artists with a wide range of inclinations and tastes proudly waved the modernist banner despite the ambiguity surrounding its meaning and its application. It was clear that despite some shared vocabulary, Mao Xuhui and the young artists from the Southwest had very different opinions from their northern counterparts.

231 | In Defence of Modern Art

Towards the end of November, Mao Xuhui wrote another essay entitled "Art Tending Towards an Expression of Inner Spirit—Yunnan Youth Art in the Context of Currents of Thought in National Youth Art" (*Yishu quxiang neizai jingshen de chengxian yu biaoda—cong quanguo qingnian meishu sichao kan Yunnan qingnian de meishu chuangzuo*), which appeared in the first 1987 issue of *Yunnan Fine Arts Dispatch*. Here, Mao Xuhui used more narrative and descriptive phrases than he had in the article that had previously been published in *Currents of Thought in Art*. As such, his argument was clearer and more accessible. He also diagnosed a broader trend amongst intellectual, cultural and artistic circles for "finding one's roots", which manifested in Ye Yongqing's essay as a re-interpretation of the origin of nature. This new approach was clearly a reaction against the politicised and instrumentalised conception of art championed by officialdom for so many years. To reflect on the past is to re-conceptualise the present, which in turn sheds doubt on the past. In his discussion of the '85 Art Movement, Mao Xuhui was quick to identify two tendencies in art emerging from officialdom or the academy which he regarded with contempt:

Having escaped from those hysterical "great themes", we slunk fearfully into a mysterious ethnic land for survival. For a period, this haven became an overly fashionable theme. Our desire for the exotic caused us to fill our art with the ethnic dress, headwear, customs, villages, architecture and various oddities that formed these postcard-like scenes. Yunnan provided the most fertile soil for this "aestheticist" trend, which began piling up the picturesque until decoration became affectation.

Every year, official art organisations set the political task of addressing "great themes" and this was clearly to be avoided by modern artists. By mentioning a predilection for the "ethnic", Mao Xuhui was alluding to the trend for intensely decorative styles initiated and practised by Jiang Tiefeng and Mao Xuhui's own teacher Ding Shaoguang, which as a purely aestheticist approach was something Mao Xuhui thought also ought to be abandoned. The scar art style pioneered by students from the Sichuan Institute of Fine Arts a few years previously also failed to capture the essence of art and as such "failed to break completely free from the artistic mode of the past", which was a "tragedy". Fortunately, however, "Yunnan avoided this tragedy probably due to regional reasons". He went on to identify the vulgar origins of scar art, aestheticism, life-stream and affected naturalism (another term for life-stream) and, in light of the problems facing the art world, expressed his hope for "a comprehensive understanding of and reflection on art's characteristics, essence, function, creation and laws—the laws of art appreciation, art criticism, art evolution; otherwise our creative work will remain in a state of blind conformity and ignorance". Although there were differences between their ideas and views, he argued that the artistic thought behind Zhejiang's '85 New Space and the Northern Art Group shared a common orientation. He saw the New Figurative as an integral part of the '85 Art Movement, which he believed "began from history to participate in the great project that is Chinese modern art's march into the future by centring human values in its rethinking of various concepts and its autonomous action". And he added: "When art is manifested in all its robust diversity, it will carry the modern

232 | IN DEFENCE OF MODERN ART

spirit of the Chinese nation into the evolving current of world art." Mao Xuhui did not shy away from the role of Western modernism and affirmed the importance of Cézanne, Kandinsky and Klee, as well as cubism, surrealism, actionism and even pop art, but he unambiguously declared: "Chinese modern art has gone from the impact of its initial emergence to a stage of transition and deepening. It is no longer merely a simple imitation or appropriation of Eastern and Western culture. It is now penetrating humans' spiritual reality to get at that being which cannot be expressed with logical language." He even clarified that the New Figurative was not opposed to tradition but was in fact a return to tradition, "a return to the tradition of creative activity". The text that follows is even more explicit: "The only tradition that ought to be opposed is the tradition of cultural despotism or the tradition of making art a tool for political illustration, as well as the modes of creation and standards of appreciation that are a result of the alienation brought about by these two 'traditions'."[75]

Like Ye Yongqing, Mao Xuhui devoted a lot of space to describing and analysing the work of his friends, attempting to theorise how they differed from official or aestheticist art, and emphasising their modernist traits. Just as he had written in the article published in the November 1986 issue of *Art Magazine* entitled "Yunnan Shanghai: The New Figurative Exhibition and its Evolution" (*Yunnan shanghai 'xin juxiang huazhan' jiqi fazhan*), he once again affirmed that art had to be freed from its subservient role as a simple tool in service of politics, that it would no longer sing the praises of icons, and that it would be open to the people's spiritual world. He concluded by saying that the New Figurative "produces figures of the mind, figures of the soul". Mao Xuhui had another article published in the fourth issue of *Yunnan Fine Arts Dispatch* that year documenting the Zhuhai '85 New Wave Large-Scale Slide Exhibition, which he described in terms of the "wind from Zhuhai". It was clear that a lot of reading and thinking had gone into the artistic practice of the New Figurative artists. Although they each had their own style, their shared expressionist bent was a result of the influence of Western art. They completely abandoned formalist painting approaches like those of the Yunnan painting school in favour of the free expression of their inner world, which they understood to be the starting point of art. Mao Xuhui would later regard the works completed in the 1980s by some of the major figures in the New Figurative movement as a means of paying back the debt owed to Western thinkers and artists for the influence and guidance they had offered to Chinese artists. His words on this subject are sincere and heartfelt:

The effort we each expended painting numerous artworks over those years was a way of paying back this debt. The dormitories in which Zhang Xiaogang, Pan Dehai and I lived were piled full of paintings. Our living space was constantly being squeezed smaller by the growing mass of our creations. A mix of the odours of animal glue, oil paint, turpentine, tobacco, rat shit and mould forever permeated our rooms. As soon as our paycheques came in, we immediately bought books and painting materials, which meant we had little left to spend on looking after our homes and health.[76]

n June 1986, Mao Xuhui bought a collection of Hesse's fiction.[77] This edition included the novel *Peter Camenzind*, but it is *Steppenwolf*, a novel Mao Xuhui was reading for the first time, that in his copy contains numerous underlined sections and annotations. The parts he highlighted were those he felt most strongly about, identified most with, or discovered had most influenced his thinking. He transcribed ideas that impressed him in the margins of the book, such as the following line he wrote on the blank space after the "Publisher's Foreword": "The great disease of our era will not be overcome by avoiding or beautifying it, but by describing it."[78] This resonated with Mao Xuhui who was encouraged to further expose the diseases he perceived—whether in society or in himself.

Like the "Steppenwolf" in Hesse's novel, Mao Xuhui was just a human being who walked on two legs and wore clothes like everybody else. However, for some reason, there was something unusual about his personality and actions, the way he expressed his thoughts and feelings. This unusualness did not manifest itself in the way he spoke or behaved, nor did it cause him to offend those around him. He took to art like a duck to water, from depicting images to understanding volume and perspective, from sketching the shapes he saw to using light to render objects on the canvas. He immediately understood that his transfer from the general merchandise store to the film company would not only benefit his artistic training but also cause his role in society to finally be associated with the arts. However, he remained dissatisfied, dissatisfied with life and with art, and unable to feel gratified about what he had achieved. It is difficult to say where such a state of dissatisfaction came from, but Hesse's Steppenwolf at least shares an inclination for exposing disease and giving free rein to those base and pathological undercurrents. Mao Xuhui was an artist who brought the inglorious nature of the wolf, whether a result of pathology or society, to the surface of human life. One evening in November 1985, he wrote the following lines at the beginning of a notebook that would later fill up with poetry:

I want what is written in this notebook to be closer to me, to be more real than the me I usually see.
—This is my aim.[79]

STEPPENWOLF

The poetry included in this book was published from 1985 to 1987. One would struggle to identify the specific situations or events addressed by these poems, but the mood, feelings and despondent sighs they contain are real. The way he responds emotionally to events—if indeed there is a discernible event being responded to—would seem unfamiliar or irrational to many. Aside from occasional expressions of hope or beauty, the poems are predominantly concerned with what is bleak, distressing, horrific and odious. He might recall a past event, such as the pigeons he once saw land on a roof, grey as the tiles beneath their feet; how he fed them, built them a nest, and released them by the banks of a river in the countryside, only to see these grey birds frequently return, often with new companions. However, this artist living in Kunming was also sensitive to the passage of time, and the arrival of autumn, the imminent passing of summer, caused him to write: "The voice is imperceptible in the dancehall perhaps, but when you are walking through the intermittent glow of a poorly lit street, an urgent emptiness presses down on you."

Sometimes, some unknown force drew Mao Xuhui into pastoral reverie where he claimed he felt confident, as though having awoken from a good night's sleep. He would look into the sky or walk on the red earth with a leafy branch in his hand. With the confidence instilled in him by nature, he imagined saluting life and the blue sky. One gets a clear impression of this experience in his paintings of Guishan.

Of course, nature is not always calming. Even beautiful clouds in the sky were complex forms that could fill him with unease, "casting their shadows on the earth" or "charging towards you like savages".

Mao Xuhui sometimes liked to imagine the people around him were containers, things on shelves, or "the fittings in a room", which gave him a little leeway to feign ignorance or naïveté, diminishing his sense of responsibility to others so he could do as he pleased. He had no interest in a society that lacked vitality. In a more dreamlike space, he could encounter all manner of living forms—dragonflies, ants, cats—and although this space could transform at any moment into a grey world of alleys, asbestos tiles, chimneys, oil barrels and concrete surfaces, life would continue to inhabit it. As Steppenwolf, he was no physical being; he resembled a gecko scurrying between worlds, albeit one that might succumb to a "medieval embrace". However, when night fell it was time for cats to rendezvous in the streets, and so once again he would disappear like a ghost. . . Such oneiric visions are frequent in his writings. Reading had opened this young man's mind to new ways of thinking, allowing him to give voice to his anxiety and unease in surrealist forms, which he believed most approached the reality of his experience. Mao Xuhui often sunk into reverie, but he never considered his somniloquy to be fictional or unreal. It was in fact the reality of his life and experience manipulating words to tell stories in the form of poetry. The night of revelry had passed, that was long ago now, and his former ardour had been washed away down the city's sewers into the eternity of night. Everything he could remember—the laughter and singing, the crying and the curses; the moonlight, the riot of neon, the wind and the drunken ravings; the yellow puddles of vomit and the acrid stink in the air—he regarded it all the following day, his mind now clearing up after lunch, as both dream and reality. These were the scenes Mao Xuhui and his friends had encountered over the years.

Naturally this lupine artist remained interested in the topics of sex, love and sexual desire. He was convinced that sexual desire was simply sexual desire and thought that on a fundamental level sex might have nothing to do with love. Such situations could inspire violent and murderous thoughts that raised one's blood pressure with an unconscious frenzy that demanded release. It was easy for him to transfer such thoughts to the canvas and imbue his compositions with the physically and sexually violent desires engendered by irrepressible savagery. In contrast to Hesse's protagonist however, who preferred the music of Mozart, this particular Steppenwolf liked to listen to the songs of melancholic guitarists and blues musicians in sunglasses.

In winter, Steppenwolf thought about death. He imagined his life coming to a stop, his memories falling to the ground, and him listening to his final breaths as all the sights and sounds around him faded away. What would life at this moment be like? It was a kind of thought experiment, a way of comprehending life and death, and an attempt to understand his own existence. However, such a reverie could never remain on the abstract plane for long. It quickly began to incorporate everyday visual elements from the physical world, but in the process Mao Xuhui's head had become red and his face yellow, likely a result of his sense of his own inferiority and incompetence. He had memories of people wearing jeans on city streets. The pipes he had seen exposed in dilapidated houses mutated into clogging blood vessels. The scene of a seagull flying from Siberia appeared in his mind, then Old Wang from the catering team, the podgy boiler room worker, a tall glass of rice liquor, glowing honeycomb coal briquettes, his estrangement from his wife, his daughter's talent. . .

Exasperated by his urban environment, this Steppenwolf sometimes—usually during winter—returned to nature, to that long-forgotten wilderness. He felt alone in the serene mountains where there were no people or even living leaves on the trees. The red of the earth reddened his feet; his whole dream was red. At dusk, a decaying portrait lay abandoned in the moonlight. Such dreamscapes reminded Mao Xuhui of Guishan, prompting him to go back and paint its scenery and inhabitants in his now already very expressionist and calligraphic style.

In September 1985, not long after returning from Shanghai and Nanjing to Kunming, Mao Xuhui painted a self-portrait in poetic form—*Self-Portrait: 85—No. 1 Midnight* (*Zihuaxiang: 85—No. 1 wuye*). This was, he said, his never-ending soul, which only rested after midnight and had never had a good night's sleep. After this, he continued to combine the contents of his experience, reading and dreams in his long poems, which while touching on historical and artistic questions, seemed more to disclose in their final form the spasms of an errant soul that had lost its way:

> *It is already midnight*
> *Two cats in the old wooden box beneath the window*
> *Seek illicit liaisons, pleasurable encounters*
> *Emit cries of joy like the screams of infants in distress*
> *It is midnight*
> *All that could not be done can now be done*

It is midnight
The earth trembles softly once more

Mao Xuhui first read *Steppenwolf* in the days before attending the Zhuhai Slideshow Exhibition. Although the event was a sign that he was finally being recognised by fellow artists and critics and new opportunities were on the horizon, the worldview Mao Xuhui had developed over the years nonetheless prevented him from regarding any changing circumstances in a purely positive or negative light. Just as Hesse's Steppenwolf greeted the good and sublime with scepticism and scorn, so too was Mao Xuhui wary of "beauty", arguing that beauty was violence that "once stepped on, will explode." August 1986 was a time when Mao Xuhui could feel the horizons of possibility in art expanding. At the very least, he had found others who shared the values he had independently formed over the years, which naturally made him excited about the future. He also truly believed in the genuine talent of his fellow southwestern artists and wrote them a poem entitled *To the Sons of the South: The First Ode* (*Zhi nanfang zhi zi: di yi ge*). However, despite being born from giddy optimism, this poem nonetheless incorporates conflict and the possibility of failure into its message of hope. In the opening lines that elaborate on the poem's title, he writes:

To all those tearful days
To all those rising stars of the South
On those days when nothing was certain
You and I were kissed to death by the lips of the moment
Its huge tongue sweeping away all hope

No meaning is absolute, no judgment singularly correct; nothing hoped for ever comes about effortlessly. Completed in December of that year, the poem *To the Sons of the South: The Second Ode* (*Zhi nanfang zhi zi: di er ge*) closes with a blessing imbued with an ominous sense of trials to come.

The Sons of the South
I have wished
Hoped
To rush to the graveyard
With your branches
The sprouted and the yet to sprout
And fulfil the calling of this boundless cemetery
—To rise from one kind of captivity
To the fate of another

A sense that one is driven by a greater purpose perhaps unites most young artists active during the 1980s. It was common to see people who saw their artistic work as a sacred duty requiring self-restraint. Their artistic manifestos and pronouncements are filled with expressions of bold ambition; characterised by loss and loneliness, but "still craving struggles imbued with unusual emotion". However,

as we have seen, the precise meaning of words like "cemetery", "grave" and "prisoner" in Mao Xuhui's writing remains unclear. This is not because he is unable to explain himself; it is more that in this age of contradictions, something unutterable has formed in his mind, something that touches on duty and doubt, which can make even the word "cemetery" no longer necessarily a site of loss and sacrifice.

We have often seen how this native son, this lover of the south, constantly yearned for love. As such, many of his poems and diary entries reflect upon the mood engendered by a single moment, period of time, or memory. This too is an important trait of the Steppenwolf whose anxious howls are shot through with compassion and an emotional response to quotidian oppression. The surging emotions that Mao Xuhui occasionally put to paper emerged in fragmented form, but this was what he considered the most authentic means of reproducing life, which itself was experienced in a fragmented way. An observer need not and could not refer to common sense to connect these fragments. That would contradict the real life of the Steppenwolf, which in the case of Mao Xuhui from 1985 to 1987 consisted of anticipation, exuberance, anxiety, love, longing, grief and plaintive howls:

It is these steps that remind me of you
These two tender drops that preserve
Your caresses
I came entirely for all this
But I have never made sense of that fact

Many things have been revealed by madness
We drink down booze and throw up tears
But there's so much more, mingled into the multicolour of dreams
That has forever lost its way

From one corner to another
The dreams extending from each miniscule part
Shade and gloom hang off every leaf
Some float away in the wind
Some fall on the stone steps and are washed away by the rain

To what specific event this poem refers is difficult to say, but the pages that follow record the period leading up to the break-up of his family. He had just left behind the solace his friends had provided at the Sunlit Courtyard in the Sichuan Institute of Fine Arts, and on the road back to Kunming he attempted to sort through his confused thoughts about emotion, art and tears:

Emotion:
I am the absurd one. Half an hour earlier, "parting for life" didn't faze me, whereas now I have truly fallen deep into this well.
Art—When language ceases, when language is not (or has stopped) working, when language is powerless, one has entered the realm of art—this fertile soil.

Art—Non-language.

Art—A form of existence.

Tears come from the heart.

The heart governs tears. By the time tears flow from the body, the heart has already borne a great deal. . .[80]

Mao Xuhui clearly craved a certain tenderness, which is why he wrote that his time in the Sunlit Courtyard had restored his humanity, memory and singing voice. Many regard the wolf roaming through the wasteland as merely a wild, howling beast, but if you place him in a warm and caring environment, he will acquire the characteristics and habits of a human. Mao Xuhui wrote that during his nights singing and discussing art at the Sunlit Courtyard "something that had been buried in me for some time cheerfully returned, as though emerging all of a sudden from the black of night". This trip to Chongqing also provided Mao Xuhui with solace of a more romantic form: "Meizi purifies my feelings. In her eyes, I see my own unspent youth. Before her I feel old and that only love can revive me." As he walked along the banks of Jialing River, the flowing water, fishermen hard at work, cargo ships and riverboats moored at the wharf, and glittering reflection of city lights on the river's surface were all images imprinted in Mao Xuhui's mind, but when the woman who had captured his attention waved goodbye, "with her heart-wrenching posture and immaculate face", he realised: "I no longer have the courage to stay any longer." Nonetheless, he felt a reluctance to leave, which can be seen in his letter to Zhang Xiaogang: "Gang'r, my good friend, we have so much still to say to one another that we will never run out." Yet with his pending return to the wilds of society, this Steppenwolf began to recover some of his former determination: "We need to spare some of our energy to take on society, to win society's recognition. We have to become a bit more 'vulgar'." When Mao Xuhui heard that Zhang Xiaogang was to hold what would be considered the Fourth New Figurative Exhibition at the Sichuan Institute of Fine Arts, he had already begun to consider the New Figurative as a stimulant that would stir up people's way of thinking and "ferment their organisms". In this letter, Mao Xuhui encouraged Zhang Xiaogang to expand the New Figurative's influence in terms so energising and frenetic as to resemble mania:

Fortunately, we have faced tragedy more than once, and thus it rises and rises, opening up new realms of solitude and emptiness. It began with the smashing of glasses by our "Seine"! It began with the maize wine we drank on old Guishan! It began with us vomiting like wolves, with the moon turning ugly on those raucous singing nights! It has begun over a hundred times!!! Alcohol has scorched our lungs, our stomachs and our throats, but it all began long before that!! The world has long enjoyed the semen, "high protein" and bodily saline of our youth!! I truly want to cry out that we are the source of the world!!![81]

Two days prior to this, Mao Xuhui had gone with his girlfriend Sun Guojuan to the hospital to visit Pan Dehai who was ill. He cared deeply for him and was concerned with his spiritual condition. Pan Dehai's aversion to the city, his love

of the mountainous wilderness and his depictions of tranquil environments moved Mao Xuhui. In the above letter to Zhang Xiaogang, Mao Xuhui also discussed his views about the critics from Beijing he had encountered at the Zhuhai Conference, particularly Zhang Qiang, although he also noted that there were delicate personal relationships between many of the Beijing critics, like Chen Weihe and Gao Minglu. Mao Xuhui's primary concern at this stage was clearly not questions of the soul, but rather how to find a path to success in the wilds of society. For example, he hoped to find a critic with a lot of sway in artistic circles to help promote the New Figurative. In a letter written to Zhang Xiaogang on 5 January 1987, Mao Xuhui explicitly argued that the New Figurative was intimately related to the '85 Art Movement. He wanted Zhang Xiaogang to understand that, "Reality is where we must act, in the current, and at the moment the focus for over a year has been on the '85 Movement. We are a part of that focal point." As such, the aim of their endeavours, no matter what form they ended up taking, was to contribute to the achievements of the '85 Art Movement: "This is a high point in the history of Chinese modern art. It will feature in every art history, just like Cheng Conglin, Chen Danqing and Luo Zhongli's *Father*."

Mao Xuhui noted that Hesse considered all artists to be Steppenwolves. He felt that one of Hesse's paragraphs about artists, which he underlined in red, validated and supported his own spiritual world. The passage is as follows:

These persons all have two souls, two beings within them. There is God and the devil in them; the mother's blood and the father's; the capacity for happiness and the capacity for suffering; and in just such a state of enmity and entanglement towards and within each other as were the wolf and man in Harry. And these men, for whom life has no repose, live at times in their rare moments of happiness with such strength and indescribable beauty, the spray of their moment's happiness is flung so high and dazzlingly over the wide sea of suffering, that the light of it, spreading its radiance, touches others too with its enchantment. Thus, like a precious, fleeting foam over the sea of suffering arise all those works of art.[82]

Those who have read the fiction of Hermann Hesse will understand why Mao Xuhui and his friend Zhang Xiaogang were so fond of his work. On the level of the soul, the two of them shared something with this German writer: all three regarded themselves as sufferers of mental illness, believed that the era and society in which they lived had fractured their humanity, and considered themselves homeless, like the wolf of Hesse's novel, relentlessly hunted by fate and tormented by the psychological pathologies of the age. Many of Mao Xuhui's friends, all of whom began as expressionists, shared these tendencies. Their lives lacked stability and they had no interest in a calm and peaceful existence. But music was something in which they had faith. They believed in Bach, Mozart, Beethoven, Tchaikovsky, Rachmaninoff and Shostakovich, believed that salvation might await them in the intangible world of music. In the period of free market reforms after the Cultural Revolution, China was bound to experience a crisis of faith, which led to the depravity and vice that Mao Xuhui and his associates sought to portray in their art. They expressed their spiritual suffering and plight through the unique images that arose

from their individual psyches. More than personal success, these Steppenwolves yearned for external affirmation of their values. They looked down upon the habits of their age, doubted the world, even their own lives, and viewed the question of the meaning of life through the prism of their own mental suffering and artistic practice.

This was a time when Mao Xuhui was still an unknown artist with no influence to speak of, negligible in the eyes of the official artistic institutions and an insignificant presence in society more broadly. However, he dared to question his reality. He despised the existing social order and its way of life. Since opening his mind to modern art and philosophy, he had been uncomfortable with the status quo. The suffocating environment at work and the antiquated customs of society induced in him a kind of split personality. On a train, "I didn't talk with anyone for the whole thirty-hour journey. I wasn't in the mood. All I had were memories. That was my life. The carriage appeared particularly odious to me at that moment, every person in it odious, repulsive. We are inherently different from them. We live in a way that is utterly unimaginable to them. We have our world, and it is closed off to them entirely." He saw a great deal of himself in the pages of *Steppenwolf*; he too was a creature in which the natures of both human and wolf coexisted. He felt solitude, fell prey to passionate love and physical desire, listened to intense and discordant music, viewed things with cynicism and experienced the world intuitively. However, he was occasionally absorbed by what was tender and warm-hearted in life, as he wrote in a letter to Zhang Xiaogang on 31 March 1987: "Twelve hours of my day are consumed by a blind longing for little Maotou, then something prompts me to do a bit more painting. Whatever kind of father I may be, after all, I am still a father. A simple thought came to me: I would like for her, when she grows up and learns about the world, at least not to consider her old man who abandoned her a complete waste of space." Despite being written not long after his divorce, the emotional shock did not prevent Mao Xuhui from constantly thinking about art and share his anxiety about how to engage with the younger generation and their different conception of art, as well as his apprehension about participating in the modern art exhibition Gao Minglu was preparing to hold in the National Agricultural Exhibition Center in Beijing.[83]

As someone who had already developed his own way of responding to society, art and opportunity through his extensive reading, Mao Xuhui naturally cannot be reduced to a mere copy of Hesse's Steppenwolf. Born in Chongqing and raised in Kunming, he had received a Chinese education before his baptism into the church of modern Western philosophical thought. He grew up in an age that saw substantial and rapid transformations to people's ways of living, seeing and behaving. Such an environment contributed to his distinct personality, attitude, morality and habits, which defy neat categorisation. He seems to have seen himself as something akin to a heinous nocturnal wanderer,[84] a species of animal that only at night could exercise its powers of imagination, weave fantasies about the future, and gather with kindred spirits to discuss the meaning of solitude, that elusive state the pursuit of which unites all nocturnal creatures. Mao Xuhui often discussed loneliness with his friends who were proud of their solitude as "Old Cossacks",[85] which could be seen from their preference for strolling by the banks of the river at night. They also liked to discuss death and imagine it in aesthetic terms, reflecting their desire not

to live like ordinary people but rather to find fulfilment in life through an understanding of death. It was in fact their pursuit of solitude that allowed them to better understand the implications of death and develop keener sympathies with historical figures who committed suicide. There was something paradoxical about this way of thinking. As Hesse theorised, the Steppenwolf is suicidal, but suicide itself has no necessary place in the Steppenwolf's being. The Steppenwolf has a sacred calling, which requires him to recreate death and suicide in art as a means of warning humanity of the painful paradox at the heart of human existence: death is only as necessary as life's resistance against it.[86] As such, "For us they are suicides nonetheless; for they see death and not life as the releaser. They are ready to cast themselves away in surrender, to be extinguished and to go back to the beginning."[87] By this line in his copy of *Steppenwolf*, Mao Xuhui wrote, "Portray living instinct through death." Aside from helping him grasp the meaning of Hesse's work, Mao Xuhui's reading afforded him an insight into his own predicament. His experience was completely different from that of Hesse, but in the sentences and descriptions he read in his Chinese translation of *Steppenwolf*, he perceived something he shared with the book's author: a common understanding of life. He did not belong to what Hesse described as the "bourgeoisie", because there was no such class in the society in which he lived, but he felt a certain kinship with the misfits only reluctantly accommodated by the bourgeoisie in Hesse's novels. They were fierce and wild. Whether sages or drunkards, they each possessed a powerful drive, a unity of the soul.

However, it is not merely in the light of Hesse that Mao Xuhui's soul acquires its multifaceted complexity. Mao Xuhui's own life and artistic journey prevent us from judging him in terms of simple binaries. This stage of his life and his journey going forward would frequently see him vacillating between two opposing poles of the numerous dichotomies he faced. Despite the guilt he felt about his family and daughter, he could not resist the draw of other women. He understood the appeal of the pastoral and idyllic but was nonetheless fascinated by the theatre of real life. He believed in the purity of the soul while yearning for social influence and acceptance (he never truly gave up on the idea of collaborating with official organisations like the Artists Association). He sought success on a secular level despite knowing this was not where the true meaning of life was to be found.

All these aspects of his character took shape at this period of his life, nourished by the books he continued to read. It was this state of inner conflict, in which contradictory elements co-existed in the psyche, which so often tormented Mao Xuhui and his friends. Just as Hesse argued, ordinary people could not cope with multiple souls living inside them, but it was possible for artists to sublimate these contradictions into their art. This is the reason for the almost convulsive quality we see in the work of these sensitive expressionist painters.

In any case, 1987 saw no miracles transpire for the Kunming artists. The blow dealt to the "New Figurative: Fourth Touring Academic Exhibition" (*Xin juxiang: di si jie xunhui xueshu huodong zhan*), which was held toward the end of 1986 in the Sichuan Fine Arts Institute, had Zhang Xiaogang in such a chronic state of despondency that Mao Xuhui was still attempting to console him in May 1987, albeit without being able to refrain from recounting his own conflicts and frustrations.

This was a time when they liked to describe their daily bouts of depression, anxiety, nihilism and escapism as symptoms of a late-twentieth-century disease, comforting each other by giving their condition a cultural character. They might have described themselves as Old Cossacks, but they tended to approach the problems they faced with the spiritual temperament of European, mostly Parisian, artists. Aside from discussing art, world and spirit with his friends, Mao Xuhui was also worried about specific issues in his daily life:

> *Lately I haven't wanted to write letters because a thick emptiness has pervaded my mind. A powerful gloom has descended upon me, which hasn't so much numbed me as rendered me catatonic. Life continues to slip away as though the past is congealing into a melancholic banquet lit only by the moon while my heart continues to cling to various feelings of love. Life, in a state of inaction on these long, impulse-less, scorching days, is killing itself drop by drop. . . I wonder if I had better put a stop to it!!*
> *I'm living alone now at the film company. It's completely over. But I'm in an awful state. The image of little Maotou keeps appearing in my dreams, tormenting me. The river of my consciousness flows through my life without end, constantly repeating itself, my past firmly embedded in my living present.*[88]

In this letter Mao Xuhui comes across as a nervous wreck on the brink of a breakdown, a mental state that was mirrored by that of Zhang Xiaogang who was similarly depressed. The spiritual connection between these two friends was one of tacit understanding and mutual support. When in need of encouragement, comforting words would emerge from the complex psychological quagmire like a refreshing breeze to the soul, reminding them of the importance of self-preservation:

> *It's been a while, but today I finally received a letter from my old friend in Yunnan! Reading it rekindled that feeling of emptiness that until now had been gradually subsiding. What's up with this year? The world outside is so barren and yet our inner world continues to "fester": it's terrifying. Brother Mao, if I'm being honest, I think this condition is fatal. Should the sublimation of a tragic consciousness lead to greater courage? Or should we yield to sentimentality as we lick our own wounds and let the hot blood of life continue to flow in vain in our veins? I hope this blood can be linked to specific events in our lives so that we can mitigate as much as possible the split between spirit and flesh, reality and thought. Perhaps to speculate in this way is simply to indulge in idealism, but it does not mean we should compromise ourselves for those things we hate but rather work ever harder to make our spirits concrete. The Old Cossacks might be nihilists, but we also cannot free ourselves from a sense of responsibility. For us, the most terrifying enemy of this contradictory, melodramatic state of mind is the mentality of the so-called "cynical" literati. It frequently causes us, when faced with reality, to vacillate between two poles, either excessively projecting our illusions upon reality or regarding reality as a rotten sore, a putrid miasma. But reality is, after all, reality. What is the best reality? Perhaps it is the reality that allows our spirits to develop, to be sublimated, to achieve a certain concrete expression?*

It matters not if it is day or night. Old Mao, recently in the real world, I find myself coming up against brick wall after brick wall, facing one dilemma after another. I truly wish we could, in a "superficial" way, return to how we were as students, but obviously this is impossible. We have been through too much. I only hope we can turn what we've been through into riches and not simply baggage. Writing this, I suddenly remember how I used to worship the giant Kuafu. I still crave Kuafu's spirit—a new Kuafu with tragic consciousness who is bursting with love.

In your letter you write, "What is to be done? The world is increasingly devoid of a clear meaning to urge the flesh forward." I think this sentence really gets to the bottom of our present state of nihilism. It's true that with the passage of time, we have increasingly come to feel the power of the absurd. Former ideals and passions often seem pale and weak in comparison, even ridiculous. But Old Mao, I suddenly have this feeling that perhaps it is precisely the "madmen" who drive world history, these ridiculous "children" who magnify what was once meaningless into something that makes sense. They're the ones who in this ridiculous drive rob some things of their meaning and imbue others with new meaning, until they become "something essential". A couple of days ago, I wrote in my notebook, "Since it has become reasonable for contradictions to exist, absurdity too must become a form of truth—to be 'loved' rather than just questioned?"[89]

Zhang Xiaogang's words of comfort were naturally helpful, but Mao Xuhui's personal situation nonetheless continued to affect him as he roamed the spiritual wilderness, a lone Steppenwolf. Whether consciously or unconsciously, his ideas began to evolve with the incidental emotional responses he had to the plethora of mundane affairs he encountered every day, from listening to pop music to taking his daughter swimming in Haigeng Park, from understanding Western thought to pining for the countryside, from gathering with friends to imagining his own future, from helping a girl apply to art academy to keeping friends posted with recent updates:

I've found it difficult to move on from this state I've been in recently. On the surface I look mostly the same. I'm talking with people, having deep, frank and spirited conversations with friends over drinks. Sometimes I end up cooking with some simple-minded women as we listen to Su Rui or Fei Xiang.[90] *And recently I've been taking Mao Yu*[91] *to swim and sunbathe in Haigeng. This is all very normal, very healthy. But that emptiness comes from the depths of my soul, those moulding parts of the subconscious I have yet to make sense of. I hate this feeling and I don't want to bring this disease into the rooms of my friends. Perhaps this is the way the world punishes eternal idealists like us, or perhaps it is a kind of favour. Either way, I find it difficult to escape. Who would want to seal themselves off in such an impersonal void? Apart from Proust, Joyce and Kafka, there are few who would willingly set foot in such a terrible place. We need a life and worldview that is full of human warmth. We would like to live a far more superficial life than we do now. There is no need for us to devote mind and body to the establishment of a religion of art, especially on this vast land of ours. We should strive to escape from that half-finished, ruinous temple and*

244 | Steppenwolf

instead get closer to the atmosphere of the "village" where we might find new feeling and liberation. I would genuinely like to take a break. After all the non-stop stuff that has been happening over the last few years, I feel exhausted. A few days ago, in this exhaustion, I had my thirty-first birthday and some friends got together for a few quiet drinks. I just want to relax and take it easy for a while. I know what this will bring, but I don't want to think about it too much. I just want to go with the flow. Maybe I'll end up the kind of person I once despised, but just like all those returning from the exile of the First World War, I just want to relax a little. I know there is not much to enjoy but I just want a little spiritual and conceptual relaxation. That's it, I guess![92]

There was nothing out of the ordinary about his situation, with the exception of a few issues in his love life,[93] but what distinguished Mao Xuhui and his friends from others was their desire to find in the ordinary something meaningful and valuable about life—a reason to exist. Conscious of Mao Xuhui's disenchantment, Zhang Xiaogang offered the following words of encouragement: "Perhaps meaning is all the accidents that occur in the struggle for a greater nothingness?"[94]

One day in 1986, Mao Xuhui made a sketch with bamboo and fountain pens, which he called *Steppenwolf*. In it are four nude bodies, of which only the one lying prostrate on the ground smoking cigarettes seems to be male, perhaps a reflection of the artist's entanglements with women. These figures occupy the wilderness of southern China where they exhibit a listless boredom. The woman in the foreground is painted in the form of an animal on all fours, a symbol of the wolf. Mao Xuhui is not merely describing himself in this painting but also his generation, the grinding ennui and solitude of all those young artists trying to make sense of life. Having reacquainted themselves with nature, they believed in the purity of the naked body but had no idea how to proceed in the wilderness of reality. Smoking, drinking, fucking, painting—it was all simply an imitation of the lifestyles and attitudes of *fin-de-siècle* Europe. They did not want to return to their places amongst the masses of ordinary society and were even more disgusted by official ideology. They simply wanted to paint from the heart. They knew this was a sickness, but it was a sickness they willingly accepted and hoped to share with the world.

 collection of writings and drawings, the notebook labelled "1986, 2 Heping Village, Notebook #1" includes Mao Xuhui's various thoughts about painting and, aside from providing an insight into what he has learnt and experienced, also reveals the dynamism of his unconscious. Unlike their northern counterparts, the southern artists based their understanding of life and art on intuition and had no qualms about indulging in what Wang Guangyi described as the "pathological" and "peripheral":

The art of painting ultimately comes out of the actual process of painting itself. It relies on sensation, receptivity and intuition. If knowledge cannot be transformed into sensory receptivity, then no knowledge however deep or broad can ever produce art.[95]

This is a similar view of art to that held by the Western expressionists, one that emphasises intuition and feeling, the integration of art and life. Mao Xuhui was familiar with many definitions of art, but he was more interested in what lay beyond the reach of such definitions: "More importantly, we must attend to those vague and undefined things and endow them with a means of expression, a form by which to be made manifest." Statements such as these recall Beckmann's stated aim of making "the invisible visible". Mao Xuhui's view of art was one that advocated activating the unconscious, that vast mass of iceberg floating unseen beneath the surface: "Art is concerned with the most fundamental human issues, the existence and anguish of the spirit, and fantasy." As such, according to Mao Xuhui, artistic problems are human problems, the result of the mind in a state of antagonism from which it cannot break free.

In 1986, Mao Xuhui described in one of his notebooks two completely divergent psychic tendencies:

In my veins, my spirit, there exist two things. One is the powerful urge to get as far from reality as possible, which gives rise to myth; another is the stubborn

PSYCHOLOGICAL

NARRATIVE

Page 85 of "2 Heping Village, Notebook #2" (with kraft paper cover, including the draft for *Red Earth Dream*), 1986

insistence on confronting reality, to peel myself layer by layer to see what lies beneath in all its raw, bloody, unacceptable glory. The hideous, tragic, dark, dismal, empty—this is the part I call figurative, philosophical, rational realism.[96]

The works completed between 1985 and 1987 clearly embody this understanding of his situation. The impact of dreams was weaker than that of reality. The image of Guishan formed the theme and allure of his dream world, but it was the concreteness of everyday life that most disturbed Mao Xuhui's mind. Although Guishan and pastoral scenes (occasionally of Eden itself) remained with him, it was his response to his immediate surroundings that most guided him. He remained in the habit of keeping an illustrated diary in which the psychological events that left the strongest emotional impression on him were always recorded in ink. Some of these sketches would form the basis for future oil paintings. From some of the manuscripts he produced in September 1985, not long after returning from the chaos and excitement of the First New Figurative exhibitions, we can see that he was still in the state of frenzy he had occupied while trying to raise money and organise the events in Shanghai and Nanjing. A certain frantic hysteria can be discerned in the lonely wandering soul in *Mountain Spirit* (*Shan shen*), while the dancing figures in *Night* (*Ye*) evoke uneasy desire. It was a time perhaps when sexual desire had a powerful influence on his state of mind, and he explored the extremes of desire between the sexes through the themes of works like *Adam and Eve* (*Yadang yu xiawa*) and *Night: Self-Portrait* (*Ye: zihuaxiang*). This mindset led him to reduce the meaning of human life to "biological survival", which was less how he saw the world than a way to give expression to his internal desires. He also produced two surrealist compositions that included images from the history of art, such as works by Van Gogh and Millet. It was a time when his mind was awash with fantasy and uncertainty. He was trying to think through the question of how to proceed with his art, but a tumult of primal urges kept interfering with the language of his thought. A few works depicting his living environment in Heping Village, which were included in the Third New Figurative Exhibition, demonstrated that Mao Xuhui had turned his

attention to his physical surroundings. In contrast to the "Guishan" or "Corporeal" series, the environment he saw and inhabited every day had become something Mao Xuhui was no longer able to avoid.

Life for Mao Xuhui in 1986 was no different from before. He did not produce many works with a bamboo pen and those he did remained thematically concerned predominantly with the confusion and depravity of life, from the emotionally erratic depictions of naked men and women in *If. . .* (*Ruguo. . .*)—on which drawing the following words appear: "Life survives, time blurs, possibility, all traces. If you were perhaps at this moment to leave, would. . .?"—to portrayals of himself in a state of bewildered agitation, like *Another Self-Portrait* (*You yi ge zihuaxiang*). Such works tended to depict human figures indoors and would become part of the "Personal Space" (*Siren kongjian*) series, of which many pieces were exhibited at the Third New Figurative Exhibition. In these intense portrayals of severe mental agitation, Mao Xuhui focuses on the everyday. Restless, jittery bodies depicted in an expressionist style are confined to simple concrete rooms in these works, which invite a metaphorical reading: it is the soul itself that is being constrained within an intangible space. More than a year earlier, when on a work trip to Chongqing in June 1984, Mao Xuhui recorded the feelings evoked in him by the room he was staying in and rooms in general. Far from describing a fascination with the formal properties of rooms, this was an account of the subtle psychological responses he had as a living being to occupying different spaces.

A yellow door, the windows two black blocks. The iron bedframe is interesting, a navy-blue grey with patches of brown showing through. The white wall appears grey in the daylight, darker where it meets the ceiling and gradually fading as you go down. The bedsheets have that greyish yellow colour of skin. The pillow is red, the floorboards a dense brown grey. This is the room I am staying in in Chongqing. It is quiet. It had nine people sleeping here before but now they've gone, leaving me to enjoy the peace and quiet. The curtains are dark green and look beautiful against the light. It's raining outside in this grey city of puddles and footsteps. A fan hangs from the ceiling, its blades a pleasant faded yellow that absorbs the light reflecting from the silver grey of the walls—translucent, graceful. All of this enters my memory, the boundless storage capacity of my mind. I have so much to say about the rooms I have encountered: the room I slept in as a child, my friends' rooms, rooms at home, and the rooms I have seen in books and films. There are damp rooms, bright rooms, and rooms with strange smells. Then there are the short, squat houses of farmers and ethnic minorities, houses stained black with smoke and made of brick, wood or bamboo. The room is a silent place. I have survived in many rooms, sometimes amongst other people, sometimes alone.[97]

As we have seen in the "Red Corporeal" and "Guishan" series, Mao Xuhui's works tend to reflect the complexity of his spiritual world, which incorporates the instinctive and sublime, the manic and lyrical, the desolate and pastoral. Such a condition is reminiscent of Hesse's reflections on the psyche in *Steppenwolf*. There is no simple unified self; each of us is rather, "in the highest degree a manifold

world, a constellated heaven, a chaos of forms, of states and stages, of inheritances and potentialities".[98] This is why we see no purely idyllic or pastoral scenes in Mao Xuhui's "Guishan" series; an instinctual terror or unease is discernible even in his attempts to "return to nature."

Indeed, as one of Mao Xuhui's favourite lines in *Steppenwolf* puts it, "There is, in fact, no way back either to the wolf or to the child".[99] The present experience of life therefore becomes the foundation upon which spirituality rests and, in Mao Xuhui's case, this meant suffering, unhappiness and discomfort, which is why he did not choose to explore happiness, contentment, joy, relief or freedom. "We need imprisonment, jail cells, torture; we need to forever torment, coerce and terrorise our hearts and nerves; we need to make our consciousness gasp for breath; we need to repress, contort and ruthlessly flog ourselves. Only then, can one attain human value, for all of this is the motivation, the driving force behind moments of inspiration." This masochistic tendency was in fact a broader social phenomenon related to the fact that artists had been forced to reconceptualise their values after becoming disenchanted from the ideals, idols and objectives they had formerly held in great esteem. Since, as far as these artists and their generation were concerned, the ideals and values that had previously sustained life had been undermined by history and the world around them, where was the meaning of life to be found? This was a perfectly natural question to ask, and it was one to which Mao Xuhui sought the answer in the thought of Western philosophers like Schopenhauer, Nietzsche and Sartre. By familiarising ourselves with the environment in which Mao Xuhui lived, including the cultural climate at the time, we can see that he found it so easy to accept these ideas because it would have been impossible to continue without them. The "personal space" theme forms part of a spiritual totality that includes the themes addressed by "Red Corporeal" and "Guishan" series, albeit one that contains a further level of social analysis.

Mao Xuhui's meditations on the concept of personal space first began with the outdoors (which of course could similarly be considered part of one's "personal space"). A number of watercolours completed in 1985 like *Redbrick Building: Window* (*Hongzhuan lou: chuangzi*) and *Redbrick Building: Alleyway* (*Hongzhuan lou: hutong*) depict a mundane world formed of various commonplace objects like red bricks, asbestos tiles, water pipes, electric cables, household items and various detritus. In contrast to the impulsiveness of the "Red Corporeal" series, there is a certain cool composure to these paintings in which the shape of each object is clearly described. The artist's inner turmoil is however discernible in the chaotic way the objects are scattered throughout the scene, giving rise to a series of interesting formal relations between the various elements. The overall effect of the red bricks, asbestos tiles and other objects however is a suffocating sense of confinement.

There is an interesting contrast to be drawn between human and animal in both these paintings where the cat depicted seems to be freer than the human figure with whom it shares the canvas. The human is either imprisoned in a dull, concrete room (*Redbrick Building: Window*) or obliterated by sunlight (*Redbrick Building: Alleyway*). Whether indoors or outdoors, humans suffer the same torment, a torment made all the crueller for the fact that it is inescapable. When Mao Xuhui

turns his sober gaze to reality, the ideal landscapes of Guishan dissolve into dust. Even if the cats in these paintings are taken to represent the possibility or hope for a "return to nature", we know that any consideration of the animal in relation to its environment is bound to end in tragedy.

Completed in 1986, the oil painting *Personal Space: Human Body in Concrete House* (*Siren kongjian: shuini fangjian li de ren* resembles what Mao Xuhui referred to as "torture". A shrivelled, naked body lies supine on a concrete slab with which it shares a similar texture, its skin so desiccated and hard that one can almost hear the scraping sound it might make on contact with the concrete beneath it. This life is being tortured, whipped, frozen, roasted, and drained by mysterious forces.

Unlike the portrayal of absolute death in *Personal Space: Human Body in Concrete House*, the human figure in *Human Body in Concrete Room: Noon* (*Shuini fangjian li de renti: zhengwu*) has been positioned in such a way as to reveal a sliver of vitality. However, while it struggles for life, this similarly fossilised body's chances of survival are no greater than the figure splayed on a concrete slab. It has been provided a window, but it is closed and the scene it contains implies that the world outside provides no possibilities for life either. There is no difference between indoors and outdoors, of this the artist is sure, and as such the window has been robbed of its practical purpose and transformed into mere ornament of no benefit to life.

Human Body in Concrete Room: A Few States (*Shuini fangjian li de renti: ji zhong zhuangtai*) portrays the struggle of life in an indifferent space by depicting four human figures that one need not interpret as different people. They are rather different states of helplessness occupied by the same life at different times. In this painting the artist has presented us with a space in which, although there are no instruments of torture to be seen, life is nonetheless interminably tortured by some invisible device that flips life on its head and subjects it to torment. Such a place is not a far cry from hell for any living being. Later Mao Xuhui would describe these works as follows: "*Human Body in Concrete Room: A Few States* and *Human Body in Concrete Room: Noon* depict the state of sentient life confined to the suffocating space enclosed within indifferent concrete walls and ceiling. I have lived a long time in just such a concrete room, the cramped and dry space full of shadows from morning to night. . . The thought of a lifetime being spent in such a place fills me with a kind of terror. But in truth, I cannot leave this kind of room." From these few paintings we can clearly see that the question of death lies at the heart of the "personal space" theme. Mao Xuhui hoped to use his art as "a response to life and death". It is worth noting that his approach to providing a response to the question of life and death was to portray individual experience, or the actual states an individual occupies, through expressive symbols stripped of their material quality.

There is no such thing as absolutely individualist art. In a society undergoing a historical transformation, an artist's work discloses to the public the universal secret that all people share but are unwilling, afraid or unable to articulate. We might be able to disguise our anaemic bodies with fancy clothes or conceal our ignorance with a muscular physique, but far from resolving the contradictions that forever plague the spirit, such behaviour only sharpens them. Rather than trying to solve an individual's specific problems, an artist picks at the festering sores in

society. These sores were always bound to burst sooner or later so even if there were no art, they would eventually be discovered. What the artist offers, therefore, is a kind of critical prophecy.

The artist's view might be extremely one-sided, and this one-sidedness can act as a kind of symbolic suicide that reveals social problems. As such, an artist's ideas can often be considered too extreme. Many people, after all, even if they would readily admit the world isn't perfect, are reasonably satisfied with life. Artists lead the charge against death in an attempt to reveal the severity of the problem, thereby providing salvation for the life of the human race even if it means sacrificing their own lives in the process. It is therefore an appeal to the possibility of health that is being made through Mao Xuhui's morbid depictions of convulsing bodies, a gesture towards the idealist notions of dignity and the sublime.

A viewer confronted with *Personal Space: Weekend* (*Siren kongjian: zhoumo*), *Personal Space: Self-Imprisonment* (*Siren kongjian: ziqiu*) and *Married Couple in Concrete Room* (*Shuini fangjian li de fufu*) might insist that they represent a kind of extreme individualism, because they seem to be related only to the artist's personal experiences.

In *Personal Space: Weekend*, we find a man and a woman sitting naked on a familiar concrete slab with expressions of indifference that fail to conceal their inner confusion and unease. The open door and grey-white arrow in the background alert us to the vulnerability of this personal space that at any moment could be (and in fact already has been) invaded. Furthermore, it is a personal space in a state of solitude, because the two lives that could have become one instead threaten each other. The life that once pervaded the room is gone, the two figures now mere objects, the scene one of silence. The "weekend" typically evokes images of fun with friends, but this weekend is one of isolation. The oppressive atmosphere is only exacerbated by the painter's use of cold tones and the distorted forms of the human bodies he has depicted. The overall effect of the composition is one of endurance and restraint, which produces the sense that some terrifying latent malevolent force might burst to the fore at any moment.

Of *Married Couple in Concrete Room*, Mao Xuhui once said: "This is a portrait of my painful family life. Adam and Eve are no longer lovers in the Garden of Eden and have instead become adversaries filled with mutual hostility and hatred. Yet, within each of them lies an ocean of suffering."[100] The impetus behind this painting did indeed arise from the artist's personal experience. In a certain sense, the work can be seen as a mirror reflecting the reality of the misfortunes he faced in his own family life. In this work, we see Mao Xuhui considering the question of whether the issues he had to confront in his personal life and had always recorded in diary-like fashion could be better resolved on a more abstract level. With regards to this question, a very distinct symbol would emerge one year later, achieving its fullest expression in Mao Xuhui's artistic explorations of the "Patriarch" theme. Here we will see that elevating something to the "abstract level" means eliminating the particular experience of the individual.

What is certain is that the personal spaces Mao Xuhui depicted were never absolutely individual. He might have once described art as "entering the

concept of individualism", but this was a reflexive rejection of the previous age of "heroic collectivism".[101] The truth of the matter is that Mao Xuhui used the simplest and most direct examples at his disposal to recount the problems of life, producing concrete images of life's pitiful state to draw our full attention to these problems. Death as a theme is far more prominent in the "Personal Space" series than it is in his "Guishan" series, because in the former a desire for life is portrayed in the form of ailing, injured bodies (as opposed to Guishan, which was merely a poetic metaphor for death). According to this logic, death and despair are more authentic than life and hope, because a living thing is forever caught in an unending struggle to rescue itself: "Despair blesses humanity with the fortune of survival. Life achieves enlightenment through resurrection."[102] This is how Mao Xuhui saw the world.

Many years later, Mao Xuhui would discuss this period of his career: "Since 1986, most of my works have been directed towards the sense of crisis in my family and my own personal distress facing such a crisis. It all portrays the gradual disintegration of my marriage. . . I think the main reason for this crisis was the fact I put all of my energy into painting and paid little attention to my family. There was no way of truly reconciling family and painting, and in the end I chose painting, an outcome I think was ultimately inevitable. But there has always been a profound conflict within me that I have found difficult to balance."[103] The "Personal Space" series reflected this emotional state of mind. The writhing bodies of men and women were all merely symbols of the soul's disquiet, an artistic approach that was in line with what Mao Xuhui had advocated numerous times in various texts: appeal to what lies within, paint from intuition, disregard what is coherent.

1987 was an eventful year in Mao Xuhui's love life. In June, at a time when things were cooling down between him and Sun Guojuan, he wrote a letter to Zhang Xiaogang in which he expressed his interest in He Weina, a student at the Sichuan Fine Arts Institute High School with whom he seems to have had a brief romantic liaison.[104] In August, he took her to Pengjiafen, and one of his drawings made at the time includes the text "Life and love in Pengjiafen".[105] They returned to Kunming around early September, and Mao Xuhui's love of He Weina is evident in many of the ballpoint pen sketches he produced from August to September, which are intricate and full of passion, with the plants, surroundings and overall composition patiently and meticulously rendered. Mao Xuhui clearly drew from his memories of the verdant luxuriance of other parts of Yunnan like Xishuangbanna in these works which display the flourishing openness of life. The text in one of these sketches reads, "Dedicated to Nana. September 1987, belle, summer smile, tender summer, summer voice, those who love summer." Mao Xuhui collected all the sketches he produced in August and September of 1987 into what he called his "Summer" (*Xiatian*) series. The works produced at the height of summer in August were given titles like *Summer Voice* (*Xiatian de shengyin*), *Summer Pastoral* (*Xiatian muge*), *Hills and Wilds* (*Shanye*) and *A Brief Account of a Mountain Village* (*Shancun xiaoji*), but after mid-September, the names of his sketches took on a different character— *Summer Soon to Disappear* (*Kuaiyao xiaoshi de xiatian*) and *Disappearing Summer* (*Zhengzai xiaoshi de xiatian*)—which also reflected his emotional response to He Weina's imminent departure. Interestingly, one can easily make out the environment

252 | PSYCHOLOGICAL NARRATIVE

of Heping Village in the sketches Mao Xuhui began working on in mid-September, which, like the series of oil paintings he had produced earlier, he titled "Personal Space". These new works, however, were imbued with the exuberance, desire and eroticism of nature, forming a stark contrast with the repressive atmosphere of overwhelming tedium on display in his oil paintings of the same name. For Mao Xuhui, the concept of "personal space" signalled a return to the real world and the fading prominence of dreams. Beneath the sketch *Personal Space No. 2: Night Cloud* (*Siren kongjian zhi er: yewan de yun*), he wrote, "Autumn nights cannot converse with demons. Comfort comes from the leaves, wild grass and the temptation of horrors in the distant future. Trembling living souls, fragrant flesh, adorable gaffes and truth are all diluted and cleansed by the gods of nature." Memories of the purity of nature linger in this metropolitan personal space, which has begun to fill up with the flora, spirits and sexuality of the natural world. On 27 September, Mao Xuhui sketched a picture entitled *Autumn Evening Stroll* (*Qiuye de sanbu*). Having returned to the city streets to idly observe ordinary life, he found himself overcome by numbness and fatigue that drained the lustre from the evening scene of roads and pedestrians, making even his decision to wash his face and go out for a walk only a means to sleep earlier and hasten the arrival of the dream world. In early October, when He Weina had already returned to school in Chongqing, Mao Xuhui produced a sketch with ink and calligraphy brush that continued the lush style of his recent sketches but with a large blank space in which he could leave a written record of how he felt:

> *You are so beautiful when you arrive*
> *And even more so when you leave*
> *Beauty, an unspecified but intact*
> *Offering*
> *Destined to whisper soft*
> *Feelings*
> *Taking shape in the passage of time*
> *Becoming patterns on porcelain bottles*
> *Slowly slowly fully fully*
> *You come and go*
> *You leave and flow*
> *Old man Yeats*
> *Is already on his island*

Autumn was coming and Mao Xuhui was still immersed in memories of love when he painted two self-portraits titled *After Summer Disappeared* (*Xiatian xiaoshi zhi hou*), the second of which features the words, "A blue floral-patterned cloth hangs in the sky as summer disappears." In the middle of the picture, the cloth flutters in the wind while a goat seems to be playing with it, perhaps symbolising Mao Xuhui's memories of the playful relationship he had with his girlfriend.

From the work he produced in this period, it would seem that 1987 was still a year of troubled uncertainty for Mao Xuhui. He was yet to settle on a specific subject matter or expressive technique and instead continued to

experiment constantly with new methods. Guishan was still a theme he returned to in his work, but the former spiritual serenity of the naked figures he portrayed there was now replaced with a barbaric quality. In some works, like *Guishan Woman* (*Guishan nü*), he rendered Guishan and its ethnic minority inhabitants in blocks of flat monochrome colour. Most of the human figures in these works are depicted in a way that emphasises their unease and isolation. When it came to his own emotional experience, Mao Xuhui always liked either to paint self-portraits or insert himself into his compositions to imbue them with a kind of fraught despair. The brushwork on display in these works differs starkly from his explorations of more sweetly sentimental themes.

Interestingly, Mao Xuhui was still obsessed with Picasso. Many of his drafts feature objects decomposed into cubist blocks in a manner that immediately recalls Picasso's work. He made liberal use of this cubist technique of block decomposition in preliminary drafts for his "Guishan" series. He even drew himself and Picasso facing one another, which was a line of thought that had an influence on his collage work. He had been working intermittently with collage and mixed media since 1983. Aside from a handful of pieces that shared the psychologically oppressive character of the "Personal Space" series, most of his collage and mixed media works were primarily guided by a Dadaist rejection of meaning as such.

"When there's nothing else to be said, when you have reached such extremes as to have escaped the confinement of all concepts, you discover that things have multiple meanings that are often misunderstood. You realise there's no need to be superior. A friend once told me that rubbish was as lovely as a nightingale. I think this is often the case." Mao Xuhui was experimenting with "cardboard compositions" as early as 1984. He took the most common of everyday materials, discarded cardboard boxes, and after emptying them and cutting them into pieces, pasted them back together to form new composite objects. These works might appear to be purely formal experiments, but this is not in fact where their function lies. In truth, these cardboard compositions lack any meaning whatsoever, even in an aesthetic sense. A nihilist inclination lay behind Mao Xuhui's decision to create these works, which are a result of escapism in the face of the ambiguity of meaning in life. After scar art, anti-art emerged as another trend that rejected the art of the past and could be seen in the Xiamen Dada movement of 1985, as well as Dada-inspired works by Gu Wenda and Wu Shanzhuan. This approach began gaining traction in the February 1989 "China/Avant-Garde Exhibition" (*Zhongguo xiandai yishu zhan*). Mao Xuhui did not seem to have considered the linguistic implications of the logical relationship between destruction and reconstruction. His cardboard compositions were more markers of his mood, visual traces of his sense of boredom, a record of the aimless actions of a man, cowed into a state of nervous turmoil, succumbing to idiocy. We can see a disorder of the soul in many of the pieces produced around this time, which reflect his instinctual awareness of the fact that the meaning according to which people were accustomed to living their lives was empty: "We need idiots. Idiots are important."[106]

The collage and mixed media works *Boring Days* (*Wuliao de rizi*) and *Premonition* (*Yugan*) tell a story of spiritual degeneracy and decay. Newspaper forms the

base of *Boring Days*, providing it with an outdated feel, upon which the scrawled human figures in the artist's humorous collage inspire sympathy for their state of boredom. No matter how one regards this work, the effect of the choice and use of materials cannot be described as "beautiful", "harmonious", "sophisticated" or "healthy".

From a formal perspective, *Premonition* might appear very different from *Red Corporeal*, but in terms of the malevolent psychic force on display, they are not without similarity.

Those sharks, cuttlefish and monsters
That do evil in the oceans of our hearts
All those moments of uncertain intent,
The tempests, ignorant terrors, and premonitions;
Those "complexes" and "fixations"
Buried deep in the mind
All those helpless states, meaningless lives, solitary days;
All those peculiar nightmares and illusions that
Unfold in dreams;
All those moments that make you feel
Inferior, forlorn, despondent;
All those uncontrollable impulses, ecstasies
And intoxications;
All those meditations on life and death,
Those confused adventures into the unknown;
Those swellings and expansions of the soul,
Its moments of intensity, impact and destruction;
They constitute life's questioning,
They constitute the soil of today's art
—It is a terrifying mother
Who teaches us to have enough courage, Amen!

The above text undoubtedly comes closest to providing an explanation for the meaning behind *Premonition*. We can conclude that the painting's visual symbols do indeed emerge from the artist's unconscious and that the work itself is an illustration of the pathological state that arises when the floodgates to the unconscious are opened. In comparison to the "Corporeal" series however, traces of metropolitan life are more prominent in these collage and mixed media works, which contain symbols that have a clear connection with a more familiar reality. Beauty appears in *Premonition* in the form of an image of a woman menaced by some demonic entity, torn apart by external forces. Furthermore, the alarming effect of the daubs of red on the canvas is only exacerbated by what initially seems to be an arbitrary selection of cuttings from film advertisements but on second viewing is revealed to be a quite deliberate arrangement that contains words like "death" and "trap".

Whilst in the same vein as *Boring Days* and *Premonition*, the collage *David and Venus* (*Dawei yu weinasi*) most corresponds to his state of mind at the time:

"*David and Venus* was a piece I made to pass the time when I was bored. Since people can be casually disposed of from the bottom up, what's left not to have fun with?"[107]

It is worth emphasising the fact that the ideas being explored in *David and Venus* are a result of Mao Xuhui's thoughts about art history as opposed to a direct enquiry into life's intrinsic needs. Boredom was certainly one of the factors behind creating this piece, which sees the artist working with cultural symbols, bringing to mind the pop art aesthetic Rauschenberg brought to China with his exhibition in 1985. The humour evoked in these works restores a sense of beauty that would otherwise have been erased by boredom. *David and Venus* is far from a mockery of classical art. By choosing Michelangelo's *David* and the *Venus de Milo*, two images very familiar to Chinese audiences, Mao Xuhui hoped to poke fun at the inflexibility of viewers' conceptions of art and even life. No value system is unique, and they can all be easily overturned.

Many of Mao Xuhui's collages make use of film advertisements and prints, partly because of his job doing promotional design for the Kunming Film Company. The glossy images of beautiful faces he worked with every day stood in stark contrast to the narrow stairways, rusting iron fences, mottled asbestos tiles, old sewage pipes, crumbling brick walls and clamorous voices that characterised his actual environment. He found the contrast upsetting, because the realisation that his surroundings could never be changed made him feel empty inside. In 1987, he began to apply collage to his quotidian environment in a manner that went beyond collage's ordinarily playful character, including works like *Childhood Memories* (*Tongnian jiyi*), which incorporated striking images from his past. These collage works see Mao Xuhui attempting to pioneer new expressionist techniques. He was still oscillating between different approaches and experimenting with different methods towards the end of 1987. He was naturally inclined toward expressionism, but his bold artistic ambitions remained far from satisfied. For many years, his artistic focus moved between Guishan, his personal life and a more private psychological narrative—often finishing the mentally gruelling work of fleshing out a psychological narrative at the same time as completing a more pleasant pastoral scene of Guishan. In 1987, the personal anxiety and sense of sexual oppression on display in Mao Xuhui's "Personal Space" paintings became even more grey and sombre. A work completed in April, and entitled *Personal Space: April* (*Siren kongjian: siyue*), features a man and woman in primitive natural surroundings. The grey tones and general mood of the painting evokes the unutterable gasping desire at the heart of human existence, albeit with more human vitality than some of the works he completed the previous month, like *Personal Space: Insomniac* (*Siren kongjian: shimianzhe*), *Personal Space: Self-Imprisonment* and *Personal Space: Dead-End* (*Siren kongjian: sijiao*). For Mao Xuhui, 1987 was a year of anxiety and emotional chaos. It was a time when, whether in his oil paintings, sketches or collages, sexual conflict and crises in love appeared more prominently and with greater intensity than in his previous work. The men and women he liked to place side by side in the confined space of his paintings never made love or snuggled up together, nor did they simply keep a respectful distance; rather they regarded one another with suspicion, scepticism, even antagonism. Collage after all is but a scene torn to pieces. We see here the psychic tension that

arises from a rapid shift in emotions, a tension that Mao Xuhui did not attempt to avoid but rather transferred to the canvas or page as if it were a diary entry, with little in the way of embellishment. He had learned these techniques from foreign exhibitions and painting albums. All that remained to him now was to use them to complete his psychological narrative.

In March 1987, Mao Xuhui and He Lide divorced. Not long after that, the on-and-off relationship he had had with Sun Guojuan also came to an end. Towards the end of the year, he started seeing a new girlfriend called Liu Xiaojin. All the romantic entanglements that had characterised his past were over. A painting called *Xiaojin*, which Mao Xuhui included in his "Personal Space" series, would serve as a tribute to this new relationship.

1 Translator's note: T. S. Eliot, *Collected Poems* (New York: Harcourt, Brace & World, 1963), p. 82.

2 In a letter written on 19 October 1984 (provided by Sun Guojuan), Mao Xuhui tells his girlfriend, with whom he was passionately in love at the time, "I bought two excellent books. One is *Mother Night*, a masterpiece of the contemporary American black humour master Kurt Vonnegut. The other one is written by the bloke who wrote the autobiographical *Peter Camenzind* that I've talked to you about before, the "last knight of German romanticism", Hermann Hesse, and it is a middle career masterpiece, *Narcissus and Goldmund*. I remember that night when we read some of the most profound excerpts from his novella *Gertrud* together."

3 See Chapter 2 of *Narcissus and Goldmund*: "In complete darkness they climbed through a window onto a pile of slippery-wet planks, one of which they pulled out and used as a bridge to cross the little stream. And now they were outside, on the pale glistening road that disappeared into the dark forest. All this was exciting and secret; he enjoyed it very much." And: "He climbed over the fence and trotted after the others out of the village toward the store. 'Never again!' commanded his will. 'Again! Tomorrow!' begged his heart." (Translator's note: Hermann Hesse, *Narcissus and Goldmund*, trans. Ursule Molinaro [New York: Bantam Books, 1968], pp. 19 and 22.)

4 Translator's note: Hermann Hesse, *Narcissus and Goldmund*, p. 152.

5 Translator's note: Hermann Hesse, *Narcissus and Goldmund*, p. 155.

6 Translator's note: Chongqing is built in the mountains where the Jialing and Yangtze Rivers meet. As such it is often called Mountain City.

7 Letter from Mao Xuhui to Zhang Xiaogang, 7 June 1984.

8 Nie Rongqing writes: "After meeting various painters from the plein-air school, Mao Xuhui . . . often went out to sketch with plein-air painters. In the garden, the Pei brothers stand in the first row facing the scenery. Su Xinhong is in the second row and standing behind him in the third row is Mao Xuhui. Lots of young painters are crowded around them, amongst whom is a frail and somewhat melancholy-looking teenager, Ye Yongqing." Nie Rongqing, *Colors of the Moat: Kunming Artists in the 1980s* (*Huchenghe de yanse: 20 shiji 80 niandai de kunming yishujia*) (Beijing: People's Fine Art Publishing House, 2015), p. 45.

9 Letter from Mao Xuhui to Zhang Xiaogang, 7 June 1984.

10 Ibid. The previous day on 6 June, in a letter Mao Xuhui wrote to his girlfriend Sun Guojuan (who kindly provided the letter), he explained his mood in Chongqing like this: "I'm stuck in Chongqing, caught in a Kafkaesque trap. I realise now that this trip was a mistake, and I feel very sad. I feel so unfortunate. Here, every minute, one faces a 34°C hot weather. Everything is numb. Life has become a mere corpse; lying down, sleeping, walking, one can't do anything. Every day, as noon approaches, you feel that the end of the world has come. I have become soft and weak, growing weak! . . . Life has come to an end, and this place is an inferno. I hate these densely packed buildings and crowds to death. The heaps of people, the piles of garbage and open graves—this cemetery is a furnace, and God is stoking the flames, trying to incinerate the people here in the intense heat."

11 "Art worker" itself is a title with historical and ideological roots, a term used by the Communist Party to emphasise the fact that painting and other artistic endeavours were simply tools in the service of the propaganda objectives of the party and nation. During the Cultural Revolution, the term "artist" was almost nowhere to be seen, usually replaced with the term "art worker". The task of "art workers" was to use their artistic talents to serve the requirements of realpolitik.

12 On 7 March 1983, the Head of the Publicity Department of the Communist Party of China Zhou Yang made a speech at the National Academic Conference in Commemoration of the 100th Anniversary of Marx's Death entitled "Discussion of Several Theoretical Questions in Marxism". The word "alienation" appeared in his talk, which attracted the attention of important figures in the party like Deng Liqun who relayed the talk's contents to Deng Xiaoping, the supreme leader of the party. The issue concerned the emergence of new opinions and discussions amongst philosophical, cultural and artistic circles that deviated from the official line, and on 12 October, Deng Xiaoping told the second plenary session of the 12th CPC Central Committee that "spiritual pollution" could not be allowed to affect soldiers on the ideological front. On 31 October, Xinhua News published an opinion piece entitled "The Struggle against Spiritual Pollution" echoing the content of Deng Xiaoping's speech, which stated that the "essence of spiritual pollution lies in the promulgation of the various corrupt and decadent ideas of the bourgeoisie and other exploiting classes, as well as the spreading of distrust in the socialist-communist cause and leadership of the Communist Party". Although this short-lived political campaign was initially a response to discussions taking place amongst the intelligentsia—and more fundamentally the creeping influence of ideas from the West on China and even the Communist Party itself, which was accompanied by broader social transformations taking place throughout the country—the "eliminate spiritual pollution" campaign affected all levels of Chinese society, inspiring anxiety and fear throughout the populace. In colleges and universities, it even led to long hair and bell-bottom trousers being banned for male students. Nie Rongqing writes of this period in *Colors of the Moat* (pp. 170–71): "In October 1983 (with the beginning of the ideological campaign to 'eliminate spiritual pollution', which in its resemblance to previous periods of upheaval led by a revitalised 'left' inspired widespread unease, particularly amongst the cultural circles that bore the brunt of its criticism), cultural institutions in Kunming required art workers to hand over any art materials that contained nudity to be registered and held by the government. Some graduates from the Yunnan Arts University were detained because they had taken photographs of models. The Sichuan Fine Arts Institute went so far as to send a letter to Zhang Xiaogang's place of work, the Kunming Song and Dance Troupe, claiming, without having confirmed the allegation, that he had taken and disseminated dozens of photos of women's bodies. Before long, Zhang Xiaogang's supervisor had taken him aside to discuss the matter and they discovered the Sichuan Fine Arts Institute had made a mistake. Although the situation was eventually resolved in his favour, Zhang Xiaogang was ashamed to show his face at work for a while."

13 On 10 May 1984, the State Council had issued the "Interim Provisions on Further Expanding the Autonomy of State-Run Industrial Enterprises", which divided production into "planned" and "unplanned" sectors, the supply of materials of the former being allocated according to a centralised system, while the latter would be free to purchase their materials freely. Products in the planned economy would be sold at state-regulated prices, while the prices in the unplanned economy were free to fluctuate within a range of 20% of the state-regulated price (although the 20% restriction was lifted not long after). As a result, China's commodity economy began to operate a "two-track system". In truth, the concept of the "commodity economy" began to be associated with "socialism" as early as 12 October with the passing of the "Decision of the CPC Central Committee on the Reform of the Economic System". The economic context informed and reflected the changing

conditions whereby artists were increasingly able to extricate themselves from official institutions and work independently.

14 Translator's note: CCTV, China Central Television, is the national broadcaster of television in China.

15 Nie Rongqing writes in *Colors of the Moat* (p. 92): "One day when he was in Beijing working on his painting *Yulong Mountain Jinchuan River*, Yao Zhonghua was invited by writer A Cheng to visit the 'Stars Art Exhibition' held on the small square outside the National Art Museum of China. The tenacity of the painters Yao Zhonghua saw there left a profound impression on him. It was a time of great activity for art groups, with new organisations like the Oil Painting Research Institute and the April Photography Group springing up all over the place at a rapid rate. There was a palpable academic spirit in the air and Yao Zhonghua was perceptive enough to see which way the wind was blowing in the art world. The creative and collaborative environment in the Kunming art scene was very good at the time and the artists there wanted to establish their own painting group, so at the beginning of 1980 Yao Zhonghua returned to Kunming from Beijing and discussed the details of setting up a painting group with his friends. Yao Zhonghua proposed that since according to the Chinese lunar calendar it was the Year of the Gold Monkey, they could name the group the Shen Society [Translator's note: "Shen" being the astrological symbol associated with monkey], which was also a nod to the phrase 'The gold monkey rises up'. [Translator's note: Originally used to describe the inexorable Monkey King from *Journey to the West*, the phrase also appears in a poem by Mao Zedong entitled *Reply to Comrade Guo Moruo 1961*.] Yao Zhonghua, Ding Shaoguang, Wang Jinyuan, Liu Shaohui and Jiang Tiefeng were elected as executive directors. Yao Zhonghua oversaw everyday affairs and Wang Ruizhang was responsible for liaison work. In Summer 1980, the 'First Shen Society Painting Exhibition' was held at the Yunnan Provincial Museum."

16 Translator's note: *Hanji*, or Korean paper, also called *gaolizhi*, is a traditional kind of paper from Korea that is made from the bark of the paper mulberry tree.

17 The question of how Chinese art evolved after 1976 is a complex one. To put it simply, after the downfall of the Gang of Four in October 1976, the older generation of revolutionaries took back control of the Communist Party of China, and in December 1978, at the third plenary session of the 11th CPC Central Committee, the party's political objective was reorientated from class struggle to building the economy. This policy change had a decisive impact on the cultural and artistic sectors because it meant that going forward artists would be able to deliberate over the style and even themes of their work in relative freedom, which transformed the world of art in China. The traditional paintings of flowers and birds (by artist Lang Sen) that featured in the Shen Society exhibition might have contained little in the way of artistic innovation, but the very subject matter being depicted demonstrated that the political themes previously demanded by the artistic policies of the Cultural Revolution could be toned down or even ignored entirely. Furthermore, the austere tone of Yao Zhonghua's works and the scar art quality of Pei Wenkun's paintings clearly did not conform to the previous aesthetic standards of official art institutions. At a time when the memories of the "red and bright" or "big and bold" styles of the Cultural Revolution were still fresh in everyone's minds, the vibrant, ethnic and decorative style of these "heavy colour" works on *hanji* paper were distinctive enough to challenge what people were visually accustomed to, and as such these works were popular for a while. However, this approach, which would evolve into what would later be categorised as the Yunnan Painting School, lacked the expressive quality sought after by

young artists born in the 1950s, and as such they did not attempt to emulate it.

[18] Translator's note: Michael Sullivan, *Arts and Artists of Twentieth-Century China* (Berkeley: University of California Press, 1996), p. 232.

[19] Mao Xuhui, "Account of the New Figurative Exhibition" (*Xin juxiang huazhan jishi*), originally a manuscript written on 8 September 1987 titled "Recollections about the New Figurative Exhibition and the Southwest Art Research Group" (*Ji xin juxiang huazhan yiji xinan yishu yanjiu qunti*), it was published under its new name in 1994 in the *Artists Digest* (*Yishujia wenzhai*), no. 1.

[20] Feng Guide was a painter from Yunnan who had been a monk and a soldier before he travelled to the Minzu University of China in Beijing to study fine art. After graduating, he worked as an editor for Yunnan People's Publishing House. The subjects of his paintings tended to involve ethnic minorities and his style had a decorative quality. Zhang Long even sent Zhang Xiaogang a clipping from the 9 March 1985 edition of *Xinmin Evening News* that featured a description of an exhibition by Feng Guide to illustrate his point.

[21] Letter from Hou Wenyi to Zhang Xiaogang, Mao Xuhui and Pan Dehai, 15 May 1985.

[22] Translator's note: The earth forest, or *tulin*, is a geological formation where large pillars of clay rise from the ground like trees in a forest. Yuanmou county in Yunnan is particularly famous for its earth forests.

[23] Jia Wei, "I'm Not Part of the Trend—Conversations with Painter Pan Dehai" (*Wo buzai chaoliu zhi zhong: yu huajia Pan Dehai duihua*), *Dushi shibao*, c. 2002: "As luck would have it, Mao Xuhui's mother and I happened to work at the same school. She'd long retired by then, but we still lived in the same compound. His mother told him about me and one day we met when he came back to visit his parents. It was all very natural. It was all because of art." Nie Rongqing describes how Pan Dehai and Mao Xuhui met in *Colors of the Moat* (pp. 136–37): "Mao Xuhui's mother had been a maths teacher at the same school as Pan Dehai. She told Mao Xuhui of a new arrival at the school, a painter from the Northeast with long hair. Mao Xuhui had often walked past Pan Dehai's open door and the image of the long-haired youth strolling along in a big woolly jumper and an ethnic minority bag had left an impression on Pan Dehai. Then one day, Mao Xuhui walked straight into Pan Dehai's little room carrying some of his own paintings, to which Pan Dehai responded by rummaging under his bed to show Mao Xuhui the works he'd brought from the Northeast. The two were happy to discover in one another fellow artists. They talked about art and their opinions of Van Gogh and Cézanne. That day, Mao Xuhui brought Pan Dehai to Zhang Xiaogang's Song and Dance Troupe dormitories where there were many people drinking and talking. It was a time when everyone enjoyed a drink, ate very simply, and smoked a huge amount. This was when Pan Dehai first became formally acquainted with Kunming artists, including Zhang Xiaogang. Many years later, Zhang Xiaogang looking back on that time would say that the two most important events of the year 1982 were his job assignment after graduation and meeting Pan Dehai. They recognised in one another people with similar passions and views, so they'd often get together to discuss art."

[24] Jia Wei, "I'm Not Part of the Trend—Conversations with Painter Pan Dehai".

[25] Lü Peng, "Deluge of Particles: On Pan Dehai's Painting" (*Miman de keli: guanyu pan dehai de huihua*), in *Pan Dehai* (Beijing: People's Fine Art Publishing House, 2007).

[26] In a letter to "Brother Z. H." dated 9 May 1985 and collected in *Amnesia and Memory: Zhang Xiaogang's Letters, 1981–1996* (Beijing: Peking University Press, 2010, p. 69), he writes: "Although on the surface everything is bustling, the company I'm currently working for hasn't made much money since opening. A lot of money alienates people; too little divides them. This is when politics in its rawest form emerges. When I see jealous suspicion developing between brothers who once sweated side by side working together, the pain I feel as a bystander is no less intense than the pain of those personally wronged. . . Recently they finally started making the large relief sculpture I designed. We've been working really hard recently, at least ten hours a day, and when the three of us get back at night we each pass out in a heap. But I feel grounded. I get pleasure and a sense of accomplishment from work. Friends in Shanghai have invited us to put on a self-funded exhibition. My more than three years of hard work can finally see a little light. We sent the paintings to Shanghai two days ago. Looks like it's definitely going ahead."

[27] In his autobiography (unpublished), Zhang Xiaogang writes: "One day in spring 1985, we received a letter from our friend Zhang Long, a fellow painter from Kunming studying in Shanghai's East China Normal University, telling us we could put on a self-funded exhibition featuring works of our choosing in the Jing'an Cultural Centre in Shanghai. He asked what I thought so I passed the letter to Mao and his eyes lit up. He said, 'Let's do it!' I've always been too lazy for all that work contacting various people, so Mao was the one to keep in touch with Shanghai. In Shanghai, aside from Zhang Long, the main person in charge of planning was a woman artist called Hou Wenyi. I remember in a letter she sent us, she suggested we name the exhibition "New Figurative"."

[28] Mao Xuhui, "Account of the New Figurative Exhibition", 1994.

[29] Mao Xuhui, "On the New Figurative" (*Guanyu xin juxiang*), *Frontier Youth* (*Bianjiang qingnian*), no. 1, 1987.

[30] According to Mao Xuhui's notebook at the time, for the five days the exhibition was open from 16 to 21 July, there was money coming in every day. However, as he recalls in "Account of the New Figurative Exhibition": "When the exhibition ended, the money was already very tight. All the oil paintings had to be taken off their outer and inner frames, and we had to roll up the canvases and send them back to Shanghai and Yunnan. The seventy or eighty frames we left behind were a windfall for our painter friends in Nanjing. Zhang Long continued his studies in Shanghai, and Hou Wenyi, soon after returning to Shanghai, went to study in the United States. Mao and Pan took the train back to Kunming, feeling much like the character in Hemingway's *The Old Man and the Sea*—having caught a big fish, only to return with a skeleton."

[31] Letter from Mao Xuhui to Sun Guojuan, 18 July 1985 (provided by Sun Guojuan).

[32] From the pink notebook entitled "New Figurative" (1985).

[33] A slang term used by students at the Sichuan Fine Arts Institute. It can describe a woman's sexiness or the intensity and excitement of a certain incident.

[34] Mao Xuhui and his friends' euphemism for alcoholic beverages, especially *baijiu* (a type of Chinese liquor). Because one of their friends, Ma Xiangsheng, was a Muslim and his religion prohibited alcohol consumption, they used this euphemism to accommodate him during gatherings, especially when there was only alcohol to drink. They called *baijiu* "white water", wine "grape water" and beer "beer water".

[35] Letter from Mao Xuhui to Zhang Xiaogang, 26 September 1985. Zhang Xiaogang had been transferred to the Sichuan Fine Arts Institute at the end of August to teach. He saw it as the second important turning point in his life, the first being when his application to study art in the same school was accepted seven years previously when he was living as a sent-down youth in Jinning.

[36] Letter from Mao Xuhui to Zhang Xiaogang, 26 January 1986.

[37] Nie Rongqing writes in *Colors of the Moat* (p. 217): "Having returned to Kunming after the New Figurative Exhibition, life for Mao Xuhui entered a stagnant phase. It was becoming increasingly unbearable, particularly after the elation of the exhibition, to settle back into his old way of life. Hou Wenyi sent him a letter in which she wrote, 'Dear Mao, the exhibition might not have captured the public's attention at the time, but now there is someone who wants to learn more about it. That person is Gao Minglu. He got in contact with me after arriving from Beijing in the hope of acquiring some materials about the exhibition. But I've lost interest in all this, so what with you being an articulate and congenial guy, I recommended he get in contact with you. I'm going to America. I wish you the best with it all.' And with that, a despondent Hou Wenyi left China and Mao Xuhui picked up where she had left off."

[38] Letter from Mao Xuhui to Gao Minglu, 16 March 1986.

[39] Ivan Bunin was a Russian writer who imbued his realist works with a classicist style. His 1933 novella *Countryside* won him the Nobel Prize for Literature "for following through and developing with chastity and artfulness the traditions of Russian classic prose".

[40] *Compilation of Historical Materials on the '85 Art Movement* (*'85 meishu yundong lishi ziliao huibian*), edited by Gao Minglu (Guilin: Guangxi Normal University Press, 2008), p. 53.

[41] This being said, in the fifth issue of that year's *Artists Dispatch*, the China Artists Association's official internal document concerning the event, a brief report summarising the notable figures from the Artists Association in attendance and the content of their talks only mentions Gao Minglu at the very end: "Finally, attendants heard an academic talk by member of the Theory Group of the Oil Painting Artistic Committee of the China Artists Association Gao Minglu entitled *The '85 Art Movement*, which featured a slideshow."

[42] In his essay "The 'China/Avant-Garde' Exhibition of 1989", Gao Minglu writes: "During the meeting, I discussed with Shu Qun, Zhang Peili, and Li Shan the possibility of having a nationwide slide show in Guangdong. . . At the time, Wang Guangyi, the leading figure of the Northern Art Group and rationalist painting, had just moved to the Zhuhai Academy of Painting (*Zhuhai huayuan*), an institution located in the Zhuhai Special Economic Zone. . . Wang Guangyi and Shu Qun came to Beijing to see me and we made a plan for the conference. I finally convinced the Zhuhai Academy of Painting, with the publisher and organizers of *Zhongguo meishubao* in Beijing as cosponsors, to organise the slide exhibition." (Translator's note: Included in Gao Minglu, *Total Modernity and the Avant-Garde in Twentieth-Century Chinese Art* [Cambridge, MA: MIT Press, 2011], p. 144.)

[43] Translator's note: A reference to the famous 1974 red film *Story of the Sunlit Courtyard*, based on the eponymous novel by Xu Ying, which tells the story of a school and the triumph of socialist ideals over the reactionary influence of a corrupt teacher.

[44] Letter from Mao Xuhui to Zhang Xiaogang, 22 May 1986.

[45] In the end, the exhibition took place from 15 to 19 August, according to Gao Minglu's essay "The 'China/Avant-Garde' Exhibition of 1989".

[46] The Northern Art Group was founded in July 1984. One of the earlier groups in the '85 Art Movement, which carried out salon gatherings to discuss art and culture, it included not only art graduates but also students of literature and the sciences. It began with fifteen members from the three provinces of China's Northeast, including Wang Guangyi, Shu Qun, Ren Jian and Liu Yan. The group's first proper exhibition was the first "Biennale" held at the Jilin University

of Arts in February 1987 and included work by Wang Guangyi, Shu Qun, Ren Jian, Liu Yan, Ni Qi and Wang Yalin. Prior to that they had only held one academic conference and a few dialogues with slideshows.

[47] "The Spirit of the 'Northern Art Group'" was published in *Art News of China* (no. 18, 1985) and understood to be the group's "manifesto". Another essay appeared in the first 1987 issue of *Currents of Thought in Art* entitled "Explanation for the Northern Art Group", which acted as a further elucidation of their artistic and philosophical ideas. Both these essays were written by the group member and artist Shu Qun. In terms of their artistic output, the group did not have a unified visual language or style, but their work shared a certain cool detachment, quiet solemnity and rejection of emotional catharsis. Local culture undoubtedly influences aesthetics, and just as the work of southern artists reflected the thriving life-force of their surroundings, so too was the Northern Art Group's pursuit of the austere and dispassionate an emotional response to their chilly environs.

[48] Translator's note: Civil servants in China are divided into various categories, with the "department and bureau" levels being the third highest after "state" and "provincial and ministerial" levels. Aside from highlighting the difference in material conditions between Kunming and Zhuhai, this comment reveals the extent to which previous centrally determined standards no longer applied to the coastal cities that at this time had already seen substantial free market reforms.

[49] Letter from Mao Xuhui to Zhang Xiaogang, 18 August 1986.

[50] Letter from Wang Guangyi to Mao Xuhui, 18 September 1986.

[51] Nie Rongqing in *Colors of the Moat* (p. 245) describes the situation when Mao Xuhui returned to Kunming: "Zhang Xiaogang, the 'trainee teacher', had returned from Chongqing for the summer holidays. One evening in July, a bunch of us crammed together in Zhang Xiaogang's dormitories waiting for Mao Xuhui to return from Zhuhai and tell us about what had happened at the Zhuhai Conference. I remember it was a hot evening and there were lots of us in the room. When Mao Xuhui arrived he was given a spot on Zhang Xiaogang's bed. His passion was no cooler than the weather. He told us everything he had seen and heard at the Zhuhai Conference, firing everyone up with his words. Of course, Mao Xuhui, an ordinary mortal like the rest of us, also told us how excited he was to see Zhuhai, a city at the forefront of the country's economic reforms, as well as the view of Hong Kong and Macau across the ocean. In that period, after returning from Zhuhai, Mao Xuhui resembled a preacher. Not only did he preach to the Zhang Xiaogang circle, he also went to the Yunnan Arts University to share what he'd learned at the Zhuhai Conference with Wu Jun, Liu Yong, Li Jiandong, Ou Xinwen, Ma Xiangsheng and Su Xinhong, inciting them to come out and put on exhibitions. At that time Mao Xuhui liked to say, 'The whole country's rising up. It's time for us to act!' It made me think of that scene in the revolutionary film *Gold and Sand* where the labour movement leader says, 'The Changsha workers are rising up! The Wuhan workers are rising up! What are we all waiting for?' And so it wasn't long before there was the 'Southern Barbarians Exhibition' (*Nan manzi zhanlan*), which took place before even the 'New Figurative' exhibition opened in Kunming. The exhibition involved a guitar getting smashed, beds being taken to the exhibition space, exaggerated colours and installations. Even Su Xinhong joined in with a work called *Swinging Taoist Shrine* (*Bai daochang*), which was made of grass."

[52] Nie Rongqing in *Colors of the Moat* (p. 247) describes it as follows: "Ye Yongqing, who had always travelled widely, knew a lot of people and what they were doing, so he acted as liaison officer for the Southwest Art Research Group. He contacted Guizhou artist Cheng Xiaoyu, Shandong's Dong Chao, Kunming artist Zhang Hua and theorist Deng Qiyao, as well as several artists from Chengdu's 'Red-Yellow-Blue Painting Society' like Wang Falin, Dai Guangyu and Li Jixiang. He went on to contact *China Art News* and had them publish an article about the Southwest Art Research Group. It was a short article but featured a couple of pictures, including work by Zhang Xiaogang and Ye Yongqing's *Spring Awakening*."

[53] In November of that year, Zhang Long collected several hundred slides, as well as some artworks and essays from Shandong and Shanghai, and presented them in an exhibition at the Shanghai Art Museum titled "The Second New Figurative Exhibition" (*Xin juxiang di er jie zhan*). As Mao Xuhui put it, "Chronologically speaking, the Shanghai exhibition was technically the 'third', but that was because of problems with the exhibition hall, which caused it to be delayed until after the Kunming exhibition had been held, even though all the preparatory work had already been completed." From 15 to 24 December, Zhang Long brought various graphic and textual materials concerning the New Figurative to Beijing to participate in the First Peking University Student Literature and Arts Festival.

[54] Published in *Currents of Thought in Art*, no. 1, 1987.

[55] A retrospective article published in the first 1988 issue of a Yunnan magazine called *Youth and Society* (*Qingnian yu shehui*) documented the impact of the New Figurative: "The signals emitted by the New Figurative were quickly greeted with a response in Yunnan. From 1986 to 1987, wave after wave of young Yunnan painters emerged from their respective corners and began announcing their existence to society. There were the 'Southern Barbarians Exhibition' (*Nan manzi huazhan*), 'Empty Room Painting Society' (*Kongwu huahui*), 'Misty Works Exhibition' (*Meng zuopin zhan*), 'Seven Stars Exhibition' (*Qi xing huazhan*), 'Three Students from Yunnan Arts University Exhibition' (*Yunnan yishu xueyuan san xuesheng huazhan*), 'Eight Kunming Youth Exhibition' (*Kunming ba qingnian meizhan*), 'Luo Hui Solo Exhibition' (*Luo Hui geren huazhan*)... a dizzying panoply of new art."

[56] Wang Yi was born in Shanghai and worked as art editor for Shanghai Fine Arts Publishing House from 1975 to 1980. In 1980 he was accepted to the Oil Painting Class of Shanghai Normal University and in 1986 joined the Southwest Art Research Group. He once worked for the Sichuan Fine Arts Institute but later resigned.

[57] Zhang Xiaping was born in Yunnan and was employed as an artistic worker for the Kunming Song and Dance Troupe. A participant in the Third New Figurative Exhibition, she moved to Austria in 1990.

[58] Li Hongyun was born in Yunnan and graduated from the Yunnan Arts University in 1985. A participant in the Third New Figurative Exhibition, she now lives and works in the USA.

[59] Cai Rong is a painter born in Fujian. She completed her studies in Stage Design at the Central Academy of Drama in 1982 and subsequently stayed on as a teacher. She has served as an executive editor for *Art News of China* and as an art editor at the China Film Archive.

[60] Letter from Mao Xuhui to Zhang Xiaogang, 25 November 1986.

[61] Letter from Mao Xuhui to Zhang Xiaogang, 15 December 1986.

[62] Letter from Mao Xuhui to Zhang Xiaogang, 21 December 1986.

[63] Letter from Zhang Xiaogang to Mao Xuhui, 26 December 1986.

[64] Translator's note: The political movement referred to here, which inspired the anxiety amongst officials about Zhang Xiaogang's exhibition and their subsequent measures to contain it, is the string of student demonstrations that spread to many cities in China in December 1986. Against a backdrop of high inflation and rising prices, students demanded China's increased openness to the world and greater civil rights. The movement continued until mid-January 1987.

[65] In a letter written by Zhang Xiaogang to Mao Xuhui and Ye Yongqing on 28 December 1986, there are the following words: "The academy leaders approached me on the first day to discuss things, and on the second day someone from the Party Office even came to see me! It was all because the student demonstrations in Shanghai had spread to Chongqing and some students from Chongqing Normal University were calling on people all over the place to get together and protest. It's just bad timing. It hadn't crossed my mind that the school might have had me down as an enemy. Also, our collaborators from the literature society at Chongqing Normal University disappeared without saying a word, dropping out at the last minute. Then the person responsible for the talks (also from Chongqing Normal) didn't turn up at the scheduled time of eight o'clock in the evening. I had everything ready, the auditorium was full, and meanwhile behind the scenes the principal's secretary was calling a meeting of the student council to discuss the student protests. Suddenly I had no idea where everyone had gone! I felt so alone!" Mao Xuhui responded on 3 January 1987: "The best New Year present I received was the invitation to 'the fourth exhibition'. And today I received another invitation and a letter—I'm so excited! I think this is a huge success, and first of all, we should be very happy and proud of the banner of the New Figurative and our lives and feel uplifted by the fact that the world has Gang'r. I have already toasted to you and your actions. Everything else that has happened is insignificant. It is normal for something like this to happen in our reality, and the crucial thing is that the New Figurative now exists in reality. It has, one way or another, taken root 'widely' in the cerebral cortices of various people, stirring their thoughts and fermenting within their bodies. I think this is the New Figurative's most interesting exhibition. Reading your letter retelling the events before and after the exhibition, I feel like I'm reading a true New Figurative comedy script. It marks one of the most comedic moments in the Chinese art world during the last days of 1986 and the first days of 1987, set in the nationally and even globally renowned Sichuan Fine Arts Institute near the Huangjueping Power Plant in Jiulongpo."

[66] In an article written for Gao Minglu entitled "Recollections about the New Figurative Exhibition and the Southwest Art Research Group" Mao Xuhui put it as follows: "Once the Fourth Exhibition ended, it felt like 'The Last Supper'. Due to the 'Anti-bourgeois liberalisation' movement, the Southwest Art Research Group had few activities in 1987, and everyone went back to painting their own works."

[67] Translator's note: Zhu Guangqian was a Chinese scholar who, having studied in Europe in the 1920s, returned to China where he taught aesthetics and Western literature. *Aesthetic Gleanings* was published in 1980.

[68] Translator's note: Herbert Read, *A Concise History of Modern Painting* (New York: Praeger, 1975), p. 324.

[69] Ye Yongqing, *Traverser Through Time Traveller: Ye Yongqing Essays* (*Shijian de chuanxingzhe: Ye Yongqing wenji*) (Beijing: China Youth Press, 2010), p. 106.

[70] Ibid., p. 112.

[71] Letter from Zhang Xiaogang to Ye Yongqing and his wife, 1 December 1986, in *Zhang Xiaogang's Letters*, p. 94.

[72] Johann Joachim Winckelmann's philosophy of art did not seem classical to many Chinese art students at the time. It was, after all, a period that saw the

arrival of many new ideas, and no book of Western philosophy or art ever seemed to them old-fashioned.
[73] Wang Guangyi in *Currents of Thought in Art*, no. 1, 1987, p. 20.
[74] "What we need is this kind of art, i.e., the supreme self-affirmation of life by life that is flourishing, which occurs when life's desire faces its natural tendency for decline—the art of sublime tragedy." Wang Guangyi in *Currents of Thought in Art*, p. 21.
[75] This was the year that Dong Xiwen's 1952 painting *The Founding Ceremony of the Nation* (*Kaiguo dadian*) was once again exhibited after a third revision. In 1955, the "Gao-Rao affair" meant that Gao Gang had to disappear from the picture. During the Cultural Revolution, after Liu Shaoqi was purged, the painting was once again amended so that Liu Shaoqi could be removed. After December 1978, one of the political changes to take place was a supposed greater respect for history. As such, Central Academy of Fine Arts artist Jin Shangyi led the project to restore *The Founding Ceremony of the Nation*, during which the two formerly erased persons were returned to their rightful places on the canvas.
[76] Mao Xuhui, "Remembering the New Figurative", *Dianchi Literary Monthly* (*Dianchi*), no. 11, November 2005.
[77] Collection published by Lijiang Press in March 1986 entitled *Steppenwolf*, which contains two novels and a few novellas by Hermann Hesse.
[78] Translator's note: As alluded to, this is not written by Hesse himself, but by the Chinese publishers of this edition of his works in the "Publisher's Foreword", p. 20.
[79] From the green, plastic-covered notebook, dated 1985–87. All the following unreferenced quotes of Mao Xuhui's poems are from this notebook.
[80] From the hardback 1986 notebook labelled "1986, 2 Heping Village, Notebook #1" (*1986 nian Hepingcun 2 #1 shougao bijiben*).
[81] Letter from Mao Xuhui to Zhang Xiaogang, 3 January 1987. All the passages quoted from Mao Xuhui in the previous paragraph also come from this letter.
[82] Translator's note: Hermann Hesse, *Steppenwolf*, trans. Basil Creighton (New York: Random House, 1963), pp. 48–49.
[83] This long-planned exhibition would eventually be held in February 1989 at the National Art Museum of China (see below).
[84] Translator's note: The reference here is to *yeyoushen*, the "wandering spirits of the night" who occasionally appear in Chinese folklore.
[85] The Cossacks are a nomadic people originating in the grasslands of eastern Ukraine and south Russia who were historically known for their bravery, combat skills and superb horsemanship. Russian culture, from Nikolai Gogol's novella *Taras Bulba* to Ilya Repin's oil painting *Reply of the Zaporozhian Cossacks* and Mikhail Sholokhov's novel *And Quiet Flows the Don*, contains frequent positive depictions of the righteous

courage and rustic heroism of the Cossacks, which left such an impression on Mao Xuhui and his friends that they liked to call themselves the "Old Cossacks".
[86] In a letter written to Mao Xuhui on 31 May 1987, Zhang Xiaogang writes, "In the past, we longed for 'the world to give us an arena in which to fight', but perhaps. . . that arena will never appear. I am starting to think that there is only one arena, and that is death. For that arena, I shall fulfil my duties toward life." (*Zhang Xiaogang's Letters*, p. 112.) In another letter dated 14 April 1987 we also see the following: "I only hope we do not catch the disease of callous numbness to the world. May we always continue to be sensitive—not to better summarise the past but to forever maintain a childlike fascination with the unknown, with the horror of death." (Ibid., pp. 108–09.)
[87] Translator's note: Hermann Hesse, *Steppenwolf*, p. 53.
[88] Letter from Mao Xuhui to Zhang Xiaogang, 27 May 1987.
[89] Letter to Mao Xuhui, 31 May 1987, in *Zhang Xiaogang's Letters*, pp. 111–12.
[90] Translator's note: Su Rui and Fei Xiang are both pop singers originating from Taiwan.
[91] Mao Yu was the full name of Mao Xuhui's daughter (who he also calls little Maotou) before it was changed to He Jing (bearing her mother's surname).
[92] Letter from Mao Xuhui to Zhang Xiaogang, 13 June 1987.
[93] Ibid. Mao Xuhui wrote: "My relationship with Sun Guojuan has been extremely tense lately and it's been hard to deal with. All I can do is take a step back, let things cool down." In October, Mao Xuhui sent him another letter in which he mentioned the topic of the Middle Ages and said he had undergone "a huge medieval Renaissance". This was because after June, having distanced himself from his girlfriend, he had spent most of his time alone living what he described as a life of abstinence. He associated this lifestyle with the Middle Ages and came to the following conclusion: "We can only truly perceive the exaltation of the soul when our lives are in a state of sublime abstinence. Only when we are absolutely alone, in that state of solitude, can we near those sublime things. When we are rushing around busying ourselves over trifles, we have completely abandoned our 'human' essence. Yes, the Middle Ages were dark, monotonous, but they gave the soul an opportunity, an opportunity most people are not willing or able to accept. The majority of people reject this kind of opportunity. Only Old Cossacks like us welcome it and discover in it the truth." He even said to Zhang Xiaogang, "I no longer buy books, have given up smoking and drinking, don't hang out with girls, and don't even really hang out with our young friends." (Letter dated 16 October 1987.) Towards the end of the year, Mao Xuhui wrote, "It's only because there is no true Eve in my vicinity that abstinence seems more appropriate, relatively speaking. So, in this matter, all I can do is patiently wait. I think that God will not after

all forget those of us who have pure thoughts." (Letter to Zhang Xiaogang, 1 December 1987.)
[94] Letter to Mao Xuhui, 31 June 1987, in *Zhang Xiaogang's Letters*, p. 113.
[95] The hardback notebook with a leather cover labelled "1986, 2 Heping Village, Notebook #1".
[96] The notebook labelled "1986, 2 Heping Village, Notebook #2—including the Red Earth Dream manuscript".
[97] From the red, plastic-covered notebook, dated 1984.
[98] Translator's note: Hermann Hesse, *Steppenwolf*, p. 65.
[99] Translator's note: Hermann Hesse, *Steppenwolf*, p. 70.
[100] Lü Peng, "Mao Xuhui—Figurative and Verbal Portrayals of Life" (*Mao xuhui—shengming de juxiang yu chenshu*), in *Mao Xuhui* (Beijing: Cheng Xindong Publishing Company, 2005).
[101] Mao Xuhui, "The Artistic Question and the Human Question" (*Yishu wenti ji ren de wenti*), *Artists Digest*, no. 1, 1994.
[102] Ibid.
[103] Lü Peng, "Mao Xuhui—Figurative and Verbal Portrayals of Life", 2005.
[104] In this letter, sent to Zhang Xiaogang on 13 June 1987, Mao Xuhui wrote the following: "On another note, last week I received a letter from He Weina telling me about her application to the Central Academy of Fine Arts and the Sichuan Fine Arts Institute. It sounds like it didn't go well. She said she got terrible marks for the Sichuan Fine Arts Institute exam and that you and Ye Yongqing gave her a low score, and also Chen Xi, which made them think it was a punishment for not coming to Kunming that time. I replied, reassuring her there was no way that was true and urging her to trust you guys. The way I see it is, He Weina should continue to study, and now I guess she and I count as friends, even if I don't like some of those crazy ideas of hers. But she is rarely insincere, which isn't easy. I was basically wondering whether you guys might be able to help her out. Obviously, I don't know exactly what happened. It's just that in the letter she seemed really upset."
[105] On the first day of the Chinese New Year in 1987, Mao Xuhui made a trip to Pengjiafen (a Christian Miao village in Fumin county a few dozen kilometres from Kunming) with Zhang Xiaogang, Zeng Hao, Sun Guojuan, Shen Jiaming, Cui Yahong, Ju Hong and Nie Rongqing. At the time, he was still in a relationship with Sun Guojuan. Nie Rongqing's *Colors of the Moat* contains a vibrant account of their travels in this rustic part of the world, during which they debated art and philosophy, and recited passages from Hermann Hesse's *The Glass Bead Game*.
[106] Lü Peng, "Mao Xuhui—Figurative and Verbal Portrayals of Life", 2005.
[107] Ibid.

Chapter 3

The New Figurative and Modernism

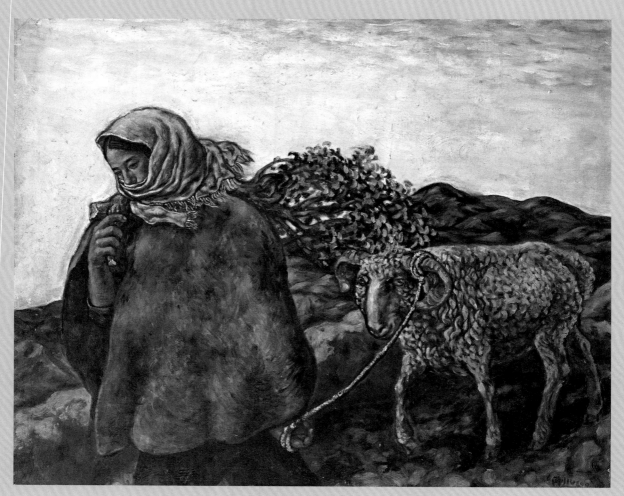

Zhang Xiaogang
Evening Wind (*Wan feng*), 1984
Oil on canvas, 78 × 96 cm

Chapter 3

The New Figurative and Modernism

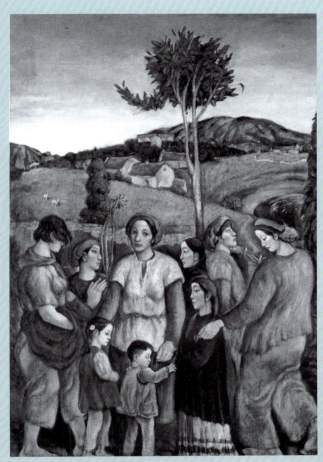

Ye Yongqing
Sani Sisters of the Shepherd Village (Muyang cun de sani jiemei), 1984
Oil on canvas, 184.5 × 126 cm

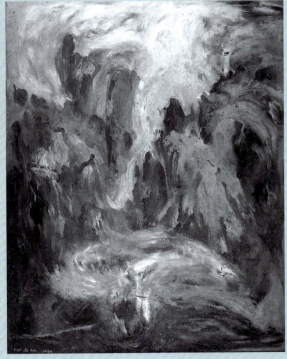

Pan Dehai
Earth Forest Series No. 3 (Tulin xilie 3 hao), 1984
Oil on canvas, 160 × 120 cm

Chapter 3

The New Figurative and Modernism

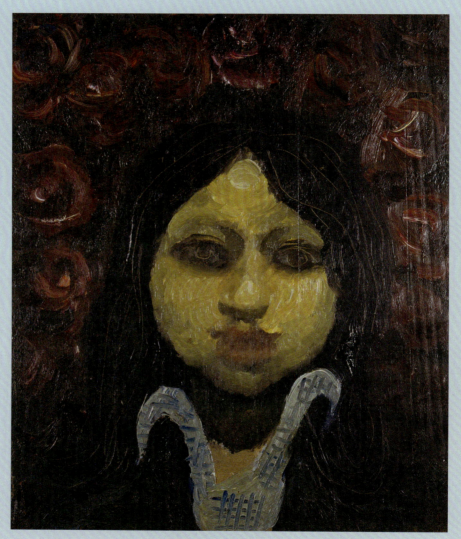

Mao Xuhui
Little Juan (Xiao juan), 1985
Oil on panel, 42.5 × 35 cm

Chapter 3

The New Figurative and Modernism

Mao Xuhui
Guishan in Winter (Dongri de guishan), 1986
Oil on cardboard applied to fibreboard, 39 × 49 cm

Chapter 3

The New Figurative and Modernism

Mao Xuhui
Guishan: Haystack (*Guishan: caoduo*), 1986
Oil on paper, 42 × 59 cm

Mao Xuhui
Drawing of Guishan (*Guishan xiesheng*), 1986
Oil on paper, 42 × 59 cm

Chapter 3

The New Figurative and Modernism

Mao Xuhui
Drawing of Guishan (Guishan xiesheng), 1986
Oil on paper, 43 × 50 cm

Mao Xuhui
Drawing of Guishan (Guishan xiesheng), 1986
Oil on paper, 43 × 52.5 cm

Mao Xuhui
Drawing of Guishan (Guishan xiesheng), 1986
Oil on paper, 43 × 54 cm

Chapter 3

The New Figurative and Modernism

Mao Xuhui
Steppenwolf (*Huangyuanlang*), 1986
Fountain and bamboo pens on paper, 22 × 39.5 cm

Mao Xuhui
Redbrick Building: Window (*Hongzhuan lou: chuangzi*),
October 1985
Watercolour and colour pencil on paper, 32 × 36 cm

Mao Xuhui
Redbrick Building: Alleyway (*Hongzhuan lou: hutong*), November 1985
Watercolour and colour pencil on paper, 30 × 41.5 cm

Chapter 3

The New Figurative and Modernism

Mao Xuhui
Personal Space: Human Body in Concrete House
(*Siren kongjian: shuini fangjian li de ren*), 1986
Oil on canvas, 120 × 90 cm

Mao Xuhui
Human Body in Concrete Room: Noon (*Shuini fangjian li de renti: zhengwu*),
April 1986
Oil on fibreboard, 65 × 100 cm

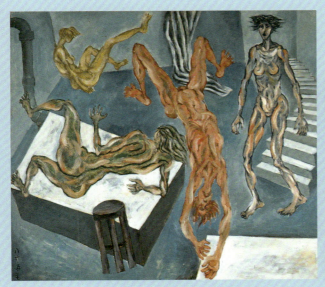

Mao Xuhui
Human Body in Concrete Room: A Few States (*Shuini fangjian li de renti: ji zhong zhuantai*), May 1986
Oil on fibreboard, 90 × 100 cm

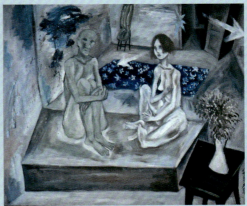

Mao Xuhui
Personal Space: Weekend (*Siren kongjian: zhoumo*),
March 1987
Oil on gauze cardboard, 76 × 88 cm

Chapter 3

The New Figurative and Modernism

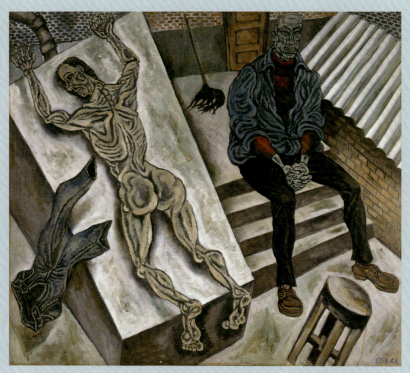

Mao Xuhui
Personal Space: Self-Imprisonment (Siren kongjian: ziqiu), March 1987
Oil on fibreboard, 96 × 102 cm

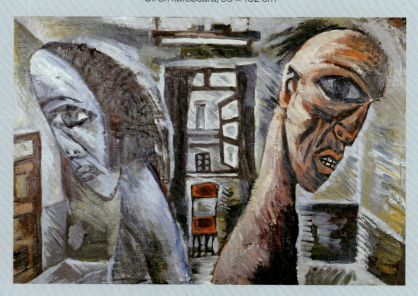

Mao Xuhui
Married Couple in Concrete Room (Shuini fangjian li de fufu), 1987
Oil on canvas, 54 × 77 cm

Chapter 3

The New Figurative and Modernism

Mao Xuhui
Redbrick Building No. 2: Noon Window No. 2 (Hongzhuan lou zhi er: zhengwu chuangkou zhi er), 1985
Oil on fibreboard, 40 × 47.5 cm

Mao Xuhui
Self-Portrait in Redbrick Building (Zai hongzhuan lou li de zihuaxiang), 1985
Oil on panel, 44 × 50 cm

Chapter 3

The New Figurative and Modernism

Mao Xuhui
Personal Space: A Few Feelings (*Siren kongjian: ji zhong ganjue*), 1987
Oil on cardboard, 78 × 108 cm

Mao Xuhui
Premonition (*Yugan*), 1985
Collage on paper, 28 × 47 cm

Mao Xuhui
Childhood Memories (*Tongnian jiyi*), 1987
Collage on paper, 55 × 40 cm

Chapter 3

The New Figurative and Modernism

Mao Xuhui
Mountain Spirit (Shan shen), 1985
Ink wash on paper, 30 × 41.5 cm

Chapter 3

The New Figurative and Modernism

Mao Xuhui
Night (*Ye*), September 1985
Ink wash on paper, 31 × 43.5 cm

Mao Xuhui
Adam and Eve (*Yadang yu xiawa*), 1985
Calligraphy brush and ink on paper,
38.5 × 27 cm

Mao Xuhui
Night: Self-Portrait (*Ye: zihuaxiang*), September 1985
Ink wash on paper, 27.5 × 38.5 cm

Chapter 3

The New Figurative and Modernism

Mao Xuhui
Vincent van Gogh (Wensente Fan'gao), 1985
Pencil on paper, 34 × 45 cm

Mao Xuhui
If. . . (Ruguo. . .), September 1986
Bamboo pen and ink on paper, 27.5 × 37.5 cm

Chapter 3

The New Figurative and Modernism

Mao Xuhui
Another Self-Portrait (You yi ge zihuaxiang), September 1986
Bamboo pen and ink on paper, 27 × 38.5 cm

Mao Xuhui
Self-Portrait and Stool (Zihuaxiang he yuandeng), 1987
Ink wash on paper, 27 × 37 cm

Mao Xuhui
Married Couple in Concrete Room (Shuini fangjian li de fufu), 1987
Calligraphy brush and ink wash on paper, 24 × 34.5 cm

Chapter 3

The New Figurative and Modernism

Mao Xuhui
Mountain Village Night (*Shan cun de ye*), 1987
Ballpoint pen on paper, 39 × 27 cm

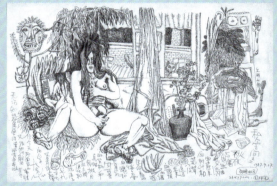

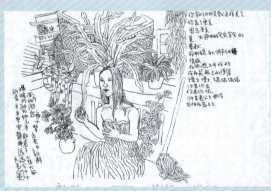

Mao Xuhui
For Nana (*Xian'gei nana*), September 1987
Ballpoint pen on paper, 25.7 × 36 cm

Mao Xuhui
Personal Space No. 2: Night Cloud (*Siren kongjian zhi er: yewan de yun*), 27 September 1987
Ballpoint pen on paper, 27 × 37 cm

Mao Xuhui
Southern Balcony (*Nanfang de yangtai*), 10 October 1987
Brush pen on paper, 27 × 39 cm

Chapter 3

The New Figurative and Modernism

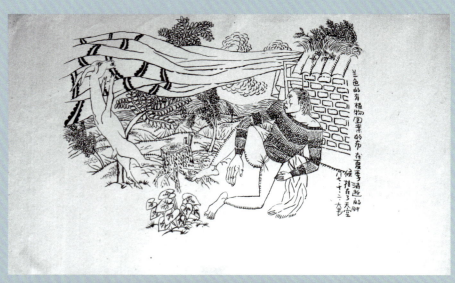

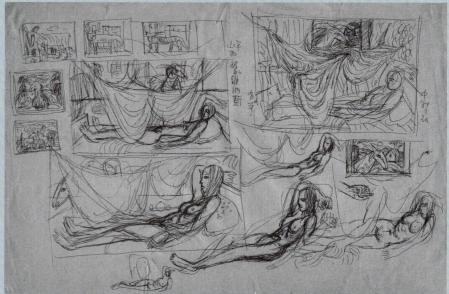

Mao Xuhui
After Summer Disappeared No. 2: Self-Portrait (*Xiatian xiaoshi zhi hou zhi er: zihuaxiang*), 2 October 1987
Brush and ink on paper, 27 × 39 cm

Mao Xuhui
Personal Space: Woman's Body with Mosquito Net, Heping Village Night (*Siren kongjian: you wenzhang de nü renti, hepingcun zhi ye*), 1987
Ballpoint pen on paper, 27 × 39 cm

Chapter 3

The New Figurative and Modernism

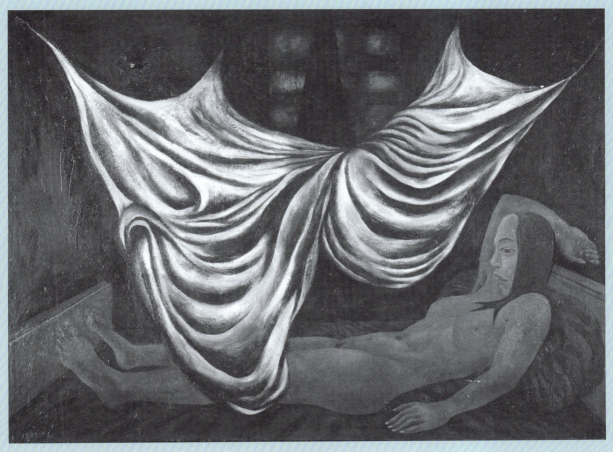

Mao Xuhui
Personal Space: Woman's Body with Mosquito Net (Siren kongjian: you wenzhang de nü renti), 1988
Oil on canvas, 90 × 120 cm

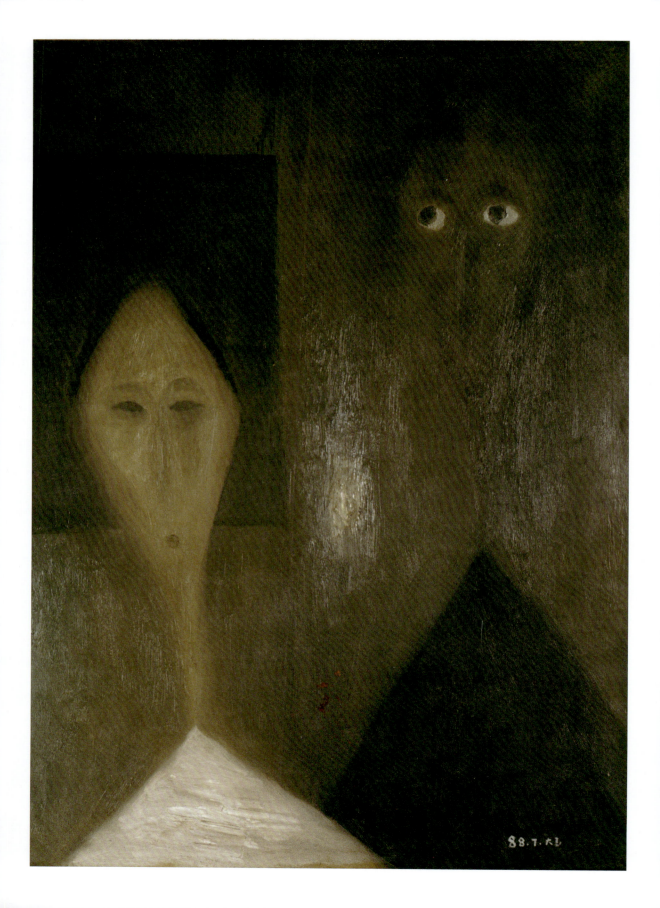

Chapter 4

THE PATRIARCH

You are constantly confronted in art with things that persistently and repeatedly haunt the soul on a spiritual level, things that are difficult to describe in words, but this in reality is what discreetly causes art to take shape—if you relentlessly pursue it.

Mao Xuhui, May 1995

My freedom thus consists in my moving about within the narrow frame that I have assigned myself for each one of my undertakings.

Igor Stravinksy[1]

n 31 December 1988, Mao Xuhui reflected on the year that had just past: "It was a year of fear, nerves, joy, worry, humiliation, striving, but also one of greater self-confidence."[2] The fear he mentioned was caused by a school and police investigation into his friend Zhang Long at East China Normal University, which ended up involving Mao Xuhui and Zhang Xiaogang and making life quite stressful for both of them. In the course of their inquiry, the Public Security Bureau confiscated much of Zhang Long's correspondence with Mao Xuhui and Zhang Xiaogang. This was a result of the ongoing Anti-Bourgeois Liberalisation Campaign, which was triggered by the 1986 student protests. It was clear that the campaign did not seek to address legal concerns but was rather a response to the systemic needs of the nation's political institutions. When it came to the actions and words of Chinese citizens, it was often difficult to draw clear lines between the spheres of personal life, social morality, political norms and legal codes, which meant that it was only arbitrarily, and within a specific historical context, that the nature of any action or statement could be decided. Although Mao Xuhui and Zhang Xiaogang were eventually cleared of any charges and were no longer the subjects of political suspicion, the fact that they knew nothing of the specific reasons and context behind the investigation unsettled them for some time.[3] At the beginning of April 1988, Mao Xuhui wrote to Zhang Xiaogang about the stress he was under because of Zhang Long:

As for Zhang Long, if it weren't for the exhibition, maybe we would never have crossed paths. We have no idea what kind of person he is and what he's into, aside from painting. I once told him in a letter that the main effect we had had on him was to make him take art seriously. The reason he was willing to put on an exhibition with us in 1985 was because he understood we were real artists. This was the fundamental reason we were able to put on an exhibition with him. If it weren't for that, as I said before, we would never have met, let alone become friends.[4]

Mao Xuhui might have been reading about Chinese traditional thought at this time, because in his letter, aside from discussing domestically and internationally salient topics like the Green Revolution, the one-child policy

RESTLESS SOUL

Page 280
Mao Xuhui
Patriarch (Jiazhang), detail, July 1988
Oil on canvas, 100 × 120 cm

and nuclear disarmament negotiations, he also gave a spirited account of his understanding of "the unity of Heaven and human"[5]: "East Asians have a peculiar ability to talk about this cosmic spirit. A couple of Chinese characters can encapsulate many feelings that are otherwise difficult to articulate: rest (*jing*), void (*xu*), emptiness (*kong*) and the like. Sometimes I really want to practise calligraphy, even if it's only a couple of characters. Not long ago we hung some bamboo curtains by the main door and on it I drew a large *jing*. I think my mind is beginning to approach this state."[6] He also excitedly described to Zhang Xiaogang how he felt when he was able to spend time with his daughter every week: "Little Maotou still runs wild at my place for a few days every week. Although she's very excitable, she's a calm soul at heart. I took her to Haigeng today, which was great. There was hardly anyone there and we went to the waterside to collect snail shells and pebbles. It was so fun we forgot about everything else as we listened to the sound of the waves. The sun was beating down on us, so we decided to take a dip in the cool water before returning to the shore to bathe in sunlight. At times like these my soul yearns for nothing and I am no longer plagued by anxiety."[7] A few days later, Mao Xuhui received an invitation from Zhang Xiaogang to participate in the "China Stars 1988 Modern Art Exhibition" (*Zhongguo xingxing 1988 xiandai yishuzhan*) in Chengdu, which naturally lifted his spirits. He submitted four expressionist pieces, which included work from the "Personal Space" series, and asked Zhang Xiaogang to send his official invitation to Kunming as soon as possible so he could apply for leave from the Film Company to attend the exhibition. He brought his daughter Maotou with him on this trip, as he wanted her to "see the world".

After the exhibition, which concluded without incident, Mao Xuhui spent a few days in Chengdu before taking his daughter back to Kunming on the train: "We made it home in one piece and are feeling pretty good in both body and mind, but it was so tedious on the train, without a trace of drama, let alone someone to talk to. It was packed, which obviously meant fewer people willing to chat. Being

Mao Xuhui celebrating the fourth birthday of his daughter He Jing at Zhang Xiaogang's home, 2 Duozi Lane, Chengdu, on 21 May 1988

on the train is like being in a desert, only with none of the desert's desolate poetry. All I saw in the crowds was boredom, a transparently empty scene—this was the first feeling I had after leaving Chengdu. Although maybe this is because there was so much culture to be enjoyed in Chengdu, with all the music and wine-drinking friends, all the art and 'fast food' to choose from. In short, there was *soul*, even if it was just a few days of laid-back fun and we didn't even pretend to be up to anything more serious than that. Thinking about playing cards, browsing bookshops, the 'psychological tests'—there was culture to it all, not to mention the cassette tapes."[8] Mao Xuhui appreciated being with his friends and thought highly of the "culture", "friendship" and "meaningfulness" of their time together, even if there was something ordinary and trivial about it all.

Back in Kunming, he told Pan Dehai about the exhibition, and over a drink of Hantanye (an alcoholic drink from Chengdu) they talked about Mao Xuhui's impressions of Chengdu. "We chatted until 3 a.m. and I did my best to give an accurate account of the exhibition and our laid-back, comfortable days in Chengdu. We talked about all the different kinds of Sichuanese snacks, Chunxi Road, Chengdu people's good skin, and the 35°C temperatures."

Although economic conditions were yet to change significantly, society itself was changing. The atmosphere in 1988 was suffused with the spirit of consumerism and the new cultural context prompted people to consider the possibility of improvements to their material conditions. Mao Xuhui began to discuss questions of money with his friends. He spoke with Pan Dehai about the money they would need to rent a studio, which he thought was the most basic requirement for being an artist. An anecdote this group enjoyed sharing was that of Pan Dehai, a few years earlier, painting on the wall of his small dark room a window through which one could see nature and blue skies. These were the basic conditions under which Chinese modern artists worked in the 1980s. For some time, Ye Yongqing liked to put his artworks on his bed for friends to see when they came to visit. In a letter written not long after returning to Kunming, Mao Xuhui shared with Zhang Xiaogang his impressions of the time:

In the past when we were painting, our minds were so simple, yet to be interfered with by consumerist society and all these emotional problems. It's so much more complicated now. Getting older is frustrating. We know too much. We've been through too much.

. . . Of course, the economic reforms have brought many good signs. Now there are people who want to become art dealers, to reach out to artists—liberating them at the same time as they "exploit" them. Of course this is no bad thing. We're in favour of it. Because if someone wants to "exploit" us, then at least they honour us by seeing us as labourers. I've always liked work, but painting is rarely seen to be a kind of work. It's normally seen as a hobby. Artists themselves understand that the task they face is not something to be done in their spare time after dinner. Why have multiple generations of people been moved by Van Gogh's biography? Because it shows that what most people consider a postprandial pastime, a certain kind of person believes is something worth taking a bullet for, worth fighting a war for. Some people are going crazy desperately trying to do things that many in this world describe as simply "boring

and incomprehensible". It's possible that amongst those moved by Van Gogh's story, most would ignore a real Van Gogh living in their midst. Maybe not even just ignore him, but actually cause him problems, pressure him for rent money. That said, things are a bit better now. There's been a massive turnaround in the West. Artists have become sacred. They've got prospects. Aside from artists possessing that special "sensitivity" ordinary people lack, artworks have now found their place in the commodity economy. There are now even rich artists, although more often than not, they just end up making other people rich. [9]

Mao Xuhui closed the letter by informing his friend of the news that Liu Yong's [10] graduation project had "been bought by a Swiss for ten thousand dollars. He's become a Kunming painting ten-thousandaire [11] overnight."

Echoing Mao Xuhui's sentiments, Zhang Xiaogang wrote back to express his own views:

You're right. Artists always make other people rich who, when they've made money, come back and "patronise" artists. This is our destiny and so we must holler slogans in praise of it. This is because we are convinced of one thing: as long as humans have not become machines, they will continue to unconsciously ask what exactly art is. In truth, art is nothing, it is simply the human. However, each human is divided. Avarice often leads them to seek favour from various material things, but once a component of the machine is installed in a human's own body, they often return to the spiritual in a panic. . . Art perhaps is not what we call the "sacred", which is too distant and indifferent. Art does not emerge from "discussions". It is in itself without definition. Art is human, which is to say, our lives, our awareness and experience of life. [12]

In a letter written on 26 June 1988, Mao Xuhui continued to discuss the relationship between art and money:

All these recent reforms are in any case a good thing. Society and culture will become more dynamic. It's hard to predict what it will be like, but there's no doubt that money is going to drive the development of culture. We'll still be poor, but things will get better for lots of people. We're used to it. We don't care. So we don't want to change our direction in life. [13]

Evidently, money had become a frequent topic of discussion, albeit somewhat reluctantly amongst Mao Xuhui and his friends who in their pursuit of art had an unconscious aversion to such material concerns. Nonetheless, these young men and women were starting to realise that the age of pure ideals was coming to an end.

In October, in the name of the Sichuan Theatre Association, Lü Peng curated the "1988 Southwest Art Exhibition" (*1988 Xi'nan xiandai yishuzhan*) in the Sichuan Exhibition Centre. The planning for the show involved various artists and took place in Zhang Xiaogang's house on Chengdu's Zouma Street. [14] It included artists from Yunnan, Guizhou, Sichuan, Hunan and Henan. The impetus behind this exhibition was the fact that the dynamism of the '85 Art Movement had been

Mao Xuhui (left) and Lü Peng (right), in front of Mao Xuhui's paintings at the 1988 Southwest Art Exhibition, October 1988

extinguished by the Anti-Bourgeois Liberalisation Campaign of 1987. Furthermore, although southwestern artists like Mao Xuhui, Zhang Xiaogang, Pan Dehai and Ye Yongqing had been active participants in this nationwide modernist movement by way of the New Figurative exhibitions and the Southwest Art Research Group, their work was widely believed to be overly influenced by local and ethnic tendencies. As a result, artwork produced in the Southwest was often considered to be merely a variation of "native art", and many critics believed that it was yet to become truly modern. News arrived from Beijing that Yi Ying, an art critic and lecturer at the Central Academy of Fine Arts, considered all art from the Southwest to be a form of "native art". Such an assessment was undoubtedly a provocation for young artists living in Chengdu, Kunming and Guizhou, and they decided to hold a modern art exhibition of their work to prove it was a worthy part of China's 1980s modernist movement. Some of the exhibited works by Guizhou artists did in fact reveal an ethnic quality, but Zhang Xiaogang's *Eternal* (*Shengshengbuxi*), Pan Dehai's *Maize* (*Baomi*), Ye Yongqing's *Escapee* (*Bentaozhe*) and Mao Xuhui's *Patriarch* (*Jiazhang*) and *Personal Space: Self-Imprisonment* were all typically modernist works. After the exhibition's opening ceremony, Mao Xuhui returned to Kunming.

The previous month, in September 1988, Mao Xuhui had received an invitation to attend a conference planned by Gao Minglu that was to be held from 22 to 24 November in Huangshan. Mao Xuhui was excited for this opportunity: there was finally going to be a "Huashan showdown"[15] between northern and southern artists regarding their differing perspectives on art.

This "Huashan showdown" will be a major event in Chinese culture. My faith has never wavered. This is why, despite being in that creative void, I still gritted my teeth and sent that box of paintings anyway.[16] *The production of "culture" requires the harmonious unity of time, space and the human. It has been a year of humiliation*

287 | RESTLESS SOUL

for me... but luckily, I don't seem to care much anymore. A psychic vitality, a kind of desire, is gradually returning to me, and I find myself going back to a few simple beliefs. "Life goes on. Continue charging forward." Do not worry my friend. Art has long become a trap from which we cannot escape.[17]

At first, the invitation to attend the conference in Huangshan had only been extended to Mao Xuhui, Ye Yongqing and Pan Dehai, which implied that in the eyes of Gao Minglu and his associates, the work of Zhang Xiaogang and other southwestern artists was not a significant part of the '85 Modern Art Movement. Mao Xuhui obviously did not agree with this assessment and hoped that Zhang Xiaogang could also be invited to increase the impact of the southwestern perspective at the conference. Therefore, on 24 October, while he was in Chengdu attending the 1988 Southwest Art Exhibition, he wrote the following rushed letter to Gao Minglu:[18]

Hello Mr Gao!
I have received the notification about the Huangshan Conference and I will be there on time to meet everybody. The 1988 Southwest Art Exhibition has opened in Chengdu and the atmosphere is fantastic! I'll tell you more about it in Huangshan. There is one thing I would like to ask, though. I hope that an invitation to attend the conference could also be sent to Zhang Xiaogang, who is one of the founders and organisers of both the New Figurative and the Southwest Art Research Group, as well as an organiser of this exhibition in Chengdu. He has thrown everything he's got into the development of modern art in the Southwest over the years, and we would love it if he could represent the Southwest Group at this conference to discuss these matters together and meet with everyone.[19]

Shortly after arriving back in Kunming, Mao Xuhui received a reply from Gao Minglu and his colleague Zhou Yan agreeing to invite Zhang Xiaogang to the Huangshan Conference.[20] Mao Xuhui tried to egg on his friend: "You must have gotten back to Chongqing by now. Try to get some rest and get ready for the Huangshan showdown. I suspect this conference is going to take place on a more purely theoretical level, with all sorts of ideas and strange perspectives coming together. We need to have enough courage and be mentally prepared. Changes are afoot in China's art world again!!" He also said that Pan Dehai's artistic ambitions had been piqued once more after they had discussed the conference over drinks: "He's getting fired up, just like he was when we were doing the New Figurative."

Clashes between artists and locals during the conference overshadowed any memories people might have had of the event itself. The discussions that did take place revealed that the viewpoints of artists from different cities were beginning to diverge.

At the Huangshan Conference, November 1988. From the left: Gu Xiong, a friend, Gao Minglu, Mao Xuhui, Pan Dehai, Zhang Xiaogang, Ye Yongqing, Li Xianting, Tang Lei, Zhou Yan, Dong Chao, Lan Zhenghui

Despite this, the Huangshan Conference, officially named the "'88 Chinese Modern Art Creators Conference" (*88 Zhongguo xiandai yishu chuangzuo yantaohui*), would pave the way for the China/Avant-Garde Exhibition the following year. Prior to the conference, Mao Xuhui, anxious to express his views, submitted to Gao Minglu an essay comprising the notes about art he had made between 1987 and October 1988. He hoped the essay could become a conference document for participants to read, but as representatives from every major art group were in attendance, there was in practice very little time for each of them to speak. In the end, Mao Xuhui was only able to give a simplistic account of his perspective that "art issues are human issues".

There was rapid social change from 1986 to 1988 as clashes between the commodity economy and planned economy produced a series of complex social problems in people's lives. Ideological conflicts and political campaigns in the cultural sphere influenced the way artists thought about the world. Toward the end of 1987, when the campaign to eliminate spiritual pollution was over, the "First China Oil Painting Exhibition" (*Shoujie zhongguo youhua zhanlan*) was held in Shanghai and featured many works of a more classical style, particularly those by artists like Beijing's Jin Shangyi, Guizhou's Li Hui'ang, Zhejiang's Xu Weixin and Shanghai's Dong Qiyu. On the other side of the formal spectrum were abstract works by Meng Luding, Zhou Changjiang, Gu Liming and Shang Yang. These two opposing styles were understood by critics to be conscious rejections of the '85 Art Movement and the "coarse" visual language used by previous modernist groups. The effort to make art more "artistic" was associated with the slogan "purify the visual language", which entailed a critical understanding of visual language that seemed to divorce conceptual from expressive form. The discussion over the question of classicism and visual language raged on for more than a year and it revolved around the question of how to respond to the '85 Modern Art Movement. Many of the movement's critics believed that there was an ideal artistic standard independent of real-world issues and that art ought to refine and purify its visual language, thereby elevating itself beyond former modernist approaches. In an article titled "A Few Ideas" (*Ji dian xiangfa*) published in the thirty-third issue of *Art News of China* in 1988, Zhu Zude and Liu Zhenggang wrote:

Modern art is too new and unfamiliar to Chinese people, which causes young artists to be so eager to express their ideas that they fail to find their own artistic language. One sees a lot of conceptual symbols acting as emotional symbols in works from this period, turning them into vehicles for expressing social ideas. Some artists have not only made works that appear awkward and disjointed, but have also unwittingly succumbed to what they most abhor—using art to describe politics. As such, purifying our visual language and elevating our aesthetic values is an inescapable task facing us today.

A different opinion can be found in an essay by critic Li Xianting included in the thirty-seventh issue of *Art News of China*, 1988. In this text, titled "The Era Awaits the Living Passion of the Great Soul" (*Shidai qidaizhe da linghun de shengming jiqing*), Li Xianting emphasised the importance of the meaning behind

an artwork. He rejected the idea that visual language could be stripped from the soul like layers from bamboo shoots and argued that there existed a "Great Soul" of humanity that transcended the artist's "own personal spirit" and without which all artistic work was meaningless.

The tragedy of artists lies in their being too obsessed with being artists, which leads them to place themselves before the entire history of art and its series of great masters rather than feeling their existence within the living, breathing age they inhabit. As soon as visual language, technique or style becomes his or her focus, an artist becomes no more than a worker who must arrive at work on time, and art, under the guise of "self-discipline", loses its autonomous vitality.

Mao Xuhui and Zhang Xiaogang agreed with Li Xianting because of their belief in universal human needs, and they were surprised to hear Wang Guangyi argue at the Huangshan Conference for the "elimination of humanist fervour". In the essay Mao Xuhui submitted to Gao Minglu, rather than regarding art as a tool in service of some external objective, he emphasised our inner lives and the spiritual conflicts and imbalances that exist within the soul. "We need imprisonment, jail cells, torture; we need to forever torment, coerce and terrorise our hearts and nerves; we need to make our consciousness gasp for breath; we need to repress, contort and ruthlessly flog ourselves. Only then, can one attain human value, for all of this is the motivation, the driving force behind moments of inspiration. It's wonderful! Raging souls, fractured nerves, flaming eyes, hopeless howls. It's all wonderful! All the preludes and thunderclaps of great art, all the passions and premises singing heartily for the soul!"[21] In his writing style, he was evidently influenced by the Western books young artists of the time were so fond of reading, which included the depiction in Hesse's novels of the human soul as split and in a state of conflict. Mao Xuhui argued that art was the result of a spontaneous process, a natural expression of inner needs that emerged as a flow of living experience. There was a sacred artistic essence and artists were mere tools in service of art. During the height of the New Figurative years, Mao Xuhui had developed an understanding of art as the concrete articulation of life and the soul, and as such in the process of understanding art, one had to prioritise understanding the nature of life itself:

Life is a living organism that inhabits our perception but lies beyond our consciousness. Because of life's unpredictability and tendency to constantly renew itself, understanding often fails to keep up. It freely moves forth or dims, unfolding like a dream that "illogically" propels us into the unknown. Relative to experience, it is always going off the rails, opening our eyes. It appears to our reason to be forever wandering the world, leading an adventurous existence.[22]

This was how Mao Xuhui argued that art issues were human issues. Art was simply a concrete manifestation of humanity that we chose to name "art".
As can be imagined, Mao Xuhui and his associates were not

pleased by the atmosphere they encountered at the Huangshan Conference. They had discovered disunity amongst the ranks of modern artists. They could not understand those artists who failed to attach importance to ideas like life, suffering, loneliness and tragedy. Mao Xuhui's epistemological outlook at the time had an evidently essentialist tendency and he even equated "truth" with "humanity": "Can we not say today that the human is both the means for pursuing truth and, at the same time, truth itself?!"[23] Mao Xuhui finished compiling the essay he hoped to distribute at the Huangshan Conference on 15 November 1988, a few days before the event. He concluded the essay by restating the argument he had made in the essay he had submitted to Gao Minglu one year earlier, to demonstrate that his fundamental position had not changed: "To reveal the state of one's life and soul is by no means an expression of vulnerability. It requires a certain fortitude. It is by no means a simple matter and is nothing like the outburst of emotion people often think it is. It is far more serious and intense than an outburst. It requires a strong nerve."[24] By this time, Gao Minglu had already become sensitive to the issues facing this group of modernist artists and was beginning to reflect upon the '85 Art Movement. Later he would address these questions in an article about the Huangshan Conference and how the coming China/Avant-Garde Exhibition seemed to be losing its purely pioneering character in favour of something between the pioneering and retrospective:

Alongside the dual impact of political and economic factors, the new direction being taken by the '85 Movement was another significant reason for the weakening of artworks. Many of those attending the conference believed that the '85 Movement needed to move in a different direction: prior to this, the '85 Movement had been an attempt to expand "humanist passion", whereas the new approach, it was argued, should in fact be an attempt to purify it. The next stage of Chinese art was one in which meaning disappeared, putting it in line with the rest of the world.[25]

Mao Xuhui had received a letter from Gao Minglu earlier that year in May:

We have already submitted the manuscript for A History of Chinese Contemporary Art 1985–1986. *It's a pretty comprehensive account, coming in at around 500 thousand characters, and the Southwest Group features before the chapter titled "Current of Life". For this book, we thoroughly organised all your materials to give a full understanding of your ideas and aims, which includes a lot that is insightful and ahead of its time. The detailed account of your group conveys your fundamental aims. In the book I compare the "current of life" and "rationalism" trends, arguing that both centre the human but adopt different approaches that may continue to influence one another as they develop.[26]*

Mao Xuhui informed Zhang Xiaogang that Gao Minglu was organising a large-scale exhibition of modern Chinese art, which would take place the following year at the National Art Museum of China in Beijing and would serve as the continuation of the 1986 Zhuhai Conference.[27] In a state of excitement and

Mao Xuhui in the plaza outside the National Art Museum of China, 5 February 1989. Covering the ground is a cloth sign bearing the words "China/Avant-Garde Art Exhibition"

nerves, he wrote, "I think you, Ye Yongqing, Pan Dehai and I should bring some good quality works to this exhibition. Not to put too fine a point on it, we could see it as a confrontation between China's southern and northern artists."[28]

The exhibition opened on 5 February 1989 and on the same day the police ordered that it be closed. Another attempt four days later met with the same outcome. It was on 19 February that the China/Avant-Garde Exhibition finally opened successfully, marking the beginning of what is widely considered to be the last major Chinese modern art exhibition of the 1980s. Gao Minglu, Li Xianting, Fan Di'an, Zhou Yan, Fei Dawei, Kong Chang'an, Tang Qingnian and Wang Mingxian were amongst the young critics involved in curating the exhibition, which featured work by Mao Xuhui, Zhang Xiaogang, Pan Dehai and Ye Yongqing. Just as Mao Xuhui had said, the Yunnan contingent arrived at this exhibition of art from all over the country with a somewhat confrontational attitude. This was a time when China was beginning to embrace the commodity economy, which gave rise to various new social phenomena frequently reported in the pages of popular magazines in 1988, from the increasing migrant populations in big cities throughout the country to a new awareness of money that affected the consumer habits of even young people and students. The exhibition was not officially organised by the Artists Association, although it was sponsored by the official publication of the Artists Association *Art Magazine*, the journal released by the Fine Arts Institute of the China Arts Academy *Art News of China*, the editorial committee of the book series entitled *Culture: China and the World* (*Wenhua: Zhongguo yu shijie*), which introduced Chinese readers to Western modern art, as well as the magazines *Chinese Aesthetics Society* (*Zhongguo quanguo meixue xuehui*) and *Dushu*. Despite this, however, it had no official connection with the Artists Association, and aside from these various sponsors, most of the exhibition's funding was secured personally by Gao Minglu and his associates.[29] As such, not only were participating artists required to pay an exhibition

fee of one hundred yuan, they were also expected to cover their own transport and insurance expenses. Mao Xuhui later recorded his memories of the experience:

On Chinese New Year's Eve, I was invited to the home of an old friend from Yunnan working in Beijing who had a bunch of us poor southwestern artists around his place to drink baijiu. Braised pork in a rice cooker, a few white cabbages, a couple of fried dishes—a solid meal! We drank as we watched the New Year's Gala on China Central Television.[30] I felt relaxed after a few days of non-stop nerves and exhaustion, happy that now, no matter what, the exhibition was finally going to take place. This time the trip from Kunming was tough. Pan Dehai and I had two boxes of paintings between us. It reminded us of how difficult it was when we put on our own exhibition. Something funny happened when we tried to put our paintings in the hold at Kunming Station. We got them into the hold, had them weighed, and then the staff asked us the value we wanted to insure our cargo for. Obviously, neither of us had any idea what the value should be, but we thought our art would be more secure if we quoted a higher price, so we casually told them that each box was worth one hundred thousand. That's when their ears pricked up. Without saying a thing, they got out a calculator and told us that the insurance premium would come to one thousand. They'd even printed us a receipt right there on the spot. That's what I call efficiency! We were dumbfounded. We quickly tried to explain that even if we sold everything we owned we wouldn't be able to afford it. We had no real concept of how insurance worked. If we had known the premium was 1% of the declared value, we'd never have plucked such a massive number out of thin air. This really annoyed the staff who subjected us to a string of abuse, accusing us of making light of the nation. We could only apologise repeatedly, hoping they'd be generous enough to give us another chance to declare. From a dizzying high of one hundred thousand, the paintings fell to a value of nothing, and we had to sign a statement of "Acceptance of Personal Responsibility for Damage or Loss" before they would sign off on the cargo. But that wasn't the end of it. They stared at us and said, "I dare you to try a stunt like that again!" Why would we want to do it again? The poor don't have the guts for this kind of stuff. Looking at those two boxes of paintings, I was reminded of Van Gogh. They might be priceless one day, but then again, maybe they'll be worthless. Who could say? All I knew was that whether they contained treasure or trash, those boxes had to get on the train to Beijing and into the National Art Museum. With this Beijing exhibition, everyone had to pay their own way. This is what's so absurd about this generation of young artists. We can barely make ends meet but we still somehow scrape enough money together to do all this modern art stuff that most people couldn't care less about. The expenses for our time in Beijing, including food and accommodation, couldn't exceed five or six yuan a day, otherwise we wouldn't have made it to the end of the exhibition. We had no choice but to stay at the student dorms of the Central Academy of Fine Arts, even though it meant risking being caught and fined by the school. Zeng Hao, a student there from Kunming, helped us out a lot. Every night he found us beds, blankets and sheets, somehow managing to sort out each of us "Old Cossacks" from the Southwest while we were there. When it came to food, we'd skip breakfast, and for lunch and dinner we'd either sprinkle some Fuling spicy pickles on

instant noodles or pool our money for dumplings and rice porridge somewhere. As Chairman Mao said, "People need a little spirit." I think this has become our motto.[31]

In the eyes of most artists and critics, the oil and ink paintings that were amongst the nationwide collection of modern art at the China/Avant-Garde Exhibition were overshadowed by performance and installation of art pieces like Xiao Lu and Tang Song's *Dialogue* (*Duihua*), known as "the shooting incident" , Li Shan's *Washing Feet* (*Xijiao*), Zhang Nian's *Hatching Eggs* (*Fudan*) and Wu Shanzhuan's *Selling Shrimp* (*Maixia*),[32] which led to the exhibition being closed twice, making things difficult for organisers like Gao Minglu and inciting a strong reaction from the public.[33] Mao Xuhui was clearly aware of the situation:

This time there were lots of photos of performance art, ranging from suicide plans to paying homage to Mount Everest in the Himalayas and dancing naked with the world's tallest mountain in the background, as well as artworks being burned and so on. All sorts of extraordinary stuff, but when these exciting performances are reduced to a photograph, they're not so direct. They lose their impact and potential to become news. Most of the paintings hanging from the wall had the same problem. No matter how diverse they were in terms of form and content, at the end of the day they were confined to two dimensions, which robbed them of their news potential. Whether it was the rationalist dissection of a Chairman Mao portrait or an appeal to a kind of religious spirit; whether it was a pair of gloves painted bigger than a person or the bizarre smiles of four bald heads in a row; whether it was giant splatters of ink or purely abstract paintings with various materials pasted to the canvas. . .[34] *Because they still smacked of that oldest and most traditional artform, painting, they did not appeal to many people. They did not inspire passion amongst the journalists and audiences eager for some excitement.*

Not long after returning to Kunming, Mao Xuhui gave a talk at the Yunnan Provincial Library, the same venue that had hosted the Third New Figurative Exhibition a few years previously, where he described in detail the main performance art incidents that took place at the China/Avant-Garde Exhibition. The fact that his own work had been overlooked did not prevent him from sharing with his audience news of the art that had so stung his pride. Despite his own complex emotional response to the event, a historical perspective and willingness to understand characterised his modernist account of the "retrospective exhibition that consisted of a comprehensive collection of the '85 Art Movement's achievements." He concluded the talk as follows:

For me personally, the inaugural China/Avant-Garde Exhibition is a somewhat melancholy milestone. So many calamities befell it: just punishments for its crimes or treasures it should cherish? It has undoubtedly provided vibrant material for future historians. The generation of artists younger than me often boast that art is a form of "aggression". But it waits to be seen whether this aggression is not precisely what buries us in the prime of our youth.[35]

The severity of the political atmosphere and social situation of the first half of 1989 forced most young artists to withdraw into themselves. Restrained in both word and deed, artists with previously romantic or expressionist tendencies began to understand the importance of suppressing emotional outbursts and passions. Meetings between friends began to lack the free and reckless conversations of the past and doubt was cast on the applicability of terms like "ideals", "principles" and "life goals". Prior to this, a romantic spirit had instilled in everyone unquestioning confidence in the value of the human and humanity's freedom, but after June it became difficult to utter phrases that were formerly commonplace. Ideas and words encountered in books no longer seemed to have any bearing on the reality in which they lived, leaving many at a loss for words. This was the psychological state of many artists in the second half of 1989.

The 1990s which followed are often seen as bringing the turn in China from "modern" to "contemporary art", although it is unclear who first began to use the latter term. When the first edition of *Art Market* (*Yishu shichang*) was published in January 1991, Wang Guangyi said the following in an interview:

As far as we can see now, Chinese contemporary art has not yet gained a status equivalent to the academic heights it has reached. The reasons for this are complex. One of the major reasons is that there are no strong national institutions to back it up. The success of post-war American art is in essence the success of America's institutions. Without it, artists like Pollock, de Kooning and Jasper Johns would not be the figures they are today. You just mentioned the "art industry". It's a very good term. It touches on the question of circulation. I think we must first participate in this circulation, and only then, within this framework, can new meaning be produced. We have now started to participate, and I am confident that in five years Chinese "products" will be playing a significant role in the world art industry.[36]

Wang Guangyi's choice of words is clearly completely different from that of the 1980s modernists. Mao Xuhui wrote a text entitled "Contemporary Art's Mission" (*Dangdai yishu de shiming*) at a similar time, October 1990, while he was living at No. 2 Heping Village (the subject of numerous of his artworks). The text begins by trying to explain what "contemporary art" is:

What is contemporary art? It is art that inherits traditional art's (i.e., global art's) great spirit. What is the great spirit of art? It is the sublime spirit that is profoundly concerned with the world and human life and passionately pursues truth. It makes use of various powerful forms to convey the voice of the human soul, to transmit the soul's ever-burning flame. Contemporary art must first maintain and expand the eternal spirit that transcends space and time, i.e., eternal humanity.

Later in the text, Mao Xuhui attempted to explain "art's contemporaneity", but he continued to approach such questions with the knowledge he had acquired in the 1980s. He was still turning to humanist philosophy or Lebensphilosophie to deal with the artistic issues of the age. He was so completely

immersed in essentialist thinking, so unable to understand art outside of this modernist philosophical and theoretical framework, that he failed to comprehend that in a post-1989 world the issues facing artists had significantly changed. However, he was vaguely aware of a problem with his "schema". He realised that a work now required inherent coherence of form; mere emotional expression no longer sufficed. He continued to emphasise the importance of the soul, but he was also becoming aware of the necessity of "constructing one's own visual language", even if he still understood visual language to be formal style. Around this time, he read an article by Lü Peng published in *Jiangsu Painting Journal* in July 1990 entitled "Explaining the 'New Stylism'" (*"Xinfenggezhuyi" jieshuo*). He saw in Lü Peng's understanding of style ideas that conformed with his own and so wrote in his own text, "As Mr Lü Peng aptly puts it, the creation of a formal style is 'proof of the soul's creativity, or to put it more simply: style is the proof of the soul'." Lü Peng's article was in fact primarily about visual language, but his use of the word "style" indicated that his analysis of visual language was yet to stray from the thinking of modernist art. In 1990, Wang Guangyi's "Great Criticism" (*Da pipan*) series began to appear, and the emergence of the "Bald Heads" (*Guangtou*) works by Beijing's Fang Lijun marked a radical departure from modernist art. It was clear to anyone with a certain analytic sensitivity that the "soul" had disappeared from these new paintings. The "spiritual" had been replaced by the "conceptual", which sought to change how people think. When Mao Xuhui was still arguing that "the essence of contemporary art is the formulation of one human's problems and highest values", Wang Guangyi and Fang Lijun had already moved on from such essentialist ideas. They and others like them were no longer discussing the "human questions" and "state of the human soul" that so concerned Mao Xuhui.

In the October 1990 issue of the *Jiangsu Painting Journal*, Wang Guangyi went to great lengths to explain the slogan "elimination of humanist fervour", which he had first proposed at the Huangshan Conference and had gone on to emphasise further at the China/Avant-Garde Exhibition in February 1989:

> *Artists begin from general epistemological facts encountered within a collective illusion and, from this, collectively construct a mythological history in which everything is exaggerated and magnified by humanism. Any artist completely immersed in such a "state of affairs" is bound to believe the "myth". The illusoriness of the myth has made artists since the Renaissance believe they are in dialogue with the divine. Scepticism about this myth began to arise amongst European and American artists in the latter half of the twentieth century, but often not consciously, such that even avant-garde artists like Joseph Beuys would occasionally find themselves straying into the mythic haze, a tragedy caused by the stubborn persistence of the language of "modern art". In fact, the visual languages of classical and modern art share the same origin, and it is within this linguistic continuity that one finds the relation between artistic representation and art. In this sense, we ought to abandon art's dependence upon humanist fervour, move beyond questioning the meaning of art and begin resolving artistic questions, thereby establishing a logically consistent and empirically sound linguistic context that draws on the cultural facts of the past as experiential material. If we discover that classical and modern art has left*

us contemporary artists with many questions, individual artists can choose or unearth some of these questions to serve as the logical starting point for their own work.[37]

In 1990, Mao Xuhui expressed his vehement disagreement with the idea of "eliminating humanist fervour" in his notebook:

Today, one often hears the somewhat-academic-sounding call to eliminate "humanist fervour" and purify artistic language. But this elimination or purification is simply the attempt to force art to free itself from or abandon its profound concern for those essential aspects of humanity's survival. I believe that today it is precisely the "humanist fervour" people are attempting to sublimate that needs to be strengthened. Without it, what meaning does this thing we call art still have?[38]

Mao Xuhui clearly equated Wang Guangyi's call to eliminate human fervour with the purification of artistic language advocated by certain figures in academia. It was a time when most artists were overcome by an oppressive sense of helplessness, during which Mao Xuhui maintained correspondence with just a few close friends. He found himself slowly awakening from the daze of the China/Avant-Garde Exhibition and, despite his professed aversion to Wang Guangyi's slogan, it seems that a recognition began to gradually take shape that there might be a problem with the previous unbridled emotionality Lebensphilosophie had inspired in him. Nonetheless, he stuck to his position. Not only did he remain faithful to the fundamental orientation behind his own expressionist approach but sought to push that approach to its extreme. What had changed, however, was the fact that it seemed that the "extreme" he now sought lacked fluidity and was congealing instead into a simple symbol. It was no longer merely a manifestation of the contingent. This is how Mao Xuhui explained it to his friend Lü Peng in a letter:

Today, the scope of artistic language has expanded and the artist is so overwhelmed by the multiple freedoms available that he or she isn't free. I agree with Stravinsky on this point. Art needs limits to be free. One must find oneself, affirm that self, and in this naïve choice exercise one's freedom.[39]

Evidently, a shift took place in politics, society and the modernist movement toward the end of the 1980s in China, which affected the thinking of artists from the Southwest. While refusing to fully accept the discursive change all at once, they nonetheless began to engage in rational introspection. While staying true to his basic artistic standpoint, Mao Xuhui also began to explore in his practice the evolution and variations of a more stable symbol, which he called the "Patriarch". Just like the cynical realists[40] and political pop artists, he had in fact embarked upon a series of works that featured symbols and stable motifs. The only difference was that he believed that the Patriarchs he drew in different styles and situations emanated from the depths of his soul and were not mere pop art designs.

n 1988, Mao Xuhui's *Personal Space: Self-Imprisonment* and *Patriarch* featured in the 1988 Southwest Art Exhibition. This marked the beginning of the extensive "Patriarch" (*Jiazhang*) series, which would consist of a range of variations on the basic form hazily rendered but nonetheless clearly discernible in this first oil painting to bear the name "Patriarch".[41] On 31 December 1988, as Mao Xuhui looked back over his recent work, he realised the now undeniable potential of the Patriarch motif: "The 'Patriarch' is full of possibility. There's humour to its affected aloofness, but it also appears as a kind of 'totem' figure. I keep thinking of that Márquez novel *The Autumn of the Patriarch*, which I haven't read, but I think perhaps I have a feeling for what it's talking about. I know the 'Patriarch' is going to be big."[42] Apparently, Mao Xuhui had not felt this way about the Patriarch for long, because only a few months earlier he was complaining about the poor state of his recent output. Around the time he sent his pieces to the 1988 Southwest Art Exhibition, he told Zhang Xiaogang, "Right now, in terms of painting quality, there are only a few Yunnan artists who are considering artistic questions. As for myself, I'm genuinely ashamed, because stuff in my life has made such a mess of my mind over the last two months that I've found it difficult to focus my energies on proper work. At night, when the world is in turmoil, I often find myself wanting to escape."[43] He even went on: "In the end I sent two paintings. Last year's one looks terrible and this year's one is extremely crude; all that I can say of them is everything about them is true. I was thinking that if these two paintings have a detrimental effect on the whole exhibition, you and Lü Peng can decide whether you think they should be excluded. I wouldn't object, believe me!"[44] What Mao Xuhui referred to as "this year's one" was in fact his earliest "Patriarch" experiment. Clearly, in stark contrast to his attitude a few months later, he had not yet come to regard this painting as a new self-discovery.

After June 1989, Mao Xuhui's artistic sensitivity was no longer confined to personal spaces. Poetic allusions to the idyll of Guishan and explorations of the quotidian spaces in which he and his friends lived had been side-lined by hitherto inconceivable social events. The discussions he had with friends extended beyond everyday experiences such as the strange nocturnal cries of cats on asbestos rooves to questions of fate and the future, quickly developing into exchanges about how humans would continue to exist in the years to come. He continued to contemplate his own artistic direction. He was still primarily informed by Gao Minglu's '85 Art

PATRIARCH

Movement framework and saw the work of northern artists like Wang Guangyi and Ding Fang to be expressions of rationality, will power or a sense of sublime tragedy, whereas he and his Yunnan associates Zhang Xiaogang and Ye Yongqing were irrational and volatile. However, such an analysis was no longer able to accommodate the Patriarch motif, which first appeared in 1988 and became increasingly pronounced throughout 1989. Although this series was still painted in an expressionist style, the crystallisation of the Patriarch figure was a result of more socially conscious considerations, as can be seen from the following passage written in 1990:

> *The emergence of "Patriarch" is different to that of "Red Earth" and "Personal Space" because it goes beyond individual spirit and existence, touching on something more primitive and profound in Chinese culture. It can be taxing trying to explain this with language. There are several aspects. The Patriarch symbol represents power, solitude, autocracy, despotism, dignity, brutality, domination and the will; it belongs to the realm of the "actual" and is essentially the fate of the Chinese people; the weight, suffering and tragedy it conveys is something we have all felt deeply throughout our long history to the present; this overwhelming force is the central question our art is concerned with, something our spirit has borne for many years; the soul's crime lies in its failure to grasp it, its historicity and contemporaneity; as reforms deepen in China, we will become more able to recognise the profundity of this symbol.*[45]

The emergence of a relatively stable symbol that is the subject of repeated development and variation represents a significant shift in Mao Xuhui's art. It signifies the artist's longing for a form that can encapsulate his complex ideas about real issues, a form that he seems to believe he has found in the Patriarch. The history of art teaches us the question of finding one's own unique visual language and form, a problem that Mao Xuhui and his associates had never stopped contemplating. This posed a challenge to these expressionists who had no interest in formalism but nonetheless recognised the importance of settling on a linguistic and formal system. To a certain extent, "Guishan" and "Personal Space" can be seen as different paths taken by Mao Xuhui in his attempt to find his own visual language, paths that also satisfied his inner needs at the time. But now a more complex and intense feeling was taking shape inside Mao Xuhui that the contingency of expressionist brushwork was no longer suited to express. The Patriarch theme remained with him, albeit in a complex and psychologically various range of forms. As with the "Personal Space" series, the "Patriarch" series came from personal reflections on real life. In his 1990 notebook, Mao Xuhui wrote the following on a page that featured a draft sketch of the Patriarch: "The Patriarch: a universal concept, a fact everyone knows and experiences, a concept used by everyone." As he hoped to use this symbolic schema to express his own thoughts and feelings, he also wrote, "I have schematised the everyday concept of 'Patriarch'." This work of schematisation was of course related to the problems of art and visual language that he constantly pondered. In a letter to Zhang Xiaogang written as early as 1987, Mao Xuhui had explained:

Another perennially distressing issue is the question of art. I've recently been looking through the Fine Art Compendium *(Meishu quanji) and reading some articles about art history. After flicking through the entirety of the* Fine Art Compendium *I realised just how serious a matter it is getting a page dedicated to one's art in there. But what should we be doing?! Many of the masters knew exactly what they were doing, whether it was Ingres, Monet, Cézanne, Matisse, Picasso or any of that motley crew of modern artists. They all knew what they ought to be doing and had a clear idea of their artistic style, vocabulary and what it was they were creating. I on the other hand often don't know. Or I don't know what it is I'm missing. Perhaps I'm too being too intellectual. Perhaps an artist should flow free and cause havoc, obeying only their own life force, without concern for all this stuff. But all these European masters must have walked in the shadow of the Louvre as they moved forward; even someone like Henri Rousseau, whose paintings can only be described with the word 'genius', must have yearned day and night to one day find a place amongst those at the Louvre. There have been few, if any, artists who have been able to find a place in the history of art based solely on their innate nature, never comparing themselves with the whole.*[46]

In this letter, Mao Xuhui also wrote, "There is nothing purely individual. The idea of something purely individual is simply a by-product of the modern ideology of individualism." He continued to believe in something essential at the heart of art, but he was becoming increasingly sceptical of the notion of absolute freedom or individualism: "I believe that there must be a supreme being watching over art, which regardless of how the latter's concepts evolve, preserves art's laws and essence, and ensures it can relate to its past. Art is, after all, art. It is not something else. Irrespective of the motive behind it, it must ultimately be art." This was how Mao Xuhui thought about art after the '85 New Wave.

Unlike the conceptual artists emerging around this time, Mao Xuhui attempted to explain that the Patriarch schema was not a visual metaphor of a specific idea but a complex symbol that caused his artworks to exhibit an intensely expressionist quality. He had not turned his back on the complexities of his psyche; he merely wanted to be better able to control them. On a sheet of paper with "Yunnan Television" as its letterhead, Mao Xuhui wrote a text entitled "On the 'Patriarch' series":

I chose a "theme", or perhaps it chose me. It gradually took shape, grew and posed more questions. My will power was ignited by it and I was constantly painting this thing I called "Patriarch" (since 1989, I've dedicated myself to it almost entirely), but I was never satisfied. Even now it inspires me to do lots of work. It's beyond my control. Through this process, I have come to understand my own power and things that were previously unclear to me. Human power eventually finds an outlet just as the magma in a volcano will always eventually erupt.

. . .

The "Patriarch" series contains my insights into human life and history, as well as my concern about the human condition. Life is not a song and dance. It's serious.

The numerous Patriarch-themed paintings Mao Xuhui completed after August 1988 mark a new phase in his output. We have seen that prior to this, Mao Xuhui did not limit himself to a single path and often produced stylistically various pieces over a single period, at times working on his idyllic "Guishan" series, "Personal Space" series and pop-art-influenced collages almost simultaneously. However, in the latter half of 1988, the problem of the Patriarch started to emerge. Some of the first paintings in the "Patriarch" series were a form of spiritual self-portrait in which the rhombus-shaped faces acquired such a symbolic character that they almost deprived the work of its function as portraiture. They reflected the artist's fear of a force coming from an obscure direction that he sensed served to devour and curtail the human body and spirit. However, the Patriarch was interestingly also precisely an image of that hostility toward the human. The first painting called *Patriarch*, which was exhibited at the 1988 Southwest Art Exhibition, emphasised the magnitude of this curtailing force. One gets the impression that the two figures on either side of the frame are retreating, while the central figure is held in place by the dark square behind his head. Overall, it is a work of hazy imagery.

The elongated rhombus that would later characterise the series makes a prominent appearance in *Patriarch 88.12* (*Jiazhang 88.12*), where a positive and negative image of the Patriarch appear side by side, sustained by a dark rectangle and a white rectangle respectively. This piece reflects a more explicitly formal approach to the Patriarch theme and serves as a foundation for subsequent paintings in the "Patriarch" series.

That certain formal characteristics of the "Patriarch" series were beginning to form in the tumult of Mao Xuhui's mind can be seen in some of the "Personal Space" works produced as early as 1987. The Patriarch's rhombus-shaped head is discernible in nascent form not only in *Married Couple in Concrete Room*, discussed above, but also *Photo Together* (*Heying*), albeit obscured behind demonic imagery that reveals inner anguish. In *Patriarch 88 No. 3* (*Jiazhang 88.3 hao*), painted in early 1988, Mao Xuhui incorporates historic symbols that complicate our understanding of the Patriarch and humorously emphasises the intrinsic formal necessity for a rhombus with sharp corners. This sharpness will become increasingly pronounced in many subsequent works in the "Patriarch" series. A more or less intact shadow of the Patriarch is also cast alongside an image of a celebrity in a collage work that imbues the Patriarch symbol with a comic sense of redundancy. The presence of the Patriarch figure in various works does not imply it acquires some external, disinterested relation with other metaphorical symbols. On the contrary, the form and meaning of the Patriarch arise from their very combination. Ultimately, the Patriarch poses its own set of questions.

Aside from the standard figure of the Patriarch himself, the "Patriarch" series also features various "human bodies", such as *White Human Body Sitting on Chair* (*Zuo zai kaobeiyi shang de baise renti*), *Human Sitting on Chair* (*Zuo zai kaobeyi shang de ren*), *White Human Body on the Run* (*Benpao de baise renti*), *White Human Body with Black and White Rectangles* (*You heibei juxing de baise renti*), *Imitation of David's "The Death of Marat"* (*Fang dawei de mala zhi si*), *Human Sitting in White Passage* (*Zuo zai baise tongdao shang de ren*) and *Black Human Body* (*Heise renti*).

We have seen the "human body" before in Mao Xuhui's paintings, but at this stage his explorations of the theme, although inherently related to his previous work, take place fully within the Patriarch rubric.

The Patriarch concept conceived by Mao Xuhui has many meanings:

The Patriarch is the personification of reality, the father of life. He strictly regulates life's existence. He endows life with its semblance of majesty, the sacred, but also that of terror and brutality. He forces life to accept what he prescribes; he leaves it no choice.

The Patriarch is also the shadow of history. It reminds us that life can never be overcome. It links life to decaying relics and distant worlds.

The Patriarch is the inescapable threat to life that can come from anywhere. It makes life submit to the instruments of death and subjects it to torture.

The Patriarch is the mask of morality and ethics that forces life to depend on it and makes life feel violated. The Patriarch is a muffled voice emanating from the mysterious depths that lures life towards it and deprives life of its ability to hear things properly.

The Patriarch is the gatekeeper of hell. Before life can enter, the Patriarch subjects it to a horrific assessment.

The Patriarch is also the mother of life. It has maternal qualities, albeit maternal qualities it shares with Medea. It is related to the massacre and blood and therefore resembles Edvard Munch's vampire.

Evidently, the Patriarch is also oneself.

In most of his compositions, the Patriarch appears as a figure imprisoned in a range of unsettling places, a life so threatened that it has become the embodiment of that threat. By taking on this visible form, it informs us of the power of this threat and reveals the depth of the solitude that afflicts all lives. Its deformed figure is a manifestation of the deformities of life. It is thus both torturer and tortured, that which controls life and the life that is controlled. Omnipresent, yet with no freedom of movement, both interrogator of life and life interrogated, the Patriarch possesses a threatening power but is also threatened by a certain power. It both wrecks life and sustains it. In short, the Patriarch is an image selected by Mao Xuhui to illustrate the existential relation between life and reality—a spiritually charged form that the artist both embraces and endures. The Patriarch also reflects Mao Xuhui's understanding of control and power. If reality is understood to be that which cannot be resisted, then this is where the limit of one's spiritual power lies. Problems of reality therefore become the complex relationship between inner life and the world beyond.

In August 1989, Mao Xuhui completed three works featuring human bodies that were part of the "Patriarch" series: *White Human Body Sitting on Chair*, *Human Sitting on Chair* and *White Human Body on the Run*, which today is part of the USC Pacific Asia Museum collection. Shortly afterwards, he completed *White Human Body with Black and White Rectangles*, *Imitation of David's "The Death of Marat"*, and *Corridor and Stairway at Night* (*Shenye zoulang he louti*).

White Human Body Sitting on Chair and *Human Sitting on Chair* are permeated with a suffocating sense of tension. Both paintings feature a simple chair imbued with hostility, on which sits a naked body (in the case of *White Human Body*

302 | PATRIARCH

Sitting on Chair, possibly a woman) whose posture resembles that of someone being interrogated. Despite this, the pyramid shape these figures' legs make with the floor conveys a sense of stability. In *White Human Body Sitting on Chair*, the sharp streak of shadow resembles a bolt of electricity that charges the scene with tension, while the blurry rendering of the sitting figure's head gives the image an ethereal quality. The head in *Human Sitting on Chair* is a crudely drawn rhombus, making the painting similar in structural form to other works in the "Patriarch" series, but one sees traces of a personal narrative in its suggestive use of colour. Smears of white paint serve to negate parts of the background's red, which in turn has bled into the human body. Clearly, here an expressionist language has acquired a symbolic function. What we see in these two works is the image of a failed Patriarch, a Patriarch that has become a symbol of the self, a document of life imprisoned and tortured.

 White Human Body on the Run presents an even more pitiful vision of life's failure—a life in a truly miserable state of helplessness. What distinguishes this work from the "Personal Space" series is the fact that the space occupied by the subject has been rendered abstract. The "personal space" no longer exists. The artist has returned once more to the fundamental premise of "existence and annihilation", which suggests that, at this point in his career, the question of how humans face the evil forces of destruction seems to him to get closer to the crux of the matter than considerations of human behaviour in "personal spaces". The contrast between the white of the human body on the run and that of its backdrop—the former's head and feet rendered in daubs of thick viscous white as opposed to the sparer application of paint on the background—arouses anxiety about the figure's future, which is only accentuated by the downward sloping line behind the white body charging insistently into an ever-narrowing space. One fears that this human body will be swallowed up by the white world, or at least enter a less free, more suffocating space. *White Human Body with Black and White Rectangles* is perhaps redolent of some of Mao Xuhui's "Personal Space" paintings, but this is not important. We are free to view its subject as life that has been fortunate enough to escape being completely debilitated but nonetheless occupies a pitiful state. We have seen something similar to this painting's symbolically significant black and white rectangles in *Patriarch 88.12*, and the reappearance here of this contrasting geometric pair implies that an old question concerning the Patriarch theme is being posed once more. On a compositional level, the two prominent black and white rectangles are echoed by another two incomplete and slanting rectangles on the top-left of the picture, while the splash of red next to the figure's right foot and the red sign above the white rectangle naturally bring to mind more familiar, real-world issues.

 Imitation of David's "The Death of Marat" is a variation on another artwork. While working on his "Patriarch" series, Mao Xuhui consulted numerous painting albums containing depictions of death by Caravaggio, El Greco, Goya and Jacques-Louis David, which gave him a new understanding of the topic. Mao Xuhui had once harboured a strong aversion to classical and realistic works, and for some time it was primarily German expressionist works that moved him. However, his experience of life had caused him to reconsider classical art, and he concluded that

what he disliked about it was its form. Caravaggio, for example, was an artist for whom Mao Xuhui had formerly expressed distaste, but later he wrote: "What I disliked about Caravaggio before was the form. Now I see that his expression is very precise." What was it that Caravaggio expressed so precisely? The themes of life and death. Mao Xuhui had seen something eternal about life in a vast array of works, leading him to the belief that he maintains to this day: "There is no real distinction between the avant-garde, the classical and the modern." *The Death of Marat* was a painting that caused Mao Xuhui to come to understand death differently. David's original serves as a kind of memorial to Jean-Paul Marat's death, whereas in Mao Xuhui's "imitation", it looks as if Marat, sustained and irradiated by some force emanating from the depths of the earth, has yet to expire. There is a contradiction between these irradiating beams and the large dark black rectangle in the foreground, the latter acting as pure negation impeding utter collapse and death. In the face of this rectangle's mystery, all powers of discernment are lost. The artist's frame of mind while painting this picture was evidently similar to that of the previous paintings discussed here. The groaning figure of Marat is of course just the Patriarch metamorphosed or, to put it another way, Marat's bodily form has been temporarily commandeered by the Patriarch so that Mao Xuhui can continue his explorations of the Patriarch theme. This work demonstrates that Mao Xuhui's decision to turn to classical art was not merely one of expediency (as was the case with many artists since 1988 who in the post-'85 climate blithely adopted classical visual forms without thinking about the essence behind them) but rather constituted an attempt to return to the most fundamental of artistic questions.

Between September and October of 1989, Mao Xuhui painted *Human Sitting on Armchair* (*Zuo zai fushouyi shang de ren*), *Patriarch Sitting in the Night Sky* (*Zuozai yekong zhong de jiazhang*) and *Patriarch Sitting in the Night Sky: Maternal* (*Zuo zai yekong zhong de jiazhang: muxing*).

Unlike the works discussed thus far, there is a sober quality to *Human Sitting on Armchair*. Although the colours of the purple-red background and the black figure in the foreground relate to one another in a way that is far from soothing, the clear shapes and measured brushwork have provided us with a coherent image of the Patriarch in a three-dimensional space. It would seem that since the previous few paintings, the Patriarch has undergone a change in status and has acquired an intimidating demeanour. That being said, the pleasant interplay between the dark human figure's maroon tones and the white of the chair cannot be denied.

Patriarch Sitting in the Night Sky and *Patriarch Sitting in the Night Sky: Maternal* seem to form a contrasting pair. The masculine Patriarch commands less awe than his maternal counterpart, his very existence forcefully sustained by the rectangle that forms the back of his chair. The maternal Patriarch, on the other hand, seems to have supplanted the chair and become herself the very structure of support. Apart from her two large breasts, her entire body has been transformed into a formidable chair. This is a terrifying conception of the "maternal".

Another two interconnected works, *White Human Body on Chair* (*Kaobeiyi shang de baise renti*) and *Human Sitting on Chair* resemble the two halves of the 1988 work *Patriarch 88.12*, which features a positive and negative image of

the Patriarch side by side. However, in these two later works, the Patriarch appears more fully realised. As a negative image of the Patriarch, the pale, corpse-like body in *White Human Body on Chair* forms a striking contrast with the huge chair on which it sits, back to the viewer, such that one finds oneself concerned for the future of the frail body perched on that imposing chair. *Human Sitting on Chair*, on the other hand, transforms once more the relationship between chair and Patriarch. This positive image of the Patriarch faces forward, legs extended in a manner that recalls the chair of the previous painting. It is difficult to form an impression of this Patriarch's rhombus-shaped head because it lacks any physical detail, something that distinguishes its identity from that of the "white human body". It seems as though, between these two paintings, a transformation has taken place, one that concerns the multiple properties of existence and the various aspects of life.

With the arrival of the "Patriarch" works completed in October 1989, space became the focal point of the artist's attention.

The subject of *Patriarch Sitting in Ruins* (*Zuo zai feixu zhong de jiazhang*) has receded into the distance. The sturdy pyramid that forms between chair and Patriarch evokes the latter's previous status and majesty. However, this majesty seems less unwavering than it once was, its force diminished by its dilapidated surroundings to such an extent that the Patriarch himself seems to have become part of the ruins.

Patriarch Series: Red Door No. 2 (*Jiazhang xilie: hongmen zhi er*) presents a rectangular doorway through which one can make out the figure of the Patriarch sitting in the distance, his splayed legs, or the legs of the chair he is sitting on, forming an outline that mirrors the shape of the doorway that contains the scene. The composition consists of two spaces, that which lies within and that which lies without the doorway. The space inside is fraught, as though filled with a magnetic field for which the Patriarch acts as both positive and negative poles, even as he has been reduced to a sliver barely visible against the white of the back of his chair. The space outside the door is calm, offering us the opportunity to observe as external spectators; we are safe, at least as long as we remain outside. Of course, we cannot be sure of the origin of the splashes of red on the outer walls. They seem occasionally to form a relation with the world inside the door, casually straying into that world of tension when the mood takes them. However, it is difficult to say if these red splashes are invading from outside or whether they are effects of the Patriarch's magnetic field. Either way, there is something unexpected about those splashes of red.

The nature of the colour red is transformed in *Patriarch Series: Red Door* (*Jiazhang xilie: hongmen*), no longer symbol of some dynamic field but rather an assertion of presence. The mottled effect of the doorframe's red evokes the passage of time, but what is unsettling is its vividness, which undermines the aged texture, giving it an artificial quality. This vibrant rendering, juxtaposed with the Patriarch who appears far away in the centre of the frame, implies that the red door is both the Patriarch's surroundings and an articulation of the Patriarch's meaning. The rectangle formed by the red doorway emanates denial and control, which keeps in check the atmosphere of tension inside, even though it is this very atmosphere that lies at the heart of the problem.

We see a reduction in tension in *Patriarch Series: White Door* (*Jiazhang xilie: baimen*), completed in January 1990. Rectangles formed of discrete white blocks come together to form a kind of underground tunnel in which the implied door is only subtly symbolic. We could consider this composition to be a means for us to approach the Patriarch.

In *Patriarch in Yellow* (*Huang sediao jiazhang tu*), we see something akin to the shimmering interior of a benign palace. Although the composition produces a sense of depth similar to previous works, the contrast between the large blocks of yellow and black gives the scene a tranquil and stately appearance that evokes the sacred and harmonious effect of music.

Patriarch in White (*Baise diao jiazhang tu*) unexpectedly abandons depth in favour of a flat composition with a decorative quality. The black and white rectangles combine with the Patriarch and the chair to form a tranquil arrangement of clearly delineated elements. Here we see the artist in a far more peaceful state of mind. There is something comical about the Patriarch's position and relation with the chair. Slightly puzzling however is the black oval in the top-left corner, which contrasts with the rest of the image that is composed of straight lines.

This more peaceful state of mind continued to accompany Mao Xuhui throughout the year when he was painting such works as *Human Sitting in White Passage* and *Black Human Body*. We can even see some humorous and playful flourishes, especially in *Black Human Body*, which recalls the nihilistic mood of the "Personal Space" series.

In *Patriarch Triptych* (*Jiazhang sanlianhua*), we see the artist pay more attention to the effects of painting itself. He seems less concerned with emphasising an atmosphere of tension than he is with his handling of the medium. In these works, we see the artist finding pleasure in the serendipitous results of experimenting with the moisture, thickness and coarseness of his application of paint, as well as his use of flat brushes (he almost never made use of standard oil painting brushes) and palette knives. In *Great Patriarch in Red Cave* (*Hongku zhong de da jiazhang*), completed in August 1990, we can see even more clearly a certain order of feeling and thought on the part of the artist.

Excessively accentuated cheekbones cause the head of the archetypal image of the Patriarch to acquire the shape of a rhombus, something particularly apparent in *Patriarch Portrait* (*Jiazhang xiaoxiang*), completed in May 1990. The Patriarch usually sits on a chair with spread legs, and if it is a symmetrical, frontal image, he often appears to merge with the chair. This is of course simply an expression of the artist's intention, meaning that it is possible, in a work like *Patriarch Sitting on Red Chair* (*Zuo zai hongse kaobeiyi shang de jiazhang*), to find that the chair exhibits more Patriarchal qualities than the Patriarch sitting in it, the latter's rhombus-shaped head having shrunk so much one wonders if it might not vanish entirely.

Mao Xuhui has provided us with numerous Patriarch images that are difficult to erase from our minds. They reflect different aspects of spiritual life while providing a kind of abstract generalisation of existence. Through these images of the Patriarch in various environments, we can see the stability that arises from control. This stability not only determines the totality of relations that comprise the

Mao Xuhui and Liu Xiaojin at No. 2 Dormitory, Heping Village, 1990

composition, but also effectively confines within a larger structure the range of activity of the explosive force that emanates from life itself (rectangles and doors in particular often play this role). On the other hand, the impulse of life to resist this stability lies at the heart of these compositions, and life's strength, instead of being diminished by its containment within certain limits, is all the more intensified as a result. Artistic expression used to be a means of relaxing or venting for Mao Xuhui, but here we see this impulse squeezed and restricted in a way that has only enhanced its expressive power. Mao Xuhui had never produced such stable compositions prior to the "Patriarch" series, at which point the stability became suddenly obligatory, a result of some force that left him no other choice. At the same time, Mao Xuhui had never given such free rein to the strength of his expressionist visual language, a logical development of life's instinct to resist death. He looked reality in the face and actively pursued all that he felt compelled to endure, for he knew that only this kind of endurance could provide him with a basis for finding his own strength: "Art is not in essence an illusion, but a product of endurance", he said.

This series of paintings would continue to evolve for many years, with Mao Xuhui reflecting upon every corner of his life and experience through the figure of the Patriarch.

Patriarch is an insomniac
Patriarch is that idol in our blood
Patriarch is a shadow warrior
Patriarch is a waste of space
Patriarch is a series of events stuck in a big tree
Patriarch is a bat flying at night
Patriarch is a cave
Patriarch is a boulder
Patriarch is a stubborn old emotion

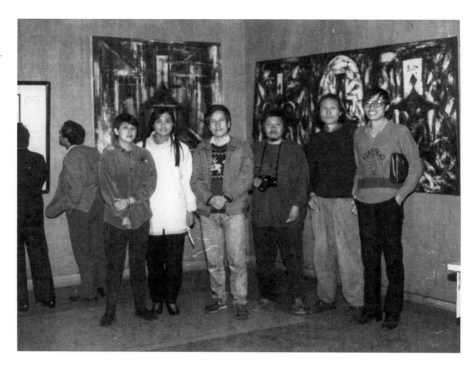

At Yunnan Ten Youths Oil Painting Exhibition curated by Mao Xuhui, 15 November 1990. From the left: Liu Xiaojin, Xian Yanyun, Yao Zhonghua, Yu Jian, Mao Xuhui, Deng Qiyao

. . .

Patriarch is a dreamer walking in the streets [47]

In November 1990, works from Mao Xuhui's "Patriarch" series were exhibited at the "Yunnan Ten Youths Oil Painting Exhibition" (*Yunnan shi qingnian youhuazhan*), curated by Yao Zhonghua and sponsored by the Yunnan branch of the Artists Association and the Yunnan Art Gallery. That same month, the Kunming Film Art Worker Association was established, and Mao Xuhui who had fallen deep into the abyss of the Patriarch, was appointed one of the directors.

[1] Translator's note: Igor Stravinsky, *Poetics of Music in the Form of Six Lessons*, trans. Arthur Knodel and Ingolf Dahl (Cambridge, MA: Harvard University Press, 1947), p. 65.

[2] From the black plastic-covered notebook used in 1988.

[3] Nie Rongqing describes it as follows in *Colors of the Moat* (pp. 291–93): "The Anti-Bourgeois Liberalisation Campaign began in late 1986. Zhang Long had stayed at Peking University at this very sensitive time, just as the student movement was at its height amongst Peking University students, so when he returned to East China Normal University in Shanghai shortly afterwards, he was already on the school's 'watch list'.

"On a sunny afternoon in January 1988, I rode my bike to Mao Xuhui's house for dinner as usual. I entered the house only to discover two very serious-looking strangers and a pile of books and paper on Mao's desk and bed. Mao saw me and told me in a solemn tone of voice that he was busy and that I should stay away for a while. Only later did I find out that the two men had travelled from Shanghai to take all the letters that had been exchanged between Mao Xuhui and Zhang Long. Luckily, there was little cause for concern in the letters, which mostly consisted of young artists rambling about art and their ideals. Mao Xuhui was pretty depressed at the Film Company for a while after that. The investigation also extended to the Sichuan Fine Arts Institute, and since a conclusion had yet to be reached about the upset surrounding the exhibition at the end of 1986, Zhang Xiaogang found himself once again in a precarious position at the school. The investigation lasted many years, during which both of them continued to be hounded by similar problems in their respective places of work.

"Towards the end of 1987, for the crimes of illegal cohabitation with his girlfriend, stealing public property (they were using a school gym mat for a mattress) and playing pornographic music in a public place (the music of Taiwanese singer Teresa Teng), Zhang Long was detained, expelled from East China Normal University, and sent to the Shanghai labour

camp on Yin'gao Road for two years of re-education through labour. His friend Zhang Xiaobo, who had had more girlfriends than Zhang Long, was given an even longer sentence. Because of his skills as a painter, Zhang Long's main work in the labour camp consisted of teaching old cadres how to produce imitations of famous paintings that could decorate the public spaces of the labour camp or their own homes. During his stay, he discovered that a certain kind of cardboard used in the camp for packaging worked well as an oil painting surface, and in the remaining year or more he had there, he quietly painted over three hundred old paintings on that cardboard. By the spring of 1988, even the Public Security Bureau considered the crimes for which these young people had been arrested contrived, but they did not know how to go about reviewing these cases, and no one was particularly keen on reopening that can of worms. Universities also believed that there was no way people who had been taken away by the Public Security Bureau could return to the school. So Zhang Long ended up staying in the labour camp until 1989."

[4] Letter from Mao Xuhui to Zhang Xiaogang, 4 April 1988.

[5] Translator's note: The "unity of Heaven and humanity" (*tian ren heyi*) is a philosophical idea that plays a role in Confucianism, Daoism and traditional Chinese medicine.

[6] Letter from Mao Xuhui to Zhang Xiaogang, 4 April 1988.

[7] Ibid.

[8] Letter from Mao Xuhui to Zhang Xiaogang, 8 May 1988.

[9] Ibid.

[10] Liu Yong was born in Kunming in 1958 and graduated from the Oil Painting Department of the Sichuan Institute of Fine Arts in 1983. He is currently a professor at the Yunnan Arts University.

[11] Translator's note: The term "ten-thousandaire" (*wanyuanhu*) as a benchmark of affluence was common in the 1980s when ten thousand yuan was equivalent to around three thousand dollars.

[12] Letter from Zhang Xiaogang to Mao Xuhui, 23 May 1988.

[13] Letter from Mao Xuhui to Zhang Xiaogang, 26 June 1988.

[14] It was Zhang Xiaogang's wife Tang Lei who secured most of the sponsorship for the exhibition.

[15] Translator's note: The reference here is to a martial arts novel by Jin Yong of the same name in which the best warriors in the world come together to test their combat skills on Huashan (Hua Mountain), which sounds similar to Huangshan where the conference will be held.

[16] The box of paintings in question contained the works he sent to Chengdu to be included in the 1988 Southwest Art Exhibition.

[17] Letter from Mao Xuhui to Zhang Xiaogang, 25 September 1988.

[18] The haste with which this letter was written is demonstrated by the fact that it was written on paper provided by Lü Peng and bearing the letterhead of the Sichuan Theatre Association.

[19] Letter from Mao Xuhui to Gao Minglu, 24 October 1988.

[20] In a letter written to Zhang Xiaogang on 1 November, Mao Xuhui wrote, "I got a reply from Zhou Yan today saying he and Gao Minglu had received my letter and have decided to send you an invitation, which should be arriving at the beginning of the month. Also, the dates for the Huangshan Conference have changed to 22–24 November. The time and date are on the official notification."

[21] Mao Xuhui, "Art Issues Are Human Issues—Extracts from Notes 1986–Oct 1988" (*Yishu wenti ji ren de wenti—1986 nian-1988 nian 10 yue biji zhailu*).

[22] Ibid.

[23] Ibid.

[24] Ibid.

[25] Gao Minglu, "Crazy 1989—The Story of the 'China/Avant-Garde Exhibition'" (*Fengkuang de yi jiu ba jiu—"zhongguo xiandai yishuzhan" shimo*), *Tendency* (*Qingxiang*), no. 12, 1999, pp. 43–76.

[26] Letter from Mao Xuhui to Zhang Xiaogang, 18 May 1988.

[27] In "Crazy 1989—The Story of the 'China/Avant-Garde Exhibition'", Gao Minglu writes: "The Zhuhai Slideshow Exhibition was a prelude to the 1989 modern art exhibition. In fact, it was during the Zhuhai event that participating artists and critics got together to propose organising a large-scale exhibition of Chinese contemporary avant-garde art. And so began an arduous and complex process of preparing for this exhibition, which I don't think anyone thought would only take place two years later. Nor did anyone anticipate just what an impact on society it would have."

[28] Letter from Mao Xuhui to Zhang Xiaogang, 18 May 1988.

[29] In "Crazy 1989—The Story of the 'China/Avant-Garde Exhibition'", Gao Minglu writes: "Far more difficult than the academic questions behind the exhibition was the issue of how to fund it. Finding a venue and securing funding are the two major challenges in preparing for a modern art exhibition. We had to secure all the funding for this large-scale exhibition ourselves. Although there were six sponsors, they only provided nominal and moral support. Furthermore, back then, these cultural institutions were struggling to keep themselves afloat." Regarding the question of funding, Gao Minglu even turned to Mao Xuhui for support but, as one might imagine, it was to no avail. There is a record of this in the letters exchanged between Zhou Yan and Mao Xuhui.

[30] Translator's note: The New Year's Gala, broadcast every Chinese New Year's Eve, is a variety show that culminates with a countdown to midnight. It is the world's most watched television programme.

[31] Mao Xuhui, "Madness, Farce, Art, or. . .—Remembering the First China/Avant-Garde Exhibition" (*Shi fengkuang, shi ezuoju, shi yishu, haishi. . .—ji Zhongguo shoujie xiandai yishuzhan*), written on 7 April 1989.

[32] Translator's note: Xiao Lu fired a gun at her own painting; Li Shan washed his feet in a basin on which was printed an image of President Reagan; Zhang Nian perched on a nest of eggs with a piece of paper around his neck that read "While hatching eggs, refuse all theory so as not to disturb the next generation"; Wu Shanzhuan started selling shrimp in the gallery.

[33] On 13 February, the National Art Museum of China issued a "Notification that organisers of the China/Avant-Garde Exhibition will be disallowed from holding exhibitions and fined for the cessation of gallery activities due to the discharge of a firearm". See Gao Minglu, "Crazy 1989—The Story of the 'China/Avant-Garde Exhibition'".

[34] Amongst the artworks referenced here are such oil paintings as Wang Guangyi's *Mao Zedong: AO*, Ding Fang's *The Power of Tragedy*, Zhang Peili's *X?*, and works by Geng Jianyi.

[35] Mao Xuhui, "Madness, Farce, Art, or. . .—Remembering the First China/Avant-Garde Exhibition". In a letter written to Zhang Xiaogang on 23 March, Mao Xuhui put it in the following way: "We stayed true to ourselves in this exhibition and only history can pass an accurate judgment on our work. It was beyond our abilities to vie for a place amongst the avant-garde with our paintings. In '85, we were the avant-garde, but not anymore, just a small remnant of it. We emerged as historical figures but the newcomers are downstairs. These troublemakers are our illegitimate children, whether we want to admit it or not—at least this is the way history may record it." Zhang Xiaogang had also shared his complex emotional response to the situation with Mao Xuhui

in a letter written on 17 March: "Seeing our impetuous peers at the 'China/Avant-Garde Exhibition', I felt something difficult to articulate, as though our silence there was not merely shyness but more a form of loneliness. I felt as if we had nothing in common with those 'vandals', those nihilistic megalomaniacs, those stylists who wanted to drag art away from the human soul and towards mere visual stimulant, those possessors of money." *Amnesia and Memory: Zhang Xiaogang's Letters, 1981–1996* (Beijing: Peking University Press, 2010), pp. 131–32.

[36] "Interview with Wang Guangyi", *Art Market*, no. 1, 1991, p. 3.

[37] Wang Guangyi, "On 'Eliminating Humanist Fervour'" (*Guanyu "qingli renwen reqing"*), *Jiangsu Painting Journal*, October 1990, pp. 17–18.

[38] The grey hard-covered notebook. On the other side of this page, Mao Xuhui wrote "October 1990" next to a small "Patriarch" drawing. It seems likely therefore that this was written towards the end of 1990.

[39] Letter from Mao Xuhui to Lü Peng, 9 November 1989.

[40] Translator's note: "Cynical realism" refers to a school of painters who emerged in the early 1990s and include Fang Lijun and Yue Minjun.

[41] Translator's note: The Chinese name for this series, *jiazhang*, is a gender-neutral term that is often translated as "parent", but more specifically refers to the head of the household. We have decided to translate it as "Patriarch" to emphasise the traditional, authoritarian aspect, while retaining the correspondence with the reference Mao Xuhui himself makes to Gabriel García Márquez's novel *The Autumn of the Patriarch*. However, it is worth pointing out that Mao Xuhui's Patriarch, although often seemingly male, is not always so. This is reflected by the fact that throughout this text, the Patriarch is referred to alternatively by the masculine, feminine or neutral third-person pronouns.

[42] Mao Xuhui's dark grey notebook/diary/sketchbook from 1988–89.

[43] Letter from Mao Xuhui to Zhang Xiaogang, 20 August 1988.

[44] Ibid. In a letter written to Zhang Xiaogang two months earlier on 26 June, Mao Xuhui described his mental state: "It's just I haven't really painted anything recently. I did a couple of small, improvised pictures but there was nothing to them. I keep finding myself in a contradictory state when it comes to questions of art, going this way one minute and that way the other. I know I'll keep swinging back and forth. Maybe that's just who I am, maybe it's something I can't simply will away, but it's something I still want to control as best I can." It was in July that Mao Xuhui finished the *Patriarch* painting that would feature in the 1988 Southwest Art Exhibition.

[45] From the red hardcover notebook labelled "1989". On the inside cover, Mao Xuhui has pasted a photo of himself carrying a "Patriarch" painting down a flight of stairs, which he has titled *Carrying the Devil*, implying that this Patriarch, released into the world, had already acquired a complex significance for Mao Xuhui. Next to it he has also drawn an outline of the Patriarch's head, dated 14 December 1989, which must have been the time he first started using this notebook. We can infer therefore, despite its label, that its contents correspond predominantly to his reflections throughout the year 1990. Mao Xuhui seems not to have had any sense that the coming year would bring any fundamental change, emphasising rather its continuity, as we can see on the first page: "There is in fact no obvious boundary between one year and another. Is there any obvious boundary between one and two o'clock, or twelve and one o'clock?!"

[46] Letter from Mao Xuhui to Zhang Xiaogang, 1 December 1987.

[47] From Mao Xuhui's 1990 notebook.

Chapter 4

The Patriarch

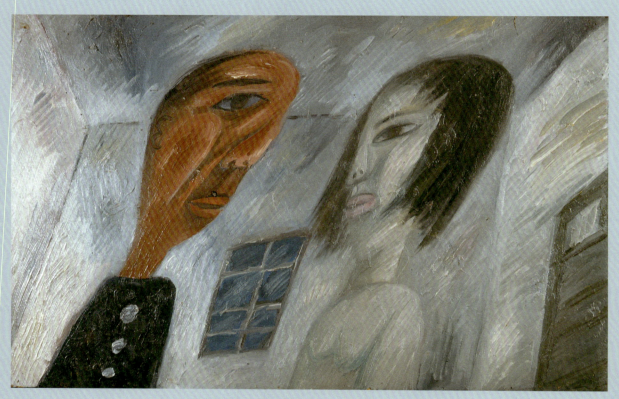

Mao Xuhui
Married Couple in Concrete Room (Shuini fangjian li de fufu), 1987
Oil on paper, 48 × 76 cm

Chapter 4

The Patriarch

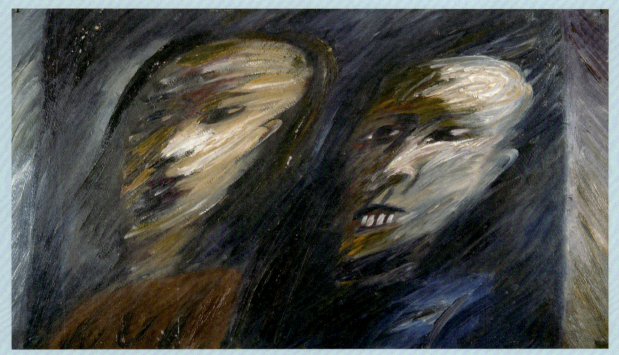

Mao Xuhui
Photo Together (*Heying*), January 1987
Oil on paper, 45 × 78 cm

311

Chapter 4

The Patriarch

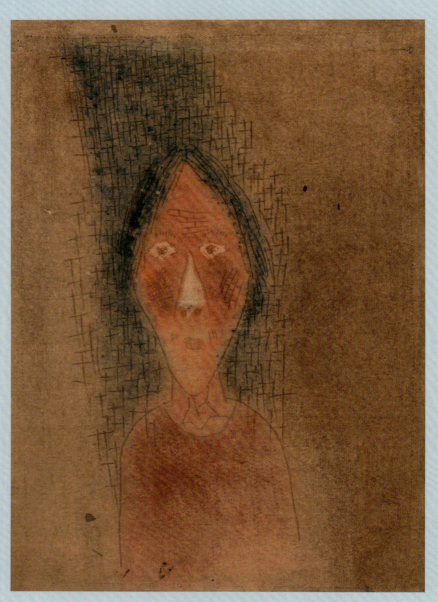

Mao Xuhui
Self-Portrait (*Zihuaxiang*), 1988
Oil on etched paper, 22 × 15.3 cm

Chapter 4

The Patriarch

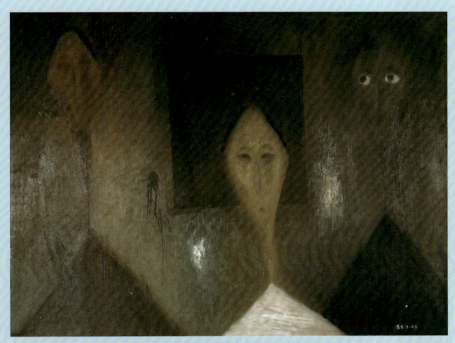

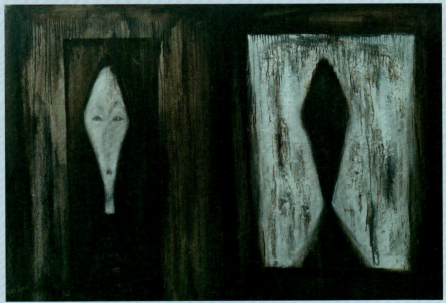

Mao Xuhui
Patriarch (Jiazhang), July 1988
Oil on canvas, 100 × 120 cm

Mao Xuhui
Patriarch 88.12 (Jiazhang 88.12), December 1988
Oil on canvas, 111 × 165 cm

Chapter 4

The Patriarch

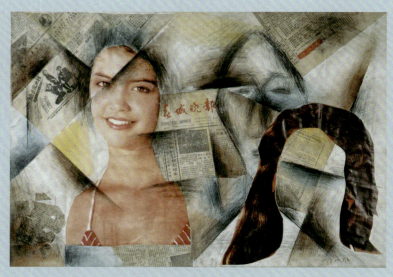

Mao Xuhui
Patriarch: Amongst Celebrity (*Jiazhang: he mingxing yiqi*), 1988
Collage, watercolour and charcoal pencil on paper, 56 × 81 cm

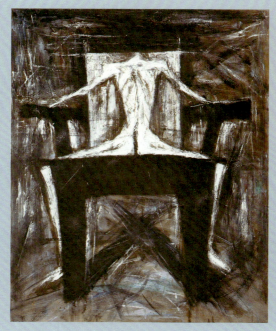

Mao Xuhui
White Human Body on Chair (*Kaobeiyi shang de baise renti*), 1989
Oil on canvas, 101 × 81 cm

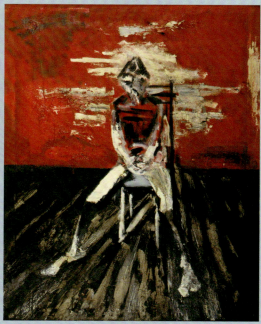

Mao Xuhui
Human Sitting on Chair (*Zuo zai kaobeyi shang de ren*), August 1989
Oil on canvas, 120 × 90 cm

Chapter 4

The Patriarch

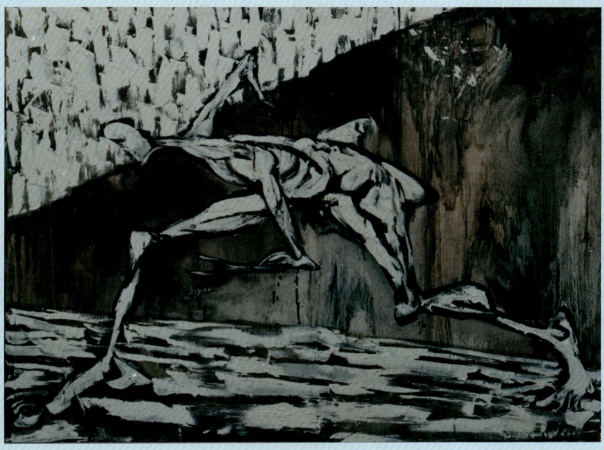

Mao Xuhui
White Human Body on the Run (Benpao de baise renti), 1989
Oil on canvas, 120 × 160 cm

Chapter 4

The Patriarch

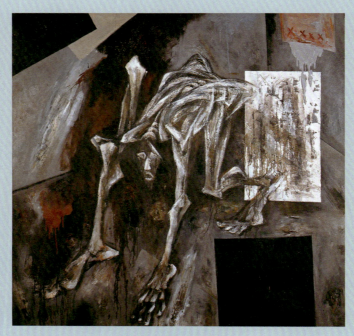

Mao Xuhui
White Human Body with Black and White Rectangles
(*You heibai juxing de baise renti*), 1989
Oil on canvas, 140 × 140 cm

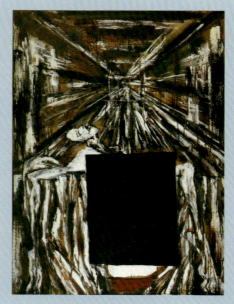

Mao Xuhui
Imitation of David's "The Death of Marat"
(*Fang dawei de mala zhi si*), 1989
Oil on canvas, 134 × 95 cm

Chapter 4

The Patriarch

Mao Xuhui
Human Sitting in White Passage (*Zuo zai baise tongdao shang de ren*), 1990
Oil on canvas, 120 × 150 cm

Mao Xuhui
Black Human Body (*Heise renti*), December 1990
Oil on canvas, 117 × 147 cm

Chapter 4

The Patriarch

Mao Xuhui
Corridor and Stairway at Night (Shenye zoulang de louti), 1990
Oil on panel, 120 × 90 cm

Mao Xuhui
Human Sitting on Armchair (Zuo zai fushouyi shang de ren), September 1989
Oil on panel, 97 × 67 cm

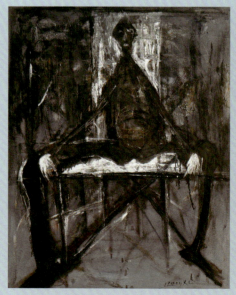

Mao Xuhui
Patriarch Sitting in the Night Sky (Zuozai yekong zhong de jiazhang), September 1989
Oil on canvas, 120 × 90 cm

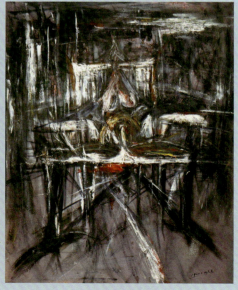

Mao Xuhui
Patriarch Sitting in the Night Sky: Maternal (Zuo zai yekong zhong de jiazhang: muxing), September 1989
Oil on canvas, 120 × 90 cm

Chapter 4

The Patriarch

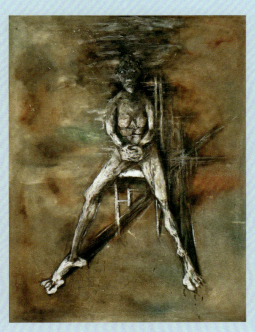

Mao Xuhui
White Human Body Sitting on Chair (*Zuo zai kaobeiyi shang de baise renti*), September 1989
Oil on canvas, 120 × 90 cm

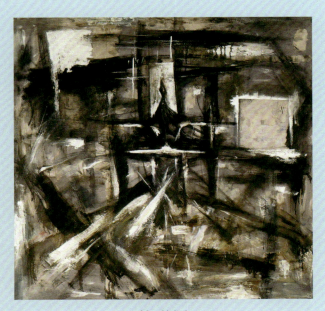

Mao Xuhui
Patriarch Sitting in Ruins (*Zuo zai feixu zhong de jiazhang*),
October 1989
Oil on canvas, 120 × 120 cm

Chapter 4

The Patriarch

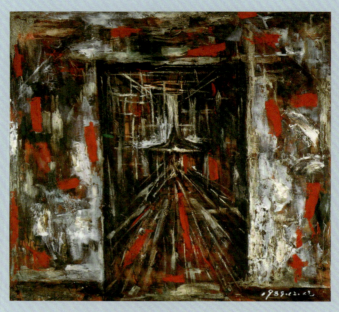

Mao Xuhui
Patriarch Series: Red Door No. 2 (Jiazhang xilie: hongmen zhi er),
December 1989
Oil on canvas, 103.5 × 111 cm

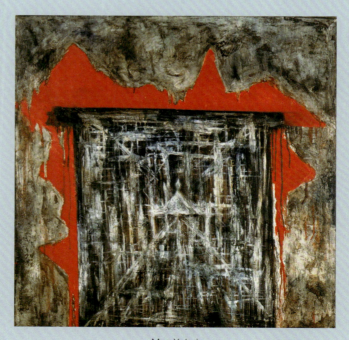

Mao Xuhui
Patriarch Series: Red Door (Jiazhang xilie: hongmen), 1989
Oil on canvas, 100 × 100 cm

Chapter 4

The Patriarch

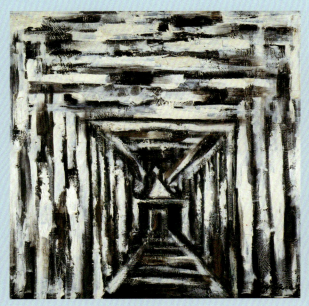

Mao Xuhui
Patriarch Series: White Door (*Jiazhang xilie: baimen*), January 1990
Oil on canvas, 98 × 98 cm

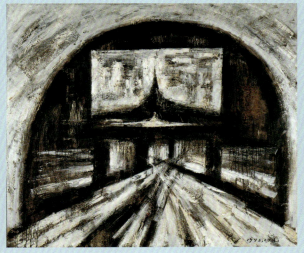

Mao Xuhui
Patriarch Series: White Arch (*Jiazhang xilie: baise gongmen*), 1992
Oil on canvas, 150 × 170 cm

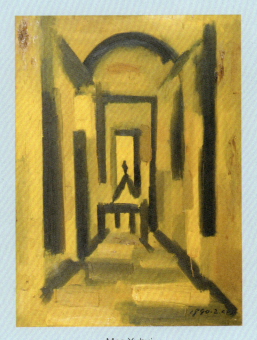

Mao Xuhui
Patriarch in Yellow (*Huang sediao jiazhang tu*), 1990
Oil on canvas, 123 × 90 cm

Chapter 4

The Patriarch

Mao Xuhui
Patriarch Triptych (Jiazhang sanlian), 1990
Oil on canvas, 120 × 90 cm each

Mao Xuhui
Picture of Big Patriarch in Red Grotto (Hongku zhong de da jiazhang tu), August 1990
Oil on canvas, 120 × 150 cm

Chapter 4

The Patriarch

Mao Xuhui
Patriarch Portrait (Jiazhang xiaoxiang),
May 1990
Oil on canvas, 80 × 60 cm

Mao Xuhui
Patriarch Sitting on Red Chair (Zuo zai hongse kaobeiyi shang de jiazhang), June 1990
Oil on canvas, 90 × 90 cm

Chapter 5

IMMATERIAL LIGHT

Our material bodies will disappear, are doomed to disappear, but the soul, this immaterial light (although perhaps this light is also a kind of material), will live on forever, meeting with other future souls and producing new energies and hopes for survival.

Mao Xuhui[1]

Mao Xuhui continued to explore the Patriarch theme for years. By 1994 he had discovered that his "Patriarch" works were becoming increasingly abstract and so decided to turn his attention to more concrete objects from everyday life. This reorientation resembled his shift from utopian "Guishan" works to the "Personal Space" series. In a letter written to Gao Minglu on 26 December 1995, he explained his reasoning:

The motivation behind my transition from the "Patriarch series" to "Everyday Epic" came from the fact that my later "Patriarch" works were becoming increasingly abstract and metaphysical. In order to avoid becoming detached from reality, I decided to return to the concrete paraphernalia of everyday life to find that something that genuinely resembles the "epic" or "metaphysical". Everything I've been through, experienced and felt tells me that this is how I should do it, because in the end I can only care about what truly relates to me.

In 1993, everyday objects like keys, computers, furniture and bookshelves started making their way into Mao Xuhui's compositions. He seemed to be considering how to incorporate the Patriarch into a more familiar setting. Since 1990, he had poured a huge amount of energy into the "Patriarch" series, and in 1994, he transformed the sharp and irresolvable conflict at the heart of the Patriarch into a pair of scissors. In his search for everyday objects to paint, he found that scissors served as a symbol which—sharp, contradictory and always changing—resonated with his previous artistic ambitions. In *Everyday Epic: Scissors* (*Richang shishi: jiandao*), a chair, empty bottle and strip of tablets are under the dominion of a massive pair of red scissors, while in *Everyday Epic: Scissors and Hallway* (*Richang shishi: jiandao he zoulang*), the scissors are evidently master of their environment—as grey as everything around them, they have taken over from the Patriarch as the conduit of Mao Xuhui's artistic intent.

A notebook used from 1991 to 1992 containing various sketches and impromptu notes reveals information about Mao Xuhui's state of mind and the questions he faced after 1989. He had noticed that since 1991, the political tone of the articles published in *Art Magazine* was clearly different from that which he had previously become accustomed to. The climate of free artistic expression that had gradually emerged in the post-Mao era was now beginning to be affected by political problems. Explorations of art's multiple functions, pioneered in the fields of avant-garde and experimental art, were criticised as harbouring "bourgeois liberal tendencies that violate the principles of socialism". This was of course related to the political climate that followed the 1989 Tiananmen incident. As an artist born in the 1950s who had a natural sensitivity to national, political and social issues, Mao Xuhui felt a tension in the air that was different from what he had experienced prior to 1989, an ideological atmosphere that even felt somewhat like a return to the era of mass criticism that was the Cultural Revolution. This sense of foreboding only began to dissipate with the expansion of free market reforms in 1992. After this, Mao Xuhui started to notice the art emerging from the "new-born generation" (*xinshengdai*),[2]

Page 324
Mao Xuhui
Upright Black Scissors
(*Zhili de heise jiandao*), 1998
Oil on canvas, 180 × 150 cm

Mao Xuhui's notes from 1991

Mao Xuhui's notes from July 1992

Mao Xuhui's notes from 1992

which began making waves in Beijing, and "political pop art" (*zhengzhi bopu*), which was centred mostly in Wuhan and Shanghai. Mao Xuhui maintained a sceptical attitude towards these new painting phenomena, which he understood to be a playful or morbidly comic form of resistance and did not like at all. He continued to believe in a critical attitude towards reality that took things seriously, even though he knew that art of this sort was "inscrutable to the general viewer." The truth was that Mao Xuhui understood only too well that his artistic language needed to change, but he had no interest in "popular and accessible" modes of expression. He was still enamoured with the techniques of expressionism and in his notebook poked fun at the new generation, cynical realism and political pop art:

These so-called new-born generation artists have become celebrities by producing paintings depicting a little tedium, which have been cooked up by some serious critics and then served on the table of fashionable art. To be honest, we faced the pressure of tedium twenty years ago, and that was in the 1970s. The Old Cossacks conquered all this long ago, what they call hollow tedium. We left that gloomy valley to face our lives and social reality head-on. We must recognise that this is the reality shared by billions of people growing up. I don't care about individual tedium. It's something we long ago dismissed as "bourgeois sentiment".[3]

He also offered a different perspective on political pop art, a genre well known amongst artistic circles at the time:

Another type of celebrity consists of our contemporaries who are said to be operating in a deconstructive sense and applying postmodernist principles specifically with regard to political problems. This is so-called political pop art. The subjects of their work are Mao Zedong and the Cultural Revolution.

In a sense they are the products of alienation from Chinese politics. This is not something we are interested in. It is completely at odds with our temperament.[4]

The new-born generation consisted mostly of young teachers at the Central Academy of Fine Arts. Their age and life experience meant that history and social reality clearly did not strike them with the same gravity as they did those artists born in the 1950s. They regarded the everyday world around them with a

"close-up" (*jin juli*) perspective (to borrow art critic Yin Ji'nan's term). Related to this was the sense of tedium exhibited in works by these artists born in the 1960s, such as Liu Wei, Fang Lijun and Yue Minjun, which led critic Li Xianting to summarise their art as "cynical realism" (*wanshi xianshizhuyi*). Mao Xuhui described his dislike for this art phenomenon originating in China's North in his letters to Zhang Xiaogang. However, he had a similar aversion to the political pop art emerging from Wuhan and Shanghai. He did not believe that the use of popular political and consumer symbols could constitute truly critical art and thought such a practice was completely at odds with the critical spirit of the 1980s. Mao Xuhui believed that the symbols used in political pop art were too simplistic. Although there is a great deal of historical irony and thought-provoking symbols and images to be found in Wang Guangyi's "Great Criticism" (*Da pipan*) series, Li Shan's "Rouge" (*Yanzhi*) series, Yu Youhan's "Mao" (*Mao Zedong*) series and Liu Dahong's "Cultural Revolution" (*Wenge*) series, such art was difficult to accept for someone like Mao Xuhui whose artistic tastes were deeply rooted in expressionism. He observed the prevalence of Mao Zedong's image in political pop art and wrote:

> *If you think a certain individual can control the course of history, then there's something wrong with your understanding of history. All you can say is that a certain person is a product of their environment. The environment is what matters. How do we make sense of Chinese society? What is it that lies behind the Mao Zedong phenomenon, behind the Cultural Revolution, behind the recent reforms? These are the questions we should truly be concerned with.*[5]

This led Mao Xuhui to the following conclusion: "So-called political pop art is the psychological product of negative resistance." However, Mao Xuhui was also clearly aware that he needed to find his own artistic schema. In truth he had been looking for a stable schema since 1988, which is what led him to the pointed image of the Patriarch. In his numerous variations on this theme, he gave full expression to the complexity of his inner world, until in 1994 the emergence of scissors as a motif in his work marked a new peak in the semantic scope of his symbolism.

Mao Xuhui was coming up against contradictions between modernism and contemporary issues. Many of his statements were thinly veiled critiques of the new-born generation art emerging from the North and he clearly disagreed with political pop art's explicit symbolism. He insisted on defending the metaphysical in art and tended toward abstraction and internalisation even when faced with real-world issues.

In December 1993, Mao Xuhui participated in "Chinese Fine Arts in 1990s: Experiences in Fine Arts of China" (*Jiushi niandai de zhongguo meishu: zhonguo jingyan*), an exhibition organised by Wang Lin, who taught at the Sichuan Fine Arts Institute. The exhibition was held in the Sichuan Art Museum and curator Wang Lin invited critics Shui Tianzhong, Liu Xiaochun, Li Xianting, Yi Ying, Yin Shuangxi, Chen Xiaoxin, Gu Chengfeng, Yi Dan and Fan Di'an to participate in a discussion on "Individual Experience and Contemporary Culture". With this Experiences in Fine Arts of China exhibition, Wang Lin hoped to emphasise what

individuals experienced in life and art during the 1990s. He was mostly concerned with artists' sensitivity and responsiveness to the world, which resonated with Mao Xuhui's own artistic aspirations. In a letter to Zhang Xiaogang written before exhibition preparations began, Mao Xuhui proposed a subheading for the show: "Visual Acts of Resistance". He went on:

> *I have always felt that we as a group are not creators of a specific form. We have always positioned ourselves in this world and the Chinese painting scene in terms of our spirit of resistance. Our art is a result of our incorporating various experiences of form, but we are not formalists. If someone insists that art is form, then I will readily announce to the world that we are not artists. The questions we are concerned with go far beyond the external form of art. Our subject is life, the reality of China. Whether we are looking at life from the perspective of an individual's personal situation or looking at life and the world from the perspective of nationality, the state or humanity, we are not the kind of people who prioritise form above everything else. . . We have an open attitude to the history of art. My art contains various modern artistic elements—expressionism, symbolism, surrealism, signs and semantics, psychoanalysis and political consciousness, existential consciousness. . . These elements exist to differing degrees in all of our work and taken together constitute the subject who resists. Because in our so-called art, art has already been transcended. We seek the realisation of the subject of humanity as a whole, the subject who resists.*[6]

These words were written in response to an inspiring letter[7] Mao Xuhui had received from Zhang Xiaogang telling his friend that Sichuanese scar art painter Wang Chuan recommended "rethinking the Southwest Art Group's strategy." This idea was clearly prompted by news about developments in northern Chinese art, which incited these artists living in the Southwest to attempt to regain their influence in this new historical period. Zhang Xiaogang described it as a "comeback", a new force in art history to follow up on previous movements from the Southwest like scar art, the New Figurative and the Southwest Art Research Group. It was this suggestion by Wang Chuan that led to the decision to organise the Experiences in Fine Arts of China exhibition.

Explicit political symbols were beginning to appear in featured works by Zhang Xiaogang. He began toning down his use of colour and brushwork in the "Tiananmen" series, which depicted spaces in pure blocks of black, white and grey to accentuate the historic symbolism. These paintings, which retained some of the expressionist brushwork of his earlier work, seemed to intimate that people's "experiences of China" were making the transition from collective to private memory. Ye Yongqing's *Big Poster* (*Da zhaotie*) combined easel painting with long silk prints and clearly built on his "Big Poster" series. Drawing inspiration from the big character posters prevalent during the Cultural Revolution, Ye Yongqing incorporated advertising and commercial symbols to produce a kind of installation piece that drew from the visual language of pop art while never coming across as trivial. In his "Blackness" (*Mo dian*) series, Wang Chuan continued to develop his abstract art, while Zhou Zhunya's "Mountain Rocks" (*Shanshi tu*) series attempted to present the

330 | IMMATERIAL LIGHT

role of traditional culture within a contemporary context. Meanwhile, after many years of exploration, Mao Xuhui's "Patriarch" series offered a generalised portrayal of the political situation, arguably influenced by the visual language of pop art.

The content and implications of the works on display at this exhibition were summarised by critic and exhibition organiser Wang Lin as that era's "experiences of China". Those involved hoped the exhibition would help establish a new orientation in Chinese art after 1989. They endeavoured to distance themselves from the sniggering irony and humour of political pop art and cynical realism, emphasising instead the importance of human spiritual depth. One could argue that it was an endorsement of a modernist position, albeit one that sought to move away from the tensions of modernism in terms of visual language. They were aware that their world had changed and that new historical questions were arising as a result of globalisation. The legitimisation of the market economy meant Chinese society was no longer characterised only in terms of political conflict, and the influence of Western culture was becoming increasingly visible in cities all over China. Just as had been implied in Wang Guangyi's "Great Criticism" series, which featured a range of Western brands, China was entering a new and ambiguous phase, described as the era of "socialist market economics". The questions artists faced and the goals they pursued were becoming more complex.

In December 1994, Mao Xuhui's girlfriend Liu Xiaojin was sent by Chinese Central Television to Beijing to participate in the creation of the television programme *Half the Sky*,[8] which combined with invitations Mao Xuhui had received from Beijing-based critics and artists like Li Xianting and Wang Guangyi, who convinced him to go to Beijing and try developing as an artist far from home, just as fellow painters like Zhang Xiaogang had done. However, by April of the next year, Mao Xuhui had given up on his Beijing plans and returned to Kunming where he started

Visiting Antoni Tàpies in Barcelona, 20 June 1995. From the left: Wang Gongxin, Antoni Tàpies, Mao Xuhui

working on paintings in which the scissors motif appeared particularly prominently. In June, Mao Xuhui's mindset underwent a visible change when he got the chance to travel with other Chinese artists to the Centre d'Art Santa Mònica in Barcelona to participate in an exhibition entitled "From the Central Kingdom: Avant-Garde Art of China Since 1979" (*Des del País del Centre: avantguardes artístiques xineses*). On this trip, he accompanied Zhang Xiaogang and others in paying their respects to the Spanish artist Antoni Tàpies, whose work had exerted a strong influence on Chinese modern artists, and also visited art galleries in Rome, Florence, Bologna and Venice before returning to China on 9 July. This journey abroad seemed to assuage the long-standing tension, anxiety and sense of oppression from which he had previously been suffering. He started to relax and develop new insights into the "contemporary". In October, he wrote Zhang Xiaogang a letter:

> *It's funny looking back on that successful "international integration": a mix of phone calls, casual chats, creative ideas, followed by more phone calls, booking tickets, moving paintings, packing them up, boarding flights, security checks, setting up the studio, interviews, art and business. Looking at it all now, with everything that came out of the process or was lost somewhere along the way, it all seems so terse and run-of-the-mill. But all of this stuff taking place in the background affects the production of a work of art, as well as the artist's state of mind and confidence. This is what the contemporary era is like: arriving all of a sudden, like a passing breeze.*
>
> *This makes me think of the artists in the 1980s and their integration into society: drinking, smoking, reading, talking, painting, packing, taking trains, riding tricycles, making manifestos, giving speeches, exhibiting, drinking again, writing, painting, fucking. . . and not much else.*
>
> *With the convenience of transportation and communication in the contemporary era, "opportunities" appear with a flash and disappear just as quickly—grab hold of one and your work establishes a relation with reality. The so-called artist is just one of countless individual units who, without a relation to society, ceases to exist for that society, in possession of only a "spiritual world" that others know nothing about and have no interest in knowing anything about. In a certain sense, only society can raise the "personal spirit" to the realm of the "human spirit".*
>
> *The contemporary merely tells us that we all live in a society, amongst others in a group. These interpersonal relations are governed by multiple rules, facilities, organisations and institutions. We must endeavour to understand and grasp these social elements if we are to avoid being overwhelmed and severely curtailed by them.*
>
> *The contemporary is a challenge for us all. If we still harbour the desire to convey to the world our personal experience of spirit, then we must embrace this challenge. We have no other choice.*
>
> *Otherwise, we will see a reality riddled with pathologies: disillusionment, irresolution, reproachfulness, futile complaints and perhaps even blaming God.*
>
> *The contemporary does not concern itself with these. It is perhaps a moment of direct confrontation during which we can grasp our own destinies and creatively work with those incomplete conditions reality and society are able to offer us.*

. . .

Perhaps the contemporary requires us to blend our "self" with society to a high degree (which does not at all imply a weakening of individuality).

In this huge society that stretches as far as the eye can see, an individual's taste and perspective are particularly important. Today, we must not only delve into what is personal but also develop a full understanding of the social. It sounds like a game, and it is, but if we play it well, we will bring something new to the world.[9]

There is no better catalyst for the transformation and elevation of one's thought than physical experience. Mao Xuhui's use of the word "game" suggests that changes were taking place in his spiritual world, which was formerly characterised by a sense of stifling oppression. The scissors he painted in 1995 maintained their sharpness, but the works as a whole and the arrangement of items surrounding the scissors began to exhibit an increasingly tranquil temperament as the artist produced a stream of paintings of scissors in various environments and alongside an array of household items. Then, in 1997, scissors started to appear in flat compositions that featured no other object, and in 1998 they started to acquire a symmetrical, decorative quality, with the artist using flat blocks of colour to depict the scissors in a cool and serene manner, even if expressionist brushwork could still be discerned on the blades. After 2000, the scissors Mao Xuhui painted became abstract symbols of calm, symmetry and composure, such that they lost all of their former aggressivity. In November 1998, Mao Xuhui published a text called "Reflecting on the 'Scissors Series'" (*Guanyu "jiandao xilie" de fanxing*):

Since 1998, my artwork has abandoned its former passion in favour of calm indifference, which above all reflects a change in my state of mind. This sober approach suits me better now than the passion and misery championed in the 1980s. In my current state of life, I no longer have so much energy to expend. I have already given up alcohol for health reasons. Many years ago, the power of alcohol helped me get through many frenzied periods.

In this text, Mao Xuhui also writes that what was deeply ingrained in his soul has not disappeared, even if he has moved on from the expressionist texture and brushwork of his previous work, because the images he paints have retained their prominence and become only more vibrant as a result of their sober rendering. He also mentions that there is no specific meaning behind the "Scissors" series, leaving room for anyone to interpret it as they wish: "Contemporary art seeks to create a shared space." He also posits a new explanation for the stripped-back clarity of his recent compositions: "This is the way things often are. Exact things produce ambiguous ideas. Superficial is another word for profound. The meaningless appears meaningful. Is this not what many endeavours in contemporary art are all about?" Here, he clearly articulates that where he had previously shoehorned meaning into his work, he now intended to leave the task of interpreting his art to the viewer. Clearly, Mao Xuhui's conception of the aesthetic had acquired a more contemporary character in comparison to his previous modernist ideas.

From 2000 to 2004, many of Mao Xuhui's compositions featured scissors calmly placed on a canvas lacking background or surrounding elements. Oscillating between warm, grey and cool tones, the scissors resembled a self-portrait, freely placed by Mao Xuhui before the viewer in a manner that betrayed little to no agitation or unease. In 2005, Mao Xuhui revived the Patriarch in artworks that also incorporated everyday objects. The scissors, originally a variation on the Patriarch motif, might appear in the same space as the Patriarch, alongside silk banners symbolising, despite their usual association with officialdom, the artist's thoughts about the glory of life). A Patriarch painted in 2006 appears on a small, isolated island against an ominous backdrop and sky. It was also in this year that the artist returned to Guishan in the visual form of scissors, producing a nostalgic series of landscape paintings that channelled his youthful sentiments about the region. In the years that followed, Mao Xuhui returned variously to the visual schema of different periods in his artistic career, applying daubs of his new emotional tenderness to various compositions, be they of scissors, chairs, flowers, birds in the sky, forests, human bodies, dramatic landscapes or people wearing surgical masks. In 2021, he reflected once more upon Guishan, the goat and spirits glimmering in the night. The origin of that glimmering light was both the eyes of goat and spirits wandering in the night, but it also emanated from the heart of the artist himself. It was what he called that "immaterial light".

It was a period in which the sky was filled with fragments from various historical eras. Unlike the hopeful years of youth, it was difficult to be sure which of those fragments were worth retrieving and returning to, or how much meaning remained worthy of consideration at all amongst the debris filling the grey sky.

Recently, for a range of complex reasons, compounded by the arrival of the COVID-19 pandemic in everybody's lives, Mao Xuhui has rarely gone out to socialise with friends, let alone to observe the city landscape. However, as usual, he frequently climbs the creaking steps that lead to his studio in Kunming's Chuangku Art Center to immerse himself in painting. He is a painter who has long distanced himself from the fashionable topics and popular tastes of the art scene, a man who, judging from art history, when he's not in his studio, is likely to be on the way. He has no interest in what goes on beyond the walls of the Chuangku Art Center. His attention is confined within narrow bounds where it is free to focus on his personal experience and the everyday questions he ponders. *Winter Corridor* (*Dongtian de zoulang*) is the logical consequence of such contemplation. Next to a sketch Mao Xuhui made of this work, he wrote the following:

> *I have not painted something distant*
> *Everyday existence won't let me go*
> *I could perhaps change how I live*
> *Leave my present environment, the sights I know*
> *That would be a big move*
> *Guishan counts as somewhere distant*
> *Chuangku is my everyday*
> *I've seen this corridor for almost twenty years*
> *It's a miracle it hasn't collapsed yet*

Dizzying abstract paintings and cutesy cartoon images abound in art today, a time when the inner feelings of someone like Mao Xuhui can seem anachronistic. The surroundings of Mao Xuhui's studio act as a familiar symbol of his youth. The environment, from the corridors to the arrangement of buildings that form the Chuangku Art Center complex, is very similar to that in which he lived and worked as a young man, from the redbrick buildings, iron fencing and asbestos-tiled rooves to the ubiquitous tangle of electrical wires and the ghostly cats prowling at night. The only difference is, in the 1980s, the redbrick walls contained eyes peering out at the world. What remains of that time is the further deterioration of symbols that began to fade long ago. This grey world no longer spares a nook for inquisitive souls. The cat's free-roaming spirit has replaced the human world as the only remaining vitality left in Mao Xuhui's surroundings, evoking memories of the past, connecting life experiences and situations spanning decades, and occasionally arousing a rare quivering in this artist's heart. To be in such an environment, the artist speculated one day, resembles reincarnation. Today, aside from the insurmountable fortress of his physical surroundings, the speed and breadth of communication technology are sufficient to instil in Mao Xuhui more generalised historical sentiments than he had in his youth. He finds it difficult to dampen the mental resonance of such information, which has affected his historical psychology—from the Russia-Ukraine conflict to the impact of war on human life, and the artist's evasion or even rejection of his formerly unwavering aesthetic judgment of Russian literature and art.[10]

Winter Corridor is one of the more art-historically significant of Mao Xuhui's recent paintings. He draws from tales from his past, his uninterrupted inner monologue, the miraculous decades-long uniformity of his work environment and notes in his diary about spiritual life, portraying them on the canvas with brushwork of unparalleled freedom. The tone and mood of the work, combined with the unrestrained spontaneity of his brushstrokes, results in an expressionist work that reflects the eternal aspects of the soul. Completed around the same time as *Winter Corridor* are two works titled *October and Cat on Roof: Diptych* (*Shiyue ji wuding shang de mao: erlianhua*) and *World of the Tabby Cat* (*Huamao de shijie*), which are equally adept at conveying spiritual messages through the superficial sheen that masks the ruins of our age. They form a stark contrast with the glimmer and commotion of the world around them. Mao Xuhui began working on the draft for *Winter Corridor* in autumn (specifically October 2022):

> *old heavy autumn, when the sun evades your grasp*
> *on the glass, ambiguous light lazily*
> *dazzles*
> *past and future swinging in this ambiguity*
> *the notion of the hero now antiquated, the river and its countless*
> *legends have become inexplicably silent and dull*
>
> *. . .*
>
> *the autumn sun was never able to raise its head, so let us wait for winter* [11]

It was in this mood, on 31 October 2022, that Mao Xuhui produced a sketch of *Story of the Chair* (*Kaobeiyi de gushi*), a composition featuring a symbol

he had used for many years. It depicted three chairs, the first upside-down, the second "kneeling" and a third standing upright. Here we see the artist returning to his early-1990s explorations of the Patriarch theme. Clearly, for Mao Xuhui, history is a continuum: although the games of the past might be over, a certain inner force or power persists eternally.

As night fell one evening in September 2022, Mao Xuhui began observing the cats that roamed all over the Chuangku Art Center. This was the moment cats became the protagonists of his sketches, a change exemplified by the cat's prominent position in *Winter Corridor*. Cats had come to his attention in earlier works but always as part of the everyday environment, a city inhabitant amongst many. Cats are often associated with nocturnal activity, and they reminded Mao Xuhui of the Romani people, a group with traits Mao Xuhui had always unconsciously admired. Cats feature in numerous sketches Mao Xuhui has produced of the Chuangku Art Center. He even devoted a lot of time to observing their behaviour so as to improve his depictions of them, although naturally he continued to adopt expressionist techniques to portray their presence, turning to what he learned from studying calligraphy to draw connections between the cats as dynamic symbols.[12] This has led to works in which the relation between cat and environment is completely self-contained, as can be seen in *Brushstrokes and Night Cats* (*Bihua yu yemaozi*):

Cats and redbrick buildings or asbestos-tile roofs are all products of the same being. There are all kinds of cat here: black, white, tabby. They constantly regenerate, breed with one another and compete for territory. They also sunbathe together and shit all over the place together. What they do at night, once I've returned home, I genuinely do not know. Some people feed them; others kick them. I belong to the former category. When eating, cats purposefully maintain a certain distance from us, not closing themselves off until they have gotten what they want, at which point they leave, showing no mercy. A cat can endure all this. I certainly wouldn't be able to.

In the 1980s, in the urban environments that Mao Xuhui painted, humans were the main characters, be they in rooms, lying on concrete slabs or amongst clusters of buildings, and their vulnerable position or state in society was often conveyed by way of their nudity. At the time, he was primarily concerned with human issues, but today, Mao Xuhui is no longer interested in elucidating the human. In works like *Winter Corridor*, the artist informs us that the human has become dispensable, whereas cats, as animals, have become living things full of vitality that transcend the human:

About cats: they are lonely walkers
They can endure solitude and darkness
In a certain sense, the cat is my idol[13]

Human issues now seem to be outdated. Although in the 1980s he was involved in frequent and heated theoretical and speculative discussions about

the human, today the individual seems to him to be of very limited capacity, at best formulated in terms of the "submission" of "ideals and the will". Mao Xuhui's intent study of cats on the other hand has elevated them to a symbol of human survival, as he wrote below a sketch of a corner of Chuangku Art Center: "The status of stray cats mirrors that of human civilisation."

Unlike many artists who confine themselves to considerations of form and visual language, Mao Xuhui's sense of art's potential has always lain in his understanding of society and the world. He is only too familiar with recent history and the tendency towards the conceptual in contemporary painting, but abandoning the traditional "hand-drawn" approach to painting would of course have been an insurmountable challenge for an expressionist painter like Mao Xuhui. The COVID-19 lockdown made him think about how to "liberate the body, let go and just act", which he related to what was happening around him: "A lot of the best effects come from liberated movement. Lift the restrictions! Remove all controls!" Unaffected by outside influence, he continued to assert that, "Painting is a craft that constantly generates experience."

It was a sunny day on 24 December 2022 and Mao Xuhui, having spent several days suffering at home after getting COVID-19, returned to his studio. It was in the period that followed that he put the finishing touches on paintings like *Winter Corridor*.

During the first two years of the COVID-19 pandemic, Mao Xuhui found himself unable to let go of familiar motifs from his earlier work, not because of any particular obsession with chairs, goats or Guishan as such, but because of the inner emotional power they exerted on him as an artist of calligraphic expressionism. Towards the end of 2021, Mao Xuhui returned to two lost paintings—*Guishan Collection: Four Goats in the Sunset* (*Guishan zuhua: xiyangxia de si zhi yang*) and *Red Mother Earth: Beckoning No. 2* (*Hongtu zhi mu: zhaohuan zhi er*)—recreating them on a much larger scale than the originals. This fondness for the past was not simple nostalgia but rather an opportune expression of the enduring passion that had not vanished from his soul. Returning to these old works inspired him to paint the "Luminous Goats" (*Faguang de yang*) series of paintings, which differ from the natural primitive style of his early "Guishan" pieces by infusing the goats with light. He has continued to view the goats in his paintings as embodiments of the soul: lonely beings in the dark that ultimately succumb to death. When humans die, however, cats will take their place as embodiments of life's intelligence and resilience, leaping through the night. Such symbolism reveals what continues to inspire and comfort Mao Xuhui.

One can imagine how the black, white and tabby cats roaming the Chuangku Art Center might have drawn the artist's attention from symbolic goats to his current and inescapable surroundings. As the COVID-19 pandemic descended upon the world, Mao Xuhui's strict confinement within a sensory space filled with tangled electrical cables, asbestos roof tiles, redbrick buildings—in short, the dilapidated remains of the previous era's socialist architecture—furnished him with a new awareness of the world in which he lived. He knew that not everything had been changed by the previous few decades and that we continued to be enclosed

within our historical context. This was the main reason he started painting the Chuangku Art Center. He realised that despite the passage of time, he had still not broken free from these familiar surroundings—the dogged persistence of this cluster of deteriorating buildings and the disorderly scenes of life unfolding within. These urban scenes, composed of brushstrokes born of the needs of the heart, form a response to the red-brick buildings of his 1980s "Personal Space" series that seems to draw this aesthetic line of inquiry, rich in concern for the historical and social, to a close. In terms of painting, this work allowed Mao Xuhui's art to enter a phase of greater self-liberation.

Concerns about the fate of painting began with modernism and doubts about its value persist to this day. Of course, when it becomes universally accepted that painting is about producing pretty patterns, when the painter's hand can no longer convey the tremors of the heart, when standing before a painting one cannot see the artist's concern for humanity, then painting will indeed have died. At the end of the day, it is the needs of the heart that give rise to the human need for painting. As a painter, Mao Xuhui remains concerned with the human and the status of the self. In his applications of paint on the canvas, he has never stopped striving to convey the sensitive and complex flutters of his mind. The subject of his painting has always been his inner world because he believes that a painter's task is to study the self. "All I've done is consistently focus on this person I am to see if I can't squeeze something interesting out of him."[14] On the first day of March 2022, Mao Xuhui drew a gloomy and terrified sketch of goats in his notebook, above which he wrote, "The Russia-Ukraine war has already entered its fifth cruel day. The unease and turmoil in the world are palpable." The goats Mao Xuhui paints have clearly become something more than mere symbols of memories of Guishan.

We can see once again in Mao Xuhui's recent works that he has indeed put everything into painting. "A painter lives in his painting. If he stops painting his life comes to an end."[15] He also wrote, "Painting is a painter's utopia, a place he can always go in the future. A painter who has died continues to live in his artworks. He is always there. You can still encounter Beethoven, Chopin and Rachmaninoff whenever you want. Just listen to their music and they're there."[16]

There is an old man in *Winter Corridor* whom we can understand to be Mao Xuhui, or perhaps his generation. On the other hand, perhaps he is just a man standing in a corridor, a soul resting amongst ruins.

[1] Lü Peng, ed., *Winter Corridor: Mao Xuhui's New Works* (*Dongtian de zoulang: mao xuhui de xinzuo*), (Beijing: China Book Publishing House, 2023).

[2] Translator's note: The "new-born generation" was the phrase used to describe artists born after the mid-1960s, the first generation whose formative experiences took place primarily *after* the end of the Cultural Revolution. Unlike artists born in the 1950s like Mao Xuhui and Zhang Xiaogang, the new-born generation never served as Red Guards or lived in the countryside as sent-down youths, and as such there was a significant gulf of experience between the two generations.

[3] The green 1991–92 notebook.

[4] Ibid.

[5] Ibid.

[6] From a draft of a letter written by Mao Xuhui to Zhang Xiaogang in June 1992.

[7] On 4 May 1992, Zhang Xiaogang wrote to Mao Xuhui: "The day before yesterday, after a discussion the three of us (Wang Lin, Ye Yongqing and I) had at Wang Lin's place, we came to the conclusion that establishing a new 'group' might look like we're trying to re-enact the New Wave, but putting on an exhibition on the other hand is a necessary and urgent historical mission. After much deliberation, Wang Lin proposed the name 'Experiences of China'." (Unpublished letter.)

[8] Translator's note: "Half the Sky" (*banbiantian*) is an allusion to the Mao Zedong quote, "Women hold up half the sky". The television programme aired for the first time on International Women's Day in 1995 and focused on women's issues and gender equality.

[9] Letter from Mao Xuhui to Zhang Xiaogang, 2 October 1995.

[10] During the Russia-Ukraine war, Mao Xuhui wrote the following: "I will re-evaluate Russian culture. By the end of the war, I will give myself an answer. Russian literature and music once deeply touched my soul, but now I find myself unsteady on my feet, my thoughts clouded and heavy."

[11] The poem is dated "*Renyin* year, second day of the tenth month" (Translator's note: This date from the lunar calendar corresponds to 26 October 2022.)

[12] Mao Xuhui wrote: "Calligraphy technique remains an important element in painting. It has a rich and vivid expressivity. I've been doing calligraphy over the last few years, drawing some characters, and have discovered that my brush hand has become steadier and my brushstrokes more assured."

[13] Dated 31 August.

[14] Dated 17 February 2022.

[15] Dated *Xinchou* year, fifteenth day of the twelfth month (17 January 2022).

[16] Dated *Xinchou* year, eighth day of the tenth month (12 November 2021).

Chapter 5

Immaterial Light

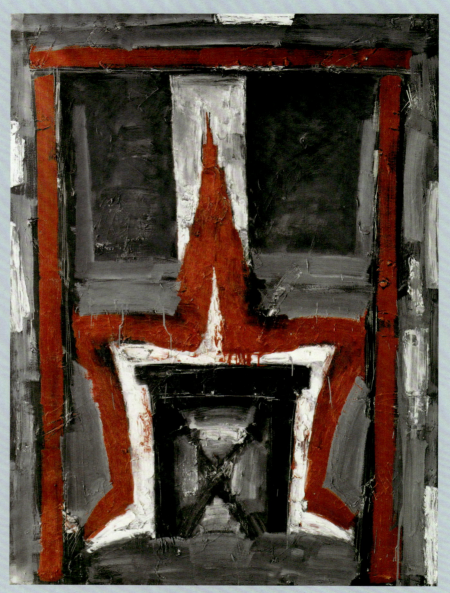

Mao Xuhui
Vocabulary of Power Series (Quanli de cihui zuhua), 1993
Oil on canvas, 180 × 130 cm

Chapter 5

Immaterial Light

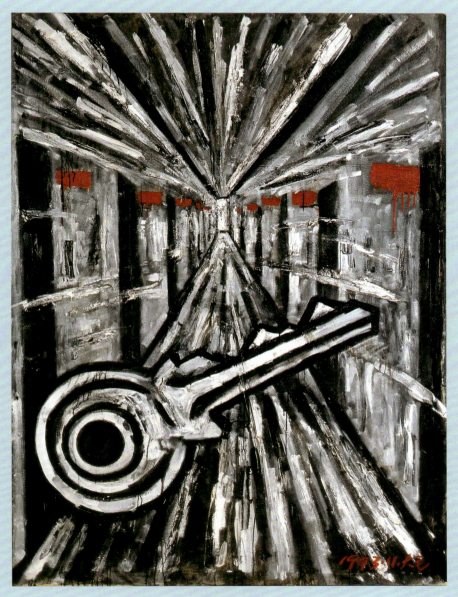

Mao Xuhui
Vocabulary of Patriarchal Power (*Jiazhang quanli de cihui*), 1993
Oil on canvas, 180 × 130 cm

Chapter 5

Immaterial Light

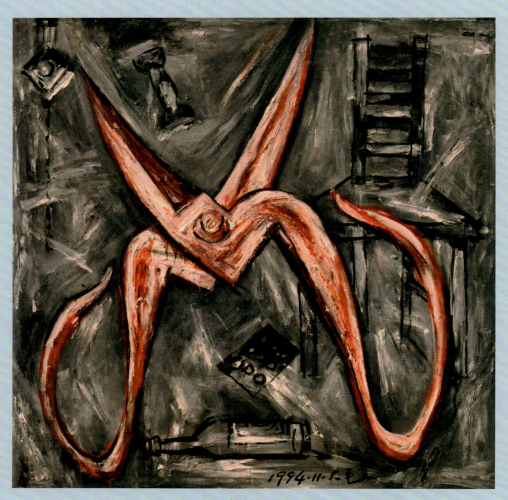

Mao Xuhui
Everyday Epic: Scissors (Richang shishi: jiandao), 1994
Oil on canvas, 140 × 140 cm

Chapter 5

Immaterial Light

Mao Xuhui
Everyday Epic: Scissors and Hallway (Richang shishi: jiandao he zoulang), 1994
Oil on canvas, 150 × 180 cm

Chapter 5

Immaterial Light

Mao Xuhui
Glory: Rain Season (Guangrong: yuji), 2005
Oil on canvas, 180 × 140 cm

Chapter 5

Immaterial Light

Mao Xuhui
Twilight of the Patriarch: Desert Island No. 5 (Jiazhang de huanghun: gudao zhi wu), 2006
Oil on canvas, 195 × 200 cm

Chapter 5

Immaterial Light

Mao Xuhui
Scissors, Guishan Dream, Torch Fruit (*Jiandao, guishan zhi meng, huobaguo*), 2006
Oil on canvas, 130 × 160 cm

Mao Xuhui
Two Chairs and Camellia (*Liang ba kaobeiyi he shanchahua*), March 2016–September 2017
Acrylic on canvas, 120 × 160 cm

Chapter 5

Immaterial Light

Mao Xuhui
Luminous No. 5 (*Faguang de zhi wu*), 1–20 May 2022
Oil on canvas, 165 × 205 cm

Chapter 5

Immaterial Light

Mao Xuhui
Winter Corridor (Dongtian de zoulang), November 2022–March 2023
Oil on canvas, 185 × 155 cm

Mao Xuhui
October and Cat on Roof: diptych (Shiyue ji wuding shang de mao: erlianhua), October–November 2022
Oil on canvas, 155 × 185 cm each

Chapter 5

Immaterial Light

Mao Xuhui
World of the Tabby Cat (*Huamao de shijie*),
12 October 2022–8 February 2023
Oil on canvas, 185 × 155 cm

Mao Xuhui
Story of the Chair Draft (*Kaobeiyi de gushi caogao*), 31 October 2022

Mao Xuhui
Brushstrokes and Night Cats (*Bihua yu yemaozi*),
27 August–6 September 2022
Oil on canvas, 155 × 185 cm

Chapter 5

Immaterial Light

Mao Xuhui
The Lost Four Goats (*Yishi de si zhi yang*), December 2021
Oil on canvas, 150 × 180 cm

Chapter 5

Immaterial Light

Mao Xuhui
The Lost Mother Red Earth (*Yishi de hongtu zhi mu*), December 2021–April 2022
Oil on canvas, 155 × 185 cm

POSTSCRIPT

Johan, who had been talking until he was blue in the face, now opened the window and looked out over the landscape, how the sun shone on the Säntis and Glarus Alps, while the whole valley below resounded with song, barking and yodelling.
"Write down what you have said if you dare!" said his friend.
"Yes, I will", replied Johan, "and that will be the end of the fourth part of The Son of a Servant."
"And the fifth? What will that be about?"
"Ask the future!"[1]

As Strindberg himself explained, *The Son of a Servant* (one of Mao Xuhui's favourite novels) "is not a confession written in the hopes of receiving others' forgiveness, nor is it mere memoir written to while away the time. Right now, there is a generation of young people about to embark on their lives who will need something to explain the present age. This book will help them better understand the times in which they live." Having finished *Bloodlines: The Zhang Xiaogang Story*,[2] I decided to start writing *Emergence of the Patriarch: The Mao Xuhui Story*, despite significant time constraints, not simply to give readers a biographical account of an artist born in the 1950s but, more importantly, in the hope of using Mao Xuhui's personal documents and materials to return to a period of history. Although this period of art history contains numerous artists and critics and cannot be reduced to the achievements of an individual, focusing attention on a single artist can shed light on the psychologies and nuances that propelled an era's culture. People like to imagine the rich complexity of history, perhaps even its unknowability, but history in itself should not be considered something mystical. History must always be elucidated concretely through writing, its contours delineated clearly and comprehensively through the accumulated study of various individual cases. History is often presented in a generalising and monotonous fashion as something self-evident, which leads people to make historical judgments lacking in nuance and insight. Such a situation requires that we focus our energies and attention on history in the hope of unearthing previously obscure historical facts. Only then can we build a great edifice of history in which to linger and contemplate the unending questions of our age. This work is also important, as Strindberg tells us, to help the next generation of young people understand that their life and work take place entirely within this edifice.

 History has always continued uninterrupted, unfolding through the lives and affairs of living people. Lord Acton once wrote, "Ultimate history we cannot have in this generation; but we can dispose of conventional history." I have written the story of Mao Xuhui precisely to dispose of conventional history and help people better understand the history they ought to know!

 Most artists have long-held artistic principles. Perhaps the fruits of his or her initial encounter with art, these principles later grow into the artist's personal garden of the mind. Mao Xuhui is an artist who has always been fascinated by expressionism, someone with a seemingly innate sensitivity to fundamental human and social questions, even if he never defined himself explicitly as an "observer of the soul".

 The age in which we live (and this of course includes artists) is one of cultural apologism in which the humanities are losing their efficacy.[3] In such an age, experience and norms serve to impede the development of culture. On the one hand, cultural apologism is an epistemological framework that turns culture into a series of formulaic texts, images and objects, thereby completely depriving culture of its fundamental essence—its powers of scepticism and critique. It is also an ethical framework that confines proper action within a superficially conceived notion of "civilisation", covertly stripping life of its right to create freely. Most importantly, cultural apologism is also a political tool and force that swathes society's debilitating

wounds with the ideological bandages it calls culture. In short, cultural apologism denies us the possibility of exposing and resolving the various problems life faces. But never before have we seen life confronted with such a wide range of urgent problems, an array of difficulties that constantly drain life of its vitality. How to make life possible again becomes a fundamental question facing those who live in such an age, and Mao Xuhui is one of the few cultural figures engaging with this question. Evidently influenced with regard to approach and perspective by ideas from other cultures, he shows us through his work that our problems can only be resolved by picking at society's wounds. There are clearly numerous discrepancies between the cultural reality in which Mao Xuhui lived and the ideas of Western figures like Nietzsche, Sartre and Hesse from whom he drew inspiration. Cultural apologism tells us that a culture's problems can only be solved by its own methods of reasoning, that it ought only to resort to its own mechanisms to perfect and repair itself. Of course, to find examples of culture "perfecting" and "repairing" itself, one need only turn to living memory.

Significantly, from the very beginning of his career, Mao Xuhui has levelled his powers of critique at the self. By dissecting the self, he lays life bare for audiences to see it in all its infirmity. He tells us that there is a certain wickedness to the fundamental impulse that arises from the soul, but it is also full of vitality, a reason for hope; that the "ideals" touted by the cultural apologists are more lacking in authenticity than the nihilism they condemn; that our "personal spaces", although insignificant individually, taken together form one of the driving forces behind the development of society as a whole; and, finally, that the resolution of cultural questions must fundamentally return to the resolution of human questions.

Any value judgments of cultural activity must be relative, but this does not mean that the power of relativity can be possessed by anybody. Since we understand cultural mutation (mutation and death are the only two possibilities available to culture) to be an attempt on the part of the individual to change his or her mode of existence through creative work, then we can say with certainty that art has absolute cultural significance. It is precisely the seemingly insignificant work of artists and intellectuals like Mao Xuhui that changes people's perceptions and ways of seeing the world. Artists cannot implement specific changes in people's lives and environments for them, but they can provide a little medicine for the mind.

[1] Translator's note: As previously mentioned, given the discrepancy between the English translation of Strindberg's The Son of a Servant and the original, we have here translated directly from the Chinese. See Nüpu de erzi, trans. Gao Ziying (Beijing: People's Literature, 1982), pp. 685–86.
[2] Translator's note: See Lü Peng, Bloodlines: The Zhang Xiaogang Story, edited by Rosa Maria Falvo and Bruce Gordon Doar (Milan: Skira, 2016).
[3] Translator's note: Initially a term used by Chinese scholars to describe advocates of culture's importance in nineteenth-century Britain like Thomas Carlyle and Matthew Arnold, "cultural apologism" has recently acquired a somewhat different meaning amongst Chinese critics to refer to a view of culture as the more or less unproblematic expression of a region's essence. Cultural apologism therefore entails the promotion of (or apologia for) culture as regional culture; culture that emphasises and consolidates the supposedly essential (and usually positive) characteristics of the region. In the last decade or so in China, the government has become more involved in the cultural and creative sectors, which has resulted in the production of culture being increasingly implemented in the service of the nationalist project. This situation naturally limits the scope of artistic expression and leads to a certain degree of cultural homogeneity, which is what the author is elliptically referring to here with the term "cultural apologism".

BIOGRAPHICAL NOTE

Lü Peng is a leading Chinese art curator, critic, and historian.

Born in Chongqing, Sichuan, in 1956, he graduated in Political Studies from Sichuan Normal University in 1982. From 1982 to 1985, he was the chief editor of *Theater and Film* magazine, and from 1986 to 1990, he served as Deputy Secretary of the Sichuan Dramatists Society. In 1992, he was appointed Artistic Director of the First Guangzhou Biennial Art Fair, China's first art biennial.

Lü's notable curatorial projects include *A Gift to Marco Polo*, a collateral event at the 2009 Venice Biennale; *Reshaping History* (Beijing, 2010); *Pure Views: New Painting from China* (Louise Blouin Foundation, Frieze, London, 2010), followed by *Pure Views* at the Asian Art Museum in San Francisco in 2011; the 2011 An'ren Biennale; *Passage to History: 20 Years of La Biennale di Venezia and Chinese Contemporary Art*, co-curated with Achille Bonito Oliva at the 55th Venice Biennale (2013); and *Global Painting. La Nuova pittura cinese* at the Mart in Rovereto (2023).

Lü has also authored several important publications, including *A History of Art in 20th-Century China* (Charta, 2010); *A History of Art in Twentieth-Century China* (New Star Press, 2013); and *Storia dell'arte cinese dal XX al XXI secolo* (Rizzoli, 2024).

Currently, Lü is an Associate Professor in the Department of Art History and Theory at the China Academy of Art in Hangzhou, as well as at the Sichuan Fine Arts Institute, and the Xi'an Academy of Fine Arts. Since 2017, he has served as President of L-Art University.